AFTER THE SILENTS

FILM AND CULTURE

JOHN BELTON, EDITOR

FILM AND CULTURE

A series of Columbia University Press

EDITED BY JOHN BELTON

For the list of titles in this series see page 385.

AFTER THE SILENTS

Hollywood Film Music in the Early Sound Era, 1926–1934

MICHAEL SLOWIK

COLUMBIA UNIVERSITY PRESS NEW YORK

COLUMBIA UNIVERSITY PRESS

Publishers Since 1893

NEW YORK CHICHESTER, WEST SUSSEX

cup.columbia.edu

This publication has been supported by AMS 75 PAYS Endowment of the American Musicological Society, funded in part by the National Endowment for the Humanities and the Andrew W. Mellon Foundation.

Library of Congress Cataloging-in-Publication Data

Slowik, Michael.

After the silents : Hollywood film music in the early sound era, 1926–1934 / Michael Slowik.

pages cm. — (Film and culture)

Includes bibliographical references and index.

ISBN 978-0-231-16582-2 (cloth : alk. paper)—ISBN 978-0-231-16583-9 (pbk. : alk. paper)— ISBN 978-0-231-53550-2 (ebook)

1. Motion picture music—United States—History and criticism. I. Title.

ML2075.S63 2014

781.5'42097309042—dc23

2014009771

Jacket image: *Love Me Tender* (1932) © Paramount Pictures/Photofest

References to websites (URLs) were accurate at the time of writing. Neither the author nor Columbia University Press is responsible for URLs that may have expired or changed since the manuscript was prepared.

To my parents, for a lifetime of love and support, and

To my wife, Amy—the Nora to my Nick

CONTENTS

ACKNOWLEDGMENTS

I OWE SPECIAL THANKS TO A NUMBER OF PEOPLE WHO HAVE assisted with this project. First, I must acknowledge my wonderful thesis committee at the University of Iowa. Corey Creekmur suggested useful ways to approach the topic, helped me obtain key film resources, and provided a particularly penetrating response to an early draft. Kim Marra raised important questions and offered a careful reading of the theater-related sections of the book. In the University of Iowa's School of Music, Bob Cook carefully read the early chapters, alerted me to new music sources, and offered numerous suggestions for sharpening my musical analysis. Happily, midway through this project the University of Iowa hired film music specialist Nathan Platte, and this project has benefited immensely from his expertise, insights, and probing questions.

My biggest debt at Iowa, however, is to Rick Altman, who went beyond the call of duty for me even before I arrived at the university. He remained the model of a generous and dedicated adviser, lending me sheet music and videos and eventually giving me an enormous collection of film sound material; reading drafts of my articles; responding promptly to my inquiries; providing rapid yet thorough responses to every chapter; and connecting me with key scholars. His film sound courses and penetrating

scholarship were major catalysts for this project, and I benefited tremendously from his commitment to it.

Many other individuals have been involved with this project at various stages and deserve acknowledgment here. My thanks to Steve Choe for offering several key ideas for framing the project, Nicole Biamonte for providing encouragement and advice during the early stages, David Mayer for offering helpful suggestions, and Michael Pisani for taking time out of his busy schedule to assist me with the complex topic of musical accompaniment in theatrical melodrama. I presented parts of this project in many different places and contexts. For their helpful and encouraging responses I especially thank Andrew Ritchey, Kyle Stine, Jeff Smith, and my wonderful colleagues at San Diego·State University: Greg Durbin, Mark Freeman, D. J. Hopkins, Paula Kalustian, and Martha Lauzen. I also wish to thank Katherine Spring for inviting me to present on a terrific panel on early sound film music at the 2013 Society for Cinema and Media Studies Conference.

I wrote much of this book while I was on a Ballard Seashore Dissertation Completion Fellowship, and I wish to thank the University of Iowa Graduate College for providing this fellowship. I am also grateful to San Diego State University for awarding me money through the University Grants Program to help offset the cost of illustrations and indexing. On my research trips to Los Angeles, Jeannie Pool of Paramount Pictures not only provided a wealth of valuable resources but also helped with the logistics of the trip and even gave a private tour of the Paramount Pictures lot. At the Warner Bros. Archives at the University of Southern California, Jonathon Auxier and Sandra Joy Lee Aguilar responded promptly to my numerous inquiries and helped set up two productive research visits. My thanks also to Shannon Fife and the legal staff at Warner Bros. for their quick responses to my inquires and for permitting me to use photographs from the Warner Bros. Archives. I received valuable assistance from staff members at Special Collections in the Charles E. Young Research Library at UCLA and the UCLA Film & Television Archive. Thanks also go to Quentin Ring and McKenzie Sweeney, who provided generous hospitality in Los Angeles. On a research trip to the Wisconsin Center for Film and Theater Research, Dorinda Hartmann cheerfully assisted me in a week of film viewing.

I wrote most of the first draft of this book on the campus of Western Kentucky University. I owe enormous thanks to Ken Foushee and Selina

Langford of the university's interlibrary loan program for accommodating a continuous onslaught of requests over the course of two years. Without their help this book literally could not have been written. I also thank the Western Kentucky University library personnel for their willingness to order crucial materials for my project.

Special thanks go to John Belton, Jennifer Crewe, and Kathryn Schell at Columbia University Press for their interest in this project and for bringing it to print. I also thank Joe Abbott for his extremely helpful copyediting, and Roy Thomas for his valuable assistance during the book's production phase. Portions of chapters 3, 5, and 6 appear in "Diegetic Withdrawal and Other Worlds: Film Music Strategies Before *King Kong*, 1927–1933," *Cinema Journal* 53, no. 1 (2013), and portions of chapters 2 and 3 appear in "Experiments in Early Sound Film Music: Strategies and Rerecording, 1928–1930," *American Music* 31, no. 4 (2013). I am grateful to editors Will Brooker at *Cinema Journal* and Neil Lerner at *American Music* for their invaluable editorial guidance.

I wish to thank my parents, John and Lynn, and my brother, Jay, who have encouraged me since the day I decided to pursue this career. Their interest in this project, along with their love and moral support, has helped keep me energized and motivated. Finally, I am indebted, in ways words cannot quite express, to my wife, Amy, who on my behalf endured six years of poverty, months of subzero temperatures, moves to four different states, and endless movie screenings. She has remained a champion, editing all of my writing, offering continual encouragement, sharing her office space, and loving me throughout the process.

AFTER THE SILENTS

INTRODUCTION

IN THE GROWING LITERATURE ON FILM SOUND, NO TOPIC HAS enjoyed more attention than film music. As film scholarship expanded in the 1970s, several writers, recognizing film music to be a crucial means for conveying affect and guiding interpretation, explored the works of outstanding film music composers and offered preliminary histories of film music.[1] The 1980s saw one of the first rigorous theoretical approaches to film music written from within academia,[2] while the 1990s featured many general histories of film music and substantial critical analyses of specific scores.[3] Film music scholarship has continued to blossom in the twenty-first century, with a comprehensive history of silent film sound and several works that bring together the substantial scholarship on film music history.[4]

Given the voluminous literature on film music, the lack of information on the film score in the early sound era is nothing short of remarkable. A fair amount has been written about the history of film music in the silent era (roughly 1895 to 1927), including its influences from prior media and its typical practices in nickelodeons and movie palaces.[5] Substantially more scholarship has been devoted to the "Golden Age" of film music (1935 to 1950)—its scoring practices, techniques, and major

film composers.[6] Yet film music scholars have almost uniformly written off film music in the early sound era (1926 to 1932). Believing the use of "nondiegetic" music (music without a source in the image) in the early sound era to be minimal, scholars have posited a striking narrative in which *King Kong* (March 1933) burst onto the scene featuring a score by Max Steiner that single-handedly revolutionized film music practices and paved the way for the Golden Age.

In fact, many film scores preceded *King Kong*, scores that with rare exceptions have received no attention. Because of this inattention, scholars have mischaracterized the nature of late 1920s and early 1930s sound film and neglected to consider any stylistic trajectory of the film score that may have occurred during these years. Ignoring the early sound era has also precluded any extensive investigation of early film music strategies for conveying emotion, signaling important events, and manipulating audiences into identifying with particular characters or accepting certain ideological positions. Several such experiments are unique to the early sound era, yet their practices remain unexamined. The consequences of this oversight extend beyond film studies. Any historian investigating the importance and function of music in American culture in the 1920s and 1930s faces scholarly literature on the dominant entertainment form that is both inaccurate and incomplete.

To fill this gap in film and music history, this book traces the history of the early Hollywood sound score for feature films between the years of 1926 and 1934. At seemingly every juncture, the story of the early sound score turns received wisdom on its head. Though the early sound era contained less nondiegetic music than did the Golden Age, it still featured a wide array of musical approaches rather than a single-minded avoidance of nondiegetic music. Scholars are in wide agreement that "rerecording"—the merging of separate soundtracks in postproduction—was generally unavailable during the early sound years, thus hampering the industry's ability to use a film score. This project demonstrates, however, that rerecording occurred repeatedly in the early sound era and—at least at the Warner Bros. studio—enabled extensive scores to be utilized as early as 1928. Film music scholars have paid little attention to early sound musicals, yet this study indicates that the musical genre was an important early site of film music experimentation. And while *King Kong* is widely trumpeted for its innovative uses of music, this project indicates that many of its musical strategies fit squarely within sound film traditions established in prior years.

Why has the historical record tended to ignore film music in the early sound era? One must recognize that accounts of the early sound era first emerged from scholars for whom the presentation of a detailed historical record of the period was not the primary goal. Rather, scholars were driven by preexisting standards of artistic value and generally discussed the early sound era only as a prelude to their stated topic: film music in the Golden Age. This tendency took shape in the 1970s, when scholars like Tony Thomas and Mark Evans focused on individual composers and their outstanding works.[7] By privileging individual achievement, these scholars drew on assumptions of artistic worth from established disciplines like musicology and literature, thus marking film music as also being worthy of study and appreciation. This approach was fairly well suited to the Golden Age of film music, which consisted mainly of original music credited to a single composer. The early sound era, however, which featured preexisting music compiled by numerous personnel, constituted a less appealing topic. Since the early sound era was not their central interest, these scholars regularly relied on the recollections of Max Steiner—a prestigious early sound film music composer—to serve as a summation of the early sound era. In particular, the following quotation from Steiner came to summarize virtually the entire early sound era:

> There was very little underscoring (background music) in those days, but chiefly main and end titles (opening and closing music). Recorded music was deemed necessary only for musical productions, such as *Rio Rita, The Street Singer, The Rogue Song* and *Vagabond Lover.*
>
> . . . Music for dramatic pictures was only used when it was actually required by the script. A constant fear prevailed among producers, directors and musicians, that they would be asked: where does the music come from? Therefore they never used music unless it could be explained by the presence of a source like an orchestra, piano player, phonograph or radio, which was specified in the script.
>
> . . . But in the spring of 1931, due to the rapid development of sound technique, producers and directors began to realize that an art which had existed for thousands of years could not be ruled out by "the stroke of a pen." They began to add a little music here and there to support love scenes or silent sequences. But they felt it necessary to explain the music pictorially. For example, if they wanted

music for a street scene, an organ grinder was shown. It was easy to use music in night club, ballroom or theater scenes, as here the orchestras played a necessary part in the picture.

Many strange devices were used to introduce the music. For instance, a love scene might take place in the woods, and in order to justify the music thought necessary to accompany it, a wandering violinist would be brought in for no reason at all. Or, again, a shepherd would be seen herding his sheep and playing his flute to the accompaniment of a fifty-piece symphony orchestra.[8]

The central tenets of this quotation—that the period contained an avoidance of underscoring and an insistence on tying music to image sources—were stated repeatedly in 1970s scholarship and have remained staples of more recent film music studies.[9] For instance, the 1980s and 1990s saw the release of three excellent theoretical and historiographical works on film music: Claudia Gorbman's *Unheard Melodies*, Kathryn Kalinak's *Settling the Score*, and Royal S. Brown's *Overtones and Undertones*. Yet because of these scholars' heavy focus on the Golden Age of film music, even these otherwise strong books feature only brief passages on the early sound era that largely reiterate the claims first advanced by Steiner.[10] Such claims about the early sound era continue in the most recent scholarship. Mervyn Cooke's *A History of Film Music*, for instance, notes a "stark avoidance of nondiegetic music in the early years of sound film."[11]

It is easy to see why Steiner's account has proved so compelling to film music historians and theorists alike. Steiner's account is witty and striking, thus serving as an excellent means to quickly summarize a period, as well as liven up a historical narrative. Moreover, Steiner himself—a prolific composer who created many scores in the early sound era—would seem to be a valuable source, able to provide hands-on facts about music in the early sound era. But Steiner's account demands a far more skeptical reading than it has been given. Steiner, in this and other writings, posits a "Great Man" theory of historical change, in which he himself is the Great Man. According to the "Great Man" theory, lone individuals are responsible for leaps forward in artistic sophistication. Positioning himself as a pioneer of nondiegetic music, Steiner is eager to claim that nondiegetic music was simplistic and impoverished prior to his innovations. Elsewhere in the same account, Steiner argues that his miniscule score

for *Cimarron* (January 1931) caused a sensation in *Variety* and the *Hollywood Reporter* reviews, that his score for *Symphony of Six Million* (April 1932) "opened up the art of underscoring," and that *King Kong* saved RKO from failure thanks implicitly to the score.[12] Steiner's claims are plainly designed to emphasize his own historical importance to the development of sound film music. Though many scholars have pointed out the drawbacks of the Great Man theory—including its too-easy causality and avoidance of broader historical contexts[13]—Steiner's Great Man approach continues to be a driving force in accounts of music in the early sound era.

This is not to dismiss Steiner's musical contributions, which were indeed substantial, but rather to point out the drawbacks of taking Steiner at his word and treating him as the sole innovator of film music in the early sound era. Indeed, even when scholars acknowledge the early presence of nondiegetic music, they often reiterate the assumption, found in Steiner's memoir, that such music was in a primitive state before Steiner's contributions. The terminology employed by scholars frequently lays bare such assumptions. For example, one scholar claims that Steiner's score for *Symphony of Six Million* was the first "full" score.[14] When compared with the Golden Age's more extensive use of nondiegetic music, some early sound scores might well be called less than "full," but such a statement marks a refusal to consider the early sound period on its own terms. *Full* here is a comparative adjective, not an absolute one, and the comparison is to the Golden Age of film music. Neglecting to compare early sound scores to anything other than the subsequent Golden Age, many scholars have labeled the early sound cinema "primitive" and have closed off an entire period of study.[15]

To date, James Wierzbicki's *Film Music* remains the primary exception to this tendency in film music histories. Recognizing that film music from the early sound period constitutes a neglected area, Wierzbicki devotes an entire chapter to films produced by Vitaphone and Movietone, and another to the early sound score up to *King Kong*. Wierzbicki's book thus offers a bold step toward building an awareness of music in the early sound era. Yet by Wierzbicki's own admission, his study contains no close analyses of particular scores, relying instead on contemporary articles from the period. Though such articles are valuable, the study's absence of close analysis causes the actual music practices during the early sound era to remain undefined. Likely owing to this inattention to the films

themselves, Wierzbicki ultimately reasserts the familiar yet problematic claim that *King Kong* "solidly established the . . . model that Hollywood film music would follow for the next several decades."[16]

Close attention to the aesthetic practices of the early film score is needed, along with an approach to the topic that avoids the methodological blind spots that have precluded serious consideration of these films. Four components of this study enable a more thorough examination of the early film score.

The study aims for comprehensiveness. Too many studies of film music draw on the same few films when describing the early sound period. After paying lip service to a few of the earliest synchronized scores (namely *Don Juan* [August 1926] and *The Jazz Singer* [October 1927]), alluding to a few of Steiner's pre–*King Kong* scores, and mentioning the continuous music used in *City Lights* (January 1931) and *Tabu* (March 1931), scholars then move quickly to a sustained consideration of the Golden Age of film music. This study instead captures the broad range of strategies on display in the early sound era. To obtain a filmography, I have read through every entry in the *American Film Institute Catalog* from 1926 to 1934 and noted each film that contained any sort of music credit. The resulting study is the product of viewing 240 films from this period. In these pages the reader will not find one central "representative" film but rather a series of brief case studies illustrating the diversity of musical approaches on display during the early sound era. The analyzed films include major releases like *The Big Trail* (October 1930) and *Trouble in Paradise* (October 1932), as well as lesser-known films like *The Squall* (May 1929) and *Party Girl* (January 1930). If we hope to gain a full understanding of the usage of the film score during the early sound era, nothing but a comprehensive examination will suffice.

The study grounds the score within its historical context rather than analyzing film music in terms of subsequent practices. Many film music histories implicitly justify their lack of attention to the early sound era by claiming that film music was in its infancy during the early years and by pointing to its deficiencies vis-à-vis subsequent practices. This study instead historically situates the early sound score within the practices and assumptions of the period in which it was made. Rick Altman's concept of crisis historiography offers a particularly useful "from the ground" approach to the topic. Crisis historiography hypothesizes that new technologies undergo three processes. First, because a new technology is not immediately understood as a separate, unique entity upon its first iteration, it

draws on existing practices to define itself. A nascent technology thus features "multiple identities." Second, these identities—derived from a jumble of disparate prior practices—come into conflict with each other. Such "jurisdictional conflict" can take the form of literal skirmishes between competing user groups or metaphorical conflicts in which differing representational practices seem to vie for prominence. Finally, a technology adopts familiar, durable features that satisfy a wide array of users. Through these "overdetermined solutions" a technology's new identity becomes clear.[17]

More than merely a theory of how a new technology evolves, crisis historiography demands that the historian reframe the very research questions to be asked. Instead of seeking to trace only the historical trajectory that will become dominant practice, the historian must consider the assumptions held by the user of a new technology *before* that technology's ultimate identity becomes clear. The user's assumptions may differ from the technology's eventual dominant use, but they are no less important to an understanding of a period's representational practices in their entirety. Following crisis historiography's mandate, this project's central question is not "How did early sound film music practices evolve into the practices of the Golden Age of film music?" Focusing on this question threatens to erase from the historical account any practices that did not survive beyond the early sound era. Instead, the question I ask is "What factors caused the early sound score to be used in a multiplicity of ways?" Only by taking a view "from the ground" can one hope to fully grasp the range of problems and solutions offered by early sound film practitioners.

The study attends primarily to music's relationship with image and narrative. In the past several decades film music scholarship has benefited considerably from sophisticated musical analysis. Though this study includes some analysis of musical composition techniques, its primary focus is on the logic relating music, image, and narrative. During the transition to sound, many of the key music questions pertained less to composition techniques than to the basic properties, functions, and parameters of the sound score. In particular, as film music practitioners sought to define the film score in the early sound era, they had to reconsider music's relationship to the diegetic world (the narrative world) presented by the image. In the late silent era, music played even when the image provided no diegetic justification. The sound film, however, introduced new questions for film music. If a "sound film" was understood as a medium that presented

sounds emitted by the image, what was accompanying music's role? Did a "sound film" feature an exclusively diegetic sound space, or could nondiegetic music enter this space? If nondiegetic music could exist in the sound film, to what extent and for what purposes could it be used? In the early sound era, film music was a central player in efforts to define the representational boundaries of sound film itself.

In addition to investigating music's diegetic and nondiegetic identities, this book examines other basic yet important questions pertaining to music, image, and narrative. How much music is used in a film? What logic determines when music is heard or not heard? In what ways is music adjusted in order to share sonic space with dialogue and sound effects? Are musical motifs used, and if so, for what purposes? How noticeable is the music? How do different musical styles impact the viewing process? Though such questions seem simple, they are crucial for understanding the origins of sound film scoring, and they reveal much about film music's potential to generate affect, channel narrative information, and guide interpretation. The multitude of responses to these questions in the early sound era has relevance not only for those interested in appreciating film music but for anyone seeking to understand the manipulative strategies taken by a dominant mass entertainment form.

The study considers the score's impact on film audiences. Many studies approach film music exclusively from the perspective of the filmmakers. The *audience's* musical background and likely response to film music is seldom taken into consideration. There are reasons for this omission: it is much harder to make accurate statements about a large population than it is to examine the background of the few individuals producing the music, and firsthand testimonials regarding film music's impact are scarce. Yet the issue of audience response cannot be ignored if one wishes to gain a comprehensive understanding of the use and function of the early sound film score. Thus, while this study attends primarily to production-level music strategies, it also considers the impact of such strategies on the audience. By examining the musical practices of the 1920s and early 1930s, we can piece together the general musical background of many audiences, thus enabling a likely portrayal of audience response to emerge.

My argument in the book, briefly, is as follows. Early "synchronized films"—which featured continuous music and periodic sound effects—largely adhered to a silent film music model. The advent of the "part-talkie" and "100 percent talkie," however, encouraged the use of several other mu-

sic models, including phonography and theater, resulting in substantial aesthetic competition and conflict. Ironically, the reduction of film music that occurred in 1929 only served to increase the range of musical approaches on display. Some films featured only diegetic music, but other films—including musicals—made important uses of nondiegetic music. Only in the early 1930s did a consistent approach to film music, which I call the "other world" approach, begin to emerge. In this approach filmmakers tied music to unusual settings and heightened internal states of mind. The "other world" approach exerted a heavy influence on *King Kong*'s score and left a substantial legacy in the Golden Age of film music. This early solution, however, was a tendency rather than a hardened convention, and the entire early sound era primarily featured rampant experimentation. Clear, stable, "overdetermined solutions" would have to wait until the Golden Age.

Through its comprehensive "from the ground" approach, this project ultimately offers a new account of the early sound era. Where *King Kong* is traditionally said to *begin* an era of film music history, this study demonstrates that *King Kong* was in many ways a *culmination* of certain tendencies that emerged in prior early sound films. In decentering *King Kong* in the historical record, this project reformulates our understanding of a whole period of film history. The following pages thus offer not only a new context for the emergence of the Golden Age of film music but also an unprecedentedly close—and decidedly revisionist—look at the practices and assumptions of the early sound era.

To help explain the diversity of approaches to music in the early sound era, the first chapter surveys a range of musical influences available to film music practitioners in the years leading up to the transition to sound. Chapter 2 then analyzes the film score in early synchronized films and part-talkies from 1926 to 1929, and chapter 3 examines the use of music in "100 percent talkies" from 1928 to 1931. After chapter 4 discusses the special case of the film score in the musical from 1929 to 1932, chapter 5 examines the score for nonmusicals from 1931 to just before the release of *King Kong*, in March of 1933. In light of the plethora of pre–*King Kong* scores discussed in this study, chapter 6 offers a radical revision of *King Kong*'s contribution to film music history. Finally, the conclusion examines the early sound score's legacy in the Golden Age of film music.

Some definitions, clarifications, and caveats are in order. The term *film score* in this study will include any musical cue not explicitly marked

as diegetic. This differs from typical definitions of the term, which equate the score exclusively with clearly nondiegetic music. To reflect the period's frequent lack of a straightforward distinction between diegetic and nondiegetic music, my definition of the score includes music that is ambiguously located. Unless indicated otherwise, *orchestral music* in this project refers to a symphonic setup and music in a classical idiom. Film music in the early sound era is a very large project, and I have thus limited the scope of my study in certain respects. For instance, although I refer on occasion to documentary, animated, and short films from the period, my primary concern is the music practices in feature-length fiction films produced in the United States for U.S. audiences from 1926 to 1934. The month and year provided in parentheses for each film refer to the time of the film's premiere rather than the date the film was released to the general public.[18] When musical themes are presented using musical notation, the reader should bear in mind that virtually every theme was altered at least slightly throughout the course of a film, and the notation reflects merely one instance of the theme. Unless indicated otherwise in the captions, I have transcribed these themes by ear.

My use of the terms *diegetic* and *nondiegetic* music also deserves explanation. These words were popularized in film studies by Gorbman and others in the 1980s and would not have been used by film music practitioners in the late 1920s and early 1930s.[19] Wierzbicki points out that nondiegetic music in the period was referred to as "underscore," as well as "accompanimental, interpolated, or background music."[20] None of these terms, however, quite fits with what I discuss in the chapters that follow. *Underscoring* generally refers to music playing at a volume lower than dialogue, but this could—and often was—accomplished in the early sound era via diegetic as well as nondiegetic music. Similarly, music can "accompany" the image whether it is diegetic or nondiegetic. *Interpolated* music generally refers either to new material added to a previously existing piece or to a sudden change in musical elements, neither of which reflects music's relationship to the diegesis. *Background* music, when contrasted with "source" music, generally refers to music without a source in the image. Yet the term *background* suffers from imprecision. It can refer to the background of either the image or the soundtrack, and in both cases it can contain diegetic music. For instance, music performed by a diegetic jazz orchestra in a nightclub scene constitutes "background" music in a sense, given that the music's image source is likely located in the background of

many of the shots. If music performed by this jazz orchestra is quieter than a scene's dialogue, then it is in the "background" of the soundtrack, even though it emerges from the world of the film. For the sake of clear analysis, this study thus retains the terms *diegetic* and *nondiegetic*.

With this book's detailed portrait of music in the early sound era, scholars can, for the first time, trace the history of the Hollywood film score in its entirety. To understand, however, the confluence of factors that contributed to the diverse practices of the early sound score, one must begin by considering the array of musical options in the years leading up to the transition to sound.

1. A WIDE ARRAY OF CHOICES

Musical Influences in the 1920s

ON AUGUST 6, 1926, *DON JUAN*, THE FIRST FEATURE-LENGTH film to receive a synchronized score, premiered at the Warner's Theatre in New York City.[1] Because of its identity as the first film with a synchronized score, many studies of the early sound score take *Don Juan* as their starting point. But beginning with *Don Juan* would do little to explain the presence of various musical techniques in the film. When a new entertainment form such as sound cinema emerges, it does not immediately adopt a new and clearly defined set of unique practices. Rather, in its nascent stage it looks toward and draws on existing media to constitute its identity.[2] To understand the trajectory of the early sound score, one must examine the wide array of musical options that were available to sound film practitioners during this period. In short, one must investigate the musical scene in the 1920s.

This approach differs from that taken by Douglas Gomery, a film scholar who remains one of the foremost authorities on Hollywood's transition to sound. In a series of writings Gomery argues that Hollywood smoothly transitioned to sound in three planned steps: sound cinema was first *invented*; then it was *innovated* (brought to the market and altered for profitability); and finally it was *diffused* (put into widespread use).[3]

Yet while Gomery's work has yielded groundbreaking insights into the *economic* perspective of Hollywood's transition to sound, his claim for a smooth, planned transition becomes less tenable when examining early sound film *aesthetic* practices. Implicit in Gomery's model is that throughout Hollywood's transition to sound, the product "sound film" remained a stable concept and that Hollywood, from the beginning of the transition, knew what the product "sound film" meant. Aesthetically, however, sound strategies differed from film to film, resulting in a startling array of diverse and often conflicting practices. Thus, while the transition to sound might have been planned on an economic level, this did not translate into an aesthetically consistent or firmly defined product.[4] Instead, as film historian Donald Crafton points out, Hollywood offered audiences *tests* of what a sound film could be rather than unified *texts*.[5]

Musically, the early sound era featured a series of "tests" because the transition to synchronized sound raised numerous aesthetic questions with no firm answers. Should music connect to narrative events, and if so, in what ways? To what extent—and how—should music coordinate with dialogue? How much music is suitable? What is music's affective potential? Should preexisting or original music be used? What styles of music are best? How can potential hit songs be showcased? What are the cultural connotations of various musical forms and techniques, and how can they be used to cinema's benefit? To respond to these and other questions, film music practitioners looked to existing musical practices, including opera, theatrical melodrama, stage musicals, phonography, radio, and silent film music.

Moving roughly in chronological order, I begin this chapter by examining music aesthetics in opera, theatrical melodrama, and 1920s stage musicals. I then consider two important sound reproduction technologies in the 1920s: the phonograph and the radio. I conclude the chapter by attending to silent film accompaniment practices, which constitute the sound score's most proximate influence. Taken together, these preexisting practices offered an array of useful methods for tying music to narrative content, generating affect, using classical and popular musical styles, and connoting cultural prestige.

Opera

Throughout its history, ranging from the seventeenth century to the present,[6] opera has featured such an extraordinary variety of forms that it would be misleading to treat the form as having a unified aesthetic practice that monolithically informed the early sound film score. Still, two operatic scoring techniques—leitmotifs and recitatives—would have suggested themselves to early sound film practitioners as particularly viable models.[7] Of the two practices, the leitmotif has received far more attention from film music scholars. A leitmotif refers to a musical motif or theme that, through consistent reuse, attaches itself to a particular character, situation, or idea in the narrative. A leitmotif thus offers a useful model for any medium seeking to tie musical accompaniment to narrative events. The term *leitmotif* has become synonymous with the nineteenth-century operas of Richard Wagner, yet ironically Wagner invented neither the term nor the technique. Music historian A. W. Ambros may have first applied the term to Wagner around 1865, and only later would Wagner address the concept in his own theoretical writings.[8] Moreover, composers such as the enormously popular Giuseppe Verdi used leitmotifs before Wagner did,[9] though not in as systematic or extensive a manner. Still, the term has become strongly associated with Wagner's work.

As initially used by Wagner, the leitmotif was a complex, multivalent symbol that fused numerous operatic elements. In Wagner's operas, especially his cycle of four operas known collectively as the *Ring* cycle, the leitmotif did not simply label or point to one particular character or object but rather conjured up a realm of ideas. For example, as music scholars John Deathridge and Carl Dahlhaus point out, Wagner's "spear" motif points not only to the literal spear but also to the god Wotan's "contract with [the giants] Fasolt and Fafner, the runes of which are carved on the spear's shaft, and by extension to agreements in general and finally to the connection Wagner sees between all such binding agreements and entanglements in the mythic destiny from which there is no escape."[10] Wagner also modified his leitmotifs throughout the course of the opera, and they accrued meanings as the work progressed. Moreover, Wagner's theoretical writings reveal that the concept of the leitmotif functioned for him as a unifying device. By using leitmotifs throughout the course of an opera or series of operas, the composer could link the moment-by-

moment levels with the work as a whole to yield a single, unified piece of art.[11] Scholars have also argued that leitmotifs suggest the presence of an external narrator. James Buhler, for instance, points out that by attaching motifs to certain story elements and ignoring others, leitmotif-based music "knows" and identifies those story elements that will prove dramatically significant as the story progresses.[12] Thus, the leitmotif implies the regular presence of a sophisticated musical narrator—arguably the "real" principal character in the opera—who organizes and regularly comments on the action as it progresses.[13]

While Wagner and the concept of the leitmotif remained well known in music circles up to the 1920s, writers and composers regularly reduced the complexity of this concept. Film music columnists in the 1910s, for instance, declared that music should connect to characters and narrative themes in a manner similar to the Wagnerian leitmotif,[14] which attests to Wagner's substantial presence among music practitioners in the early twentieth century. These columnists, however, often reduced the leitmotif to a simple series of signposts that marked—in a simplistic one-to-one correspondence—a certain character or object in the narrative. By the 1920s, film music practitioners were far more likely to deploy what they believed to be a "Wagnerian" leitmotif aesthetic by simply repeating the theme rather than varying it or using it to articulate a wealth of different ideas.[15] Regardless of its complexity or lack thereof, however, the leitmotif served as an important concept for early sound cinema.

If the leitmotif forged a closer link between music and narrative via association, the operatic recitative provided a model for how music could share the same space with voices and communicate affect. A foundation of opera itself, *recitative* at its most basic level refers to the effort to mimic dramatic speech with song. This often involves using music to accompany two characters as they have a narratively important sung discussion. Used as far back as the seventeenth century,[16] the recitative was by the eighteenth century a formulaic convention and was generally separated quite clearly from the *aria*, which was a solo number for a singer in which he or she often expressed passion or other emotions. In the nineteenth century the distinction between the aria and the recitative tended to blur, particularly in the operas of Wagner. Still, while not necessarily referred to explicitly as "recitative," operas continued to present passages of narratively important "dialogue" that was sung instead of spoken.

The beginning of act 2 of Wagner's opera *Lohengrin* (1850) shows how recitative music could underline the emotional tone of the singers' conversation while not interfering with the semantic content of their words. In this scene the two villains of the opera—Ortrud and Telramund—discuss their belief about the true nature of a mysterious knight's (Lohengrin's) secret power, and they form a plan to eliminate what they believe to be his magical power. Narratively, the discussion is crucial: it explains and justifies these characters' actions, and these actions in turn drive much of the remainder of the opera. During this scene the music often precedes a line of sung dialogue with a brief loud note, or *sforzando*, which suggests the passion and hatred that the two characters feel toward the knight, thus setting the mood for the dialogue to follow. During the pauses between the sung dialogue lines, the music again rises in volume to a *forte* (high volume). Yet during the lines of song themselves (which function virtually as spoken dialogue), the music is generally either silent or played at *piano*, a very low volume. A loud chord will periodically punctuate moments in a sentence, especially endings of lines. In this way the music seldom if ever obstructs the audience from understanding the meaning of the sung words, while still chiming in to highlight the passion, anger, and hatred for the mysterious knight expressed in the dialogue. In this situation the emphasis is on the close coordination and timing of the words and music, in which music amplifies emotional expression while still privileging words as the most important sonic element.

The scoring techniques generally used for this sort of recitative are laid out particularly lucidly in composer Nicolas Rimsky-Korsakov's guidebook *Principles of Orchestration*. Not only does Rimsky-Korsakov argue that orchestration should be a mere handmaiden to phrases and words, but he also reiterates the technique heard in *Lohengrin* by stating that outright orchestral outbursts should occur only when the singer is silent, presumably so as not to interfere with the singer's voice and, if narratively important, the semantic content of the song. Moreover, Rimsky-Korsakov states that the orchestra's volume level should dip during passages featuring the singer's voice. The score, however, should not draw attention to these adjustments: "Too great a disparity in volume of tone between purely orchestral passages and those which accompany the voice create an inartistic comparison."[17] In other words, although opera orchestration is built around and is subservient to the libretto (the text of the opera) in these circumstances, the composer should labor hard to conceal this fact from the audi-

ence. During moments in which the libretto conveys narrative develop-ments, then, music should function as an unnoticed assistant. For early sound cinema practitioners searching for ways to allow voices (whether sung or spoken) and music to share space, the principles behind the rec-itative would have been a useful reference.

Though leitmotifs and recitatives were familiar to film music practi-tioners, the majority of American moviegoers in the 1920s probably had less familiarity with opera. In the nineteenth century, as music historian Katherine Preston has noted, opera "was a normal part of musical reper-tory,"[18] and this familiarity with opera extended to less populous areas of the country thanks to traveling opera troupes. The extent to which opera remained a popular entertainment in the early twentieth century, how-ever, remains uncertain. Historian Laurence Levine argues that around 1900, the elite class, believing that change was in the air as a result of the period's urbanization, rising immigration, and spatial mobility, tried to maintain its privileged position by transforming the space of the "fine arts" via "rules, systems of taste, and canons of behavior."[19] Opera and symphonic performances became more rarified entertainments, to be consumed only by the small proportion of the population who understood how this music was originally "meant" to be appreciated.[20] In this process opera was transformed from popular music to an art form.[21] More recently, music historian Joseph Horowitz has taken issue with some of these con-clusions. He argues that Levine overstates the cultural elite's impact and that classical music instead became elitist during the interwar decades.[22] Despite this disagreement, however, both accounts would suggest that the public's familiarity with full-length, live opera performances was on the decline by the 1920s and early 1930s. The state of opera compa-nies by the early 1930s affirms this decline. By 1930 in the United States, year-round opera companies existed only in New York City and Chicago, with shortened seasons for opera companies in Philadelphia, Boston, San Francisco, and Los Angeles. Further suggesting opera's increasingly elite rather than popular status, opera companies generally operated at a deficit and often relied on wealthy patrons to offset some of their costs.[23] In 1932 the Department of the Treasury deemed that opera could avoid the amuse-ment tax because it was an educational, nonprofit institution.[24]

By the time that Hollywood transitioned to sound in the late 1920s, most moviegoers would have been familiar with opera primarily through phonograph records, music heard on the nascent medium of radio, and

live introductory orchestral overtures for silent films. Enrico Caruso's opera recordings enjoyed a massive popularity among a broad range of consumers; classical music of various sorts—including opera—ruled the radio airwaves in the early to mid-1920s; and movie theater orchestras frequently introduced the 1920s film program with an opera overture from nineteenth-century masters such as Wagner or Verdi.[25] Unlike the elite mode of consumption, which involved experiencing a live operatic performance in its entirety, the general public's experiences with opera were probably often fragmentary. Audiences would have possessed knowledge mainly of famous opera tunes rather than an understanding of opera as a large-scale composition with specific scoring practices.[26] For the general public, then, opera would have functioned as a marker of cultural prestige and uplift yet as an art form generally appreciated only in bits and pieces.

THEATRICAL MELODRAMA

For early sound film music practitioners, theatrical melodrama offered a model for linking discontinuous music to narrative events. In the eighteenth century the term *melo-drame*—coined by Jean-Jacques Rousseau—referred to "the use of short passages of music in alternation with or accompanying the spoken word."[27] As theatrical melodrama grew in popularity during the eighteenth and nineteenth centuries, the term *melodrama* shifted to mean a whole type of drama, whether accompanied by music or not.[28] Melodrama took several forms, including public narrations of famous speeches or stories spoken to accompanying music. By the 1880s, one popular strain of theatrical melodrama reached a pinnacle of sorts by offering colossally popular spectacles of action and danger that featured numerous real objects onstage. During horse races, for instance, spectators were treated to actual horses running on carefully concealed treadmills with a moving painted panoramic backdrop simulating their movement. A train or automobile wreck might feature an actual train or automobile, while underwater action sequences would utilize enormous tubs of water. These melodramatic spectacles were so popular that during cinema's first two decades (1895 to 1915), films frequently attempted to imitate them.[29]

By the end of the nineteenth century, theatrical melodrama produced by the best-known impresarios like Augustin Daly, Charles Frohman,

and David Belasco catered to upper-class audiences in grand theaters that housed productions heralded as major social events. In the "popular-priced houses," people generally saw shorter (around thirty-minute) takeoffs of these dramas. During the mid-1910s, theatrical melodrama experienced a decline from which it would not recover. Nevertheless, in the late 1920s many film producers and audience members would have still remembered theatrical melodrama's model for linking musical numbers to narrative.

Musical accompaniment in melodrama remains a much-neglected area of theater history. Based on existing scholarship, however, it seems clear that music was an integral part of theatrical melodrama and was tied closely to the onstage narrative. The fact that theatrical melodrama music often accompanied spectacles of action and heightened emotion only made it an even more appealing model for film, which often presented similar kinds of spectacles.

Music in theatrical melodramas served to entertain the audience during breaks in the onstage action. An audience could, at a minimum, expect to hear overture and scene-change music, the latter particularly likely at the beginnings and ends of acts.[30] Such music could be quite diverse within a single play. In Belasco's production of *The Heart of Maryland* (1895), set during the Civil War, the overture before the beginning of the play included popular folk tunes like "Dixie," "Oh Maryland My Maryland," and "Columbia the Gem of the Ocean."[31] In contrast, the play's script calls for scene-change tunes ranging from "a soft melody" to "a descriptive battle piece . . . with the far-away sound of booming cannon" to "impressive music, indicative of a lull after severe fighting."[32]

Within the play itself melodrama music nearly always featured intermittent musical cues rather than music that played continuously throughout the production. Yet the number and duration of music cues probably varied considerably from play to play. In her analysis of the melodrama *The Count of Monte Cristo* (1883), music historian Anne McLucas demonstrates that music cues for the play were sparse.[33] The play features twenty-eight cues, but fourteen are repetitions. Cues are also short and sporadic. Outside of overture and entr'acte music, music cues range from a single chord to, at most, only sixteen bars of music. Spaces in between cues are as long as six, fifteen, or even twenty-two minutes.[34] In his recent book on the subject, however, music scholar Michael Pisani examines a wide array of archival evidence and indicates that the amount of music

MUSIC → CUES

music with narrative situation emotional clues

cues for theatrical melodramas varied considerably from play to play and from location to location.[35]

When music was heard, it would often herald a character's entrance or exit from the stage. Perhaps surprisingly, however, even the most important characters would not necessarily receive the same theme for each entrance and exit. Instead, theatrical melodrama music more commonly attended to the narrative situation than to the identity of the character. For example, Rick Altman indicates that in the version of *The Count of Monte Cristo* that McLucas analyzes, the hero, Edmund, receives three completely different compositions on his first three entrances, the second of which had previously been used to introduce the secondary, bumbling character of Caderousse. Later the villain Villefort receives "music previously used for Edmund's arrival."[36] Because Edmund's entrances occur during three different narrative situations, the music shifts to attend to situation rather than character. Thus, although theatrical melodrama used musical themes, these themes were generally tied to emotional situations such as "doom" rather than to character.

In addition to marking character entrances and exits, music also helped the play express emotion, underline onstage action, and manipulate the theatergoer into the appropriate mood. Melodrama music used *tremolos*—rapid reiterations of single or paired notes—and bass drum heartbeats to symbolize danger, dissonant diminished seventh chords to denote villainous activities,[37] and "hurry" music to underline scenes of intense action and races to the rescue.[38] Music could also be used to highlight or underline a particularly emotional speech to give it more poignancy.[39]

At times, music could also implicitly become part of the diegesis. The script for *The Count of Monte Cristo*, for example, describes act 2, scene 1 as the "Apartment in the house of the COUNT DE MORCERF, handsomely furnished" and then states, "Music, as for a ball, heard within."[40] The servant's early line in this act ("A ball to celebrate my master's return from Janina")[41] affirms that audiences should interpret the music as being part of the world of the play. In a larger theater such music probably would have been played offstage, while a play performed on tour with limited resources would more likely have relied on the pit orchestra to produce such music.[42] Regardless, melodrama music was periodically permitted to become part of the play's diegetic soundscape.

In terms of the timing between pit orchestra and onstage narrative actions and dialogue, the challenges faced by theatrical melodrama dif-

fered markedly from those of opera. Opera favors singing over physical action. Vocal and orchestral parts share a musical logic of rhythm, chord progression, and cadence (the ending of phrases or sections), thus ensuring precise timing throughout the production. Theatrical melodrama music, when not tied to singing, was instead an exercise in what I call *near coincidence*: two items (words or actions onstage versus music in the pit), each following their own internal logic or syntax, strove to conclude at nearly the same time, the music sometimes adjusting itself to accommodate the lack of perfect synchronization. Altman points out that music for melodrama was often written in easily repeatable eight- or sixteen-bar sections, and cadences were often written every four or eight bars.[43] This meant that the music could be either repeated or quickly concluded to suit the narrative, thus enabling music to achieve as close a coincidence as possible. Still, asymmetrical musical cues could sometimes be designed to coincide quite precisely with the stage action. Pisani points to a Grecian Theatre production of Henry Leslie's sensation drama *The Orange Girl* (1864), in which a scene of planned murder features a violin-leader book containing five pages of continuous music, including chords that coincide with punctual physical actions.[44] Composers and arrangers of melodrama music utilized other techniques to attain coincidence as well, such as the practice of fading the music out in the middle of a scene. The importance of achieving near coincidence differed depending on the situation: a musical cue that concluded a scene, no longer needing to adhere to the stage narrative, was more likely to be played in its entirety.[45]

Preexisting music played an important role in theatrical melodrama. Preston indicates that for "toga plays"—plays that featured Christians and their Roman oppressors—music accompaniment might include stock melodrama music, symphonic works, opera or operetta music, period dance music, and popular songs.[46] The use of such preexisting music in melodrama would have been especially appealing in less expensive theaters. Altman points out that beginning in the 1870s, combination companies of actors traveled from town to town, yet local musicians in each town provided the music.[47] Thus, stock theater musicians would have found it more practical to use familiar music than to hurriedly and ineptly learn new music for each new combination company. Still, some less expensive theaters did use music that had been written for the play. Pisani demonstrates that the Golden family, a theatrical company that

— channel attention
voice over narrator

toured the central and southwestern United States, would sometimes borrow music from Boston and Philadelphia theaters.[48]

Many of melodrama's musical practices channeled the audience's attention toward the action occurring on the stage. By using conventions of affect to forge close emotional links between musical style and narrative situation, melodrama music reinforced the onstage action while simultaneously manipulating the audience's emotions and alliances in the directions deemed most useful by the play's producers. From this perspective melodrama music functioned as a covert omniscient narrator, coaxing and coercing the audience into thinking about the narrative and its characters in the "proper" ways. Other musical cues, however, would have directed the spectator's attention toward the audience as a communal group. For instance, Altman points out that during the performances of popular, recognizable songs and dances that were prominent in between acts of a melodrama, audiences often vocally joined in with the song.[49] Though different classes of melodrama patrons surely responded in different ways, to a certain extent such moments would have made audiences aware of themselves as a group as they recognized their shared music and culture. For some audience members—especially the notoriously vociferous patrons in the cheap seats—these moments would have moved theatrical melodrama from a "for me" narrative toward a more celebratory "for us" entertainment.

Though theatrical melodrama from Daly, Frohman, and Belasco was pitched to upper-class audiences, the popular-priced melodramas did not enjoy this elevated cultural currency. The common use of contemporary popular music and symphonic works within the same theatrical performance partially explains this fact. Presenting symphonic or operatic snippets in the context of a theatrical production that also featured the latest popular songs and dance violated the highbrow goal of appreciating music in its "pure," original form, a goal that seems to have been on the rise during the heyday of theatrical melodrama.[50] The tiered pricing system of popular melodrama, which was designed to attract the working, middle, and upper classes alike, further affirms that most theatrical melodrama constituted a popular rather than elite entertainment. By the time of Hollywood's transition to sound, the American population would have been far more familiar with the musical conventions of theatrical melodrama than with opera, yet opera increasingly conveyed a highbrow prestige that popular melodrama lacked.

Stage Musicals

If theatrical melodrama offered early sound practitioners a general model for tying discontinuous music to narrative events, musical theater of the 1920s provided strategies for deploying new potential song hits through-out the course of a narrative. The stage musical was a rather salient sound model in the period: before its substantial decline at the end of the 1920s and the beginning of the 1930s, the stage musical was probably the most popular theatrical entertainment of the 1920s.[51] Though narrativeless re-vues such as the *Ziegfeld Follies* were enormously successful, the most relevant models for film music came from those musicals that featured a stage narrative.[52] Indeed, during the transition to sound, Hollywood quickly adapted several of the most popular 1920s narrative musicals, including the stage versions of *No, No, Nanette* (1925), *Show Boat* (1927), and *The Desert Song* (1928). Moreover, by 1930, stage-musical composers such as Irving Berlin, George Gershwin, Jerome Kern, Richard Rodgers, Herbert Stothart, and Oscar Straus had all participated in the scoring of Holly-wood films.[53]

Even for stage musicals featuring narratives, song plugging—the prac-tice of performing a song to generate sheet music and recorded music sales—was always one of the central goals. This emphasis on song plug-ging stemmed from the practices of the late nineteenth-century musical theater, which would habitually feature a variety of interpolated songs and dances that had little or nothing to do with the narrative action of the play (such songs were in fact billed as being "incidental to the play"). With the explosion of the Tin Pan Alley sheet music industry for popular music in the mid-1890s, musical theater—along with vaudeville—became an essential venue for plugging the latest popular song. Musical theater composers such as Victor Herbert demanded that interpolated songs be banned from performances of their musicals, yet despite such efforts popular songs remained a major presence.[54]

In the first three decades of the twentieth century, musical theater continued to serve as a vehicle for song plugging. Theater historian Kurt Gänzl has argued that for musical theater during those decades, the notion of a "composer" who created a score of "music" gave way to a "songwriter" who created a score of "songs."[55] This claim overlooks the importance of interpolated songs in the late nineteenth century, but Gänzl's point about song hits being the raison d'être of musical theater is crucial to an

composer ——> a score of music | Song
songwriter ——> a score of songs | hits

understanding of this form in the 1920s. Indeed, by the 1920s many of the most popular song hits came from Broadway rather than Tin Pan Alley. Not by accident, the finales of many 1920s Broadway shows consisted of reprises of what were deemed the most pluggable (i.e., the most potentially popular) songs of the show.[56] Once popularized onstage, these songs could be purchased as sheet music or phonograph recordings. The notion of using a medium as a forum for song plugging would play an enormous role in the constitution of sound film's identity during its early years.

Not only was a theater song judged by its potential sales in ancillary markets, but its danceability was also increasingly seen as a major asset. Dancing was an enormous part of urban culture in the 1920s. By 1929, for example, more than seven hundred dance bands toured the United States.[57] In the world of musical theater the twentieth century shift to American composers and modern settings encouraged dance, swing music, and jazz to enter the musical theater. For most music listeners in the period, "jazz" simply meant syncopated (hence danceable) rhythms, occasional "blue" notes, and lyrics detailing such illicit topics as drinking, dancing, and sexual freedom. For many, the music of Irving Berlin epitomized jazz.[58] Many "jazz" 1920s musical theater songs, then, were simple, direct, syncopated toe-tappers, the better to showcase the latest dance craze.[59] No, No, Nanette, a phenomenally and internationally popular stage musical, illustrates the importance of dance numbers for stage musicals in the period. What made No, No, Nanette so successful was not its routine plot, which centered on a young woman (Nanette) who wants to have her fun before settling down to marriage, but rather the seemingly nonstop, modern, expertly choreographed dancing. The show featured one-on-one dancing, tap dancing, and chorines performing complicated dance steps rather than a few basic steps.[60]

Without recognizing the centrality of song plugging and modern dance, one cannot properly understand 1920s stage musicals. For example, in his generally excellent book-length study of musical theater conventions, theater scholar Scott McMillin rightly claims that 1920s theater contained stunning musical numbers that demanded hours of rehearsal and, if successful, recordings as well, yet he derides these musicals for containing weak stories.[61] This criticism misses the point: a successful musical in that period was defined precisely *by* its ability to create song hits and to dazzle and delight audiences with its complex dance num-

bers. To criticize 1920s musicals for weak stories places more recent standards on musicals whose aims were substantially different.

Musical theater in the 1910s and 1920s contained some basic music conventions. Orchestras always accompanied musicals, and audiences could expect the production to feature overture and entr'acte music, both of which would contain multiple song melodies from the musical. From an economic perspective, overture and entr'acte music helped direct the audience's attention toward those songs most likely to become hits.[62] Though overture and entr'acte music was continuous, the orchestra would generally make clear transitions between each song, thus enabling the play's songs to become isolated, purchasable commodities.[63] Within the play itself the orchestra not only accompanied the singer(s) during each song performance but also commonly preceded a song with an orchestral introduction. Often, the start of the music would be cued to a particular line of dialogue, and the orchestra would then play underneath a short dialogue exchange or monologue before the actor began to sing. In such an instance, timing between music and dialogue became essential: as with melodrama, two forms, each with their own syntax, had to conclude at nearly the same time. To ensure coincidence, the orchestra would sometimes hold a leading tone until the actor was ready.[64]

In situations other than song performances, the reiteration of song tunes as instrumental pieces could serve as an important form of underscoring. Published scores from the period demonstrate that after an actor formally performed the song onstage, the orchestra would sometimes repeat the tune periodically throughout the remainder of the musical. Such repetitions certainly helped create song hits by further embedding the tune in audience's minds, but the songs were also closely tied to the narrative situation and served clear narrative purposes. When a song is first performed in a musical, it often halts the narrative and provides an alternative way for characters to express their relationship.[65] Through this initial performance, the song acquires a particular narrative meaning or connotation. Consequently, when the same song is heard later in the production, it summons up a prior narrative meaning that reflects on the new narrative situation. With each subsequent reiteration, the song both draws on its prior meanings and has these meanings adjusted by the new narrative situation in which it is heard. In addition to reflecting narrative evolution, such songs also provide the musical with an overall sense of narrative cohesiveness and consistency.

Music an alternative way for characters to express their relationship

A good example of the use of a previously performed song as under-scoring occurs in *No, No, Nanette*. In act 2 Lucille sings to her husband, Billy, "You Can Dance with Any Girl" to indicate that she will readily tolerate Billy's flirtations with other women as long as he remains true to her. As initially sung, the tune suggests an underlying trust between Lucille and Billy. In act 3, however, Lucille becomes convinced that Billy has cheated on her. She confronts Billy and they fight. During their spoken argument, the same song is played under the dialogue. Some chromatic notes (notes that are foreign to the current musical key) are introduced, which "sours" the tune. By reiterating this song, *No, No, Nanette* composer Vincent Youmans reminds the spectator of the song's original meaning: Lucille's trust in Billy. Yet by "souring" the song with a few chromatic notes, the altered melody suggests that Lucille and Billy's relationship, too, has gone sour. Thanks to the reiteration of this song, the general tune now conveys multiple meanings: it reminds the spectator about the couple's trust *and* the potential violation of that trust.[66]

A similar situation obtains for the title song in Rudolf Friml's *Rose-Marie* (1924). Beginning as a love duet between Jim and Rose-Marie, the tune then underscores their later romantic events, such as the moment when Jim, according to the score, "gives her his ring" to show his intention to marry her. After this event, however, Rose-Marie is falsely led to be-lieve that Jim has committed murder. In the next act the tune is played again when Jim and Rose-Marie meet, but the previously romantic song has been changed to an *espressivo* (expressive) style to denote sadness and yearning, indicating that Rose-Marie will reject Jim because she believes he is a murderer.[67] Although this underscoring technique has much in common with the operatic leitmotif, musical theater used songs that had previously been isolated and overtly presented as discreet attractions. Consequently, the reiteration of musical numbers constitutes a particu-larly overt and noticeable commentary on the narrative events onstage.

By far the most notable innovator of underscoring during this period was Jerome Kern, and his work reveals a marked emphasis on fusing song, character, and narrative situation. In *Show Boat*, for instance, Kern underscores a song *before* the song is even performed onstage, thus imme-diately connecting certain characters with certain themes. When Steve, the troupe leader, makes his first entrance, the published score calls for a strain of "Can't Help Lovin' Dat Man of Mine" to be heard from the or-chestra. Narratively, this is appropriate because the song—later to be sung

by his wife, Julie—is about him, and the bond between the couple will play an important role in the events to follow. Kern uses a similar tactic for the introduction of the gambler Ravenel. When Ravenel is first revealed onstage, the score indicates that the orchestra should play "Where's the Mate for Me?," a song that Ravenel will soon sing that foreshadows his romance with Magnolia. In both cases Kern immediately ties particular characters to songs that—when sung later in the production—will encapsulate their role in the narrative and the relationship problems that their respective songs suggest. The song "Ol' Man River" also occurs regularly in the underscoring throughout the musical, which again is narratively appropriate because the song suggests that all the characters are affected by a fate higher than themselves, symbolized by the inevitable river that "jes' keeps rollin' along" throughout the forty-year span of the musical.[68] Through the early and regular deployment of song underscoring, Kern forges and sustains a link between the characters and their place in the musical's overarching narrative. Still, this extensive use of songs as underscoring was unusual for the period.

For audiences attending 1920s stage musicals, the music would have impacted them on both an economic and narrative level. Economically, songs in stage musicals hailed the audience as potential purchasers of the sheet music and phonograph versions of the songs. On a narrative level the use of musical numbers for underscoring demonstrates the orchestra's ability to grasp the full significance of the narrative events onstage.[69] By knowing precisely when to utilize musical numbers for underscoring, the orchestra—in a manner similar to operatic leitmotifs and the stock music of melodrama—signals to the audience that it instantly understands the stakes behind a particular narrative, and it presents itself as a trustworthy guide for interpreting the onstage narrative. Still, the intermittent nature of the orchestra indicates only *periodic* omniscience; thus, the music only guides interpretation during certain intervals of the production.

The use of music to accompany both singing and spoken sections also highlights music's dual address system in stage musicals. Song underscoring directs the audience's attention *forward* onto the narrative world of the stage by promising to be a trustworthy guide to the narrative action that is taking place. In contrast, song or dance performance puts the narrative world on pause and projects *outward* into the audience. For the audience, then, the music regularly shifted between music for narrative

comprehension and music directly addressed to each audience member for his or her personal enjoyment. This presentational aspect of musicals would become an important factor for the use of the score in the early film musical.

Outside of silent film music the stage musical was the most familiar form of narratively related musical accompaniment for most audiences attending early sound films. Despite the fact that high-profile stage musicals premiered in the sophisticated urban setting of New York City, however, the stage musical generally used jazz styles and modern dancing that would not have sat well with the cultural elites. To be sure, the situation was complex, as some middle- and upper-class whites were known to "slum" in Harlem and to enjoy the music that they heard there. But many other elites considered jazz animalistic, undisciplined, and hence not even real music.[70] Historian David Savran has demonstrated that the presence of jazz in 1920s musical theater—along with musicals' light, "escapist" plots—served to lock musical theater into a lowbrow position.[71] Thus while musicals might have signaled a level of urban sophistication, they lacked the "fine art" status that increasingly characterized opera or symphonic performance.

Phonography and Radio

Though phonography and radio were important components of American musical culture in the 1920s, their impact on the early sound score was substantially different from opera, theatrical melodrama, and stage musicals. Unlike these three theatrical forms, with rare exceptions phonograph records and radio broadcasts did not tie music to a broader narrative, and by definition they featured sonic reproduction rather than original sound events. Nevertheless, phonography and radio offered the nascent sound film medium models for the kinds of music that could be reproduced—particularly classical and popular music—and the potential purposes to which such music could be put.

Culturally, the stakes surrounding phonography and radio were quite high in the 1920s because of their identities as both *mass* and *reproductive* technologies. As technologies designed to reach masses of people, phonography and radio contributed to a culture in the 1920s of greater shared experiences with performed music. Even the most popular stage musical of the 1920s, for instance, could not reach anywhere near the

*piano playing → phonograph
musical instrument for
A WIDE ARRAY OF CHOICES 29 the
home*

number of people that a phonograph record or—increasingly in the
1920s—the radio could. As reproductive technologies, phonography and
radio distanced the listener from the actual performed event by repro-
ducing sound within a different reception context. Phonography and ra-
dio thus invited questions pertaining to how musical performance should
be reappropriated to impact its users.[72]

Of particular interest to phonography and radio practitioners was the
way that classical music reproductions could signify prestige and pro-
mote cultural uplift. In the case of phonography this tactic had occurred
well prior to the 1920s. Around the turn of the century the phonograph
increasingly became understood as a musical instrument for the home
rather than a business technology.[73] Consequently, phonograph compa-
nies had to convince the American public that the phonograph served as
an adequate substitute for live piano playing, which in the 1890s was the
most popular form of home musical entertainment. To do this, phono-
graph companies emphasized their product's ability to provide profes-
sional-level classical music to the ordinary American home. A particularly
famous series of efforts in this regard was the ubiquitous Edison Tone
Tests in the 1910s. During these highly publicized theatrical events, audi-
ence members were treated to a comparison between a live opera singer
and a phonograph recording of that singer, with the intended conclusion
being that the sound quality of the phonograph was so lifelike that spec-
tators could not tell the difference. Through efforts like the Edison Tone
Tests the phonograph trained its patrons to listen for and favor "quality"
professional-level music.[74]

From the turn of the century to the 1920s, phonograph companies also
used classical music recordings to suggest that their companies provided
"high-class" music entertainment for their entire range of recorded offer-
ings. The most visible efforts in this regard came from the Red Seal series
produced by Victor Records. Beginning in 1902 and extending through
the early sound period, the Red Seal series featured high-profile operatic
and classical performers, including Caruso, Geraldine Farrar, Sergei Rach-
maninoff, and dozens more.[75] Classical music and opera never accounted
for more than 10 percent of sales, and at prices ranging from one to seven
dollars a disc in the first decade of the century, the Red Seal series tended
to attract a wealthy clientele.[76] Thanks to the Red Seal series, however, *all*
Victor records—including popular and dance music—carried connota-
tions of quality and prestige, thus helping to boost record sales.[77]

The notion of classical music as a mark of cultural prestige also served an important function for women in the first few decades of the twentieth century. Though phonograph recordings could be heard in public locations such as storefronts, the general public recognized that the phonograph's primary location was in the home, a space widely understood to be the domain of women. Women bought the majority of phonographs and made even more of the buying decisions in terms of which discs to purchase. Music historian William Howland Kenney has demonstrated that there was a widespread belief that listening to music of "the better sort" (i.e., classical and operatic music) would stimulate such important female qualities as "a sense of proportion, good taste, high moral sense, love, companionship, and familial affection." Such music, says Kenney, was particularly important for "proper" female social gatherings like tea parties and receptions.[78] Classical music via the phonograph, then, functioned as a marker of proper female behavior, as well as designating high-class entertainment.

If the phonograph suggested to the film industry the cultural value of reproduced classical music, the nascent radio medium in the 1920s only reaffirmed this notion. As many scholars have pointed out, rhetoric pertaining to radio—especially in the mid to late 1920s—was filled with utopian predictions about the medium's future as an uplifting, culturally enlightening presence,[79] and classical music played an important role in this vision. Rural farmers were particular targets in the push to uplift the general public. Between 1922 and 1926, radio sections in daily newspapers across the country claimed that by broadcasting urban symphonies into the farm home, radio could elevate the farmer in class and sophistication to the same level as the city dweller. As radio historian Randall Patnode points out, such claims demonstrated a widespread belief that city values were inherently superior to rural values.[80] Yet while publications in the 1920s hailed the possibilities for cultural uplift that radio provided, these claims probably emerged largely from the middle class. Radio historian Clifford Doerksen argues that, in spite of middle-class claims to the contrary, the commercialization of radio developed because most Americans did not object to "lower-brow" commercialized programming.[81] Still, up to the late 1920s radio unquestionably conveyed impressions of cultural prestige via the use of classical and operatic music.

These classical and operatic performances on the radio were frequent. From 1922 to the end of the 1920s classical music dominated the air-

waves. Up until 1923 it was common practice to simply broadcast phono-graph records of classical music over the air. In 1923, however, Secretary of Commerce Herbert Hoover, theorizing that radio should offer some-thing not provided by another medium, reallocated radio waves so that no high-powered stations—defined as those that served large areas—would be allowed to broadcast phonograph records. Only mid- and low-powered stations, which served regional or local areas, could continue this practice.[82] It was also during this year that the American Society of Composers, Authors, and Publishers (ASCAP) barred radio from playing phonograph records unless royalties were paid to the phonograph com-pany.[83] For these reasons radio moved increasingly toward live, rather than recorded, musical performance. The most popular radio show that played classical music was "Roxy and His Gang," a variety show hosted by Samuel Rothafel (more commonly known as Roxy), a well-known movie theater manager. According to media historian Ross Melnick, Roxy's show included ballerinas, singers, cellists, and other musicians.[84] Thanks in part to the success of "Roxy and His Gang," a format emerged on high-powered stations in which a program would typically alternate between performances by a singer and then an instrumentalist, and the music would be largely classical or operatic in nature. Probably owing to space and microphone restrictions, radio performers in this period were gener-ally limited to individuals or small groups.[85] Only with the rise of commer-cial radio in the late 1920s would classical and operatic music fall from its preeminent position on radio.

Though classical music was important to both media, phonography and radio also demonstrated the economic value of featuring popular styles of music on a sound reproduction medium. For the phonograph, popular music such as ballads, comic songs, Broadway music songs, and dance hits had dominated sales from the turn of the century up through the 1920s.[86] By the early 1920s, African American jazz and blues had been added to the repertoire, to be followed by hillbilly music in the mid-1920s. Economic determinants played a large role in this repertory expansion. With the phonograph industry booming and many classical singers and musicians already under contract to major record companies like Victor or Columbia, blues and jazz offered new companies an important alternative entryway into the business.[87]

The expansion of musical styles on phonograph records served to fore-ground the stakes behind mass-produced, shared musical entertainment.

By collecting and storing a musical performance, the phonograph abstracted performance from its original contexts, thus allowing it to be put to new uses. In the case of African American jazz music, the fear existed that this type of music—seen by many as belonging to the sordid urban nightclub environment—could, through the phonograph and increasingly via radio as well, engage in a wide-scale permeation of the "respectable," "feminine" space of the home. These fears would also have applied to early sound film, which similarly had the capability to reproduce various forms of music in new, almost universally available exhibition contexts. Revealingly, the 1920s saw the widespread appropriation of jazz by white artists such as Irving Berlin and Paul Whiteman. By making jazz into a white-produced sound (albeit an ethnically "Other" Jewish man in the case of Irving Berlin), the troubling possibility of black music penetrating the home could be ameliorated.

As the 1920s progressed, popular music played an increasingly important role on the radio as well. Music historian A. J. Millard has argued that the perceived sonic superiority of dance music on the radio versus the phonograph contributed to radio's spectacular economic rise. In the early 1920s the American public was used to hearing reproduced music via the phonograph, which was an acoustic medium. Phonograph music was collected in the studio through a horn and reproduced in the home via another horn, the overall goal being to produce a facsimile of an actual performance in a concert hall.[88] Radio, in contrast, utilized an electric recording and reproduction method that many consumers found more satisfactory. Thanks to continuing technological improvements, by 1924 radio provided its listeners with a substantially louder sound than what the phonograph offered. Amplifiers in the studio could adjust volume and tone, creating a sound that functioned more as a manipulable "aural signature" than as a direct reflection of concert hall aesthetics.[89] Inside the home the radio sounds could be broadcast via loudspeakers, enabling a substantial increase in music volume. Moreover, many listeners found the radio's bass levels to be more satisfactory than those provided by the phonograph. For radio listeners in the mid to late 1920s this meant that the electric sounds of radio made popular tunes danceable in a way that similar tunes on the phonograph were not.[90] Seeing radio's advantage, phonograph companies began shifting to electric recording in 1925,[91] but most of these records were still played in the home on acoustic devices.

Partly as a result of this sonic difference, phonography experienced a dramatic fall that was inversely proportional to radio's success. In 1925, phonograph sales were thriving, while radio sets, though clearly on the increase, still occupied only 10 percent of American homes.[92] Phonograph sales remained strong in 1927, but by 1932 they totaled only 6 percent of what they had been in 1927,[93] while the radio industry continued to boom. To be sure, the Great Depression was also a major contributing factor. Where listeners had to pay for each individual record heard on a phonograph, radio—outside of the initial purchase of the set and periodic maintenance and upgrades—offered an entertainment that was entirely free to the public, and this proved particularly appealing during the cash-starved 1930s. But the radio in the late 1920s also benefited from its status as an electric medium. Early sound filmmakers, who also worked in an electric medium, would have recognized this important potential of electric sound.

Silent Film Music

In the earliest years of sound cinema, no practice offered a more logical or convenient music model than late silent film accompaniment. Not only was silent film music the most proximate influence, but it had already developed techniques for attending to narrative events and accompanying a medium featuring regularly changing images. Had Hollywood transitioned to sound fifteen years earlier, silent cinema would have offered a far less practical model. For much of the silent era, film accompaniment practices were extraordinarily diverse and in many cases depended on the particulars of each exhibition space. By the 1920s, however, a push to standardize silent film sound had yielded a musical accompaniment style that was far more consistent across the country, thus offering early sound practitioners a better-defined set of aesthetic guidelines.

Many of the developments in silent film music in the 1910s and 1920s can be attributed to Roxy, a man who was instrumental in popularizing the practice of using top-quality music to suggest the presence of high-class, prestigious entertainment in the movie palace. After honing his theater managing strategies at the Alhambra Theatre in Milwaukee and the Lyric in Minneapolis,[94] Roxy took over the Strand Theater in New York City in the mid-1910s. He hired top-flight musical talent and substantially

increased the size of his motion picture orchestra. Replicating this tactic at three other high-profile movie palaces in New York City (the Rialto Theatre, the Rivoli, and the Capitol Theatre) and aided by his regular radio broadcasts, Roxy and his theaters soon became synonymous with high-class musical experiences at affordable prices. By the 1920s, Roxy's theaters provided music that was literally as good as anything that could be found in the New York City classical concert scene.[95]

Roxy's exhibition practices had an enormous impact on movie theater managers across the country and helped elevate cinema to a higher cultural standing. Other picture palaces in major urban areas quickly began imitating Roxy's strategies, and smaller theaters in turn sought to imitate larger ones. Consequently, the average size of motion picture orchestras roughly tripled in the late 1910s and early 1920s, with the premiere theaters featuring forty or more orchestra members.[96] In most cases the increase was in the string section rather than the brass. As Altman discusses in *Silent Film Sound*, a key work on the subject of silent film music, brass instruments were at this point associated with less prestigious entertainments like vaudeville or local band performance. By increasing the number of string instruments, movie theaters positioned themselves as providing the kind of classy, highbrow entertainment associated with orchestras in Europe. So important was "high-class" music in movie theaters in the late 1910s and 1920s that in some cases the theaters would simply hire the city's symphony orchestra.[97] Because of the increase in both the quantity and quality of motion picture orchestra musicians, music—especially in upscale motion picture palaces—became nearly as important as the feature film, if not more so. Testifying to the importance of musicians, in the picture palace the musicians' salaries generally cost about as much as the film service.[98] Like phonography and radio practitioners, then, movie theater exhibitors also used classical music as a mark of cultural prestige.

Though film producers occasionally provided theaters with original sheet music scores for particularly prestigious films, the bulk of 1920s film music consisted of compilations of preexisting pieces. In many cases such film music was selected on the basis of cue sheets. These were separate commodities distributed for free—sometimes by film producers and distributors, sometimes by music publishers and independent cue sheet companies. For each film, cue sheets provided a list of recommended music to be used at specific points during the film. Cue sheet publishers would generate this list by screening a film and deter-

mining which music to use. Though useful to each movie theater's music director, who generally had to provide music for a weekly turnover of films, cue sheets also effectively served as a form of advertising for photoplay music, as the suggested music was often owned by that particular cue sheet provider.[99]

Though cue sheets helped a movie theater's music director decide which photoplay music to acquire and use for each film, the music director's job was still considerable. Late silent film music was nearly always continuous, meaning that overseeing musical accompaniment for each film was an enormous job. For this reason the music director became a particularly important person in the motion picture theater. As music scholars James Buhler, David Neumeyer, and Rob Deemer explain, "The music director oversaw a range of musical activities in the theater. These activities included: rehearsing, acquiring and cataloguing music, fitting music to the film, laying out the musical portion of the program in consultation with the general manager, hiring musicians, assistant conductors, and librarians."[100] This model of the music director would also be applied to the creation of sound film scores in the early sound period.

In the 1920s, film accompaniment contained a mix of classical and popular music. According to Altman, classical music would typically be used for large impersonal scenes, while popular music was more likely to accompany intimate or sentimental sequences.[101] Though classical music helped theater managers portray their product as high-class entertainment, it was chosen for legal reasons as well. In 1917 the United States Supreme Court ruled that performing a copyrighted piece of music in a venue where money was charged was illegal unless that venue paid a tax. Prior to 1917 many people in the music business believed that performing copyrighted music without paying a tax was permissible provided that patrons were not present *specifically* to hear the music. Recognizing that theater managers were suddenly finding themselves forced to pay a tax they had not reckoned on, cue sheet publishers increasingly poached from the classical music repertoire because in many cases its copyright had expired.[102] Classical music was all the more accessible because the two main American publishers of classical music, Schirmer and Fischer, continued to publish their music tax-free.[103] This copyright situation would continue to impact scores in the early sound era.

By the 1920s, a series of music practices for accompanying the feature film had solidified into common, familiar usage. Conceptually, the

music sheet

overriding goal in the period was to dissemble the sound source by making it seem to emerge from the film's production. As Altman has demonstrated, in the nickelodeon era (roughly 1905 to 1913) pianists had exploited the audience's knowledge of popular song lyrics to provide commentary on the film, a tactic sometimes referred to as "kidding." When a film depicted a woman putting on a hat, for instance, a nickelodeon pianist might have provided a rousing piano rendition of the old favorite "Where Did You Get That Hat?"[104] Where this practice positioned the music as a force *external* to the film, by the 1920s the goal had become to make the music seem as though it were *internal* to the film—that is, as if it were part of the film's production. Consequently, the spectator was encouraged to become more fully absorbed in the fictional world and less aware that a force external to the film provided the sound.[105]

A host of techniques was deployed to achieve this goal. Whereas in the earliest years of the expanded motion picture orchestra the performers would be placed on the stage itself, by the 1920s the orchestra would invariably be located in the orchestra pit during the feature film, the better to hide the instruments from the movie audience. Because silent film music was continuous, music directors sought to minimize awkward key changes that might distract the audience's attention from the diegetic world presented onscreen. As Altman has demonstrated, music pieces that were likely to be played consecutively—particularly those that reflected similar moods—would often be written in the same or related keys so as not to be jolting or even noticeable when an orchestra transitioned from one piece to the next.[106] Silent film music also sought to tie accompaniment to character rather than situation. Accompaniment to stage melodrama had attended to narrative situation over character, thus tying the music to an external force that acted on the characters.[107] Silent film accompaniment of the 1920s instead attended to specific characters' thoughts and feelings, thereby aligning the audience more closely with the characters' internal emotions. Also, while silent film accompaniment had long changed musical selections in conjunction with scene changes, by the 1920s orchestras regularly anticipated scene changes by switching to a new music cue a second or two prior to the scene change, thus giving the impression that the music was part of the film's production rather than an external agent commenting on it. Finally, music was also used to smooth such potentially jarring edits as crosscuts, flashbacks, and intertitles. For example, rather than play an entirely new piece of music dur-

Continuous music - transitions not noticeable, → change music with scenes 1 or 2 seconds prior to scene change

ing a flashback, thus creating a jolting transition, orchestras would often simply play the same piece at *piano* or *pianissimo* volume (the two quietest levels of playing).[108] Even the published rules of conduct for orchestra members emphasized their invisibility, stating such maxims as "When the tuning bell is struck, get the pitch immediately, preluding or improvising is absolutely forbidden."[109]

Given the presence of top-echelon orchestras, drawing attention away from the source of the music may seem counterintuitive. In essence, orchestras were being asked to perform in a way that made them seem as though they did not exist. Yet in order to move away from the lower-brow practices of the nickelodeon era, dissembling the orchestra during feature film accompaniment was a must. Only during the overture that regularly opened the film program would the orchestra truly have the opportunity to show off by playing prestigious music—most commonly opera overtures from masters like Wagner and Verdi or single movements from larger symphonies from composers like Beethoven or Tchaikovsky.[110]

For practical reasons several specific accompaniment practices solidified in the 1920s. First, owing to the orchestra's heavy reliance on cue sheets, limited rehearsal time, and increased size, theaters seldom tried to match music to specific actions. To help music fit the picture, cues tended to be short and contain many repeats,[111] yet music still more commonly corresponded to setting, general actions, or general mood. Though orchestras sought to create the impression that they were part of the film's production, in reality they were reacting to an already-produced product, and matching music to precise moments in the film was both a complex and risky proposition.[112] Second, the presence of a large orchestra encouraged the use of themes that simply repeated, as opposed to the Wagnerian tendency to vary leitmotifs throughout a narrative. While a lone performer could theoretically vary a theme extemporaneously, to accomplish this with a large orchestra would have necessitated far more rehearsal time than motion picture orchestras generally had. Consequently, the same theme, often tied to a particular character, would usually be heard regularly and without variation virtually any time the character appeared onscreen. The increased use of classical music also contributed to this tendency to use a static theme: if the audience recognized a piece from a "master" composer, tampering with such a piece might be considered virtually criminal by the audience members. Though simplistic and surely monotonous at times, static themes did serve important purposes

Song plugging

for several different groups: they were easier for musicians to perform, useful for song plugging purposes, and their familiarity could help audiences sense a shared community of filmgoers.[113] Much like the performance of popular tunes in stage melodramas and musicals, the repetition of themes could enable a community of spectators to bask in their mutual recognition of a particular number.

Song plugging, an essential part of the era's numerous stage musicals, also became a major factor in silent film accompaniment during the late 1910s and 1920s. Though song plugging had been important in the nickelodeon era through the regular use of illustrated song slides that alternated with one- or two-reel films, in the late 1910s film producers and exhibitors began to capitalize on a hit song's ability to promote a specific film. Beginning with the title song from the film *Mickey* in 1917, theme songs increased in importance throughout the silent era, culminating with the massive success of "Charmaine" from *What Price Glory?* (1926) and "Diane" from *7th Heaven* (1927), both written by Roxy Theatre music director Erno Rapee.[114] As with any cross-promotion, the theme song was mutually beneficial to multiple markets. By associating a song with a particular film, the film's success could trigger the sale of sheet music and phonograph recordings. This, in turn, increased audience awareness of the film and was likely to further boost ticket sales. When Hollywood began its transition to sound in the late 1920s, it did so at a point when song plugging in film was at an all-time financial high.[115]

One final component of silent film accompaniment deserves attention: the organ. Though the orchestra would generally accompany the bulk of the feature film in the 1920s, in theaters that had organs, the organist would usually take over the middle section of the film. This organ interlude offered theaters the chance to show off the mighty Wurlitzer organ, but it was also done to prevent performer fatigue. In addition to the feature film, the orchestra was expected to provide the overture and accompany several of the short films leading up to the feature. Clearly, the orchestra needed a break during the feature. As a result, 1920s audiences would have experienced contrasting styles of performance during the course of a single feature. Because the orchestra depended on the coordination of a large number of musicians, its performance would have felt somewhat impersonal. In contrast, the organist, as the lone performer, had the opportunity to use a more improvisatory style, thus allowing a sense of the organist's unique musical personality to emerge. Not coinciden-

(handwritten annotation at top: catching the falls in Flame — music & screen action)

tally, the organist was often called on to accompany the short comedy that preceded the feature. In terms of musical practices, the short comedy remained the one holdover from the nickelodeon era: musicians often used "kidding" and "catching the falls" (musical notes that coincided with punctual onscreen actions, particularly body falls) to provide an overt, lively, personal commentary on the onscreen events.[116] The organist, then, offered a sense of individualism and personality that would have exceeded that of the large orchestra.

Although the vestiges of its lower-brow nickelodeon practices remained, cinema by the 1920s had arguably elevated itself to a middlebrow entertainment. As a bona fide mass entertainment form, cinema was pitched to respectable, genteel patrons through the presence of first-rate musicians and music, while still catering to the middle- and working-class crowd via its accompaniment style for comedies and its relatively inexpensive tickets. Though cultural elites may have abhorred the mix of classical and popular music and perhaps also derided the mix of various social classes in the same theater, motion pictures—particularly when exhibited in opulent picture palaces with top-notch orchestras—enjoyed a reasonably respectable social standing in the years leading up to the transition to sound.

(handwritten marginal note, right side: mix of social classes ?)

(handwritten notes at bottom of page:)

Theme song : song — film
↓
sheet music

+ popular music

Flame
→ classical → middle brow
music entertainment

Rublee adds Mexican songs. W
→ still uses catching the fall techniques
→ parallel cut scenes with the same music running through so as not to interrupt action development.

2. MUSIC IN EARLY SYNCHRONIZED AND

PART-TALKING FILMS, 1926–1929

Flame is a synchronized film

HOLLYWOOD'S TRANSITION TO SOUND WAS NOT A SMOOTH PROCESS in which the industry produced a consistent aesthetic product. Instead, the period featured a diverse and often chaotic array of films. By 1929, Hollywood filmmakers recognized that they had produced three major types of sound films. "Synchronized" films featured mechanically linked music and often sound effects but contained no dialogue. "Part-talkies" contained talking sequences in alternation with synchronized music. And "100 percent talkies" featured talking and/or singing for the duration of the film.[1]

This chapter investigates the ways in which music was used for synchronized and part-talking films, and it considers what was lost in the large-scale removal of live orchestras from the motion picture theater. Chapter 3 then examines the film score for "100 percent talking films"— excluding musicals—from 1929 to 1931. Though a few isolated analyses of individual early synchronized and part-talking films do exist,[2] to date no scholar has provided any substantial or systematic examination of music in these two types of early sound films. As this chapter demonstrates, Hollywood initially used silent film accompaniment practices—including motifs, theme songs, and orchestra-generated sound effects—to produce

Theme song —> scored

Diegetic performances

its scores for "synchronized" films. Doing so enabled film music practitioners to draw on a proven method for guiding audiences through the narrative while simultaneously serving as a vehicle for ancillary profits via the publication of theme songs. As the appeal of onscreen musical performances and dialogue became increasingly clear, however, Hollywood's part-talkies began incorporating diegetic performances and dialogue while attempting to retain the near continuous music model of the late silent era. Though this cobbling together of music practices from silent film, phonography, and theater seemingly satisfied numerous user groups, it inadvertently created problems pertaining to nondiegetic/diegetic distinctions. Consequently, music in the part-talkies increasingly displayed attempts to clarify and differentiate these categories. Unceremoniously abandoned in the process, however, was the live motion picture orchestra, the last major human intermediary between the audience and recorded film entertainment.

synchronized film

THE RISE OF THE SYNCHRONIZED FILM

When Warner Bros. first introduced synchronized sound to feature film production in 1926, the intention was not to create a series of films leading to a 100 percent talking film. Rather, the studio sought something far less radical: to use recorded music as a replacement for the live portions of the program, namely the orchestral accompaniment and the increasingly elaborate stage acts that sometimes preceded the feature film.[3] By presenting a single recorded performance to audiences across the country, Warner Bros. hoped to cut costs and standardize film entertainment, important goals since the studio had recently expanded distribution and acquired a chain of first-run theaters in an effort to become a major film studio.[4]

Warner Bros. premiered its Vitaphone system at the Warners' Theatre in New York City on August 6, 1926. The program consisted of a series of synchronized music shorts—mainly of operatic numbers—and the feature film *Don Juan*, which contained sound effects and synchronized orchestral music recorded by the New York Philharmonic. By privileging classical and operatic music, Warner Bros. demonstrated the potential for synchronized films to offer top-quality orchestral accompaniment even in smaller communities with substandard musical practices, an advantage apparently hyped by the Warner Bros. publicity machine.[5] The

near continuous music model

use of a heavy classical and operatic repertoire also would have helped imbue the occasion—and the Vitaphone system itself—with a sense of prestige, a tactic that had already been successful in the realms of phonography, radio, and silent film.

Given the subsequent financial success that Vitaphone films would enjoy, it is easy to overstate the importance of this first instance of a feature-length synchronized score. One film music historian, for instance, states that *Don Juan* "ignited a revolution in cinematic practice."[6] Yet the film had no discernible impact on contemporary live music accompaniment practices,[7] and the trade presses gave very little attention to sound film until the summer of 1928, a full two years after *Don Juan*'s premiere. Even those closely associated with film music decisions did not see *Don Juan* as the catalyst for a larger industrial change. In an article on film music practices published three months after *Don Juan*'s premiere, for example, prominent New York City film music director and arranger Hugo Riesenfeld devoted only a paragraph to the Vitaphone process, focusing in the rest of the article on the various methods and logistics of silent film accompaniment.[8] Financially speaking, *Don Juan* and the second Vitaphone release, *The Better 'Ole* (which premiered two months after *Don Juan*), did not have unequivocal success. The synchronized music versions of these two films played well on Broadway but had mixed results elsewhere in the country.[9] In many cases the short films fared better with the public than did the feature film accompaniment.[10]

If *Don Juan* did not exactly ignite a revolution in cinema practice, however, it did constitute the first of what would be hundreds of films produced with a synchronized score that drew heavily on silent accompaniment practices. This reliance on silent film is partly attributable to personnel, since many creators of early sound scores—including Riesenfeld, Erno Rapee, William Axt, Major Edward Bowes, and David Mendoza—supervised silent film accompaniment in New York City, a location considered the pinnacle of silent film music in the 1920s.[11] Drawing on silent film music practices gave early sound film practitioners a ready-made model of film accompaniment with a proven ability to define characters, clarify narrative development, smooth over filmic transitions, guide interpretation, and channel emotion. But early sound cinema's heavy indebtedness to silent film music also suggests that sound film practitioners did not initially see themselves as doing anything substantially different from the silent era. Indeed, the Vitaphone synchronized

sound system was regularly referred to simply as the "score" in trade press in the period.

Even the process of scoring synchronized films in the late 1920s re-mained similar to late silent practice. In an article from March of 1929 Mendoza explained that first a film would be previewed to provide "an ac-curate idea of the mood, atmosphere and general type of music required for the film," as well as to generate ideas for a theme song. A cue sheet would then be plotted, followed by a visit to the music library to select appropriate tunes. Mendoza further reveals that for MGM scores this "musical library" meant the music collection in the Capitol Theatre—a major silent film theater that MGM had recently purchased. Also like late silent film music, the finished score would either be a compilation or consist of preexisting music interwoven with some original music.[12] In addition, the early synchronized score continued the silent-era practice of favoring continuous music and using classical and popular music within a single score.

The following four sections identify and analyze four elements of early synchronized film music—motifs, theme songs, sound effects generated by the orchestra, and diegetic/nondiegetic distinctions—that deserve particular attention. This analysis is based on viewing and listening to the synchronized films released between August of 1926 and November of 1929 listed in the appendix. Examining these techniques reveals syn-chronized film's debt to silent cinema and indicates the ways in which the stakes changed with the arrival of synchronized sound.

Musical Motifs

A central technique of the late silent era, musical motifs or themes con-tinued to be the dominant organizational principle in the early sound score. As I noted in chapter 1, themes in the late silent era tended to be static, which differed from Richard Wagner's tendency to modulate and develop his leitmotifs to reflect the evolving narrative.[13] Probably a result of longer preparation times, motifs in early synchronized films do con-tain a bit more variation than in the silent era, particularly via the trans-position of motifs into minor keys at narratively appropriate moments. Still, on the whole motifs in synchronized films remained relatively static: filmmakers seldom changed their rhythm, number of beats in a measure, number of measures, and so on. Even these static motifs served

multiple crucial narrative functions, however. Musical motifs not only helped immediately identify and differentiate characters, but they could more subtly embed a range of ideas pertaining to character agency, psychological transformation, gender, and race, as well as provide films with a sense of unity and cohesion.

The scores for three early Vitaphone features—*Don Juan, The Better 'Ole* (October 1926), and *Old San Francisco* (June 1927)—demonstrate these functions. *Don Juan*'s score—credited to Bowes, Mendoza, and Axt—provides all major characters with their own themes, including Don Juan (John Barrymore), the evil seductress Lucrezia Borgia (Estelle Taylor), and the pure and wholesome Adriana della Varnese (Mary Astor). However, the frequency with which the film connects specific themes to these characters coincides with each character's degree of agency in the film.

Of the principals, Lucrezia occupies the position of greatest power. The music signifies this by doggedly providing her motif—a downward run followed by a sustained chromatic note—virtually every time she appears on the screen (fig. 2.1) (a "run" is a fast series of ascending or descending notes). Don Juan is regularly provided with a waltz—conventionally a signifier of sexuality and courtship—that is tied to his character (fig. 2.2). The powerless and demure Adriana receives her theme—a slower, statelier waltz—only at infrequent intervals (fig. 2.3). For example, when Don Juan sees Adriana for the first time, the film provides her theme only briefly before shifting to what will quickly become the couple's love theme (fig. 2.4). The brevity of her theme and the immediate connection between Adriana and the love theme suggest that she exists less as a character in her own right and more as a prize to be won by the male lead.

In addition to character agency, *Don Juan*'s score also highlights character transformation. Unlike Lucrezia, who remains unchanged throughout the film, Don Juan undergoes several psychological shifts in which he changes his mind about whether women are fundamentally evil creatures or capable of purity and genuine love. The score highlights this by providing Lucrezia with an unchanging theme throughout the film while allowing Don Juan's theme to be altered in accordance with his psychological shifts. For example, Don Juan's theme is initially tied to his womanizing lifestyle: one of the earliest instances of this theme coincides with a list of Don Juan's many planned meetings with different women

What is the role of the theme song?
→ Appears means

FIGURE 2.1 Lucrezia's theme in *Don Juan*.
Transcribed by the author.

FIGURE 2.2 The title character's theme in *Don Juan*.
Transcribed by the author.

FIGURE 2.3 Adriana's theme in *Don Juan*.
Transcribed by the author.

FIGURE 2.4 The couple's love theme in *Don Juan*.
Transcribed by the author.

in a single day. Later in the film, however, this lifestyle is called into question when a woman he has been seeing kills herself rather than face her husband. When this occurs, Don Juan orders all of the other women out of his house. As he does this, his theme is transposed to a minor key and played by the brass in an angry *staccato* style (short, sharp notes detached from each other) to suggest that Don Juan has recognized the repercussions of his libertine ways and denounced his prior code of ethics.

Don Juan's transformation is nowhere more evident, however, than in the score's alternation between his motif and the soaring theme used to represent the love between him and Adriana (film historian Harry Geduld calls these tunes the "Lust" and "Love" themes, respectively).[14] Initially thinking that Adriana is like all of the other loose, dishonest women in his life, Don Juan barges into her bedroom uninvited and

brass → Mexican revolution and political change – Taxco
string → couples / countries love

begins violently kissing her despite her protestations. During his assault the audience hears the Don Juan waltz. Only when Don Juan realizes Adriana's goodness and purity does the love theme play on the soundtrack. From here until the film's end, this theme will represent not only the love between Don Juan and Adriana but also Don Juan's more positive attitude toward women, which on this movie's terms are one and the same. Though this use of motifs helps explain Don Juan's psychological crisis, it also (perhaps inadvertently) clarifies an important reason behind Adriana's lack of agency. Lacking a strong personality of her own, Adriana matters only in terms of how the male lead sees her. She is important largely as a catalyst for the male's transformation and matters little as a psychologically fleshed-out character in her own right.[15]

If motifs in this period can illuminate character psychology and reinforce patriarchal gender conceptions, Riesenfeld's score for Warner Bros.' *Old San Francisco* demonstrates the ease with which themes can also be used to ethnically brand the film's characters. Like *Don Juan*, *Old San Francisco* gives every major character his or her own distinctive theme. Here, however, Riesenfeld uses overtly stereotypical music to reinforce the ethnicity of the central characters. This tactic is particularly clear during the first meeting between Dolores Vasquez (Dolores Costello) and Terrence O'Shaughnessy (Charles Emmett Mack), the romantic leads in the film. Terrence sees Dolores picking roses in the garden of her Spanish-style villa, and he walks over to speak with her as Dolores's waltz theme is heard on the music track (fig. 2.5). Dolores leaves, and Terrence pursues her, stating via an intertitle, "Please, Senorita—I am not bold—I'm Irish." Immediately upon the mention of his ethnicity, the score features "Believe Me, If All Those Endearing Young Charms," a famous old Irish melody that will become Terrence's theme. A few moments later, Dolores responds with, "We Vasquez are Spanish—our women remain at home." Upon the beginning of this intertitle, the score obligingly switches back to Dolores's waltz, this time complete with a Spanish castanet accompaniment. Moments later, Dolores accidentally drops a rose from her bal-

FIGURE 2.5 Dolores's theme in *Old San Francisco*, a graceful waltz. Transcribed by the author.

Díaz's Calamity ← Thornton / Rosita
Rafael / Rosita → inter-ethnic marriage
Revolution

cony, which Terrence catches. Terrence's intertitle then reads, "By Irish luck I got it—by Irish pluck I'll keep it," and the music hurriedly returns to Terrence's Irish theme once more. Thanks to the combination of music and intertitles, these two characters become ethnically branded for the duration of the film.

Though simplistic, such stereotyped themes do help articulate a central issue posed by *Old San Francisco*: the extent to which different ethnicities should mix romantically. The string-heavy orchestration and romantic tone of the Spanish and Irish motifs immediately suggests that a union of these two European ethnicities is healthy and natural. In contrast, the film features a Chinese man named Buckwell (Warner Oland) who poses as a white man and also has a sexual interest in Dolores. Along with events in the narrative, Buckwell's motif—an ominous, low-register, staccato passage played on the tuba—makes it clear that European-Asian mixes are entirely unacceptable (fig. 2.6).[16] Moreover, by saliently marking Dolores and Terrence's ethnicities through the combination of intertitles and music, the film further indicts Buckwell's ethnic deception. If a "healthy" relationship is one in which different ethnicities are acknowledged, then the score implicitly condemns Buckwell's efforts to masquerade as an ethnicity that he is not. Through the use of motifs, then, music can be mobilized to reinforce the perceived boundaries of ethnic mixing.

Immanently flexible, motifs could also help provide comedies with a sense of cohesion. The comedic *The Better 'Ole* contains a narrative in which the British soldier Bill (Syd Chaplin) and his friend "Little Alf" (Jack Ackroyd) fall into enemy hands during World War I. Through a series of gags they escape and prevent the American soldiers from marching into a trap. On one level the music's preoccupation with accompanying physical comedy seemingly precludes the use of sustained motifs throughout the course of the film. During the numerous moments of slapstick, the music deploys what could be called a *moment-by-moment* aesthetic: the music responds to each gag as it occurs rather than highlighting connective links between scenes. Cymbal crashes accompany virtually every

FIGURE 2.6 Buckwell's low-register *staccato* theme in *Old San Francisco*.
Transcribed by the author.

Not ethnic mixing in Theme but acknowledgement of Mexico's value—linked to a politics of respect for sovereignty

FIGURE 2.7 Bill's theme in *The Better 'Ole*. The filmmakers often add glissandos to emphasize Bill's comedic role.
Transcribed from *The Better 'Ole* music files, Warner Bros. Archives, University of Southern California.

FIGURE 2.8 Danger to the troops theme in *The Better 'Ole*.
Transcribed by the author.

character's fall in the film, a pinprick is matched with a strike of a high-register piano key, a slide whistle is heard when one German soldier has his hat accidentally shot off by another German soldier, and numerous instances of "kidding" recur throughout the film. Yet despite this moment-by-moment aesthetic of punctual music effects, the score still uses two themes that are tied to the film's larger narrative arc. A brass melody played staccato represents Bill (sometimes played with pronounced slid-ing notes, or *glissandos*, to mark him as a comedic character) (fig. 2.7), and a gliding, minor-key melody occurs when the British army is in danger of being defeated thanks to German spies (fig. 2.8). By regularly deploying the large-scale motifs along with moment-by-moment accompaniment, the score demonstrates that the film's seemingly isolated gags are all driven by a common push toward an end goal. This provides even a disjointed comedy like *The Better 'Ole* with a sense of unity.

The Theme Song

If instrumental motifs served a variety of *narrative* uses, theme songs in the early synchronized film offered an even broader spectrum of functions. In opera, leitmotifs remained separate from performance "numbers" such as arias. In early synchronized films, however, a vocally performed theme song could also recur instrumentally as a narrative motif. A theme song could thus operate both as a narratively related motif and as a com-modifiable product.

Erno Rapee and Lew Pollack's hit theme song "Angela Mia," from Fox's *Street Angel* (April 1928), offers a useful illustration.[17] *Street Angel* tells a love story between Angela (Janet Gaynor)—a woman previously arrested for theft and attempted prostitution while trying to obtain money to buy her dying mother some medicine—and the itinerant painter Gino (Charles Farrell). The couple's relationship undergoes a substantial test when Angela, unbeknownst to Gino, is forced to go back to prison for her crime. Like many other films directed by Frank Borzage, the narrative ultimately serves as a testament to love's ability to transcend any real-world problems.

On one level "Angela Mia" functions as an important motif in the narrative. Outside of the opening credits—a mandatory location for the theme song in the early sound era—the soundtrack first features "Angela Mia" when Angela, after being romantically pursued by Gino, finally begins falling in love with him. From then on, the film uses this song in nearly every scene that visualizes the couple's love for each other. There are many of these. "Angela Mia" plays when Gino begins painting Angela's portrait, when he shows the portrait to Angela, when he transports the injured Angela across the water to see a doctor, anytime Gino experiences artistic success (the implication being that his love for Angela fuels his art), during any scene featuring the couple's premarital domestic bliss, during Gino's marriage proposal, and during their final reconciliation, to name only some of the instances. The theme is modified in ways that fit the story. For instance, the filmmakers transpose "Angela Mia" to a minor key during scenes in which Gino and Angela's love is in doubt, such as a scene in which the morose Gino—unaware that Angela is back in prison—hopelessly wanders the streets in search of her.

As a narrative tool, then, "Angela Mia" underscores the couple's love and charts for the viewer the magnitude of the obstacles thrown in the lovers' path. Yet it is precisely this narrative function that also justifies its incessant song-plugging function in the film. Every time the tune is used to suggest the couple's love, it simultaneously fuels phonograph record and sheet music sales by increasing the audience's familiarity with the tune. This is particularly notable during a scene in which a police officer gives Angela only one more hour with Gino before the police take her away to jail. Again and again during this drawn-out scene, the score repeats the "Angela Mia" theme to indicate the tragedy of separating so strong a love. What might ordinarily constitute an instance of obvious and irritating

song plugging is rendered more acceptable through the theme song's additional role as a guide to narrative comprehension.

If a theme song's narrative connection justifies its repeated usage, its lyrics—which often relate to the narrative—can help to further excuse its extensive repetition. MGM's *Wild Orchids* (February 1929), for example, uses the eponymous theme song to illuminate the psychology of its central characters. *Wild Orchids* tells the story of Lillie (Greta Garbo)—a woman married to a sexually timid (perhaps impotent) older man—who slowly finds herself attracted to a handsome dark foreigner known as Prince De Gace (Nils Asther). Outside of the opening credits, the audience first hears "Wild Orchids" after the camera cuts from a shot of the prince, lustfully gazing off-camera at Lillie, to a medium shot of Lillie herself. Just as this eyeline match traces the prince's gaze, the audience soon learns that the *lyrics* for "Wild Orchids"—revealed in a subsequent scene—represent how the prince *feels* about Lillie:

> You are my wild orchids,
> Wild orchids, so rare.
> I've seen flowers everywhere
> There's no one I dare compare.
> You're just as pure as all wild orchids
> That grow in the sun and
> Bloom for me, constantly.
> Deep in my heart.

Through the theme song's lyrics, the film conveys the prince's knowledge that while Lillie is initially cold toward his advances—behavior that befits an upper-class American woman—she is capable of great passion if liberated from stuffy upper-class societal conventions. The film further drives home the connection between lyrics and character through dialogue intertitles that are presented while the song plays on the soundtrack. The prince says to Lillie, "You are like the orchids of your country—you have the same cold enchantment," and shortly thereafter, "In Java [the prince's home island] the orchids grow wild—and their perfume fills the air." As Lillie spends time in Java, she comes to believe the prince's assessment of her personality, and the score responds by occasionally using this theme song even in instances when the prince is *not* present to look at her lustfully. The lyrics to "Wild Orchids," then, comment specifi-

cally on the psychology of *Wild Orchids'* protagonists, further justifying the song's regular accompaniment to the narrative. Like numerous other early synchronized films,[18] *Wild Orchids* hides its overt song-plugging efforts by using its theme song as a narratively consistent motif.

Though the theme song on one level functioned as a mere continuation of late silent film practices, the fact that the theme song was now recorded and synchronized to the film only elevated its economic potential for film studios. Filmmakers could now be assured that for every screening of the sound version of the film, the theme song would be permanently "glued" to that particular film. A *Variety* article from January of 1929 that summarized the previous year affirms this importance: "The disk recording process[,] and its suggestion of the phonograph record and the popular song, inspired the thought of *permanently* synchronizing a theme into the picture."[19] The silent era had already proven that money could be made from fusing theme song to film. With the coming of sound, that fusion became literal. Moreover, unlike the silent era, in which a massive countrywide coordination and effort was needed to plug songs, sound era song plugging required only a single recorded performance of the song. Studios could control the sound of the theme song by offering a sung rendition that they were pleased with. The theme song also benefited from electric sound's amplification abilities. Film historian Richard Koszarski points out that the amplification of music made possible by electric sound would have been a particular selling point of early sound film, since few—if any—spectators had experienced the "clarity, range, and sheer volume" produced by electronically amplified theater sound.[20] By the late 1920s, the radio was beginning to prove its ability to promote popular tunes through the amplification of sound, and filmmakers could use the theme song to capitalize on a similar thermionic technology.

Thanks to synchronization, logistical convenience, and amplification—as well as the part-talkie's ability to plug popular music even more overtly—the major studios invested heavily in music publishing companies during this period. As film historian Katherine Spring has demonstrated, all major studios either affiliated with music publishing firms or bought those firms outright. By owning song copyrights, the major studios could avoid expensive licensing fees. Moreover, plugging a song in a film would generate additional revenue for the major studios through sheet music sales.[21] Investing in music publishing thus made good financial

sense for the majors, but it is worth noting that this investment began only after Hollywood had committed to sound cinema; nothing along these lines had been attempted during the silent era. Indeed, film's identity changed so much with the transition to sound that by 1929, movies were seen as the primary way to generate a hit song.[22]

Music and Sound Effects

As in the late silent era, the orchestra—mostly the percussion section—provided many of the sound effects in synchronized films. Yet while the generation of sound effects by the orchestra was a continuation of silent film practice, the sheer *amount* of precisely synchronized moments in these scores exceeded virtually anything found in live accompaniment practices. Again and again, films from the early sound period contain scores that catch precise sound moments. In *The Better 'Ole*, for example, an early scene set at night during trench warfare features numerous cannon blasts on the screen, each blast clearly visible as a flash of white. These flashes are quite brief, and nothing in the image indicates when the next bomb blast will occur, yet each flash is precisely matched with the strike of the timpani. In Warner Bros.' *When a Man Loves* (February 1927), a cymbal crash occurs when Chevalier Fabien des Grieux (John Barrymore) throws his former lover, Manon Lescaut (Dolores Costello), to the ground. Meanwhile, a sforzando chord played by violin and brass is heard when des Grieux turns the tables by striking the prefect of police with his own pistol. Fox's *Sunrise* (September 1927) uses a gong to accompany The Wife's (Janet Gaynor) fall into the water, a quick cymbal strike to match a stranger's sudden clutch of his own throat when he believes he is about to be stabbed, and a quick timpani drum roll to match a statue's fall to the floor. In Universal's *The Man Who Laughs* (April 1928), short timpani drum rolls accompany numerous body falls, and a cymbal crash catches Gwynplaine (Conrad Veidt) as he hurtles himself through a glass window. In one scene alone from Universal's *Uncle Tom's Cabin* (November 1927), a cymbal crash represents a glass bottle shattering after the evil Simon Legree (George Siegmann) throws it against a door, a short timpani drum roll occurs when Legree winds up to punch Uncle Tom (James B. Lowe) in the face, and a brass-heavy sforzando matches Legree's actual punch.

Synchronized punctual effects increased partly for practical reasons. Where a silent film orchestra had to accompany an entire film in one session, recorded orchestras generally performed the score one ten-minute reel at a time, with somewhere between two to ten recordings taken for each reel.[23] Thanks to a shorter playing duration and the possibility of retries, the orchestra could devote more attention to close synchronization than in the past. But these conditions only enabled closer synchronization to take place; they explain little about why recorded orchestras attempted it. Efforts at synchronization during the early years almost certainly escalated because filmmakers wanted to showcase the new technology's ability to achieve precise and regular synchronization, an issue that had dogged previous efforts at synchronized sound.[24] Not surprisingly, by early 1929, attempts at synchronization had diminished somewhat. With synchronization technology becoming increasingly familiar to its audiences, the need to show off the technology lessened.

The use of orchestra-generated sound effects brings up a curious question: What, exactly, is the difference between music and sound effects? Today, few people would feel the need to answer such a commonsensical question. But for many early synchronized scores the boundary between "music" and "sound effect" is inextricably blurred. Consider, for example, a wind whistle that is used to denote storms in *The Man Who Laughs*, *Uncle Tom's Cabin*, and United Artists' *Eternal Love* (May 1929). Though the sound is most likely generated by the orchestra, one could reasonably claim that it is a "sound effect" because it imitates a sound suggested by the onscreen image. But how, then, does one define the rapid, up-and-down orchestral runs that also denote the wind in these examples? The wind whistle and orchestral runs are similar in pace, movement, and pitch. The main difference is simply that the whistle constitutes a single "slurred" up-and-down note while the stringed instruments use rapid, separated thirty-second notes to indicate the same idea. What, then, divides music from sound effects?

Such questions of musical illustration were not unique to the 1920s. They arose during the Renaissance, when musicians became concerned with proper text setting. "Word painting" or "madrigalisms" developed into conventional melodic and harmonic figures for images, emotions, and concepts. Later, opera would also regularly use some form of word painting.

In these instances, it mattered less that the effect sonically "matched" the sound in reality. Creating affect in the listener—rather than differentiating between music and sounds produced by diegetic action—was the greater concern.[25]

Film composers would have been aware of this history of musical illustration. Judging from the films, they, too, felt little need to strictly differentiate between accompanying music and sounds emitted in the diegesis. Instead, synchronized films gave them a vested interest in blurring this line rather than sharply defining it. If a sound functioned equally well as diegetic source (sound effect) and nondiegetic commentary (music), then implicitly the synchronized musical accompaniment as a whole was a seamless match for the images presented onscreen. This blurring suggested to spectators that a *perfect fit* between sound and image had been achieved. Sound effects, then, benefited multiple users by displaying the score's proper coordination with the film, as well as the technology's ability to precisely synchronize sound and image.

Though the orchestra generated some sound effects, many other effects during this period clearly emerged from beyond the confines of a traditional orchestra. Sword clinks, car horns, and generalized shouting are three particularly popular sound effects in this period. During such moments, sound film practitioners encountered a problem not faced in the silent era: when music and sound effects occupy the same sonic space, how—or should—their respective volume levels be adjusted? By and large, synchronized films treat music and sound effects as if they were independent elements wholly unaware of each other's existence. Sound effects' volume varies: sometimes the effects are quiet (the sword clinks in *Don Juan* and *When a Man Loves*) while at other times they are quite loud (the sound effects suggesting the crowds and commotion in *Sunrise* and *The Man Who Laughs*). Yet in these films, and many others, music remains at its usual volume level regardless of the presence or loudness of the effects.[26] *Old San Francisco* provides one of the only exceptions to this rule. During the sound effects for the famous 1906 earthquake that closes the film, the music dips substantially, thus making way for the sound effects to be the loudest element on the soundtrack. Yet this dip in music to accommodate sound effects—probably done to draw further attention to the expensive visual effects of the earthquake—remains the exception. Early sound practitioners, eager to showcase the novelty of amplification, probably found the lowering of music's volume to be counterintuitive.

Sound track music (not in Flame)

Diegetic sound — coming from the serenade

→ the hero and heroine songs

artists

ability to love

Diegetic/Nondiegetic Distinctions

One final categorical issue in the early synchronized score—the difference between diegetic and nondiegetic music (sometimes called source and background music)—deserves attention here, since it would be subject to substantial revision in the years that followed. For some film analysts, this distinction is clear: diegetic sound has a source in the story world, while nondiegetic music emerges from outside the story world. Recent scholars have increasingly noted instances in which the boundaries are blurred and have even attempted alternate categorizations of film music.[27] Yet the historical development of diegetic/nondiegetic distinctions has received scant attention. Instead, scholars have generally applied the terms *diegetic* and *nondiegetic* sound across the whole time frame of sound cinema, thus implying that these distinctions always existed.

The early synchronized score, however, indicates that perceived music-image relationships are based on the particular representational assumptions in the period and are thus historically rather than ontologically determined. Consider, for example, the boat-ride scene from *Street Angel*. The image depicts Gino alternating between singing and talking with his love interest, Angela. On the soundtrack, however, a male tenor sings the title song even during the moments when Gino appears to be talking to Angela rather than singing. Does this instance of song plugging constitute diegetic or nondiegetic sound? On the one hand, the link between the image of Gino singing and the sound of a song is surely not coincidental. On the other hand, no effort is made to synchronize Gino's moving lips with the tenor's voice. Indeed, one can even read the song as coming from the gondolier, whose image the audience briefly sees several times during this segment.

A similar categorical confusion occurs during a scene from *The Man Who Laughs*. An image of two horns corresponds with a fanfare tune that heralds the arrival of Queen Anne (Josephine Crowell). Yet the music quickly segues into a different orchestration of the same theme that adds timpani and cellos to the brass, two types of instruments that are clearly not present in the room. Should the audience understand this music to be diegetic, even though it features instruments not present in the story world? Or should the audience consider it nondiegetic, even though it clearly strives to represent—if not perfectly—the music heard in the royal hall?

Based on the plethora of diegetic/nondiegetic ambiguities on display in these early synchronized scores, the distinction seems to have been largely irrelevant. The early synchronized film score was largely a transplant of late silent film accompaniment practices. Because music in the late silent era emerged from an orchestra that was visible in the theater, diegetic/nondiegetic distinctions would have held little meaning. Instead, the late silent orchestra would have focused primarily on the *general suggestions for music that the image evokes*. Creators of the early sound score maintained this practice. In *Street Angel* images of a character singing indicate that singing on the soundtrack would make an appropriate musical accompaniment. Similarly, in *The Man Who Laughs* the two horns and the royal setting presented in the images serve as inspiration for a regal tune on the soundtrack. In these instances a categorical confusion exists only if diegetic and nondiegetic sound are considered anachronistically. In early synchronized films the musical styles suggested by the image mattered far more than the clear delineation of diegetic or nondiegetic space. With the advent of synchronized dialogue, however, these concerns would begin to change.

THE PART-TALKIE

Though the earliest synchronized feature-length films contained music and effects only, a second type of film soon emerged that alternated between synchronized music—based heavily on silent film techniques—and sequences featuring directly recorded sound. These sound sequences generally contained song performances, dialogue, or both. Though it is tempting to see these films simply as transitional, *en route* to "100 percent talkies," late 1920s sound film practitioners and audiences instead entertained the possibility that the "part-talkie" was a new but permanent form of cinema. Film historian Donald Crafton points out that in December of 1928 Jack Warner—cohead of production at Warner Bros.—told *Variety* that the "ideal proportion" for a film was 75 percent talking, 25 percent silent.[28] Echoing that general sentiment, *Variety*'s January 1929 review of Warner Bros.' part-talkie *Weary River* praised the film's mixture of 50 percent dialogue, 50 percent music/effects as an effective way to circumvent the "nervous exhaustion" that the all-talking film induced in the spectator.[29] Musical practices for part-talkies thus stand as a road not taken, a briefly dominant and important aesthetic model that would ultimately be abandoned.

Three Warner Bros. part-talkies—*The Jazz Singer* (October 1927), *The Singing Fool* (September 1928), and *Weary River* (January 1929)—reveal the changing approaches to part-talkies in the early sound era. I focus on Warner Bros. because this studio engaged in the greatest film sound experimentation in the period while still maintaining some consistent practices across their films, a consistency due perhaps in part to the presence of Louis Silvers, who supervised the music in all three of these films.[30] Taken together, *The Jazz Singer*, *The Singing Fool*, and *Weary River* indicate a movement from conflicting to unified sound practices. This progression adheres quite closely to Rick Altman's concept of crisis historiography, which I outlined in detail in my introduction. The collision of competing identities, a hallmark of the early use of a new technology, is evident in *The Jazz Singer* and *The Singing Fool*. In these two films the continuous music practices of the late silent era clash rather jarringly with recorded diegetic performances and dialogue, practices that stem from theater, phonography, and sound shorts. The conflicts between different musical accompaniment models provoke questions from the audience pertaining to where within the diegesis the music is coming from—questions that had held little importance for silent film music. *Weary River*, in contrast, finds ways to unify these disparate musical practices, resulting in a film that smoothly blends its silent and sound sequences. Yet its solution would be short lived, as the part-talkie ultimately failed to find a permanent place in sound film production.[31]

Recorded diegetic sound film was not possible as the film was shot silent

THE JAZZ SINGER AND
DIEGETIC/NONDIEGETIC CONFUSION

For numerous film historians *The Jazz Singer* is the definitive film in Hollywood's transition to sound. According to many accounts, *The Jazz Singer* was the first feature-length sound film and the movie that single-handedly convinced Hollywood to shift to sound film production.[32] Neither claim is accurate, however. Not only did feature-length sound films like *Don Juan*, *The First Auto* (June 1927), and *Old San Francisco* all precede *The Jazz Singer*, but, as Crafton has demonstrated, *The Jazz Singer* was only a second-tier hit. It was instead the "one-two punch" of Warner Bros.' *Lights of New York* (July 1928) and *The Singing Fool* that convinced Hollywood to shift permanently to sound film production.[33]

Singing is, afterall, an art.

According to Rubler's account, it is the first film shot in

A series of performances that emerged from the world of film.

58 MUSIC IN EARLY SYNCHRONIZED AND PART-TALKING FILMS

Yet while it is important not to ascribe excessive importance to *The Jazz Singer*, the film *is* notable for its use of recorded diegetic performances within a music model that is otherwise based on silent film accompaniment. Though early synchronized scores for feature-length films like *Don Juan* and *When a Man Loves* had met with mixed commercial success, audiences were far more impressed with the short, recorded musical performances that preceded the feature film.[34] Likely for this reason, Warner Bros. hired Al Jolson—the proclaimed "greatest entertainer on earth" who had already sung in a Vitaphone short titled "A Plantation Act" (1926)—to appear and sing in a feature-length film. The result was a film that alternated between a music-and-sound-effects-only score and a series of performances that emerged from the world of the film.

On the surface the combination of these two aesthetic models may have seemed unproblematic. Filmmakers could enjoy the best of both worlds by using a near continuous score to channel audience interpretation and emotion while simultaneously capitalizing on the popularity of short sound subjects. Yet the coexistence of these two forms created unexpected problems in terms of diegetic/nondiegetic musical distinctions.

Consider, for example, Jolson's "Dirty Hands, Dirty Face" number, his first in the film. The scene featuring this number begins with the continuous music style typical of late silent and early synchronized sound films. An establishing shot at Coffee Dan's restaurant reveals customers eating their meals, a dance floor with many couples dancing, and an orchestra playing behind them. On the soundtrack an up-tempo dance song suggests that the music might be intended as a representation of what is being heard in a restaurant. When the couples stop dancing, the same music continues. For silent-era accompaniment this musical continuation is common practice: the dancing that opens the scene simply inspires a certain kind of music, which can then continue even after the dancing has ceased. Here—as elsewhere in the late silent and early sound period—diegetic and nondiegetic distinctions seem to matter little. This distinction *does* matter in *The Jazz Singer*, however, because, following this dance number, Jack Robin (Al Jolson) performs "Dirty Hands, Dirty Face." This number showcases Jolson's performative abilities and thus depends on the audience's understanding that the music *does* emerge from the diegetic world. Suddenly, then, a representational conflict rears its head. The late silent era's regular blurring of diegetic and nondiegetic

Continuous score → channel audiences' interpretation + emotion + popularity of sound subjects

sound clashes with a recorded performance aesthetic that depends pre-
cisely *on* the audience's recognition of diegetic sound.

As a result, the music remains unsettling throughout the rest of the
scene because the audience is left wondering how much of the music
is part of the diegetic performance. After Jack concludes his second
number—"Toot Toot Tootsie"—the soundtrack provides a few moments
of clapping and cheering, followed by music with instrumentation simi-
lar to the orchestra that just accompanied Jack onstage. The audience
could easily interpret this music as coming from the band in Coffee
Dan's, until an ensuing shot of Jack still onstage reveals that none of
the orchestra members are playing. Operating within a silent-era frame-
work of virtually continuous music, *The Jazz Singer* has simply resumed
its score following the conclusion of Jack's recorded performance. But
because the film has just provided explicitly diegetic music, the audience
is left wondering where, precisely, the music is coming from.[35]

At times in *The Jazz Singer*, diegetic/nondiegetic transitions are more
clear-cut. For example, young Jakie Rabinowitz's saloon performance of
"My Gal Sal" signals itself as diegetic music via a sudden, major shift in
instrumentation between the nondiegetic score and diegetic performance.
Even here, however, diegetic/nondiegetic distinctions remain a bit murky
because no attempt is made to synchronize Jakie's mouth and the pia-
nist's motions to the music heard on the soundtrack. Though not a prob-
lem in a music/effects-only film like Fox's *Street Angel*, in *The Jazz Singer*
the coexistence of synchronized and nonsynchronized performances
within the same film draws attention to the fact that nonsynchronized
performances occupy a nebulous diegetic terrain.

Further blurring the distinction between diegetic and nondiegetic
music, *The Jazz Singer* does not alter volume or sound quality in a way
that could help articulate diegetic and nondiegetic musical distinctions.
Moreover, this uniform volume occasionally renders spatial relationships
unclear. Early in the film, the young Jakie, having been whipped by his
father, returns to the family apartment to look at a picture of his mother
before leaving home for good. Just prior to Jakie's entrance, the audience
sees and hears Jakie's father, Cantor Rabinowitz (Warner Oland), per-
form "Kol Nidre" to his congregation. The camera cuts back to Jakie en-
tering the apartment, yet the diegetic "Kol Nidre" continues at the same
volume. Even though the synagogue is visible through the apartment

window, the song's consistent volume level causes the spectator to question where, exactly, this performance is coming from. Is the synagogue somehow in a room adjacent to the apartment? Only during the penultimate scene does the film definitively reveal Cantor Rabinowitz's synagogue to be the one visible from the window by having a character open a window to allow Jack's rendition of "Kol Nidre" to be heard more clearly, an ironic gesture since the audience hears the song at the same level of clarity and volume regardless of whether the window is open or closed.

Again, representational conflicts between silent film accompaniment and recorded performance help explain the film's refusal to alter the music's volume and quality. Silent film accompaniment and recorded performance practices—whether via phonograph records, radio, or sound shorts—strove to provide the spectator with clear, easily audible music featuring mainly direct sound (meaning sound with a low level of reverberation). Since neither practice involved a reduction in volume level or an alteration in sound quality, the filmmakers saw no need to adjust these elements. Consequently, however, the daring decision to underscore Jakie's return to the apartment with diegetic singing creates unexpected confusion regarding the spatial layout of the scene.

Elsewhere in *The Jazz Singer*, the conflict between silent film and recorded performance aesthetics ironically serves to further the film's themes. In a famous scene in which Jack performs "Blue Skies" for his mother, the conservative Cantor Rabinowitz enters and is horrified to hear modern music coming from his own apartment. Cantor Rabinowitz yells "Stop!" on the soundtrack, while an intertitle redundantly provides the same word. Following a sustained sonic pause—provided in part to enable the projectionist to change discs[36]—the characters begin moving their lips, yet only the nondiegetic orchestra can be heard. Characters who could speak earlier in the scene now seem to have been suddenly struck dumb. From the perspective of noticeability, such a transition constitutes another representational "conflict." Yet this clash between silent and sound sections helps articulate the cultural clash in the film between jazz—often represented through sound sequences—and traditional Jewish values—generally represented via silent passages.[37] Cantor Rabinowitz's ability to stop the recorded performance and cause a reversion to silent film aesthetics thus speaks to Rabinowitz's willpower, formidable authority, and value that he places on established traditions. Whether in-

tentional or not, this representational conflict helps further concepts in the narrative. Interestingly, silent/sound divisions would also further narrative comprehension in Jolson's follow-up, which remains one of the most neglected films in film scholarship.

THE SINGING FOOL AND UNDERSCORING

The Singing Fool remains one of film history's best-kept secrets, both in terms of its contemporary success and what its film production method suggests about the creation of film scores in the early sound years. Though virtually forgotten today, it was probably the most influential film of the entire early sound era. It was—according to Douglas Gomery—the most profitable film until *Gone with the Wind* (1939), featured the biggest hit song ("Sonny Boy") of the early sound era, and was instrumental in convincing Hollywood that sound films could be profitable.[38] Historian Richard Barrios even argues that because many midsized theaters had recently been wired for sound and *The Singing Fool* was a marquee attraction, it was "most likely the first talking film that many people saw."[39]

The Singing Fool's music has received little scholarly attention.[40] Yet *The Singing Fool* is a key early sound era film, as it contains extensive music that both reflects prior practices and moves in new directions. Like *The Jazz Singer*, *The Singing Fool* draws heavily on silent and recorded performance aesthetics, and it features similar disjointed moments where representational practices seem to compete and conflict. Yet *The Singing Fool* deviates from *The Jazz Singer* in two key respects: the presence of extensive dialogue underscoring and a heavy reliance on rerecording to generate most of the score.

The Singing Fool was Warner Bros.' follow up to *The Jazz Singer*, and it similarly features copious amounts of sorrow. The film tells the story of Al Stone (Al Jolson), a waiter who manages to become a success at songwriting. He marries Molly (Josephine Dunn), a shallow, unfaithful woman who cares only for Al's ability to make her a stage success and for the money that he can provide. Following a quarrel with Al, Molly leaves and takes Sonny Boy (Davey Lee)—their son and Al's favorite thing in life—with her. In utter misery Al quits his job and becomes destitute. Al makes a comeback on the stage but then must suffer through the agony of watching Sonny Boy die. Despite such unrelenting misfortune, Al still manages to perform onstage at the end of the film. He gives his friends

a scare by dramatically collapsing in grief at the end of his stage number, but he then vows to go on with his life and "keep on singing."

The Singing Fool's three distinct musical practices—silent-style continuous music, recorded performances, and dialogue underscoring—are all on ample display throughout the film. As in a silent film, music is not only nearly continuous, but it features several motifs tied to particular characters, including specific themes for Al's unfaithful wife and his beloved Sonny Boy. The film also occasionally uses its most successful theme song—"Sonny Boy"—as a narrative motif in its own right. Also as in a silent film, with rare exceptions the background music is not original to The Singing Fool but rather is taken from preexisting silent film music collections.[41] The film's recorded performance aesthetic occurs when Jolson performs musical numbers onscreen. While silent-era music tactics and recorded performances had also been prevalent in The Jazz Singer, The Singing Fool's extensive use of directly recorded dialogue marked a striking contrast to The Jazz Singer. So prevalent is spoken dialogue that silent-era aesthetics occur only for around thirty minutes of the film's 105-minute running time, a far cry from the predominantly silent film style of The Jazz Singer.[42] According to received wisdom, underscoring was generally avoided until the early 1930s. Yet in The Singing Fool, music plays throughout the dialogue scenes, even in locations where the music cannot be justified diegetically. Consequently, The Singing Fool offers a surprising early instance of nondiegetic underscoring.

The frequent coexistence of continuous music and dialogue in The Singing Fool raised new questions about the use of music. With dialogue now occupying part of the soundtrack, were motifs still an appropriate musical tactic? What adjustments, if any, should music make during dialogue sequences? Should music's volume level be lowered to accommodate dialogue? Should music be paused or otherwise altered for particular words, phrases, lines of dialogue, or physical actions?

In general, The Singing Fool's filmmakers continued to rely on the silent film music model, while making occasional adjustments for specific lines of dialogue and physical actions. A lengthy apartment scene thirty-five minutes into the film illustrates this approach. The scene features a contrast between Al's problematic relationship with Molly and his loving relationship with Sonny Boy. For the most part music in this scene follows a silent film model by attaching themes to contrasting characters and attending only to broad changes in the narrative rather than overtly

synchronizing with precise moments in the image. "Fanchonette"—a slow-paced *legato* (a style of playing in which consecutive notes are smoothly connected) tune that becomes Molly's theme—opens the scene, though the tune actually begins at the end of the previous scene at Al's nightclub.[43] "Fanchonette" continues during the early moments of the apartment scene, in which Molly looks at Al coldly before closing the bedroom door and leaving him alone in the hallway. After this downbeat beginning, the scene shifts to an affectionate tone during a playful conversation between Al and Sonny Boy in which Al tells his son some bedtime stories. When Sonny Boy first appears, the score provides his theme: "Impish Elves," by Gaston Borch—a bouncy tune played staccato—which contrasts strikingly with "Fanchonette." Later in the scene, Al returns to Molly, she coldly rejects his advances, and the music obligingly returns to "Fanchonette." Wedded to silent film practices, the score is organized mostly around character-oriented motifs, and it shifts music mainly for large-scale changes like Al's contrasting relationships with Molly and Sonny Boy.

The film is so indebted to silent film practices, however, that a mild conflict emerges in terms of volume level between music and dialogue. The apartment scene—as well as many other scenes in the film—features only a slight dip in volume during moments of dialogue. Consequently, even though the dialogue is louder than music and thus remains intelligible, the music regularly feels as though it is in competition with dialogue, as if threatening to drown out snatches of dialogue at any given moment. This is surely due in large part to silent film accompaniment conventions, in which music thrived on its ability to be heard clearly and did not need to reduce its volume for dialogue. For this reason the film contains a soundtrack in which music and dialogue do not so much cooperate and share space as they seem to *compete* for that space.[44]

If the score seems inattentive to dialogue in terms of volume level, it also seems relatively unaware of individual lines of dialogue, instead resolutely playing a tune to its conclusion regardless of the dialogue. Scattered exceptions do exist, however, and these exceptions constitute early efforts to coordinate two disparate sound aesthetics. For example, when Al decides to tell Sonny Boy a bedtime story about two little frogs, the music pauses for a moment before Al begins the tale, and then the orchestra plays "Queer Antics" by J. S. Zamecnik. "Queer Antics" begins with a bassoon playing short, staccato notes with plenty of leaps (substantial changes in pitch). This suggests the lighthearted nature of the children's

story and perhaps even the hopping motion of the frog. "Queer Antics" ends just as Al finishes the story, and after another brief pause the music starts up with "Impish Elves" again. Here, unlike most of the film, music more noticeably attends to the specific reference points in the conversation.

Only during the tragic concluding scenes does the film provide music that saliently matches precise moments in the image. Such moments seem designed to align the audience more firmly with Al's anguish and owe much to popular-priced melodrama's tendency to use music to help convey emotionally laden situations. When Al receives a note stating that his son is very ill, the music pauses just before a messenger's knock is heard on his dressing room door. The music remains silent until Al looks at the note, at which point the audience hears a dissonant sforzando tremolo chord and a timpani drum roll. Similar sharp, dissonant tremolo chords occur at the instant when Al realizes that his son has died and again in the final scene when he collapses in grief on the stage. One contemporary review observed that *The Singing Fool* caused massive crying among audience members,[45] and the score's effort to align closely with Al during moments of intense suffering may well have been a contributing factor.

Like *The Jazz Singer*, *The Singing Fool* features moments in which silent film and recorded music aesthetics seem to conflict, such as distracting situations where music on the soundtrack can be heard even though the imaged musicians are not playing. Also like *The Jazz Singer*, *The Singing Fool* features some jarring transitions between silent and sound segments that nevertheless comment on the narrative through their very saliency. For example, *The Singing Fool* uses silent aesthetics up to Al's songwriting breakthrough. When Al finally performs a successful song, the soundtrack shifts by providing Al's directly recorded performance of that song. Though jarring, this transition articulates the idea that Al's voice and career ambitions will be cooped up no longer. Practically speaking, then, foregrounding silent/sound shifts helps to articulate a central theme, as well as isolating Jolson's singing ability as a major appeal of the film.

THE SINGING FOOL AND RERECORDING

The Singing Fool's underscoring of substantial amounts of dialogue was quite innovative for 1928, but the extent of the film's innovation did not stop there. To fully appreciate music in this film, the logistics involved

with creating the score must be considered. According to film scholars, Hollywood in the early sound years generally lacked the ability to rerecord sound; that is, separate sound records could not be electrically recorded onto a new sound record to attain a new, composite soundtrack.[46] Though some scholars acknowledge the occasional existence of rudimentary rerecording, virtually all film music scholars agree that the major reason for the absence of rerecording was the substantial drop-off in sound quality that occurred.[47]

Standard accounts of the early sound era regularly cite rerecording as a major culprit in the period's avoidance of nondiegetic music. This account began as early as 1937, when composer Max Steiner, who had arrived in Hollywood in 1929, offered the following account of the early sound era: "In the old days one of the great problems was standard (actual) recording, as dubbing or re-recording was unknown at the time. It was necessary at all times to have the entire orchestra and vocalists on the set day and night. This was a huge expense."[48]

This claim has continued to be a driving force in film scholarship. In numerous film history books, one encounters claims that music and dialogue had to be recorded together on the set. According to these scholars, providing an orchestra on the set was not only too expensive but also too complicated logistically, since a single mistake from anyone on the set could necessitate reshooting the entire scene. Moreover, if music was recorded alongside dialogue, the soundtrack could not be edited since the break in the music would be evident.[49] Owing to the absence of rerecording, nondiegetic music was said to be anathema in the early sound era.

To date, a few scholars have identified isolated instances of rerecording during the earliest years. Discussing early sound films at Warner Bros., Robert Gitt—in an interview with John Belton—indicates that short stretches of rerecording occurred as early as the earthquake scene in *Old San Francisco* and the brief sections of dialogue in *Noah's Ark* (November 1928). Gitt further states that by 1928 Warner Bros.' use of rerecording was "extensive,"[50] an unusual claim that few scholars have noted. Geduld writes that sound engineers removed part of *Old San Francisco*'s soundtrack by rerecording the disc and "deleting the unwanted passages," while Crafton indicates that part of Cantor Rosenblatt's performance in *The Jazz Singer* was rerecorded.[51] More recently, an excellent article by film historian Lea Jacobs examines trade journals and oral histories and offers a thorough assessment of rerecording in the 1930s. Describing rerecording

across studios before 1931, Jacobs characterizes it as "an experimental phase . . . in which [rerecording's] possibilities were discussed, experiments were carried on in labs and at the studios, the first dubbing facilities were improvised, and questions were raised about the optimal way to organize labor for this process." Like Gitt, Jacobs acknowledges that Warner Bros. possessed the ability to rerecord sound. Still, for Jacobs, rerecording in the early 1930s remained "minimal by the standards of the late 1930s."[52] Though not focusing primarily on film music, Jacobs reiterates the claim that the period's minimal use of rerecording meant that music was seldom used in conjunction with dialogue during the early years of sound cinema.[53]

Based on most of these accounts, one would assume that an on-set orchestra played off-camera during the numerous dialogue sequences in *The Singing Fool*. The conductor's part for *The Singing Fool*, however, reveals that filmmakers made regular and extensive use of rerecording to produce such music in postproduction. *The Singing Fool*'s conductor's part consists of a series of discreet musical "cues" that, taken together, constitute the score for the entire film. For Warner Bros. and other studios in this period, when the music shifted to a new number, this was considered a new "cue." The conductor's part for most cues from *The Singing Fool* contains penciled-in markings pertaining to certain actions in the film—such as "Molly takes receiver"—or the beginnings of particular lines of dialogue such as "Well kid . . ." Surprisingly, many markings in the conductor's part make sense only if the music was recorded in postproduction. Several penciled notes, for example, describe titles that appear in the finished film, such as a title beginning with "The New Year . . ." and another later in the film that begins with "The heavy heart . . ." Another pencil marking indicates a moment when a certain bar of music is supposed to match a "close up of [the actress Betty] Bronson." Ends of reels are also penciled into the conductor's part. Theoretically, information for shot scales and titles could have been obtained from an original script rather than an edited film. Yet placing such information in the conductor's part for an on-set orchestra would have made little sense because there was no way for such an orchestra to ascertain shot scale or see intertitles. Such information—along with the ends of reels, which are unlikely to be known until postproduction—holds relevance only for a postproduction orchestra. Clearly, the orchestra relied on cues from the finished film when it performed the film's score, meaning

that the film's background music could only have been recorded in post-production. Studio records reaffirm this by stating that the score was recorded from August 27 to 31, 1928, a period that is far too short if the music had been recorded during production itself. Since directly recorded dialogue occurs regularly during these musical cues, the only sensible explanation is that *The Singing Fool* used rerecording to generate its nearly continuous score.[54]

How much music for *The Singing Fool* was generated via rerecording? Nearly all of the music listed on the cue sheet (a list of all music present in the film generated for copyright purposes) appears in the postproduction conductor's part, meaning that the vast majority of the score—whether for scenes with dialogue or without it—was recorded in postproduction. The only major exceptions are Jolson's numbers, which had been recorded prior to the rest of the score (this presumably occurred during shooting). Outside of the accompaniment to Jolson's songs, then, rerecording was responsible for nearly all of the extensive dialogue underscoring heard in this 1928 film.

Warner Bros.' sound-on-disc format likely inclined the studio toward rerecording. As Jacobs points out, because Warner Bros.' sound-on-disc system did not permit the studio to cut and splice sound recordings, the studio would have felt a greater urgency to develop an alternative system for postproduction sound manipulation.[55] According to some sources, the rerecording equipment that Warner Bros. eventually developed was quite sophisticated for its time. Robert Gitt, who supervised the restoration of Vitaphone discs in the early 1990s, describes the process as an "elaborate synchronizing system for multiple turntables, using some kind of mechanical device that would kick the individual turntables on at the right point, keeping the various recordings in almost perfect sync."[56] George Groves, a music mixer at Warner Bros., also described an automated turntable device in his oral history.[57] Longtime soundman James G. Stewart, despite not being a Warner Bros. employee, described seeing a machine with numerous turntables in the Warner Bros. dubbing room. According to Stewart, the device featured a gear-driven wheel and holes where sound technicians would place pegs. Each peg would trigger a needle drop, thus enabling the sound from that disc to begin at the proper time.[58] It remains unclear whether the Warner Bros. rerecording device was this elaborate when *The Singing Fool* was produced in 1928, but some form of rerecording was in use.

A sample sheet from the conductor's part for *The Singing Fool* reveals some of the specific logistics involved with recording early sound film music accompaniment for dialogue scenes in postproduction, as well as methods for handling transitions between recorded dialogue and song performances (fig. 2.9). By peppering the staff paper with penciled-in cues from the edited-together film, the conductor endeavored to shift to new musical cues at precise moments and smoothly transition back and forth from material already recorded by the studio orchestra, all the while laboring to accomplish these feats in a single pass. The music on this page pertains to a scene in which Al sits down in a chair with his son on his lap and prepares to sing "Sonny Boy" (fig. 2.10). All of Jolson's performances, including "Sonny Boy," had been recorded during filming with an on-set orchestra accompanying him. The music on this page, however, was recorded in postproduction. Because the music was recorded at different times, the filmmakers needed to find a way to shift from the postproduction orchestra to the on-set orchestra and back to the postproduction orchestra once more. The first transition—from postproduction orchestra to the beginning of "Sonny Boy"—is accomplished through the use of a *fermata*, a musical marking indicating that the postproduction orchestra should hold its final note. This sustained note serves as a lead-in to the beginning of Al's performance (fig. 2.11). In the finished version of the film the postproduction orchestra holds this note before a rather jarring sound edit is made to the on-set orchestra playing the same note. By having the postproduction orchestra play the same note as the studio orchestra, the filmmakers were likely attempting to enact a smooth and imperceptible transition from postproduction to studio orchestra, an attempt undermined by the audible break in the music on the soundtrack.

The shift back to the postproduction orchestra is more successful. At the end of Jolson's performance of "Sonny Boy," Jolson silently rocks in his chair with his now-asleep son on his lap (fig. 2.12). At this point the postproduction orchestra once again takes over the score by reprising six bars of "Sonny Boy." This technique is exactly in line with musical theater orchestral practices in the period, which regularly featured a reprise of a song immediately after its onstage vocal rendition. Capitalizing on the continuity afforded by the musical reprise, the filmmakers forge a fairly smooth transition back to music produced by the postproduction orchestra.

A different notation on this sheet of music reveals a key logistical issue for Warner Bros.' rerecording technology. When Jolson sings "Sonny

FIGURE 2.9 A sheet from the conductor's part for *The Singing Fool*.
The *Singing Fool* music files, Warner Bros. Archives, University of Southern California.

Boy," the postproduction orchestra is instructed to remain silent, as indicated by the "Song = Tacet" notation in the score (*tacet* is a musical direction indicating that musicians should not play). This provides evidence that music for the entire reel was recorded all in one pass, with musicians remaining quiet when the production-recorded sound had exclusive domain. This insistence on recording all in one pass is almost surely because Warner Bros. used a sound-on-disc system. Unlike a strip of sound film, a disc could not be chopped apart and edited together, thus necessitating that all sounds on a single disc be recorded at once. To make rerecording synchronization easier, the studio apparently insisted on putting an entire reel's worth of music onto each disc, a process that would have involved ten to twelve minutes of unbroken recording.

Despite needing to record a substantial amount of music in one pass, the postproduction orchestra nevertheless placed considerable emphasis on having its cues begin and end at specific moments. For instance, not only must the postproduction orchestra play the final note of cue 39 at the same time that the sound is played by the production orchestra in the film, but the lead-in to cue 40 is also quite precise. Just after the orchestra reprises "Sonny Boy," it launches into a fast series of runs that coincides exactly with an intertitle reading, "The New Year always kindles old loves—and brings new hopes" (fig. 2.13). This intertitle occurs just before the first shot of the next scene, which takes place at Al's club on New Year's Eve. A penciled-in marking in the conductor's part indicates the first five words of this title ("The New Year always kindles"). This intertitle, in turn, triggers the next cue, a rousing rendition of the New Year perennial "Auld Lang Syne." Thanks to rerecording and the use of penciled-in cues from the finished film, the postproduction orchestra is able to shift to a new cue at the precise moment that the image moves to a new scene.

Chapter 3 traces in greater detail the extent to which rerecording may have been used in the period and examines the implications that the early availability of rerecording has for the history of the early sound film score. What should be noted here, however, is that *The Singing Fool*'s filmmakers were not as hamstrung by technological difficulties as scholarship on early sound films would suggest. During the dialogue sections of the film, an orchestra was *not* off-frame desperately trying to adjust its volume level in accordance with the dialogue and to match its tempo precisely with the live actors. Thus, if *The Singing Fool*'s music was relatively

FIGURE 2.10 In *The Singing Fool* Al puts his son in his lap . . .

FIGURE 2.11 . . . sings "Sonny Boy" . . .

FIGURE 2.12 . . . and silently rocks his sleeping son in a long shot.

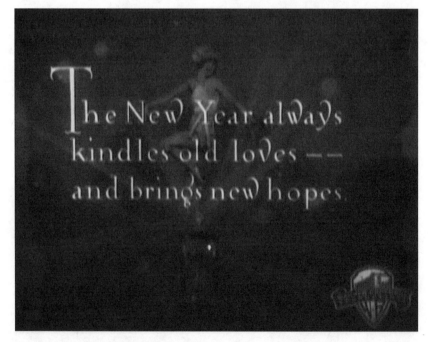

FIGURE 2.13 An intertitle then marks the shift to a new scene.

limited in terms of its coordination with specific dialogue or character actions, this was surely more of an aesthetic decision than one dictated by the limitations of primitive technologies. Indeed, the score's markings indicate that care *was* taken to match music to dialogue and action, but this match was one that was not intended to be noticeable to the audience. Instead, the filmmakers conceived of matching the music to image and sound cues in *The Singing Fool* largely in silent cinema terms. Rather than being moments for the orchestra to announce its awareness of the diegesis, image and sound cues were understood as guideposts that helped ensure that a given piece of music would start and finish at the appropriate time.

The ramifications of the studio's disinterest in small-scale musical synchronization are considerable. Film histories frequently cite technological advances as an important reason for changes in film style. Too seldom recognized, however, is the fact that for film style to change, the filmmakers' representational assumptions must also shift. In the case of the early sound era, rerecording would seem to facilitate a close, moment-by-moment synchronization between music and narrative material. Unlike silent-era accompaniment, which featured live music in the movie theater, rerecording offered orchestras multiple attempts at accompanying each reel, thus granting filmmakers the opportunity to create an unprecedentedly close synchronization between music and film. So pervasive were the conventions of silent film music, however, that this prior model initially played a bigger role in the application of film music than the current technological capabilities of the medium.

In addition to being the all-time-box-office champion during the early sound years, then, *The Singing Fool* may contain the first substantial use of both rerecording and dialogue underscoring in the sound era. In spite of *The Singing Fool*'s colossal success, however, some of its music aesthetic practices would soon be abandoned. Only five months after *The Singing Fool*, Warner Bros. released *Weary River*, a film that—unlike the more jarring *Jazz Singer* and *The Singing Fool*—stressed *smoothness* and *seamlessness* between silent and sound portions of the film.

WEARY RIVER AND TENTATIVE SOLUTIONS

Like *The Singing Fool*, *Weary River* features a mix of silent film accompaniment, music accompaniment for dialogue, and recorded performance.

Yet whereas *The Singing Fool* contains moments when these somewhat disparate aesthetic practices come into conflict, *Weary River* utilizes methods for blending these practices. Thanks to sound bridges between silent and sound sequences, music that is tied even more precisely to character psychology and mood, the regular use of theme songs as narratively related motifs, and a more concerted effort to allow music and dialogue to share space, *Weary River* smoothly binds silent and sound aesthetics together, and also binds film music to narrative events.

Weary River tells the story of Jerry (Richard Barthelmess), a bootlegger who is imprisoned for a murder he did not commit. While in jail, he finds his true calling as a songwriter. When his tune "Weary River" becomes a nationwide sensation, he is granted a pardon by the governor and endeavors to reenter society as an honest man. After a few false starts, he manages to stay straight for good, thanks to the sympathetic prison warden and Alice (Betty Compson), the woman he loves.

Though *Weary River* contains numerous shifts from silent to sound aesthetics and vice versa, the film employs several tactics to make these transitions less noticeable. First, unlike *The Jazz Singer* or *The Singing Fool*, *Weary River* never shifts from one aesthetic to the other within a single scene. Gone are situations like the eerie return to silence after Cantor Rabinowitz yells "Stop!" in *The Jazz Singer* or the jarring arrival of synchronized sound when Al performs his first number in *The Singing Fool*. By always changing aesthetics during major scene breaks, directly recorded sound functions less as a salient statement of a film's themes and more as a consistent background aesthetic for the duration of a particular scene.

At times, *Weary River* uses musical continuity to render the transition even less noticeable. For example, after Jerry reprises his rendition of "Weary River" over the radio from jail (in response to popular request), the image fades out, thus ending this synchronized sound sequence. After a brief musical pause that accompanies the fade out, an intertitle states that "Weary River" has become a nationwide hit. On the soundtrack during this intertitle, a small orchestra reprises part of the melody from the song. After another pause to accompany another brief fade, the orchestra again plays "Weary River," this time as music to accompany a silent scene in which Jerry is released from prison and signs a vaudeville contract to promote the song. This repetition is narratively justified, since the score reflects the fact that Jerry's song has become successful

thanks to repeated play throughout the United States. Yet this repetition has an additional benefit: by suggesting one unified performance of the song—singing and an immediate reprise by the orchestra—the film diverts the audience's attention away from the fact that *Weary River* has undergone a shift from sound to silent film aesthetics. The narrative justification for musical repetition, then, helps to render the transition from sound to silent aesthetics nearly unnoticeable.

Elsewhere in the film, a sound bridge (sound that plays steadily across a scene transition) goes even further toward smoothing over the transition from sound to silent aesthetics. Early on, a talking sequence shows the police arresting Jerry. The next scene—which depicts Jerry's conviction—returns to a silent film style. During Jerry's arrest, a somber cello plays underneath the dialogue. Two accented notes occasionally punctuate this tune, and their sharpness suggests the very real danger of jail for Jerry. As this scene fades out, the "to jail" theme continues to play: the same somber cello tune from the previous scene accompanies a newspaper article indicating that Jerry is about to hear his sentence, while the first appearance of the judge in this silent-style scene is matched with the same two sharp accented bursts. The film thus uses the same unbroken theme from sound to silent sequence to minimize the audience's awareness of this transition.

Conceptually, such a sound bridge requires a substantial paradigm shift. Silent film music generally operated on a scene-by-scene logic, in which the music paused and changed during or near each major change of scene. Here, however, film music practitioners apparently felt that the necessity of minimizing the audience's awareness of the shift from sound to silent film demanded that this scene-by-scene logic be jettisoned. Consequently, the music helps produce what seems like a unified film rather than what—in *The Jazz Singer* and *The Singing Fool*—feels as much like a series of isolated short-subject performance films as it does a cohesive film.

If *Weary River* uses music to smooth over its transitions between sound and silent aesthetics, it also binds music to narrative by attending carefully to dialogue volume levels and character psychology. Music regularly dips in volume to accommodate dialogue, and unlike *The Singing Fool* these dips are quite substantial. Consequently, music recedes to the background during dialogue sequences and dialogue intelligibility is never in question. Thus, unlike in *The Singing Fool*, music and dialogue show an awareness of, and cooperation with, each other.

Moreover, where music in *The Singing Fool* generally attends only to broad-level narrative changes, the music in *Weary River* is more likely to adjust to small shifts in mood and, in a few instances, particularly pointed lines of dialogue. As a result music seems even more tightly fused with the image. In many cases these mood shifts and accompanying musical changes also help align the audience more firmly with Jerry. For example, when the police arrive to take Jerry to jail, the music that initially plays under the exchanges between Jerry and the police is a light, cheerful, string-oriented tune with plenty of skips, which suggests that Jerry does not fear too much from these police officers (a "skip" refers to two notes that are more than one degree apart on a scale). Yet when the conversation becomes less lighthearted and Jerry begins to realize that he might be arrested, the aforementioned "to jail" music is heard. Much later in the film, after Jerry gets out of jail, he is casually addressed as "convict." With this word, the music provides a sharp, accented note (known as a "stinger") and another short rendition of the "to jail" music. In both cases music represents Jerry's emotional state and channels the audience's attention, identification, and loyalty toward him.

The music in *Weary River* is so attentive to narrative that it occasionally pauses for a particularly pointed line of dialogue and accompanying action. For example, when Jerry appears ready to regress to his gangster lifestyle after he gets out of jail, Alice—who loves him and wants him to reform—runs to the door before Jerry can leave, blocks his path, and verbally exclaims, "Jerry, don't go, please! I'm not going to let you go back to the racket!" During the first line of dialogue, a sustained, tense minor chord is heard. This chord ends with a brief sforzando followed by a quick timpani roll. Then, Alice's second sentence is spoken during a rare moment of musical silence, which only serves to amplify her feelings of urgency and desperation. In such instances, music, image, and dialogue function as an integrated whole. They work together to enhance narrative clarity and forge emotional connections between the audience and the film's central characters.

The film's two theme songs—"It's Up to You" and "Weary River"—also contribute to the film's fusion of sound, image, and narrative. Though films like *The Jazz Singer* and *The Singing Fool* do use a few of their performed songs as occasional narrative motifs, *Weary River* ups the ante for a part-talkie by deploying instrumental versions of these songs extensively throughout the film.

Beginning with Jerry's first diegetic performance of "It's Up to You," *Weary River* labors to tie this song to a specific narrative situation. Katherine Spring notes that when Jerry first performs "It's Up to You" for Alice, Alice's reaction is "excessive. She swoons and collapses in rapture on the bed. A striking tracking shot toward Alice invites us to focus on her orgasmic facial expressions and body gestures"[59] (fig. 2.14). Alice's reaction may be excessive from the perspective of realism, but seen from the perspective of quickly forging a connection between song and character, her reaction is quite functional. The salient tracking shot and Alice's orgasmic response serve to link "It's Up to You" with Alice and her intense devotion to Jerry. Moreover, the song showcases Jerry's talent as a songwriter and performer rather than as a gangster. By tying this song to Alice, the motif reiterates her central character trait: her love for Jerry is bound up with her belief that he has the ability to do something beautiful and worthwhile with his life and his music.

FIGURE 2.14 In *Weary River* Alice's orgasmic display during Jerry's performance of "It's Up to You" helps to immediately and firmly connect the song with Alice's love for Jerry.

Throughout the rest of the film, "It's Up to You" is regularly used to indicate Alice's love for Jerry and her belief that he can redeem himself through song. It plays when the couple says good-bye following Jerry's conviction, as underscoring when Alice tries to visit Jerry in prison, when Jerry proposes to Alice, and even during an intertitle stating that Alice contacted the warden to prevent Jerry from getting sent back to jail. By playing in many different contexts throughout the film, "It's Up to You" helps convey the sense that the film's silent and sound sections are all unified by a central theme.

Though "Weary River" is not underscored as often as "It's Up to You," it is inextricably woven into the film in other ways. As I have mentioned, Jerry composes the song while he is in prison. This enables the lyrics to comment explicitly on the film's central narrative dilemma: how to "go straight" after being in jail. Outside of the opening credits the first strains of "Weary River" occur when Jerry gets the idea for the song. While in prison, Jerry hears a priest say, "Our lives are like rivers. Some take the wrong course and become torrents, creating havoc and discord, destroying everything in their path. Others wind their way slowly and carefully into the fields, bringing peace and contentment into the world. And so it is with us. We can direct our lives through strife and discord, or through the broad sun-lit fields of right living." In a medium close-up Jerry looks up during the word *river*. When the priest finishes these lines and begins speaking additional ones, the music, originally a church hymn, shifts to a few notes from "Weary River"—with some chromatic notes added— while the image stays on Jerry. The audience can easily read this music as what Jerry "hears" inside his head as he composes the song, with the chromatic notes suggesting the song's unfinished state. Further affirming this, the music keeps attempting renditions of "Weary River" while the scene changes to Jerry sitting thoughtfully in his jail cell composing.

Thanks in part to the filmmakers' decision to show the impetus behind Jerry's composition of the song, the completed lyrics for "Weary River" provide an explicit commentary on Jerry's difficult journey toward living an honest, crime-free life. The lyrics draw a comparison between a "weary" river and Jerry's life: despite turns and journeys, "every weary river someday meets the sea." In other words, every troubled person can find his or her purpose in life. For Jerry that purpose includes cultivating his songwriting gift and consummating his love for Alice. Having tied the lyrics to this journey, the rest of the film deploys "Weary River" as nondiegetic underscoring to suggest the difficulty of Jerry's journey to-

ward "right living." The tune is heard, for example, when Jerry—certain that the world disrespects ex-convicts—returns to his old gang of friends. Toward the end of the film Jerry decides to go straight for good. As he dashes through the streets toward Alice's apartment, the soundtrack plays an instrumental version of "Weary River" to indicate that he has finally "met the sea," meaning that he has found his purpose in life. As with "It's Up to You," the presence of "Weary River" during sections featuring both silent and sound aesthetics helps to unify these disparate aesthetics under one common theme.

To be sure, the film also regularly repeats "It's Up to You" and "Weary River" because of their potential to generate income for sheet music and record sales. Indeed, both songs are even played as exit music, virtually ensuring that many audience members would be humming the tunes after they left the theater. The static, unvarying nature of these songs throughout the film would have also helped popularize the tunes, and Spring points out that *Weary River* takes steps to isolate its two songs within the film for commodity purposes.[60] The filmmakers also had the model of musical theater to draw on, which thrived on its ability to com- modify and profit from its hit songs. Still, the film remains remarkable for the extent to which it weaves these song-plugging functions into the narrative itself. Synchronized music-and-effects-only scores often used theme songs as narrative motifs, but for a part-talkie like *Weary River*, the frequent transference from diegetic performance to nondiegetic score far exceeded anything attempted in previous part-talkies like *The Jazz Singer* or *The Singing Fool*. Consequently, multiple user groups were satisfied. Irving Berlin Inc., the firm that published the phonograph records and sheet music for these two songs, could count on increased sales. Warner Bros., which shared in the profits of these sales, would also prosper.[61] Finally, *Weary River's* filmmakers could use theme songs to unify silent and sound film aesthetics, clarify narrative events and character psychol- ogy, and more firmly align audiences with specific characters.

This is not to say, however, that *Weary River* uses its music in a "bet- ter" way than *The Jazz Singer* or *The Singing Fool*. Rather, *Weary River* simply provided its audiences with a different musical experience. Both *The Jazz Singer* and *The Singing Fool* thrive on what might be termed "pre- sentational" aesthetics. Through abrupt transitions in and out of perfor- mance sequences, and musical accompaniment that generally connects only to broad-scale narrative events, *The Jazz Singer* and *The Singing Fool* present a series of discrete attractions. In a manner consonant with crisis

historiography's early stages, when various aesthetics conflict in these films, it is as if the attractions inherent in each aesthetic practice are vying for the audience's attention. This presentational aesthetic extends to the persona of Jolson himself, a born entertainer who always seems to be addressing an audience even when he is merely speaking to an onscreen character. In contrast, *Weary River* offers an absorptive experience in which various sound strategies work together with the image to concentrate attention chiefly on a single element: the film's narrative trajectory. Consequently, the disparate elements of a sound film—music, dialogue, image, silent sequences, sound sequences—lose their distinctiveness, blurring together to channel attention toward the narrative.[62] For an industry that had long relied on absorptive narrative cinema to generate maximum profitability, such a style for the part-talkie was a very reasonable approach to take.

LOSING THE HUMAN ELEMENT

By offering a sound model that allowed three major aesthetic practices—continuous late silent-era music, recorded performance, and recorded dialogue—to smoothly cooperate rather than compete, *Weary River* offered an early "overdetermined solution" to the problem of sound film aesthetics. As Altman points out, however, overdetermined solutions can also result in the annihilation of a prior practice.[63] This final section examines what was surely the biggest loss in the shift to recorded music: the disappearance of what Joseph N. Weber, president of the American Federation of Musicians (AFM), referred to as the "human element" in film music.[64] This disappearance took two forms: the movement of orchestra musicians from a live theatrical entity to an unseen recorded entity and the almost complete erasure of solo organ playing in association with feature films. Just as *Weary River* moved toward a practice of reducing the sense of isolated attractions in favor of a unified entertainment, so, too, did Hollywood largely eliminate the isolated attraction of live film music in favor of an entertainment produced entirely by a machine.

The loss of the human element was nowhere more evident than in the substantial advertising campaign mounted by the AFM against what it termed "canned music" in the theaters. From the middle of 1928 to 1930, as movie theaters increasingly made the switch from live musicians to synchronized sound accompaniment, thousands of movie theater musi-

cians found themselves out of work. By November of 1929 Weber re-
ported that there were "7,000 musicians, including 2,500 organists, out
of work in [the United States] because of canned music."[65] An article in
the same issue claimed that owing to sound film, nearly one out of every
three musicians was out of work.[66] Those movie musicians fortunate
enough to keep their jobs in these years often suffered a substantial de-
crease in wages.

Musicians did not take this lying down. Throughout 1929 a series of
musician strikes rippled across the United States. Most prominent was
an extended strike by the St. Louis musicians union because the theaters
"refuse[d] to comply with musicians' insistence upon [a] minimum num-
ber of men to be employed in each house."[67] With sound film on the
rise, however, musicians did not hold very much negotiating power, and
the agreements reached were generally weighted heavily in favor of the
theaters. Many deluxe theaters did retain their live musical shows for
a time, but the elevated rental costs for a sound film, combined with the
Great Depression, eventually forced even those theaters to dismiss their
musicians.[68]

While several scholars have examined the plight of musicians in the
early sound era,[69] less attention has been given to the argumentative
strategies used by the AFM in its fight against recorded sound in the
movie theater. The organization's rhetoric foregrounds the loss of a hu-
man intermediary between the live audience members and the recorded
entertainment. Shortly after the major studios committed to Western
Electric recorded sound in mid-1928, a revealing interview with Weber ap-
peared in the September issue of Metronome. Weber stated that "machine
music is threatening to displace the human element," which was a particu-
lar problem to him because "a machine has no soul nor personality and
never will have."[70] Other Metronome articles during the 1928–29 film sea-
son expressed similar views. In an examination of music in the theater,
Henry Francis Parks stated in April of 1929 that though "the machine"
had eliminated long hours of rehearsal drudgery for the orchestra, without
live music the moviegoing experience would be a "Robotical farce."[71]

The organ, on the other hand, at first seemed impervious to the threat
posed by synchronized films. Metronome articles initially expressed con-
fidence that organists' jobs were safe because the organ's grandeur and
tone quality could not be duplicated on a disc or strip of film. The mistaken
assumption made in many of these articles was that film music had a

fixed aesthetic identity: it would *always* feature an organ for part of the show, and audiences would *never* adjust to the monotony of hearing all music in the theater via a recording. Perhaps realizing the possibility that the organ could be eliminated, a March 1929 *Metronome* article urged organists to stress their personal contact with the audience, since this was something that the machine would never be able to duplicate.[72]

But the most overt indication that "canned music" meant the loss of human interaction came via a series of striking advertisements by the AFM that began in October of 1929. Full-page advertisements deriding recorded music began to appear in newspapers, and readers were instructed to clip these advertisements, fill in their name and address, and send them to the AFM. The AFM then filed the advertisements alphabetically so that the relevant batch could be presented to a particular theater as proof that patrons in the area wanted live music.[73] In one representative ad from October 1930, a robot representing canned music tries to woo a woman on the balcony (fig. 2.15). The lady covers her ears in disgust while behind her a cat apparently coughs up a hairball. The text exclaims, "But the robot has no soul. And having no soul, It cannot love. Small wonder the lady spurns Its suit. Now, if the Robot cuts a ridiculous figure beneath the lady's balcony, why expect IT to thrill intelligent theater goers in the character of Canned Music?" Music mediated by a machine, the advertisement argues, lacks the immediacy to impact audiences in the way live music can.

An equally bizarre AFM advertisement literalizes the term *canned music* by featuring a grotesque parade of canned goods and canned tunes outside a sound theater (fig. 2.16). A can of beans stands arm in arm with a can of Mozart, while a can of beets dances a cheerful jig with a can of Beethoven as a can of Liszt watches and applauds. The implication is clear: recorded sound transforms great music into nothing more than bland, impersonal, and uninteresting commodities like canned beans or beets. Though canned music can save the theater owners money, it separates spectators from a genuine experience with music. Moreover, recorded film music, like canned food, is serialized: each "performance" is exactly the same as the next, and the possibility of impromptu or even anarchistic musical performances vanishes.[74] In what appears to be a dig aimed at sound shorts in particular—and may also constitute an anti-Semitic smear—text below the cartoon inquires, "Have you, too, heard the Cannery racket—the little tin-clad 'Sound' operas and jazz numbers

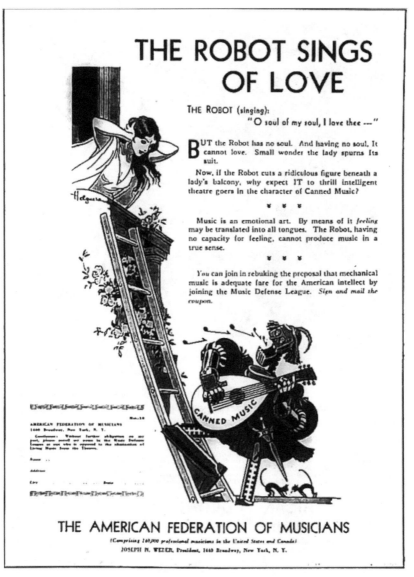

FIGURE 2.15 An advertisement from the American Federation of Musicians expresses disdain for recorded music in the movie theater.
Metronome, October 1930, 11.

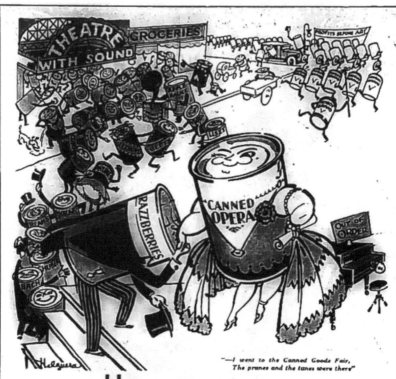

FIGURE 2.16 Another American Federation of Musicians advertisement ridicules "canned" music.

Metronome, March 1930, 5.

so joyously welcomed here by the delicatessen set?" Despite the increasing hopelessness of the AFM campaign, these types of full-page ads appeared in *Metronome* throughout 1930. The ads continued in 1931, albeit in half-sheets. By 1932, however, they had vanished from *Metronome*'s pages.

Of course, many AFM members were fighting for their livelihood through these articles and advertisements, so their arguments cannot be taken simply as objective indications of the period's valuation of live music. Yet disdain for canned music appears in other sources as well, suggesting that the AFM touched on a value of film music seen by more people than just the union itself. A *Variety* article from July 1929, for example, states that a huge rural demand exists for chorus girl revue pictures. The author writes, "It matters not how long or how short the films are, provided they have a good looking line, the less dressed the better, doing its stuff to canned music."[75] In other words, rural folks have no taste: they care nothing about the quality of the film, just as they care nothing about the fact that the music is canned. This class snobbishness echoes the "canned music" AFM advertisement: both suggest that if you like canned music, you are lower class and unappreciative of the finer elements of music.

Initially, Hollywood apparently tried to ameliorate the loss of the human element by showing the orchestra onscreen. The *Don Juan* premiere in August of 1926, for example, opened with Wagner's *Tannhäuser* overture performed by the New York Philharmonic and conducted by Henry Hadley, the same orchestra and conductor that would accompany *Don Juan* later in the program. In *When a Man Loves*, the third Vitaphone feature, after "The End" appears on the screen the audience receives two more title cards featuring credits for the score's composer, the Vitaphone Symphony Orchestra, and the conductor. As the final note of the score is heard, the image cuts to an extreme long shot of the entire Vitaphone orchestra playing that note. The orchestra then rises, and in a medium shot, the conductor bows to the camera. These isolated filmic attempts to convey the sense that real people produced the orchestral accompaniment, however, would not continue past 1927.

The plight of theater musicians illustrates that even when nearly identical strategies are transplanted from one form to another, something is invariably lost in the process. On a literal level many musicians lost their jobs, but the audience also lost a certain kind of experience with film music. By removing individual organ players from the film

accompaniment repertoire and reducing the orchestra to a recording, the film industry subsumed film music within the general technology of film exhibition. Doing so had its aesthetic advantages: it enabled music to synchronize more closely to the image, opened up a new array of music accompaniment options in the years that followed, and provided higher-quality music to nonurban areas. Yet it had its downside as well. Live music was a visible attraction that could potentially vie for the audience's attention via its immediacy and spontaneity. By the late 1920s, music increasingly became another behind-the-scenes technical aspect of the film experience, produced by a faceless entity and piped into the auditorium via the less personal technology of the loudspeaker.

3. TOWARD A SPARSE MUSIC STYLE

Music in the 100 Percent Talkie, 1928–1931

In 1928 Hollywood began producing "100 percent talkies" alongside synchronized films and part-talkies. Filmmakers who chose to use music in the 100 percent talkie faced questions similar to those for part-talkies. Does an all-talking film need to be explicit at all times about where the music is coming from? If a film uses diegetic song performances, must the film mark a clear distinction between these performances and nondiegetic music? If so, how can this be achieved? Should the music's volume be lower during dialogue sequences, or should it remain at the same level as it generally did in the silent era? Must the continuous music practice of the silent era be maintained, or is intermittent music an acceptable solution? If intermittent music is used, what logic dictates where it should be placed in the film? Finally, what role, if any, should musical motifs play in the all-talking film?

The answers to these questions varied widely, not only from year to year but also from film to film. While some general musical tendencies can be detected, the period from 1928 to 1931 was also rife with experimentation and roads not taken. To demonstrate the diversity of film music, as well as some of the common approaches in the period, this chapter offers a series of case studies, as well as an outline of some common

practices. My focus here is on nonmusicals from 1928 to 1931; chapter 4 addresses the particular case of the early film musical. Because the exhibition season in the early sound era ran from Labor Day to Memorial Day,[1] this chapter considers the 100 percent talkie only through May of 1931. Chapter 5, in turn, addresses the use of film music in the following two seasons.

This chapter's assessment of film music in 100 percent talkies is based on a viewing of the nonmusicals released from July 1928 to May 1931 listed in the appendix. I begin with an analysis of two early all-talking films—*Lights of New York* (July 1928) and *The Squall* (May 1929)—that contained extensive music and provided early, yet very different, film music strategies. Shortly after the release of *The Squall*, the film industry substantially reduced its use of nondiegetic music. After examining this reduction and offering explanations that differ from the standard scholarly account, I outline several musical practices that filmmakers used regularly from 1929 to 1931. In many cases nondiegetic music was not eliminated but rather was deployed in ways that minimized the audience's awareness of its presence. I then examine two films from 1930—*Liliom* and *The Big Trail* (both October)—that feature unusually complex uses of nondiegetic music for the period. Finally, I examine *Cimarron* and *City Lights* (both January 1931)—two of the only films from the period to enjoy substantial attention from film music scholars—within the context of broad film music practices from 1929 to 1931. When situated historically, *City Lights* can be seen as an anomaly, while *Cimarron*'s deployment of nondiegetic music—despite regular claims to the contrary—was relatively typical for the period.

The findings in this chapter directly challenge decades of film music scholarship and demand a reconceptualization of the history of film music from 1928 to 1931. As discussed in my introduction, the prevailing view among film music scholars is that the period featured the complete or near complete reduction of nondiegetic music, thus suggesting that nondiegetic film music held little importance for the period's filmmakers. This chapter presents an avalanche of filmic examples that feature nondiegetic music. Certain films from 1928 to 1931 explored nondiegetic music's uses in sound film in substantial and meaningful ways.

EARLY 100 PERCENT TALKIES:
LIGHTS OF NEW YORK AND *THE SQUALL*

From the beginning, approaches to music in the 100 percent talkie were diverse. This becomes evident when considering two early Warner Bros. releases: *Lights of New York* (July 1928) and *The Squall* (May 1929). Both films feature efforts to incorporate the near continuous music practices of silent film, but the films differ in the extent to which they retain this style in the face of a recorded performance aesthetic and the desire for a diegetically comprehensible sound space. Where *Lights of New York*'s score enters nondiegetic terrain cautiously and makes numerous concessions to the film's diegetic performances, *The Squall* displays a more concerted effort to maintain silent film accompaniment practices.

Telling a contemporary gangster story that, as an introductory intertitle states, "Might have been torn out of last night's newspaper," *Lights of New York* centers on two men—Eddie (Cullen Landis) and Gene (Eugene Pallette)—who inadvertently team up with two bootleggers in an effort to make money in New York City. Thinking that they are going into a legitimate business, Eddie and Gene soon discover that Gene's barbershop is merely a front for a speakeasy known as the Night Hawk. The unscrupulous speakeasy manager known as "Hawk" (Wheeler Oakman) convinces Eddie to use his barbershop to hide illegal alcohol that has been linked to a police murder. Hawk plans to pin the murder on Eddie, but Eddie catches wind of the plot. In a dramatic scene in the barbershop, Hawk pulls a gun on Eddie but a mysterious assailant then kills Hawk. In the final scene Eddie is nearly arrested for Hawk's murder before the real murderer—Hawk's jealous former girlfriend—turns herself in.

Upon its release in mid-1928, *Lights of New York* enjoyed the distinction— advertised heavily by Warner Bros.—of being the first "all-talking" film. Though the film was a tremendous box-office success, today it serves mainly as a poster child for the static camera and stunted dialogue of the earliest sound films. To date, film music scholars have not attended to *Lights of New York*,[2] perhaps assuming that nondiegetic music would not have played a role in an early and awkward sound film. But music constitutes a regular and extensive presence in this film. All of the sequences contain at least some music, and in many scenes the music plays continuously underneath dialogue. Since it was released two months before the

dialogue-laden *Singing Fool* (September 1928), *Lights of New York* likely constitutes the first instance of extensive dialogue underscoring.

The decision to use accompaniment music in *Lights of New York* was a carryover from previous types of films. In mid-1928 a film—whether a silent or early synchronized film—virtually always featured continuous or nearly continuous music. Yet as with the part-talkie, the addition of dialogue required filmmakers to face questions about diegetic/nondiegetic distinctions, appropriate balances between music and dialogue, and whether to continue the late silent-era practice of using musical motifs. *Lights of New York*'s responses to these issues were sometimes contradictory, indicating that the filmmakers did not always have a consistent sonic strategy for this early talking film.

If music was to be heard through much of this film, did it need a source in the image? *Lights of New York* hedges its bets on this question by initially tying music to an obvious diegetic source before gradually presenting music that is less and less plausibly diegetic. This tactic begins during one of the earliest shots in the film. The image presents a radio while the soundtrack features the popular 1917 tune "Where Do We Go from Here?"—a title that reflects the two bootleggers' desire to move away from their small town and back to New York City. When one character asks the other to switch off the radio, all music promptly stops for the duration of the scene. Because this abrupt cessation of the music draws the audience's attention toward the song and its clear diegetic source, viewers might assume that the film as a whole will provide music with sources in the image.

Subsequent scenes, however, contain music that becomes progressively more difficult to locate. The next two scenes feature music during conversations in a hotel lobby and then an apartment. While both locations could conceivably contain a radio, no radio is visible, meaning that the diegetic status of the music has been rendered less clear. Further pushing the music toward diegetically ambiguous territory, the filmmakers use a different style of music in the lobby and apartment. The lobby music includes the 1902 song "In the Good Old Summer Time," which, like the song heard on the radio at the beginning of the film, is an older popular tune and is thus easy to interpret as another radio song. The music in the subsequent apartment scene, however, features a fuller range of instruments, a slow pace, and a far less pronounced rhythm—it is much closer to a classical than a popular idiom. Classical music was

heard frequently on the radio during this period, but *Lights of New York*'s shift in musical style still marks the classical music as potentially belonging to a different sphere. Moreover, this music conveys a sentimental mood that almost too conveniently matches the heartfelt conversation between Eddie and his mother to be diegetic. A few scenes later, the score finally moves into clear nondiegetic territory by featuring orchestral music during a conversation in Central Park. Unlike part-talkies like *The Singing Fool* or *Weary River* (January 1929), *Lights of New York*'s music only gradually eases toward nondiegetic territory, thus making its eventual nondiegetic identity harder to detect.

After the scene in Central Park, the filmmakers face a new musical question during a lengthy sequence inside the Night Hawk club. Scenes inside the nightclub alternate between musical numbers performed in the stage area and conversations advancing the plot that take place in other locations, most notably Hawk's office. As Rick Altman points out, during conversation scenes inside Hawk's office, the diegetic numbers are presented like an on/off switch: the music plays full blast when the door is open, but then—despite the fact that Hawk's office is right next to the stage area—it is reduced to nothing when the door is shut.[3] This situation creates a new problem for nondiegetic music. When Hawk's door is closed and diegetic music ceases, should nondiegetic music reemerge on the soundtrack? In other words, which model rules the roost: the continuous music model of silent and early synchronized sound films or a soundtrack that features only diegetic music?

Unlike part-talking films, *Lights of New York*'s filmmakers avoid nondiegetic music in spaces featuring performances. Since the film audience knows that diegetic music is being performed elsewhere in the nightclub, a return to nondiegetic music during the nightclub sequence could create confusion over whether such music contains a sound source within the diegesis. Invested in a musical model that directs attention away from vexing diegetic and nondiegetic questions, the filmmakers are willing to jettison the nearly continuous musical model that had dominated the late silent era. Only after the end of the Night Hawk sequence do the filmmakers return to a nondiegetic music aesthetic. Nondiegetic music, though plentiful, consistently takes a backseat to diegetic sound concerns in *Lights of New York*.

Though *Lights of New York* contains a consistent strategy for when to use nondiegetic music, the same cannot be said for its volume-level

balance between music and dialogue. As with Warner Bros.' *The Singing Fool*, music continues to play at a rather high volume during dialogue sections, sometimes even threatening to exceed the volume of the dialogue. Yet at other times, the music *does* adjust its volume for dialogue. Altman points out that during the Night Hawk sequence, dialogue sometimes occurs when the music volume is not at *fortissimo* (a very high volume) and that at one point the music volume noticeably dips for an important conversation.[4] One might add that conversely, music sometimes swells during climactic moments when no one speaks. For instance, when Eddie—whom Hawk and the audience thought had been killed—walks into the barbershop at the film's climax, this surprise is amplified by an increase in music volume. The volume then lowers again to accommodate the next line of dialogue. Inconsistency, rather than a unified strategy, characterizes the respective volume levels of music and dialogue.

Perhaps most surprisingly, music for *Lights of New York* does not feature the motif strategies that served as a structuring principle for numerous late silent and early synchronized scores. *Lights of New York*'s filmmakers avoid the use of strong, easy-to-detect melodies, sometimes burying the melody within dense harmonization. With one exception,[5] no cues repeat in this film. Instead, the film provides what might be termed "general mood music"—sentimental music when Eddie and his mother talk, ominous music for a murder, and so on. This music makes few alterations for specific characters' actions or lines of dialogue. The score changes its musical style only for major narrative mood shifts, such as a sudden tempo escalation when Eddie introduces his mother to unscrupulous bootleggers, or soaring utopian music when Eddie realizes he has been saved from a murder charge. The lack of themes may well be attributable to the film's low budget and short production schedule, as filmmakers likely had little time to devise a thematic logic for the film. But it constitutes another way in which *Lights of New York* separates itself from its silent film predecessors.

Ultimately, *Lights of New York* constitutes a conflicting assortment of late silent accompaniment practices and on-location recording aesthetics. Music sometimes plays at a steady volume—as it generally did in the silent era—yet at other times it dips to accommodate dialogue. Some scenes contain silent-style continuous music, yet the filmmakers sometimes jettison musical accompaniment for the sake of diegetic sonic

clarity. Musical themes—a staple of silent film music—are abandoned in *Lights of New York*, perhaps out of fear that nondiegetic themes might conflict with the showcasing of diegetic sound. As I indicated in chapter 1, motifs have the potential to draw attention to the presence of an external (nondiegetic) narrator who guides viewer response. *Lights of New York*, through its lack of motifs, actively avoids drawing attention to such an agent, instead highlighting diegetic musical performances and dialogue.

By itself, *Lights of New York* might suggest that the 100 percent talkie immediately broke with the thematically driven, continuous music practices of late silent, early synchronized, and part-talking films. Yet film style seldom moves in wholly unified directions, especially during the early years of a new technology. In May of 1929 Warner Bros. released *The Squall*, a film that features a more concerted effort to retain a silent film aesthetic in the face of the increasingly popular 100 percent talkie.

Set in Hungary, *The Squall* stars a young Myrna Loy as Nubi, a stunning yet morally questionable gypsy woman. Believing Nubi to be a Christian by birth rather than a full-blooded gypsy, a trusting farming family rescues her from an abusive gypsy man. Once she enters the family's home, however, the dark-skinned Nubi uses her exotic beauty to turn men's heads and wreck their previously stable relationships with their exclusively white partners. Nubi first breaks up the relationship between the servants Peter (Harry Cording) and Lena (Zazu Pitts). Next, she turns the head of Paul (Carroll Nye), a young man who was previously interested in Irma (Loretta Young), and she even receives attention from Paul's father, Josef (Richard Tucker), who is married to Maria (Alice Joyce). As the men begin to argue and connive against each other, Nubi revels in the attention that she receives and the family discord that she causes. Ultimately getting wise to Nubi's narcissism and less-than-honorable intentions, the family is only too happy to return Nubi to the gypsy man, who reappears, announces that Nubi is his wife and belongs to him, and drags Nubi out of the house while brandishing a whip.

Despite extensive dialogue throughout, *The Squall* features nondiegetic music for nearly 70 percent of its running time. This high percentage by itself is remarkable, given regular scholarly claims that Hollywood avoided underscoring in this period. But equally striking is the fact that the filmmakers used rerecording to produce this score. Instruction sheets contain a reel-by-reel list of music selections to be placed into the film,

and these reel numbers match those in the conductor's part.[6] Only in postproduction would a list based on reels be possible, demonstrating that this music was added during this phase and mixed with the film's copious dialogue via rerecording. Further attesting to the presence of rerecording, the filmmakers sometimes simply lifted recordings of tunes that had been played during earlier reels and reused them in later sections of the film. Figure 3.1, for example, features a handwritten list of cues for reel 3. Next to cues 4 and 36 ("Gypsy Theme"), the handwritten instructions indicate that these cues need not be recorded but can be merely reused from the sound record for cue 2, which is also "Gypsy Theme." Far from an occasional tactic, *The Squall's* entire score was the product of rerecording.

Like the filmmakers for *Lights of New York*, *The Squall's* filmmakers conceived of the music not as an object to be molded and reworked to fit with specific actions or lines of dialogue but rather as an autonomous entity that should coincide in a segment-by-segment manner. The film features short segments of preexisting classical music associated with Hungary and gypsies, such as Franz Liszt's *Les préludes*; Liszt's Second, Fourth, and Sixth Hungarian Rhapsodies; Antonín Dvorak's "Tune Thy Strings, Oh Gypsy" and "The Old Mother (Gypsy Song)"; Theodore Moses Tobani's Second Hungarian Fantasia; and Johannes Brahms's Hungarian Dance no. 3. Yet while the film's location and gypsy characters clearly impacted musical selection, these preexisting numbers were not modified to fit the film. Instead of attending to small-scale screen events, *The Squall's* filmmakers—as in the late silent era—remained primarily concerned with ensuring that musical cues began and ended at "proper" points.

This concern is amply illustrated by the first violin part for cue 46, a thirty-second cue that consists of portions of Dvorak's "Tune Thy Strings, Oh Gypsy" ("Reingestimmt die Saiten") (fig. 3.2). The cue begins with the first shot in the scene, which features an extreme long shot of Paul, who is smitten with Nubi, pulling up his buggy next to a haystack. Paul watches jealously as Nubi literally fights off the affections of two farmhands and then jumps into the hay. Just after the end of this musical cue, Nubi walks over to Paul and successfully seduces him. Within this thirty-second cue, seven different penciled markings refer to specific cues from the film. "FARMERS" refers to the workers who are visible in the film's establishing shot (fig. 3.3); "COME ON NUBI" (spoken as "Come on gypsy" in the film) is spoken by one of the farmers as he attempts to kiss her

FIGURE 3.1 A list of cues for reel 3 of *The Squall*.
The Squall music files, Warner Bros. Archives, University of Southern California.

(fig. 3.4); "GO AWAY" is Nubi's line as she fends off both farmers; "CLOSE" and "CLOSE ON BOY" (fig. 3.5) both refer to close-range shots of Paul; and "NUBI FALLS ON HAY" (fig. 3.6) refers to her leap into the hay to escape the farmers and attract Paul.

Though the score features numerous penciled markings pertaining to moments in the scene, in general these moments are not precisely

FIGURE 3.2 The first violin part for "Tune Thy Strings, Oh Gypsy," in *The Squall*. *The Squall* music files, Warner Bros. Archives, University of Southern California.

synchronized with dialogue or image actions. For instance, in the final version of the film, Nubi's "Go away!" line occurs two measures before it is listed in the score, and it occurs merely in the middle of the melody. The only penciled marking denoting a salient match between music and action is the final notation reading, "NUBI FALLS ON HAY." When Nubi leaps in the hay, her landing coincides with the final note of the song, a

FIGURE 3.3 "FARMERS" (*The Squall*).

FIGURE 3.4 "COME ON NUBI" (*The Squall*).

FIGURE 3.5 "CLOSE ON BOY" (*The Squall*).

FIGURE 3.6 "NUBI FALLS ON HAY" (*The Squall*).

D played as a short sforzando. Immediately following this note, the score returns to "Gypsy Charmer," a theme regularly tied to Nubi and her efforts to seduce white men. Timing the end of "Tune Thy Strings, Oh Gypsy" to Nubi's land in the hay is thus doubly important: it not only matches a physical action, but it triggers the beginning of a narratively appropriate cue. Indeed, the orchestra—having gotten slightly ahead of the image—significantly slows down the final measure to complete the cue as Nubi lands in the hay.

Because only the final note of "Tune Thy Strings, Oh Gypsy" requires precise timing with the image, the function of the other penciled markings becomes clear. In this and other scenes throughout *The Squall*, penciled narrative cues serve primarily as guideposts to ensure that one cue ends and the next cue begins at the proper time. The frequent excisions of musical passages serve as an additional way to enable the cue to end at a precise point in the narrative. For "Tune Thy Strings, Oh Gypsy," for instance, the filmmakers' excision of the first four bars and the *un poco più mosso* section helps the cue reach its conclusion just as Nubi leaps into the hay. Here and throughout the film, *The Squall*'s score was largely a postproduction amalgamation of preexisting music, kept essentially intact and timed to correspond with the general, large-scale changes in the image. As with *The Singing Fool*—which also used rerecording—*The Squall*'s filmmakers seldom used rerecording to achieve precise synchronization between particular actions or lines of dialogue. Instead, *The Squall* remains heavily indebted to the late silent era, which also favored preexisting music and conceived film music in terms of a series of short, self-contained cues.

Though both *The Squall* and *Lights of New York* generally avoid overtly synchronizing music with small-scale actions, *The Squall* breaks with *Lights of New York* in its regular use of character-based motifs, a staple of the late silent era. These motifs serve key narrative functions. As we saw in chapter 2, motifs—in addition to helping identify important characters—could also coerce audience members into feeling certain ways about the characters. In *The Squall*, motifs serve to condemn Nubi's overt sexuality and her ability to attract men. From a certain perspective, an audience could easily feel sympathy for Nubi. Not only does her flight to the Hungarian family allow her to escape a physically abusive man, but also one might reasonably blame the men on the farm, who pursue the gypsy girl quite aggressively, for the conflicts that ensue. The film, however, places

the bulk of the blame for the family's strife on Nubi's shoulders. Narratively, she constitutes a disruption to the happy status quo, an agent hell-bent on violating "proper" all-white couplings. The film also falls back on the assumption that if a woman turns a man's head, the woman is at fault for making herself so attractive; the man, in contrast, simply cannot resist his primal urges. Such underlying messages are embedded in the film's images and narrative trajectory, but they also emerge through the score's deployment of motifs.

As is typical in the period, the most prevalent theme in the film—a lilting, mysterious, minor-key melody titled "Gypsy Charmer"—is first heard during the opening credits (fig. 3.7). Once the narrative begins, the function of this melody is initially unclear. The theme plays when Nubi seduces Paul, which might cause the audience to assume that this motif constitutes Nubi and Paul's coupling theme. As the film progresses, however, the same theme is again heard when Nubi seduces Josef and during moments when Nubi, alone in a room, admires herself in the mirror. By this point it is clear that this theme belongs solely to Nubi, and this distinction has repercussions for the film's attitude toward her. On one hand, when a film grants a romantic love theme to a central couple, this can suggest the film's tacit endorsement of that pairing by implying that this coupling is somehow "right" through its generation of new, beautiful music on the soundtrack. Attaching a theme to only one character, on the other hand, can indicate self-centeredness and a failure to interact with others in a positive manner. In *Don Juan* (August 1926), for instance, the score gradually jettisons the motif tied exclusively to Don Juan in favor of a "collective" motif that signifies the romantic union between him and Adriana. The evil, self-absorbed Lucrezia, in contrast, receives her own, separate, unchanging theme throughout the film. In *The Squall*, centering the score's theme on only Nubi subtly condemns her selfish, amoral nature long before the family on the farm reaches that conclusion.

While tying a motif to a central character to guide interpretation was hardly an unusual practice in the period, *The Squall* also more daringly uses *silence* as a character motif. This "nonmusic motif"—attached to Josef—guides the viewer through the film's shifting power relationships. Josef's initial lack of music induces the audience to believe that he is impervious to Nubi's feminine charms. In contrast to Nubi's lilting theme, Josef's musical silence suggests his level-headedness, rationality,

They call you gy - psy charm - er Be - cause your blood is warm - er

FIGURE 3.7 The beginning to "Gypsy Charmer," Nubi's theme in *The Squall*. The film usually presents this theme without words, but at one point Nubi sings the lyrics while admiring herself in the mirror.
The Squall music files, Warner Bros. Archives, University of Southern California (notation modified to better fit the version in the finished film).

and, implicitly, male power. However, linking Josef with silence then helps convey a narrative in which Nubi progressively uses her sex appeal to overcome his resistance. Consider, for example, a scene in which Josef fires Peter and then accuses Nubi of deliberately luring Peter away from Lena. Here the filmmakers are faced with a decision: should they provide "Gypsy Charmer" on the soundtrack (Nubi's theme) or no music at all (Josef's "theme")? The decision to provide "Gypsy Charmer" throughout this long conversation implies that despite Josef's outward appearance of male authority, Nubi is in fact the underlying possessor of power. Nubi has "hooked" Josef, in spite of his stern admonishments. Further reinforcing this fact, Nubi hums "Gypsy Charmer" after Josef exits, and shortly thereafter we hear Josef himself—the man previously associated with musical silence—humming the catchy "Gypsy Charmer" as well.

This argument between Nubi and Josef ties directly to a scene late in the film in which Nubi overtly seduces Josef, thus implicitly undermining his patriarchal authority. At first, musical silence reigns while Josef speaks sternly to Nubi, suggesting that Josef may have control of the situation. Then, however, the following exchange takes place. Josef accuses Nubi of making advances toward Paul, which causes Nubi to smile. Josef exclaims, "Don't lie, I can see it in your eyes," and Nubi responds by saying, "You cannot read these eyes, master. You be blind! Blind!" She rises up and kisses him, and Josef exclaims, "What is that infernal light shining in your eyes?" During this exchange, in which Nubi gains the upper hand via her exotic and sexual allure, the soundtrack moves from silence (Josef's "motif") to "Gypsy Charmer" (Nubi's motif). Nubi, the score indicates, can use her sex appeal to control even the male head of the household. Little wonder, given the overtly patriarchal society of the late 1920s, that the narrative posits such feminine power as dangerous and ultimately needing to be reined in by male authority.

If *The Squall* shares the late silent era's tendency to make regular use of themes, it also adopts silent film's indifference toward diegetically justifying its music by featuring blatantly nondiegetic music from the outset. This, too, differs from *Lights of New York*, which only gradually allows its music to venture into nondiegetic terrain. But *The Squall* does avoid presenting diegetic/nondiegetic confusions that might distract the audience. Early in the film, for example, the score stops just before the family hears Nubi scream, which prompts one character to exclaim, "Did you hear that?" Here the filmmakers are apparently aware that playing nondiegetic music during this moment might render the diegetic sound space confusing. The audience might even wonder whether a particular character has somehow detected the score. Determined to prevent diegetic/nondiegetic ambiguities from occurring, the filmmakers coordinate the score to cooperate with the construction of a diegetically understandable sound space.

The Squall's filmmakers are so concerned with creating a comprehensible diegetic sound space that diegetic and nondiegetic music never occur simultaneously on the soundtrack. During the few instances in which characters whistle or sing songs—such as Peter's "I'm Unhappy" or Nubi's various instances of singing or humming "Gypsy Charmer"—the nondiegetic music stops before the song begins and resumes only after the diegetic performance has been completed. The filmmakers plainly did not want the nondiegetic score to complicate the audience's understanding of the film's diegetic sound space.

Taken together, *Lights of New York* and *The Squall* serve as eye openers to scholars who assume that early 100 percent talking films featured no music. Rather than severing ties with the continuous music practices of the late silent era, certain 100 percent talkies continued to use extensive musical accompaniment. Equally important, both films reveal early efforts to grapple with a key representational conflict: how to negotiate between the late silent era's continuous music practices and the desire in the early sound era to present a comprehensible diegetic sound space. Of the two, *Lights of New York* is more musically cautious. Not only do the filmmakers carefully ground music in the diegesis in the early going, but they also remove nondiegetic music at the slightest provocation from the diegesis. *The Squall*, in contrast, makes no effort to tie its music to image sources. Instead, *The Squall*'s music halts primarily during moments that *depend* on the audience's precise understanding of what constitutes

diegetic sound. Though their approaches differ, both *Lights of New York* and *The Squall* reveal a growing belief in the period that diegetic/nondiegetic music distinctions were important in the 100 percent talkie. Efforts to retain extensive music in "all-talking" films would be short-lived, however. By late 1929, Hollywood films featured a sudden and substantial reduction in nondiegetic music.

The Reduction of Film Music, 1929–1931

Given the plethora of continuous or near continuous music scores in 1928 and early 1929—whether synchronized scores, part-talkies, or a 100 percent talkie like *The Squall*—few could have predicted that by late 1929, Hollywood would have shifted gears by drastically reducing the amount of music present in nearly all its films. Yet from the fall of 1929 through the spring of 1931, music regularly occupied significantly less than half of a film's soundtrack. Outside of film musicals, audiences during these years could generally expect to hear relatively short, intermittent musical cues—a far cry from the continuous music regularly provided only a year or two earlier. One of the only exceptions to this tendency is Paramount's *Fighting Caravans* (January 1931), a western set during the Civil War that features nonstop music for its eighty-minute running time. *Fighting Caravans* remains a curious anomaly in a period generally dedicated to the drastic reduction of nondiegetic music.

This shift to sparse accompaniment music was remarkable considering that many of the people in charge of film music from 1929 to 1931 continued to be prominent former silent film music directors and thus had been accustomed to film as a continuous-music medium. Hugo Riesenfeld, the well-known silent film music director and arranger, was hired as music director of United Artists in 1929.[7] Erno Rapee, an equally prominent creator of silent film scores, received what was believed to be a record-breaking salary to become the general music director at Warner Bros. in 1930.[8] William Axt, the musical director for MGM, had contributed to the scores for two major silent films—*Passion* (1920) and the 1921 reissue of *Birth of a Nation*—and had served arranging and conducting duties at the high-profile Capitol Theatre.[9] Further attesting to the comprehensiveness of this aesthetic shift, by the end of 1929 *all* major studios switched from continuous to intermittent music. Viewing the films listed in the appendix from 1926 to 1931 reveals slight differences among

studios: MGM conservatively stuck with music and effects-only scores for longer than other studios, while Fox tended to use musical cues a bit more extensively than the others. Overall, however, the substantial reduction of music occurred at all studios.

Yet while studios reduced their amount of film music during this period, they were not in agreement on the terminology used to credit music personnel. The variety of terms in the credits suggests the multiple prior influences on the use of music and how its role in film was understood. From the middle of 1929 to the middle of 1931, by far the most common music credit was for the film's "score." But this credit pertains mainly to the continuous or near continuous music scores for films like Warner Bros.' *The Squall* or MGM's *The Single Standard* (July 1929). Exceptions do exist, such as the score credited to Richard Fall for the intermittent music used in Fox's *Liliom*. But typically, studios opted for different terminology to indicate the presence of intermittent music. These options included "background music," "incidental music," "music advisor," "music arrangement," "music by," "music composer," and "music conductor." Each term suggests slightly different conceptions of film music. "Incidental music," for instance, draws on theater music terminology, while "music arrangement" suggests a compilation of preexisting music (as opposed to "music composer," which implies original music).

The most common credit for intermittent music in this period, however, appears to have been "music director" or—in the case of Warner Bros.—"general music director," a term used by all major studios except MGM. The term *music director* harks back to the late silent era, when major movie theaters had musical directors who were in charge of music acquisition, cataloguing, and deciding which music to include in the film. The reuse of this term by studios in the early sound era suggests that studios conceived of film music in much the same way: as a process of acquiring, cataloguing, and ultimately placing *preexisting* music into the film. Indeed, from 1929 to 1931 preexisting music constituted a far larger presence in film scores than original compositions.[10] Furthermore, where silent-era music directors shouldered leadership responsibilities that included hiring musicians and organizing rehearsals, the music director in the early sound era was also an overseer. According to music archivist Jeannie Pool, the music director led a team that included composers, songwriters, "orchestrators, arrangers, copyists, conductors, musicians, [and] scorers," as well as non-silent-era personnel like "cut-

ters, sound engineers, [and] sound effects specialists."[11] Still, this team, as music historians James Buhler, David Neumeyer, and Rob Deemer point out, tended to have an ad hoc rather than a standardized arrangement owing to the rapid aesthetic changes in the early sound era.[12]

Since music directors led a team of musical staff members, the importance of musical collaboration during this period cannot be underestimated. Pool writes that various composers "wrote and rewrote one another's compositions; they corrected, edited, and expanded each other's work, with the goal of making the best music possible in service of the film."[13] Revealingly, when the Academy of Motion Picture Arts and Sciences began giving out awards for Best Score in 1934, the award went to the studio music department rather than to individual composers, a practice in keeping with the way scores were produced in the period.[14] This tendency toward group authorship makes it risky to assign credit to specific persons, and in this and subsequent chapters I generally assign musical responsibility to the filmmakers as a group rather than to a particular individual.

The sparse, intermittent music style of the period was unlike anything witnessed in the silent era, and thus the shift to this style demands an explanation. To date, scholars have almost uniformly offered what might be termed the "Max Steiner Explanation." The explanation, advanced by Steiner himself beginning in the late 1930s, provides two reasons for the absence of a film score in the late 1920s and early 1930s.[15] First, Steiner writes that rerecording was "unknown at the time," meaning that the entire orchestra had to be on the set should music be desired. This was not only a big expense but a virtually insurmountable logistical headache as well. Second, Steiner claims that Hollywood's newfound need to diegetically justify each and every musical cue also resulted in the elimination of nondiegetic music. Steiner's catchy description of a wandering violinist conveniently providing a love theme has encouraged scholars to argue that an "aesthetics of realism" precluded the use of nondiegetic music in the early sound period.[16]

Though many scholars have accepted the Max Steiner Explanation, it is nevertheless fraught with misrepresentations, inconsistencies, and inaccuracies. As the remainder of this chapter demonstrates, nondiegetic film music was not eliminated but simply reduced. But even if one overlooks this misrepresentation, one should note that Steiner's two explanations for the reduction of music contradict each other. The first component

of his explanation suggests that filmmakers *would* have wanted nondiegetic music if the hassles of an on-set orchestra were not so great, while the second component indicates that filmmakers would *not* have wanted nondiegetic music because it would have created audience confusion about where the music was coming from. Perhaps this paradox reflects filmmakers' uncertain attitudes toward music during this period, but it paints a confusing and unresolved picture of the early sound era nonetheless. Why would filmmakers have cared about the logistical headache of an off-camera orchestra if their attitude toward nondiegetic music precluded them from wanting such a service in the first place?

Further undermining Steiner's explanation, I have indicated that rerecording was not only known at the time but was used extensively in Warner Bros. films as early as 1928. Archival evidence reveals that rerecording remained extensive at Warner Bros. at least through 1930, as films like *Sally* (December 1929) and *Golden Dawn* (June 1930) relied heavily on the process.[17] As I suggested in chapter 2, Warner Bros.' use of rerecording was probably partly driven by the nature of the studio's sound-on-disc system, a process that no other major studio adopted. Still, even a cursory look at some of the major films from this period indicates that other studios—including those using sound-on-film rather than Warner Bros.' sound-on-disc method—also used rerecording. During a ten-minute charity ball scene from United Artists' *Hell's Angels* (May 1930), continuous music plays while depicting dialogue in multiple rooms in the manor, as well as outside on the terrace. During these shifts from one location to another, the music remains unbroken. Recording this music during production would have been a logistical impossibility. Fox's *Seas Beneath* (January 1931) similarly features continuous background music that bridges shots featuring dialogue in two different places, thus almost guaranteeing that some form of rerecording was used.

But perhaps the best indication of substantial rerecording at studios other than Warner Bros. comes from two westerns: Fox's *The Big Trail* and Paramount's *Fighting Caravans*. In both films music repeatedly plays underneath dialogue scenes that are shot outdoors. In many of these dialogue scenes the camera is too close to the moving lips of the characters to make postproduction dubbing a possibility, meaning that dialogue was directly recorded outdoors during filming. Setting up an orchestra on locations like a cliff face, the desert, or a snowy mountainside was a near impossibility, so the music was very likely obtained by recording the

music separately and mixing it with the recorded dialogue in postproduction. Even obtaining the music track by playing a phonograph during shooting would not have worked for films like *Hell's Angels*, *Seas Beneath*, *The Big Trail*, and *Fighting Caravans*, since the music remains unbroken despite cuts to dialogue in different spaces.

Several scholars have claimed that rerecording was avoided in the early sound period because of the substantial loss in sound quality that resulted.[18] Yet if rerecording can be found in a range of early sound films, to what extent did rerecording's deterioration in sound quality truly prevent filmmakers from using the process? Evidence suggests that the loss of sound quality was sometimes seen as acceptable among filmmakers. In a May 1929 article in *Transactions of the Society for Motion Picture Engineers*, K. F. Morgan reports on the status of rerecording, stating that sound quality is not significantly impaired even with five rerecordings. Morgan acknowledges that each rerecording "introduces a slight loss in quality" but that some of these issues can be "artificially improved."[19] During the ensuing discussion of the paper, J. I. Crabtree reaffirms, "It is not necessary to sacrifice quality appreciably in the matter of making rerecording."[20] Morgan's paper would appear to indicate that rerecording, including the placement of music into a dialogue scene, was a regular practice by this point. According to the article, by May 1929 a machine had been developed that automatically rerecorded predetermined portions of sound records. Morgan also offers a description of rerecording for film as well as disc,[21] affirming that rerecording was not limited to the sound-on-disc format.

Recently, film historian Lea Jacobs has argued that Morgan's article was naively optimistic in its claim that rerecording featured a minimal drop in sound quality. Jacobs cites other trade journal articles detailing the technological drawbacks of early sound recording, and she concludes that rerecording entailed a "serious compromise" in sound quality during sound's early years.[22] Film preservationist and historian Robert Gitt, who has listened to Vitaphone discs featuring original sound records and rerecorded sound, concurs with Jacobs's assessment. Regarding the rerecorded versions, Gitt writes, "Everything—both music and voice—sounds as if it's coming through layers of cardboard. The primitive playback equipment of the time takes away the treble and takes away the bass, leaving a dull, thin sound."[23]

Yet while sound quality may have been reduced, whether this reduction was deemed acceptable by film sound technicians plainly remained

an open question in the period. In an endnote to her article, for instance, Jacobs quotes another early sound technician who extols the virtues of rerecording.[24] The situation is further complicated by the advent of noiseless recording, which greatly reduced ground noise in both variable density and variable area sound recording. According to Jacobs, ground noise had been a major impediment to rerecording, and the advent of noiseless recording made rerecording more feasible.[25] Because noiseless recording appears not to have become widespread until early 1931, it is uncertain whether films like *The Big Trail*, *Fighting Caravans*, and *Seas Beneath* used rerecording as a result of the advent of this new technology. At the very least, however, it is clear that in some cases, the benefits of rerecording outweighed the potential deficits in sound quality.

Steiner's claim that rerecording was avoided in the early sound era is an overgeneralization. His second claim—that Hollywood felt the need to diegetically justify every cue in the film during this period—also demands reconsideration. To be sure, from 1929 to 1931 Hollywood did increase its efforts to connect music to a diegetic sound source, sometimes straining credibility in the process.[26] Still, the notion that Hollywood required *every* sound to have an image source is an oversimplification. The period's reduction of music is better understood as part of a broader effort—seen in part-talkies and 100 percent talkies—to construct a *comprehensible diegetic sound space*. Diegetic comprehensibility *could* be accomplished in a film featuring nondiegetic music. *The Squall*, for instance, offers clear demarcations between diegetic and nondiegetic music sections. Consequently, the audience is never induced to question which domain a music cue comes from. Yet reducing nondiegetic music constituted a far easier means for ensuring diegetic clarity, and filmmakers increasingly used this option in 1929 and 1930. Reducing nondiegetic music was not driven primarily by a belief that audience members *required* diegetic sources for all music (many films did feature nondiegetic or ambiguously located music); rather, reducing nondiegetic music enabled filmmakers to avoid any potential diegetic/nondiegetic confusion.

A second factor—and one ignored in Steiner's account—surely contributed to the reduction of music: the emerging importance of recording the voice. Initially, when sound recordings served as a substitute for live music performances in the movie theater, little effort was made to record the voice. For instance, in *Sunrise* (September 1927), when a character shouts to announce that The Wife (Janet Gaynor) survived a dan-

gerous storm, the soundtrack famously provides not the character's voice, but a French horn that mimics her voice. Several historians have demonstrated, however, that Hollywood increasingly focused its technological efforts on recording the voice during the early sound period. This interest took two forms: obtaining a clear vocal record and showcasing "naturalistic" speech patterns. During the 1930–31 season, for example, quieter recording technologies and directional microphones were both designed primarily to isolate the voice and record it more clearly.[27] Moreover, around 1929, Hollywood and its audiences became obsessed with "natural" deliveries, which included accents, "realistic" vernacular, and peculiar deliveries.[28] Films from 1929 to 1931 are loaded with such vocal oddities as pronounced accents (Swedish, French, and German accents in particular), street-life or gangster dialects, and stutterers.

The continuous music accompaniment of the silent era directly conflicted with this recorded voice aesthetic. Music, when played at the same time as dialogue, threatened to reduce the audience's ability to hear and appreciate these odd vocal deliveries. Early microphones, especially those prior to the 1930–31 season, were "weak in sensitivity, fidelity, dynamic range, and directionality,"[29] thus increasing the likelihood that the inclusion of a competing sound element like music might interfere with dialogue. Consequently, filmmakers probably faced pressure to eliminate music for the sake of showcasing the voice. Revealingly, even Fox's *The Big Trail*, which contains an unusually large amount of music for the period, almost universally eliminates all music when the three characters with the most unusual vocal deliveries—a comical Swede (El Brendel); the gravelly voiced Red Flack (Tyrone Power Sr.); and a man named Windy (Russ Powell), who imitates sounds such as coyotes and Indians—deliver their lines.[30] Interest in the voice may also explain the reduction of what constituted typical music volume level: when music *is* played during moments of dialogue in films from late 1929 to 1931, it is generally at a substantially lower level than prior part-talkies and early 100 percent talkies.

The reduction of music, however, caused a new set of problems. In the silent era, film music had served a range of useful purposes: it signified the prestige of the film, heightened anticipation for the feature, identified and instantly characterized important characters, underlined emotion, and even served song-plugging functions. Reducing film music meant that these important narrative functions might have to be abandoned. To address this problem, Hollywood employed tactics that minimized

diegetic/nondiegetic confusion while still allowing film music to serve some of its prior uses. These tactics can be seen as tentative solutions to the representational conflict between late silent film accompaniment and sound film's emerging expectations for its sound space.

These solutions were not universal, and filmmakers used music in quite diverse ways. Still, the following four sections provide what no scholar has yet offered: an outline of general music strategies from 1929 to 1931. Nearly all films used music during the opening and closing title sequences to guide the audience in particular ways. A number of films also employed what I term "diegetic withdrawal": a situation in which a film initially uses only diegetic music before gradually introducing ambiguous or downright nondiegetic music cues. Films also regularly featured scenes that were set in locations where music was plausible or likely, and this diegetic music sometimes guided audience attention and interpretation in a manner nearly identical to nondiegetic music. Finally, Hollywood continued to use the theme song as a method of guiding the audience through the narrative.

Opening and Closing Title Sequences

From 1929 to 1931, films almost always feature music during the opening and closing titles, even if they contain no other nondiegetic music. In many cases the tunes that play during the opening credits also play at the end of the film. For films featuring a theme song, the presentation of the song during both the beginning and end title sequences was a must, but other films also contain similar or identical tunes at the beginning and end. For example, United Artists' *Abraham Lincoln* (August 1930) provides a medley of patriotic American music over the opening and closing titles; *Hell's Angels* features the second movement from Tchaikovsky's Fifth Symphony during the opening credits, intermission, closing credits, and subsequent blank screen; and *Seas Beneath* offers military marches during the beginning and end title sequences.

Title sequence music served a range of purposes. For more expensive films, classical music could elevate the film's prestige. *Hell's Angels*, for instance, had the highest budget in film history up to that point, a fact that was heavily publicized.[31] It received a much-hyped premiere at Grauman's Chinese Theatre in Hollywood, and newsreels in the period emphasized the colossal number of prestigious film personnel who

attended, including Gloria Swanson, Cecil B. DeMille, Dolores Del Rio, Charles Farrell, and Buster Keaton. Musically, the film used the second movement from Tchaikovsky's Fifth Symphony to announce itself as a prestigious film. Tchaikovsky's music was a frequent source for orchestral overtures during the silent era, and silent-era overtures often strove to raise the prestige of the moviegoing experience.[32] Not surprisingly, the musical arranger for *Hell's Angels* was Hugo Riesenfeld, a veteran of late silent film accompaniment practices.

Opening credit music could also suggest genre, thus immediately coaxing the audience to respond to the film in a particular way. Though a single tune could accomplish this purpose, many films used two contrasting themes to foreshadow the nature of the film, a strategy that would become conventional practice by the late 1930s.[33] The opening title sequence for RKO's *Lonely Wives* (February 1931), for instance, begins at a very fast, or *presto*, tempo with the xylophone featured as a prominent instrument, followed by a far slower and more romantic piece featuring strings. This opening predicts the nature of the film: it is a zany comedy (the first theme) with some romance (the second theme). Similarly, Fox's *They Had to See Paris* (September 1929)—a fish-out-of-water story about an Oklahoma family that travels to Paris to hobnob with the upper class—begins with a Gershwinesque tune (representing the sophistication of the city) followed by faster-paced, rousing band music (presumably representing good ol' small-town American life).

A particularly clear example of how opening title music could indicate the central appeals and themes of the film occurs in the three-themed opening to *Party Girl* (January 1930), a B film produced by Personality Pictures. *Party Girl* ostensibly tells a cautionary tale about how companies exploit sexually attractive young women by using them to sell their products. However, in a mixed-message tactic typical of Hollywood, the film contradicts its own public service message by regularly titillating the audience via images of scantily clad women and overt reminders that naked women are just off the frame's edge. The opening credits' music suggests these contradictory messages by beginning with a perky jazz theme titled "Oh! How I Adore You," written for the film by Harry Stoddard and Marcy Klauber. As we saw in chapter 1, jazz during this period had connotations of drinking, dancing, and sexual promiscuity. Lest the audience get the wrong idea about the film's appeals, however, a "foreword" appears after the opening credits that condemns the party girl

system. The disclaimer begins with the sentence, "Sex in business—the 'Party Girl' racket—threatens to corrupt the morals of thousands of young girls who seek to earn their living decently," and the music underscores the seriousness of this message by shifting from jazz to a dramatic, minor-key classical music passage. After more text bemoaning "the shameful effects of this practice," the film reveals its supposed public service agenda: "It is our earnest hope that this film may arouse you and other public-spirited citizens to forcibly eliminate the vicious 'Party Girl' system." Though the timing is a bit off, triumphant brass-heavy music roughly coincides with this inspirational line. The three music styles during the opening suggest three ways to read the film: as sexual titillation, as an illustration of a tragic social practice, and as a call to action.

If opening credit music could assist the audience by foreshadowing some aspect of the film, closing music offered a guiding hand by regularly dipping into the last few seconds of the narrative to provide a final statement. On occasion this spillage lasts more than a few seconds. *Abraham Lincoln*—a film that otherwise contains music that can be read diegetically—allows nondiegetic music to slide into the last minute and a half of the narrative to convey a final take-home message. The filmmakers use songs like "When Johnny Comes Marching Home," "Battle Hymn of the Republic," "The Star-Spangled Banner," and "My Country 'Tis of Thee," combined with images of the log cabin where Lincoln was born and the Lincoln Memorial, to suggest that Lincoln attained immortality in the eyes of Americans by sacrificing his own life in the pursuit of the larger goal of preserving the Union. Because immortality is a transcendental, nonmaterial concept, the filmmakers likely felt justified in deploying nondiegetic music, which itself seems to exceed the physical confines of the diegesis. Though not strictly "part" of the narrative, opening and closing music raised expectations and guided audiences toward particular interpretations.

Diegetic Withdrawal

First used in *Lights of New York*, what I call "diegetic withdrawal" was one of the most common methods for incorporating nondiegetic music into a film in the early sound era. Diegetic withdrawal refers to a situation in which a film begins with clearly marked diegetic music, only to drift toward music that is either ambiguous or downright nondiegetic in the

later sections of the film. This ambiguous music often enables the film to reflect a character's emotions and guide audience response. The drift from diegetic to nondiegetic terrain is usually quite difficult for the spectator to detect, thus resulting in music that seemingly emerges organically from the diegesis rather than emanating from an external, nondiegetic narrational force.

Scholars have noted film music's potential to slide between diegetic and nondiegetic boundaries and even blur those distinctions,[34] yet it has not been pointed out that many filmmakers systematically exploited this film music potential in the early sound era. In Paramount's *The Wild Party* (March 1929), Clara Bow's first talkie, the first few musical cues are located firmly within the diegesis. Duke Ellington's "Jig Walk" accompanies a college girl dance party, and Scott Joplin's "Maple Leaf Rag" plays during a scene in a seedy saloon. In neither case does the film present an actual image of diegetic performers, but based on the match between musical selections, instrumentation, and location, the urge to tie these songs to the diegesis is a strong one. "Jig Walk" was a popular dance tune in the 1920s and is thus appropriate at a college dance party, while "Maple Leaf Rag" sold many sheet music and piano roll copies.

As the film progresses, however, several cues become impossible to justify diegetically. After providing dance numbers inside a house party, for example, the filmmakers cut to the beach outside the house, where two characters share a romantic moment to a ukulele-based rendition of the Buddy DeSylva, Lew Brown, and Ray Henderson tune "The Song I Love." The presence of prior diegetic music makes the audience less likely to notice the fact that there is no justification for this exterior music. Similarly, two later moments in the film—when the lead character, Stella (Clara Bow), spends a romantic evening with her professor (Fredric March) and later when she tearfully packs her things in preparation to leave college—receive diegetically unjustifiable music cues. Both are clearly in keeping with the emotional tone of the scene: the former tune is a *largo* (slow tempo), string-oriented version of—once again—the romantic "The Song I Love," while the latter tune is a minor-key rendition of "Wild Party Girl," the film's theme song. Thanks to the use of music that is clearly diegetic early in the film, however, the nondiegetic status of these cues is not particularly noticeable.

Film historian Donald Crafton argues that, beginning in mid-1929, the industry moved toward a more subdued use of sound, a tactic that by

mid-1930 meant unostentatious sound that receded into the narrative.[35] Diegetic withdrawal, with its emphasis on music that nearly always seemed to emerge from the narrative world, was part of this movement. Even when music drifted into nondiegetic territory, it often retained close ties to the narrative rather than serving as a source of attention in its own right. United Artists' *Alibi* (April 1929), for instance, uses diegetic withdrawal to convey character emotion and guide audience allegiances. The first two-thirds of *Alibi* present diegetic renditions of many jazz tunes, including "I've Never Seen a Smile like Yours," which United Artists exploited as a theme song.[36] These contemporary jazz tunes take place in a nightclub and a theater, two locations where audiences would expect to hear music. But during an extended and emotionally intense scene in a back room of the nightclub, the music slowly eases into potentially nondiegetic territory. During this scene Danny (Regis Toomey), an undercover police informant, enters the room, unaware that the gangsters in that room have discovered his connection with the police. After the gangster Chick Williams (Chester Morris) fatally shoots Danny and flees, the police officers arrive and hold Danny in their arms until he dies.

This scene is pivotal to the narrative. Thanks to the suppression of key information, the audience remains uncertain whether Chick is a law-abiding man for much of the film. His cold-blooded murder of the likable and brave Danny resolutely and permanently directs the audience's ire and disgust directly at Chick and suggests that the audience respect and admire the heroic efforts of police to bring gangsters like him to justice. Moreover, Danny's death justifies the film's final scene, in which a police officer and personal friend of his pretends to shoot the panic-stricken Chick, thus demonstrating Chick's cowardice. In short, the heightened emotions of this scene dictate the audience's loyalty and drive the remainder of the narrative.

The filmmakers use music with an increasingly tenuous tie to the diegesis to help communicate the scene's tension and shift the audience's alliance toward Danny and away from Chick. Diegetic withdrawal begins when Danny enters the room and shuts the door. On the soundtrack frenetic jazz from the nightclub is heard. Though such music would seem to qualify as diegetic, in all previous scenes music is rendered inaudible the moment that this door shuts. Violating the film's own sonic rules, this loud and salient music increases in volume when the door is shut,

and continues during striking close-ups of Danny and the mobsters. Here, then, music has shifted functions: where it once operated as what David Neumeyer terms "disengaged" background music (meaning music that displays no awareness of the narrative action), it has now violated the film's own sonic logic to convey the intensity and extreme danger that Danny suddenly faces.[37] In this way the "neutral" music up to this point has subtly become a narrational force that urges the audience to align itself with Danny and sympathize with his plight.

After Chick mortally wounds Danny, the music aligns the viewer more firmly with Danny by veering even farther into ambiguous territory. As Danny lies dying in the arms of the police, the soundtrack unexpectedly supplies Hawaiian ukulele music. Danny, near death, exclaims, "Listen! Pretty!" Is this music coming from the nightclub? All of the nightclub's other music has consisted of contemporary jazz tunes, and the ukulele music thus seems a poor fit with the diegesis. Perhaps the tune is subjective sound—music that the dying Danny hears inside his head before going to heaven? The smile on Danny's face as he dies supports this interpretation—for countless films in this period, death is a painless process tantamount to peacefully falling asleep—and surely also suggests that Danny will go to "paradise" upon his death. If this odd music can be recuperated diegetically, however, the scene's final cue cannot. When Danny dies, the soundtrack shifts to a choir, a decision that accentuates Danny's noble self-sacrifice. Bit by bit, film music in this and many other films in the period subtly shifts from "realistic" background music to music that reflects interior states and guides audience response.

When film music from the period drifts toward nondiegetic territory, it most commonly underscores moments of heightened emotion. In *Party Girl* the one instance of music that has only a tenuous tie to the diegetic world occurs when Ellen (Jeanette Loff) sits down and bemoans the fact that her former fiancé, Jay (Douglas Fairbanks Jr.), has married someone else. As a series of superimpositions on the image track encapsulates Jay and Ellen's past romance, a vocal rendition of the song "Farewell" is heard on the soundtrack—a song with no clear source in the image. Similarly, *Little Caesar*'s (January 1931) only ambiguous musical cue occurs when Tony (William Collier Jr.), a gangster who has lost his nerve, returns to his mother. As Italian music plays from no obvious source, Tony and his mother talk about how he used to be a "good boy" and "sang in the choir," and the two wind up hugging and crying. Again, a diegetically tenuous

music cue in Warner Bros.' *Other Men's Women* (January 1931) occurs during a dance hall scene in which Bill (Grant Withers), the main character, gloomily remembers Lily (Mary Astor), the woman he loves but cannot have. This recollection coincides with a change of music to Joseph Burke's "The Kiss Waltz," a song that had previously been associated with their romance. Though this could be read as a change in dance numbers, the image shows couples continuing to dance in the background, and the instrumentation and volume level differ markedly from the prior song. In these instances—as well as many others from the period—diegetic withdrawal allows the film to present what seems to be an exclusively diegetic sound space while simultaneously allowing music to aid in the presentation of emotionally laden moments.

In the early sound era, then, many films systematically shifted from diegetic to nondiegetic music during the course of the story. Diegetic withdrawal thus reveals a newfound awareness of diegetic/nondiegetic distinctions that was not generally evident in late silent and early synchronized films. However, because diegetic withdrawal features a *gradual* shift to the nondiegetic realm, the early sound era features a copious amount of ambiguously located music. This ambiguity encourages the film music analyst to consider what, precisely, qualifies as diegetic or nondiegetic music. Film music cannot be identified as diegetic or nondiegetic based on sound alone—it is the interaction between sound and image that dictates how an audience will categorize the music. The preceding examples suggest that diegetic and nondiegetic categorizations are best thought of in terms of a range of factors: Does the provided music seem likely to be diegetic given the setting and character actions (such as dancing) onscreen? Does the musical instrumentation match any onscreen musician(s) that might be imaged? Do volume and reverberation levels change based on the camera's distance from a possible sound source? Since these questions often do not result in answers that fit entirely within strict diegetic or nondiegetic categories, films from this period demonstrate the importance of thinking in terms of a diegetic/nondiegetic *spectrum* rather than an either/or categorization.[38]

Location-Based Music

From 1929 to 1931 Hollywood regularly justified the presence of music by featuring it in diegetically plausible locations. Like diegetic withdrawal,

location-based music hides the fact that an external narrative force guides the selection and application of music. Diegetic music is not the main focus of this study, but in the early sound period it—like nondiegetic or ambiguously located music—sometimes played an equally important role in guiding audience response and interpretation. If one wishes to obtain a full understanding of the trajectory of the early sound film score, diegetic music also needs to be considered.

Rather quickly, filmmakers established locations in which music was deemed appropriate, and they frequently reused these locations. Nightclubs regularly feature jazz music (*Alibi*); dance halls contain dance/jazz music (*Other Men's Women*); parties at upper-class mansions feature string-oriented orchestral or chamber music (*Hell's Angels*, *They Had to See Paris*); scenes set in smaller houses or apartments contain phonograph or radio music (*Other Men's Women*, *Little Caesar*); and bars/saloons often feature piano roll music (*The Wild Party*).

In location-based instances of music, its attentiveness to the narrative varies widely. At one end of the spectrum is a "realist" film like RKO's *Millie* (February 1931), with cabaret music that demonstrates neither awareness of nor consideration for narrative events. Volume levels remain constant regardless of dialogue levels, and major narrative shifts—such as Millie's (Helen Twelvetrees) sudden realization that her husband has a secret girlfriend—are not accompanied by any change in the cabaret performance number. Instead, the songs exist within their own realm, offering complete performances in the background regardless of narrative events.

In other films, however, the music's volume is "conveniently" raised, lowered, or kept steady in ways that assist the narrative. Most often, this occurs during romantic portions of the film. In *Hell's Angels*, diegetic orchestral music accompanies a ball. When characters move outside for a romantic interlude, the music's volume does not lower, as one might expect, but remains constant—the better to provide lush music that matches the romantic moment in the narrative. A more salient adjustment of volume to express a scene's romantic tone occurs in *Other Men's Women*. During a scene in which Bill professes his love to already-married Lily, the phonograph plays "The Kiss Waltz." When dialogue occurs, the music's volume level decreases substantially, while during moments of silence—which include embraces and kissing—this romantic tune is allowed to swell to a much louder volume, thus reflecting the passion

that the couple feels. Through this tactic, the dialogue remains entirely intelligible while the music still plays a vital role in expressing the passionate mood of the scene. Both *Hell's Angels* and *Other Men's Women* offer a way to feature a "realist" aesthetic of diegetic music while simultaneously utilizing music's affective potential.

On occasion, films even link the subject matter of the diegetic song to a romantic scenario. For example, RKO's *Check and Double Check* (October 1930)—the heavily promoted and financially lucrative film adaptation of the *Amos 'n' Andy* radio show[39]—features only diegetic music outside of the opening and closing titles. The film still uses music, however, to overtly comment on the narrative. An instance of this occurs when the film cuts from a house party performance by Duke Ellington and his Cotton Club Orchestra of the love song "Three Little Words" to a scene exterior to the party in which the in-love couple, Richard (Charles Morton) and Jean (Sue Carol), row down a river outside the house and then sit on a bench. After some romantic exchanges, Richard says to Jean, "Listen! Do you hear what they're singing? That seems to say it so much better than I can." Though the music remains entirely diegetic, it has changed functions from a "realistic" backdrop to something that "coincidentally" comments on the narrative. This use of music is nearly identical to how the theme song's lyrics in the early synchronized film comment on the narrative. The difference is that by this 1930 film, such a song is more likely to contain a diegetic pretext for its presence.

The Persistence of the Theme Song

Given the sparse musical aesthetic of 1929 to 1931, one might assume that the theme song—so prevalent during the synchronized score period—would have disappeared. Yet the theme song offered such profitability in terms of ancillary sales that filmmakers refused to abandon it entirely. Unlike theme songs from 1927 to early 1929, however, theme songs from mid-1929 to 1931 were far more likely to contain a diegetic justification. For example, though *Millie* features very little music, the filmmakers still find an extraordinary number of opportunities to plug the eponymous theme song, several of which take place within the diegesis. A melodramatic instrumental version of the tune accompanies the opening credits. Bouncier "soft jazz" versions occur when Millie first visits a cabaret (the music stops at one point and then resumes with the same

song), during a second cabaret scene in which the words to "Millie" are revealed (the song here is presented three different times within the same extended scene), as nondiegetic underscore for love interest Tommy (Robert Ames), during an intertitle that indicates the passing of time, during a third cabaret scene, and throughout the closing credits. Similarly, "Wild Party Girl"—the theme song to *The Wild Party*—is heard not only during the opening and closing credits but also as a diegetic vocal performance and as a nondiegetic minor-key instrumental version that accentuates a sorrowful moment late in the film.

The increased need to link the theme song with a diegetic source might on the surface appear to be quite limiting, but Fox's *Up the River* (October 1930) demonstrates that limitations can in fact foster creativity. *Up the River*, despite being a prison film, still manages to incessantly plug "Prison 'College' Song," a tune written by Joseph McCarthy and James F. Hanley. To justify the tune's many diegetic renditions, the filmmakers treat it as the prison equivalent of a college alma mater song. Inmates of the fictional Bensonatta prison perform the song regularly throughout the film, know the tune by heart, and sometimes even remove their caps to sing the tune. Its identity as an alma mater song helps justify its performance during moments such as the beginning and end of a variety show run by the inmates and a baseball game against an opposing prison. If such measures to plug a theme song seem absurd, this approach is nevertheless consistent with the way the film depicts Bensonatta jail in general. Like college, Bensonatta is a place where residents chat amiably with the staff, put on theater productions, root for the sports team, and leave and return to the premises seemingly at will. Seeing a song-plugging opportunity in this humorous take on jail life, the filmmakers were able to justify the repeated presence of the theme song within the broader world of incarceration.

The above examples demonstrate the continued importance of music from 1929 to 1931, even for films that did not feature musical numbers as central attractions. Nondiegetic music *did* play an important role for many films from this period, but tactics like diegetic withdrawal tended to draw attention away from music's nondiegetic identity. Far from being a period that entirely abandoned nondiegetic music, the years from 1929 to 1931 contained numerous explorations into the ways in which diegetic, ambiguously located, and fully nondiegetic music could be deployed to serve narrative ends.

From a modern perspective, one might expect the period's sparse approach to film music to be restrictive to filmmakers. The perceived need to venture into nondiegetic territory in piecemeal fashion, combined with intermittent rather than continuous music, would seem to result in limited opportunities to employ music to mark characters, reflect themes, or convey affect. But while diegetic withdrawal and a sparse music aesthetic may have rendered certain music functions more difficult, it simultaneously opened other options for filmmakers in this period. Two films in particular, *Liliom* and *The Big Trail*, deserve attention for their efforts to capitalize on advantages offered by a relatively small amount of music. As is the case with many films made from 1929 to 1931, neither film has received attention from film music scholars.

LILIOM AND THE SPARSE MUSIC AESTHETIC

A major advantage of sparse music is that those moments that *do* contain music become infused with a heightened level of significance. Richard Fall's relatively sparse score for *Liliom* helps articulate the enduring potential of true love, directs attention toward the film's use of movement as a metaphor for a character's purpose in life, and above all reflects love's potential to transcend the difficulties and banalities of physical reality—a central theme for Frank Borzage, the film's director.

Based on the 1909 play by Ferenc Molnár, *Liliom* tells a story that has since become more familiar to moviegoers through Fritz Lang's 1935 adaptation of the same play and especially through the Richard Rodgers and Oscar Hammerstein musical *Carousel* (1956). Liliom (Charles Farrell) is a carousel barker in Budapest whose life is going nowhere. He is handsome but uneducated and is known primarily for his womanizing lifestyle. Julie (Rose Hobart) is a simple working-class girl who falls in love with Liliom and is willing to sacrifice everything for him. Though the match seems an odd one, Liliom is struck by Julie's faith in him, and the couple marries. When Julie becomes pregnant, Liliom—crippled by fears that he cannot provide for his family—is induced by his friend "The Buzzard" (Lee Tracy) to commit robbery. The plan goes awry, and Liliom kills himself rather than allowing himself to be caught by the police. In the supernatural world the Chief Magistrate (H. B. Warner) offers Liliom a chance to return to earth ten years later and set things right with his family. Liliom returns and speaks with his daughter without introducing

himself, but he quickly loses his temper and slaps her. Incredibly, when his daughter describes to Julie how she was slapped in the face, this reminds Julie fondly of Liliom. Liliom's return to earth is thus ultimately a success, since it has reminded his wife of her happy memories of Liliom.

Musically, *Liliom* restricts its cues mainly to motifs that articulate the nature and strength of Liliom and Julie's love. Through this restriction the film suggests that the couple's love drives the narrative events and explains their behaviors and reactions. In accordance with the period's typical practice of diegetic withdrawal, the film first uses explicitly diegetic music to tie certain themes to the couple's love. For instance, when Liliom and Julie share an intimate moment on the carousel ride, carousel music plays while Liliom wraps his arms around Julie and leans her outward into space. Liliom then hops on the tiger that she is riding, and Liliom and Julie stare intently into each other's eyes. Through these intimate gestures the filmmakers suggest a link between Liliom and Julie's attraction for each other and the carousel music heard on the soundtrack. During these moments the filmmakers eliminate all other sounds of the fair other than the carousel music, which helps tie carousel music even more closely to the couple's love.

The filmmakers also use the first half of the film to tie diegetic Hungarian music to the love couple. The same night as the carousel ride, Liliom and Julie enter a beer garden and hear a jovial Hungarian song played by a small orchestra in the garden. This song consists of two sections that alternate repeatedly: a lively tune and a slower, more romantic, tune that Julie also sings at the beginning of the film (fig. 3.8). Though the alternation between such contrasting pieces may seem odd, the filmmakers were likely drawing on the *verbunkos* form of Hungarian folk music. Originating in the 1700s, verbunkos is a genre of music that alternates between slow and fast sections. Though originally used as recruitment music, verbunkos came to be viewed as the national dance.[40] Using such music serves two important functions: it lends the film a sense of authenticity while simultaneously using its contrasting themes to reflect the emotional roller coaster of elation and sadness that will characterize Liliom and Julie's relationship.

Having connected carousel and verbunkos music to the romantic couple, the second half of the film employs these motifs in an increasingly nondiegetic manner to demonstrate how the couple's love for each other influences subsequent events. The first drift toward nondiegetic

FIGURE 3.8 The beginning four measures of the couple's slow, gentle love theme in *Liliom*. The tune marks a strong contrast to the other, faster-paced *verbunkos* theme.

Transcribed by the author.

music occurs just after Liliom learns that Julie will have a baby. After exuberantly dashing through the streets announcing the news to everyone he knows, Liliom returns home only to hear Julie's Aunt Hulda (Lillian Elliott) inform him that he is a drunk and a deadbeat. In tears Liliom collapses on a couch located just under a large window that reveals the lights of the carnival. At this moment the filmmakers provide the same carousel music that was heard when Liliom and Julie shared their romantic ride on the carousel. Because of the image of the fair in the background, the music *could* be read as diegetic, but such a reading is undercut by the fact that prior nighttime scenes occurring beneath this same window contain no music.

By reusing this carousel music, the filmmakers articulate the factors and pressures that will determine the actions leading to Liliom's death. Although the music reminds the audience of Liliom's genuine love for Julie displayed on the ride, Liliom remains paralyzed by his inability to believe in himself as a family provider, an insecurity enhanced by Aunt Hulda's regular parade of insults. Like a carousel ride that travels around in circles and winds up in the same place, Liliom is "going nowhere in life"—an idea that he articulates later in a deathbed delirium. When Liliom collapses on the couch, the carousel music thus also reminds the audience of his belief that he lacks the ability to give his life direction and purpose. Not coincidentally, this scene segues directly into Liliom and The Buzzard planning the heist, an action that Liliom had earlier sworn he would not participate in. This change of heart does not take place on-screen; instead, the filmmakers rely on the music to explain that Liliom's love for Julie combined with his personal insecurities cause him to attempt to support his family by turning to crime.

If the carousel music helps explain why love drives Liliom to crime and suicide, the nondiegetic return of the Hungarian beer garden music during Liliom's deathbed scene articulates the love that endures between the couple even in the face of Liliom's colossal mistakes. During the death-

bed scene, Julie professes her love for Liliom, while he, in a delirium, bemoans his lack of ability as a provider. The soundtrack provides a slower, more somber version of the verbunkos music heard in the beer garden, music that has already been tied to the couple. Through the reiteration of this music, the film indicates that the couple's love constitutes a force that cannot be broken by extraordinary tragedy.

The film also uses the verbunkos theme during Liliom's deathbed scene to indicate that the couple's love plays a central role in the events that follow. It is precisely the strength of the couple's love that explains Liliom's desire to return from the spirit world to see his family one more time and accounts for Julie's fond memory of Liliom at the end of the film. Revealingly, the slower, romantic verbunkos tune plays again at the end of the film, when Liliom's rotten behavior toward his daughter nonetheless makes Julie think happily about him. During this final reiteration of verbunkos music, the Chief Magistrate of the spirit world comments, "Women like Julie are endlessly faithful. It's touching. It's mysterious." If there was any doubt that the lovers' theme is fundamentally tied to the fact that—as the opening intertitle states—"Julie's love endures for him always," the underscoring of the romantic verbunkos theme during the Chief Magistrate's comment cements the relationship.

In addition to conveying Liliom and Julie's enduring love, *Liliom*'s music also regularly coincides with the movement of two "rides": the carousel and the spirit train. By consistently deploying music during these instances of movement, the filmmakers posit movement as a central element of the film and direct the audience's attention toward its metaphoric significance. Visually and thematically, the spirit train offers a stark contrast to the carousel. Where the carousel's circular, aimless movement suggests Liliom's directionless, frivolous life, the train that enters the bedroom to take Liliom to the spirit world is directional and utilitarian, which indicates that the spirit world will finally provide Liliom with the guidance and purpose that he lacked in life. Appropriately, the spirit train arrives via the directionless roller coaster tracks of the carnival, as if to suggest that the spirit world will "straighten out" Liliom's aimless existence.

Every time the spirit train moves—from the roller coaster tracks to Liliom's deathbed room, from Liliom's deathbed to heaven, from heaven to hell, and from hell back to heaven—it is accompanied by music that underlines the fact that death has ironically infused Liliom's existence

with purpose and forward movement. Lest the audience doubt the use-fulness of these directional train trips, the music selected for the train helps eradicate any such thoughts. In contrast to the carousel's mechani-cal, tinny-sounding music and simple tune, the recurring train theme features clear and prominent brass, a series of quick downward flute runs, and dense string orchestration. In terms of recognized music con-ventions, the use of brass suggests regality and authority—in this case tied to heavenly judgment and to the angel Gabriel (Harvey Clark), whose trumpet will later summon Liliom out of the depths of hell and back to earth. The flutes, meanwhile, retain a heavenly aura due to their high pitch, while the downward rather than upward runs seem—like the brass—to convey a sense of authority or definitiveness. Music, then, not only highlights movement as a central metaphor but infuses it with par-ticular values as well.

Finally, *Liliom* also capitalizes on music's ephemeral, nonphysical quality to articulate a central theme found in many Borzage films: love's ability to transcend the limitations of physical reality.[41] All moments of unambiguously nondiegetic music—Liliom's deathbed scene, the travels of the spirit train, and the final conversation between Liliom and the Chief Magistrate—occur during scenes that are at least partly "super-natural." In one sense, reserving nondiegetic music for the spirit world helps convey a sense of separation between the mundane physical world—in which life for the central characters is very difficult—and the world of the heavens, a more philosophical place in which people take the oppor-tunity to reflect on the lives they have led.

This careful reservation of nondiegetic music also implicitly elevates the importance of the spirit world. In prior high-profile Borzage-directed films such as *7th Heaven* (May 1927) and *Street Angel* (April 1928), Borzage presents "love spaces" in the film that are cloistered from the outside world, and this cloistering enables the couple's love to transcend the dif-ficulties of physical existence.[42] From this perspective the problem with Liliom and Julie's relationship is that the lovers are *unsuccessful* at clois-tering themselves from the outside world. Once Liliom and Julie marry, a parade of characters constantly invades their home to either remind Liliom of his inadequacies or tempt him toward immorality and crime. Only in the spirit world can Liliom free himself from these influences. By rising above the mere physical world and living in their memories of each other, Liliom and Julie forge a relationship free from the real world's

formidable obstacles.[43] *Liliom*'s deployment of nondiegetic music only during scenes that transcend the physical world thus draws the audience's attention to this "love space" and heightens the sense of the supernatural world's importance to the couple's love.

Though music helps communicate several narrative and thematic ideas, it is largely absent *outside* of these functions. Through a sparse musical aesthetic, *Liliom*'s filmmakers isolate a few choice themes and elevate their significance by underscoring them with music. This is a far cry from the continuous music aesthetic of opera or silent film, which can use music to identify numerous characters, articulate a number of themes, and convey a wide range of emotions. *Liliom* sacrifices thematic range in favor of an aesthetic that precisely pinpoints only a few key ideas, thus marking those ideas as central features of the film.

Tying cues to narrative and thematic ideas was one approach for filmmakers employing a relatively sparse music aesthetic. In the same month, Fox would release another film featuring intermittent music, but this film would deploy music for vastly different purposes.

THE BIG TRAIL, MUSICAL SPARSENESS, AND MYTHMAKING

The Big Trail depicts an Oregon Trail expedition from the perspective of Breck Coleman (John Wayne), a young wagon scout who joins the expedition to avenge the death of his friend, and Ruth Cameron (Marguerite Churchill), a young woman who attempts to make the trek to Oregon without a husband. The story of the Oregon Trail would have been familiar to 1930 moviegoers, as prior silent films had treated the subject, including *The Covered Wagon* (1923).[44] Yet for technological and musical reasons, *The Big Trail* was an unusual film for 1930. It was one of the earliest sound films to use widescreen technology. Filmmakers shot each scene twice, once in the usual 35 mm format, and the other in Grandeur, a brand-new 70 mm widescreen format owned by Fox.[45] Though the Grandeur process was widely hyped, *The Big Trail* was exhibited in Grandeur in only a few venues: the *Variety* reviewer saw the film in Grandeur at the Roxy Theatre in New York City, and the film was screened in Grandeur at the Gaiety Theatre in New York City and an unnamed theater in Los Angeles.[46] Outside of these venues *The Big Trail* was released nationally in 35 mm.[47] Differences between the two versions do exist: the widescreen

version contains roughly fourteen extra minutes of footage, consisting mainly of additional dialogue scenes.[48] Still, in both versions the same music accompanies the same scenes. The analysis below focuses on the 35 mm version, since this was the version available throughout the United States.

If *The Big Trail*'s use of a widescreen format was unusual for 1930, so, too, was the amount of its nondiegetic music, which exceeded most 100 percent talkies from late 1929 to early 1931, musicals excluded. Though the film contains an occasional diegetic cue—such as dance music when the wagon caravan halts at night—by far the majority of music consists of orchestral selections, a decision surely resulting in part from efforts to elevate the film's prestige.[49] Counting the opening credits and a minute and a half of end music over a blank screen, nondiegetic music occupies just under 30 percent of the film's total running time.[50] This percentage was sparse when compared to early synchronized and part-talking films from previous years, but it constituted a fairly high percentage for 1930.[51] *The Big Trail*'s twenty music cues average approximately eighty-five seconds per cue, though the lengths are diverse, ranging from intertitle-only music that lasts ten seconds to a nearly five-minute music cue for an Indian attack.

Prior models do little to explain *The Big Trail*'s use of music. Though the music cues are—like much silent-era music—loosely synchronized to narrative events, they are sparse and do not feature the repeated themes that characterized silent and early sound era accompaniment. Nor does the film seem to draw heavily on other contemporary accompaniment strategies. The film includes a credit for "incidental music" to Fox music director Arthur Kay, which suggests that filmmakers may have conceived the music in terms of theater accompaniment, since the term originated in that sphere. Yet where theatrical melodrama tended to tie music to a character's emotional state or to the entrances and exits of important characters,[52] *The Big Trail* does not tie its music to these elements.

Instead, *The Big Trail*'s filmmakers appear to have used music for a rather unusual purpose: to help draw attention to the film's broader mythic moments rather than to narrative specifics. By "mythic," I mean a definition in line with cultural historian Richard Slotkin's understanding of the term: myths are stories that, through repeated retelling, ultimately function as a society's accepted explanation for its ideological contradictions. Often featuring stories pertaining to ostensibly formative

moments in a nation's past, myths offer the illusion of a unified national identity.[53] Drawing on a similar notion of myth, film music scholar Royal S. Brown has described mythic moments in cinema in which a character, object, or situation escapes from the time and space of the narrative to link with other characters, objects, or situations from other narratives.[54] In light of Slotkin's point that myths are *familiar* and *regularly retold*, one can extend Brown's claim: mythic moments occur when the *familiarity* of certain characters, narrative tropes, or ideas causes them to transcend the particulars of the specific narrative and connect with other, similar elements from different stories. *The Big Trail*'s score uses intermittent music to isolate those familiar, oft-told instances in the film, extract them from the particularities of the narrative, and imbue them with mythological significance. Music thus helps suggest that *The Big Trail* presents not just a narrative but the construction and celebration of national identity.

Perhaps the most central U.S. myth in the early twentieth century was the Myth of the Frontier, which Slotkin has traced extensively in a series of three books.[55] According to this myth—which derived partly from nineteenth-century colonial notions of Manifest Destiny—Europeans' ability to endure the harsh frontier, defeat the native inhabitants, and build a new society implicitly serves as a Darwinian justification for their right to colonize the West. By reproducing narratives of victory over physical hardships, the Myth of the Frontier suggested that Europeans rightfully belonged in the West, thereby justifying and smoothing a key ideological contradiction: that the expansion of the United States occurred via the extermination of the land's original inhabitants. The Myth of the Frontier ultimately provides the illusion that U.S. national identity is singular and wholly linked to the rugged living inherent in the colonization of the West.[56]

As Slotkin has demonstrated, the Myth of the Frontier was pervasive in early twentieth-century U.S. life.[57] For this reason *The Big Trail*'s Oregon Trail narrative—in which white settlers travel west, experience hardship on the frontier, and battle Indians—would have been understood by many audiences as a story central to the constitution of U.S. identity. Indeed, as the settlers face increasing hardship on the Oregon Trail, *The Big Trail* occasionally, if awkwardly, pauses to consider questions of national identity supposedly wrought through hardship and the vigorous U.S. spirit. Most prominently in *The Big Trail*, when the pioneers get stuck in a blizzard late in the film and want to turn back, Coleman

declares, "We can't turn back. We're blazing a trail that started in England. Not even the storms of the sea could turn back those first settlers . . . and they carried it on further. They blazed it on through the wilderness of Kentucky. Famine, hunger, not even massacres could stop them. And now we've picked up the trail again, and nothing can stop us! . . . We're building a nation, but we've got to suffer. No great trail was ever blazed without hardship." This speech demonstrates rather baldly that the experiences in *The Big Trail* serve as a testament to the strength and endurance of the American character writ large.[58]

Music constitutes a subtler act of mythmaking in the film. To understand how this works, however, it is important to recognize that the score largely avoids attending to the film's narrative trajectory. *The Big Trail* features two central stories: a "revenge" narrative in which Coleman tries to get even with the men who killed his friend, and a love story in which Coleman tries to woo Ruth on the voyage. The revenge narrative goes through many changes, including Coleman's gradual discovery of which men are responsible for his friend's murder, his survival of two murder attempts, and his eventual "frontier justice" killing of Red Flack. Aside from the first murder attempt, however, the crucial moments in the revenge narrative receive no music. Likewise, Coleman's relationship with Ruth features a number of plot reversals: Coleman's kindness toward Ruth causes her to feel fondly toward him, then a misunderstanding causes her to hate him, then another Coleman kindness makes her like him again, and so on. Yet only the (rare) moments of tenderness between the couple receive music. The filmmakers display little interest in using the music to track the couple's on again/off again relationship.

Instead, music is generally saved for rugged experiences on the Oregon Trail that had entered the history books as foundational moments of U.S. character building. Orchestral cues connoting tension—often through the use of chromatic runs and repeated sforzando chords—play during a buffalo hunt, a dangerous river crossing, an equally dangerous cliff descent in which the wagons and cattle are lowered by rope, a trek across the dry desert, and an Indian attack. Audiences would have understood these events as formative experiences in the West—indeed, the buffalo hunt and Indian attack had already been made into myth as staples of Buffalo Bill's Wild West show (1883–1913). By associating these moments with nondiegetic music, the filmmakers draw particular attention to the perseverance of the European settlers and the magnitude of their diffi-

culties. The very nature of nondiegetic music helps mythologize the set-tlers' struggles. Like mythic moments, which transcend the particulars of the narrative, nondiegetic music's lack of a source also causes it seem-ingly to float in an alternative sphere from the diegesis. Nondiegetic mu-sic can encourage the audience to view these scenes as "oft-told myths" abstracted from *The Big Trail*'s narrative.

One piece of music is repeated in a manner that at first seems tied to the particularities of the narrative. What might be termed the "love theme"—a soaring, string-heavy legato—occurs at three different times during the film (fig. 3.9). It plays twice when Coleman tells Ruth that he will leave the settlers for an extended period and once, at the end of the film, when Coleman and Ruth permanently reunite after a long separa-tion. Yet while the deployment of the same cue may seem to be based on the Coleman-Ruth narrative, this music can also be tied to the idea of successful procreation by the European settlers as an important mythic component. If fighting off Indians and surviving the elements constitute two aspects of U.S. vigor, the fruitful multiplying of the species in an unfamiliar land further attests to the rigorous American spirit. Reveal-ingly, other scenes of settlement and nurture also receive music. Soft music plays during a nursing montage in which a human infant nurses at its mother's breast, followed by shots of a young horse and a number of pigs also nursing. Music is also heard near the end of the film during shots of the settlers building their new homes in the valley. Coleman and Ruth's romance, it would seem, is given music not primarily as an effort to track their relationship but rather as a way to transform into myth a key element of U.S. frontier narratives: the successful settlement of, and reproduction in, an unfamiliar environment.

If the application of music to specific scenes helps with the process of mythmaking, music's tendency to end conclusively on a full cadence or half cadence also aids this process (a "cadence" refers to a melodic or

FIGURE 3.9 The first eight bars of the "love theme" from *The Big Trail*. This theme plays at three different points, including the couple's reunion at the end of the film.
Transcribed by the author.

harmonic resolution in the music). Unlike the beginnings of music cues, which tend to start very quietly in the middle of a musical phrase, *The Big Trail*'s music generally concludes at the end of the scene by stopping on a note that offers a clear, conventionally "natural" finish to the song. For instance, after Coleman tells Ruth how much he loves scouting, he says good-bye to her and departs just as the accompanying "lovers' theme" concludes with a definitive cadence. Such a tactic would soon become anathema during the Golden Age of film music, which historians generally claim started around 1935. During this Golden Age, composers commonly delayed musical resolution in order to bind together disparate shots and scenes.[59] *The Big Trail*'s conclusive cadences, in contrast, often make the film seem fragmentary or episodic rather than unified. But from the perspective of mythmaking and the creation of a national epic, *The Big Trail*'s use of cadences serves a purpose. The regular presence of cadences helps convey the sense that *The Big Trail* contains an epic series of self-contained, mythic scenarios that operate outside of any cause-and-effect chain of events. Unlike Golden Era film music, which is used to smooth together and unify the inherently fragmentary shots that constitute a film, *The Big Trail* seems to *exploit* fragmentation to assist in the construction and affirmation of mythic American episodes.

Music was thus an important component in *The Big Trail*'s epic presentation of episodes of American heroism and national character. One might also note that *The Big Trail*'s use of a rare widescreen format would have further contributed to the film's epic presentation. Publicity surrounding this unusual widescreen process and the increased screen size of Grandeur would have enhanced the sense that the film provided a large-scale recreation of foundational U.S. episodes. Ultimately, *The Big Trail* offers an early instance of how music, film content, and technology could combine to provide a sound film experience so "big" that its spectacle could exceed the particularities of the story.

CODA: *CIMARRON* AND *CITY LIGHTS*

Thus far, the numerous filmic examples in this chapter have, with rare exceptions, received no attention from film music scholars. This final section switches gears by briefly examining two high-profile films released in January of 1931—*Cimarron* and *City Lights*—that *have* received

substantial scholarly analysis. Thanks to the preceding filmic examples, we can now reassess the historical importance of both films.

According to accounts provided by a number of film music scholars, the most influential film score from the mid-1929 to mid-1931 period was Max Steiner's score for RKO's *Cimarron*. For instance, in her influential book *Settling the Score*, film music historian Kathryn Kalinak points to the lack of diegetic motivation for the music heard during the film's final shot: "There is no diegetic justification for the orchestral music which swells the soundtrack transcending the film's diegetic boundary and spilling over into the final credits." Though Kalinak acknowledges that *Cimarron* was not the first film to use music to violate "the industry's priority on diegetic realism in a dramatic context," she contends that *Cimarron* was important because the industry recognized that the film's music departed from the "accepted norm." To demonstrate this, Kalinak draws on the following Steiner quotation: "The picture [*Cimarron*] opened. The next morning, the papers came out and reported that the picture was excellent. And what about the music—it was said that it was the greatest music that ever was written. Their [the producers'] faces dropped, and I got a raise of fifty dollars."[60] Kalinak claims that though Steiner's remark regarding press attention "is a bit hyperbolic," the *Los Angeles Times, Los Angeles Evening Express*, and *Hollywood Reporter* did indeed mention the music.[61] According to Kalinak, thanks to *Cimarron*, "Hollywood now had yet another practice for the musical accompaniment to sound films, distinguished by a selective use of nondiegetic music for dramatic emphasis."[62]

In quoting Kalinak extensively here, I do not mean to level criticism on *Settling the Score* as a whole or on Kalinak personally. With its focus directed primarily toward films made during the Golden Age, there is little reason to expect *Settling the Score* to provide a detailed account of early sound film music practices, and the book remains an invaluable source for those wishing to understand film music in the Golden Age. Still, the historical record needs correcting here, since in light of the numerous films analyzed in this chapter, it is difficult to sustain the claim that *Cimarron* was a major player in early sound film music. Selective nondiegetic music occurred in many films prior to *Cimarron*, including major releases like *The Wild Party, Alibi, Liliom*, and *The Big Trail*. *Cimarron*'s amount of music is also not exceptional. When compared to the numerous examples in this chapter, *Cimarron* is perhaps more striking for its *lack* of music than

for its use of it. In contrast to *The Big Trail*, *Cimarron*'s major set piece—the Oklahoma land rush—features no music. The only musical cues are the opening credits music; diegetic piano music in an Osage bar; plausibly diegetic organ grinder music on an Osage street; two diegetic orchestral music passages during Sabra's (Irene Dunne) luncheon late in the film;[63] and a nondiegetic music cue, timed with the unveiling of a statue, that begins twenty seconds before the end of the film.

Not only is music remarkably sparse in the film, but it also is not generally used in ways that deviate from fairly common practice in the period. I have demonstrated that from 1929 to 1931, opening credits regularly contained music, that diegetic music commonly helped establish a setting, and that diegetic music also sometimes served as underscoring. *Cimarron*'s final cue, as Kalinak points out, precedes the final fade to black and thus violates diegetic realism, but this closing music "violation" was in fact quite conventional in the period. Moreover, this final song is a rendition of one of the same tunes heard in the opening credits, which was yet another common practice. When situated within Hollywood film music practices from 1929 to 1931, *Cimarron*'s use of music appears fairly ordinary.

If there is anything unusual about *Cimarron*'s score, it is not the score's challenge to diegetic realism but the length and precise timings of the opening title music. This music lasts two minutes and forty seconds, and its length is due to the fact that in addition to regular title cards, *Cimarron* also features a person-by-person introduction of the main and numerous supporting characters as well as two intertitles that provide background for the Oklahoma land rush that opens the film. During this opening Steiner provides three themes, two of which are strongly linked to screen images. After a minor-key tune featuring tom-tom-like beats and open fifths to denote Native Americans, the music shifts to a rousing march.[64] Marches conventionally evoke heroism and triumph, and this tune plays through the introduction of Yancey (Richard Dix), the character who embodies the restless spirit of westward expansion. Immediately upon the introduction of Sabra, the soundtrack shifts to a completely different tune and instrumentation: a slower, stately, melodic string piece (fig. 3.10). By changing music at this precise moment, the filmmakers implicitly connect this theme with Sabra. Strings conventionally denote emotion, and their coincidence with the first appearance of a woman helps suggest that the film will explore the role that femininity and a civilized mentality played in settling the West. Then, when the

FIGURE 3.10 Sabra's stately, melodic tune in *Cimarron*, timed precisely with her character's introduction in the opening credits.
Transcribed by the author.

first of two title cards that introduce the Oklahoma land rush appears, the music switches back to the march, thus cementing the association between this tune and westward expansion. A luncheon scene late in the film reaffirms the deliberateness of this timing. When Sabra suddenly remembers her long-absent husband, the ostensibly diegetic music switches to Sabra's opening credits theme, and the camera frames her in a solitary one-shot. Clearly, the filmmakers intend the song to be linked to Sabra's psychology.

Though mildly unusual, the presence of a few precisely timed themes would not have been seen as especially daring in the period. Filmmakers regularly tinkered with music in various ways from 1929 to 1931, and when situated historically, Steiner's experimentation is rather slight. It should also be noted that while certain publications may have mentioned the score, neither *Variety* nor the *New York Times*—two of the period's movie review sources that featured the most knowledgeable reviewers—make any mention of *Cimarron*'s music in their reviews. In terms of technique *Cimarron*'s score did not constitute a major contribution to film music, nor did it open up a new musical practice.

Unlike *Cimarron*, *City Lights* has not been credited with introducing an important new film scoring practice. Yet while *City Lights* failed to have an impact on subsequent production practices, it remains notable for its unusual conglomeration of innovations and throwbacks to earlier practice.

The continuous score for *City Lights*—which was composed by Charlie Chaplin, arranged by Arthur Johnson, and overseen by a young Alfred Newman as the music director—draws on many tactics from silent and early synchronized filmmaking, including the conventional tactics of "catching" specific actions with music and using popular songs as "kidding." During the scene in which the Tramp (Chaplin) and the Eccentric Millionaire (Harry Myers) first meet, the orchestra catches the Tramp's walk down the stairs, his tip of the hat to the Millionaire, his dusting off of the bench, the numerous times in which a rock falls to the ground, the various exclamations of the Tramp and Millionaire, and repeated falls

into water. The orchestra also provides a moment of kidding by playing the "Way Down upon the Suwannee River" section from the old favorite "Old Folks at Home" after the Tramp falls into the river, followed shortly by "How Dry I Am." Other moments also feature precise synchronization, such as the scene where the Tramp swallows a whistle and then makes whistling sounds whenever he hiccups.[65]

The film's use of musical counterpoint and the music's unsettling conclusion at the end of the film were more innovative. Recalling his general approach to music, Chaplin wrote, "I wanted the music to be a counterpoint of grace and charm" to the Tramp character.[66] This effort is perhaps most effective during the boxing match. The Tramp's efforts during the match are anything but noble: he is willing to use any underhanded tactic to keep from getting hit, including hiding behind the referee, repeatedly hugging his opponent, and prematurely pulling the bell to end the round. Yet during the Tramp's pathetic maneuvers, the orchestra provides a light, birdlike flute solo with background string accompaniment, which imbues the Tramp's tactics with a measure of dignity and even grace.

If Chaplin's approach to the boxing match functions as a musical counterpoint to the image, his music for the famous final shot of the film matches the unresolved nature of the ending. Rather than finishing the film with the usual conclusive tonic chord (a tonic chord is a "home" chord that in Western music conventionally conveys closure), the filmmakers provide music that fails to achieve resolution as the image fades to black. Furthermore, the final note in the film keeps the audience unsettled since it is in a somber, tense minor key. The ambiguity and lack of narrative resolution in the film's final image has been much discussed among film scholars, but it should be noted that the score, as well as the image, articulates the film's open-endedness.

City Lights was an instant and unequivocal commercial and critical success. One of the most profitable films of 1931, it was named the best film of the year by the National Board of Review and one of the year's ten best films by the *New York Times*.[67] Chaplin had hoped that his film would cause "silent" filmmaking to return as a minority practice.[68] This hope was not realized. Outside of Paramount's *Tabu* (March 1931)—a film set in the South Seas and shot without directly recorded sound—no major studio released films without dialogue in the next few years.

As this chapter's examples demonstrate, films from 1929 to 1931 displayed an enormous array of options when it came to the use of nondi-

egetic music. Avoiding such music entirely was certainly an option, but many other films experimented with the amount of nondiegetic music used in the film and the degree to which recorded film music could be considered nondiegetic. From continuous scores to intermittent music, from plausibly diegetic to outright nondiegetic music, and for purposes ranging from narrative functions to mythmaking, films from 1928 to 1931 featured a diverse range of methods for deploying the score. For a full understanding of the early film score, the 1928 to 1931 period must be recognized for its numerous instances of musical experimentation rather than simply for its musical impoverishment.

4. INTERLUDE

The Hollywood Musical, 1929–1932

FROM 1929 TO 1932 SOME OF THE MOST INNOVATIVE APPROACHES to the film score came not from dramatic films but from musicals. Yet if the early sound score has been marginalized in academic scholarship, early scores for musicals have been even more neglected. In countless academic studies of the film score and its history, the musical is understood to be a special case and outside the scope of the study.[1] The few scholars to touch on this topic have made claims that are often brief, generalized, unsupported by specific examples, or simply inaccurate. One scholar writes that the early sound musical "used recorded musical cues for the main title and end credits, but only source music (the actors' performances) otherwise."[2] In other words, outside of credit sequences, musicals featured only diegetic music. Yet no evidence is offered to support such an assertion, nor is the claim expounded upon in any way.

Even studies focusing exclusively on the film musical seldom attend to the genre's use of nondiegetic music. In a rare exception to this tendency Rick Altman's *The American Film Musical* devotes substantial attention to what Altman terms the "audio dissolve"—a passage from diegetic sound to nondiegetic orchestration that often occurs when a scene moves from narrative to number.[3] But the book's focus on the musical's

narrative structure and generic functions precludes a broader historical consideration of the genre's use of nondiegetic music. Other books on the musical devote even less attention to nondiegetic music. In *Lullabies of Hollywood*, an examination of American popular songs in the Hollywood musical, Richard Fehr and Frederick G. Vogel limit their discussion of early background scoring to dramatic films, despite the fact that some early musicals featured this practice as well. In *Hollywood Rhapsody* Gary Marmorstein studies Hollywood songwriters and their music, yet he, too, neglects to consider the use of these songs as background music. Richard Barrios's *A Song in the Dark*, an extensive and valuable study of the early film musical, makes only a few quick references to background scoring, at one point stating that an absence of background music "became the rule in some musical comedies."[4] Yet Barrios does not explore the logic that dictated when background music was used or avoided.

Basic questions pertaining to the score in the film musical thus remain unanswered. During the early sound era, did the musical face the same pressure to diegetically justify much of its music as nonmusicals did? What prior representational practices impacted the musical's use of nondiegetic music? Did the musical's decline in popularity that occurred in the 1930–31 season cause the remaining musicals to present music in different ways? This chapter demonstrates that musicals often *did* feature more nondiegetic music than nonmusical films, that the competing practice of musical theater and the use of presentational aesthetics played major roles in the use of nondiegetic music, and that the decline of the musical encouraged the genre to feature salient, commentative, and even experimental scores. Contrary to received wisdom, the early film musical played a key role in opening up the possibilities of nondiegetic music in the early sound era.

Owing to the diversity of musical techniques in the period, this chapter contains a series of short case studies rather than a lengthy analysis of a musical that "exemplifies" period practices. After considering questions of genre, I examine two 1929 musicals with original screenplays—*The Broadway Melody* (February 1929) and *Sunny Side Up* (October 1929)—that contain largely diegetic music. I then examine how three other films that were more heavily influenced by musical theater—*The Cocoanuts* (May 1929), *The Love Parade* (November 1929), and *Golden Dawn* (June 1930)—featured increasingly nondiegetic music. I conclude by examining the innovative scores of three Paramount musicals that

postdate the decline of the musical: *One Hour with You* (February 1932), *Love Me Tonight* (August 1932), and *The Big Broadcast* (October 1932). Taken together, these case studies demonstrate how competing representational practices impacted the musical strategies of the early film musical.

DEFINING THE MUSICAL

Defining the early film musical constitutes an especially complex issue because the musical was not generally recognized as a genre during its first heyday in 1929 and 1930. Analyzing rhetoric in *Photoplay* magazines from the period, Altman reports, "During the early years of sound in Hollywood, we . . . find the term 'musical' always used as an adjective modifying such diverse nouns as comedy, romance, melodrama, entertainment, attraction, dialogue and revue. . . . Ironically, use of the term 'musical' as a freestanding label designating a specific genre was not broadly accepted until the 1930–31 season, when the public's taste for musicals took a nosedive."[5] Altman's claim could be taken to suggest that to analyze the "film musical" in 1929 and 1930 would be to retrospectively investigate a category that had little relevance for filmmakers during 1929 and 1930.

Although the musical may not have cohered as a unified genre, however, contemporary trade journal articles indicate that the industry was aware early on that something new was afoot. In 1929 and 1930 a wide array of films had at least one musical number, but commentators still recognized the existence of a certain type of film featuring frequent song-and-dance numbers. A *Variety* article from January of 1929 titled "18 Musical Talkers Lined Up, Costing $9,000,000 with No Musical Yet Done for Guide" is worth quoting at length, as it illustrates the nature of the industry's awareness of this new type of film:

> Scheduled for talking picture production during the coming year are approximately 18 musical comedies, two originals and about 16 based on Broadway hits, which will cost from $350,000 to $750,000 to produce each, without one musical in picture form having yet been seen. . . .
>
> Differences between stage and film musicals are too great and too numerous to bear listing. One of the great difficulties is in cast-

ing. There are less than 10 film stars or featured players suitable for
musicals. Less than 10 with any previous musical comedy success
on the stage. . . .

Warner Bros. may have had some success in production of "The
Desert Song," shortly to be exhibited, that experience probably de-
termining the plans of First National-Vitaphone, which will call for
the production of five or six musical comedies next season.

Fox, first announcing the "Fox Movietone Follies" as an original
musical to be produced in films, was followed by others.

FBO will produce "Rio Rita" and one or two more musicals in
addition, from reports. Warner Bros. will probably have one or two
additional musicals in production shortly; MGM is to produce an
original musical with William Haines and Karl Dane. . . .

Tiffany-Stahl will produce a musical with Belle Bennett and,
pending the reception of "Lucky Boy" plans are under way for an-
other musical with George Jessel.

Paramount, in addition to "Cocoanuts," with the Marx Bros., is
reported angling for the rights to another musical. Universal will
have "Show Boat."[6]

Throughout the article the unnamed author oscillates between three
terms: *musical comedy, musical,* and *original musical.* The author's selec-
tion of these terms reveals an assumption that this new cycle was de-
fined by its considerable debt to musical theater. In 1929 a "musical com-
edy" was a recognized designation for jazzy 1920s *stage* musicals with
thin plots and plenty of dancing. The author ties the terms *musical com-
edy* and *musical* exclusively to films adapted from musical theater produc-
tions (*The Desert Song* [April 1929], *Rio Rita* [September 1929], and *The
Cocoanuts*), whereas a film not directly adapted from a stage production,
like *Fox Movietone Follies of 1929* (May 1929), needs the qualification "*orig-
inal* musical." This nomenclature, along with the author's stage-to-screen
discussion in the first two quoted paragraphs, indicates that this new
cycle was at least initially comprehended in terms of its musical theater
antecedents.

Recognition of a new cycle—in spite of terminological inconsistency—
would continue through 1930. In June of 1930, for instance, an unnamed
Variety writer attempted to grapple with the terminological difficulties of
this new form:

Confusion is arising somewhat in the picture trade over the confus-
ing terms of musicals and operettas on the screen. Both are linked
as one by many of the film people. Into this same joined classifica-
tion is often thrown revues. Each is different.

A musical in the show sense is more the musical comedy. The
operetta is usually looked upon as a No. 3 grand opera, a couple of
degrees under light opera. While a revue is a revue, always and al-
ways a disguised vaudeville show.[7]

Once again, despite generic confusion, evidence indicates that the indus-
try viewed this new cycle largely in terms of such theatrical antecedents
as musical comedies, operettas, and revues. This debt to theatrical ante-
cedents constitutes the central definition of the "musical" in this chapter.
By *musical*, I refer to a film whose format reveals clear theatrical influ-
ences. A musical could include an original screenplay featuring regular
song-and-dance numbers or a filmic adaptation of a stage musical. Thus,
while this generic term may be somewhat anachronistic, it nevertheless
represents a group of films that the industry recognized as constituting a
distinctive new filmmaking trend.

ORIGINAL MUSICALS, 1929–1930

In 1929 and 1930, musicals featuring original screenplays nearly always
contained little or no nondiegetic music. Such was the case with *The
Broadway Melody* and *Sunny Side Up*, two of Hollywood's first major mu-
sical successes.[8] *The Broadway Melody*'s narrative features a love triangle
between song-and-dance man Eddie (played by Broadway leading man
Charles King) and sisters Hank (Bessie Love) and Queenie (Anita Page).
Eddie brings the sisters to Broadway to sing and dance to a song he has
written called "The Broadway Melody." Though Eddie has been in love
with Hank for a long time, he is smitten with Queenie the first time he
lays eyes on her. He composes "You Were Meant for Me" for Queenie.
Although Queenie seems interested in Eddie, she is loath to abandon her
sister by becoming romantically involved. Hank, however, eventually
catches wind of the couple's love. In a remarkable display of self-sacrifice
she pretends that she never loved Eddie and travels westward to continue
her small-time vaudeville career, thus freeing Eddie and Queenie to
marry. The two above-mentioned songs, along with "The Wedding of the

Painted Doll," helped make a name for the film's songwriters, Nacio Herb Brown and Arthur Freed.

The Broadway Melody is well known for popularizing the playback method for musical numbers, a technique in which the music is recorded prior to, rather than simultaneous with, the image recording.[9] The advantages were considerable: not only could playback help liberate the camera and actors, but it also meant greater control over the sound record, since songs could be recorded in near-perfect conditions.[10] Despite this innovation, however, the film was heavily influenced by the period's preference for diegetic music cues. This interest in diegetic sound becomes apparent in the first scene, which depicts songwriters at a Tin Pan Alley music publishing company composing and practicing their melodies. The camera repeatedly cuts in and out of practice rooms. The resulting sound captures only what can be heard from each specific camera position. Because of the absence of background sound to smooth the cuts between shots, the sound transitions from one room to the next are rather jarring.[11] This treatment of sound is impossible to produce on the stage, since an audience member can receive sounds only from a single spatial position: his or her seat in the theater. Early on, then, *The Broadway Melody* announces its intent not to mimic theatrical sound practices but to showcase various diegetic sounds that can be heard thanks to the nascent sound film medium.

Throughout the rest of the film, music will usually have a clear source in the diegesis. This includes music that both accompanies vocal performances and reprises tunes underneath dialogue. Musical instruments are clearly visible during Eddie's first rendition of "The Broadway Melody" in the music publisher's office, while many other vocal numbers are performed on a diegetic theater stage and thus imply the presence of a pit orchestra. During dialogue sections containing music, orchestras are often conveniently present in the diegesis and "happen" to play a narratively appropriate theme. On Broadway, pit orchestras sometimes replayed previously performed songs during subsequent moments in the narrative. *The Broadway Melody* modifies this technique by finding a diegetic pretext for the theme's presence, thus suiting Hollywood's increasing tendency toward diegetic music.

Only during a few of the song performances does the music venture into what might be considered nondiegetic territory. However, calling music accompanying song performances "nondiegetic" is a tricky proposition

in the musical genre because singers and dancers seem to "hear" the music, and perform to it, even if the music has no obvious source in the image. In such instances the music is probably best thought of as "metadiegetic," a term outlined by film music theorist Claudia Gorbman that refers to music imagined by a character in the film.[12]

In *The Broadway Melody* only song performances are permitted to feature music without an apparent image source, and in these situations the filmmakers take notable steps to suggest a link between music and character thoughts. Early in the film, Eddie sings "The Broadway Melody" to Hank and Queenie in an apartment. Despite the lack of instruments present in the apartment, an orchestra accompanies Eddie as he sings the song, and then it accompanies all three characters as they dance. The accompanying music is metadiegetic because the characters are "hearing" it and dancing to it, but the film suggests a metadiegetic reading in other ways as well. Because the characters hope to perform the song together on a Broadway stage—and are acting out an imaginary Broadway performance—the music could represent how the characters imagine the pit orchestra will sound. The scene also suggests a metadiegetic reading by having music with a peppy tempo coincide with the characters' elated expressions. For instance, when Eddie performs "The Broadway Melody," the camera provides several close-ups of Hank and Queenie listening to Eddie's singing with rapturous expressions. Then the three characters impulsively begin an energetic dance, perhaps because, in their ecstasy, they are imagining the music heard on the soundtrack.

A similar situation obtains in an apartment scene later in the film, where Eddie professes his love for Queenie by singing "You Were Meant for Me." Queenie appears to nearly swoon during the song, suggesting that—despite her reluctance to hurt Hank by becoming involved with Eddie—she shares Eddie's feelings. Again, while the music is certainly metadiegetic because Eddie "hears" it as he sings, the romantic nature of the music and the shared emotions of the characters further suggest the music's connection to character psychology. The music can be understood as a representation of what *both* lovers hear in their state of mutual affection. Furthering this reading, the orchestral music stops abruptly in midphrase when Hank enters the room, as if Hank's presence yanks the shared melody from both of their heads. In sum, even during moments when the music accompanying song performances lacks a clear image source, *The Broadway Melody* takes steps to tie this music to characters'

thoughts and imaginings. This enables the music to retain a link to the diegesis, a general concern for filmmakers from 1929 to 1931.

Sunny Side Up, another "original musical," also adheres to the period's tendency to tie much of its music to obvious diegetic sources. The film's original screenplay, combined with the presence of two famous *film* actors—Janet Gaynor and Charles Farrell—likely suggested to the filmmakers that they use a distinctly "filmic" approach to music, which in late 1929 meant a largely diegetic music aesthetic.

Sunny Side Up depicts a love story between Molly (Gaynor), who lives in a working-class New York City neighborhood, and the wealthy Jack (Farrell). The couple meets when Jack, distraught over his girlfriend Jane's (Sharon Lynn) disinterest in him, drives aimlessly into Molly's neighborhood. After seeing Molly successfully perform "Sunny Side Up" at the neighborhood block party, he invites Molly to sing at an upcoming charity ball in Southampton. Though Molly loves Jack, Jack simply hopes that his affectionate gestures toward Molly will make Jane jealous. The plan works: Jane agrees to marry Jack. Molly, heartbroken and subject to a false Southampton rumor that she is having an affair with Jack, flees back to her New York City neighborhood. Only when Jack finally realizes and repeatedly professes his love for Molly does the couple unite. Throughout the film Jack, Molly, and Molly's friends Bea (Marjorie White) and Eddie (Frank Richardson) sing songs written directly for the film by famed Tin Pan Alley songwriters Buddy DeSylva, Lew Brown, and Ray Henderson.

Like *The Broadway Melody*, *Sunny Side Up* signals strong interest in diegetic realism in its opening moments. In a tour de force shot lasting two minutes and forty seconds, the camera tracks and cranes through a New York City block, showing typical summertime activities like boys playing baseball on the street near a sprinkler, various family happenings in several apartment units, and a young couple walking hand in hand down the street. As with the beginning of *The Broadway Melody*, sound functions as the "ears" of the camera, presenting only those sounds that can be heard from the camera's vantage point as it roams through the block. Like the opening to *The Broadway Melody*, which "collects" the everyday sounds of an office of ambitious songwriters, *Sunny Side Up* immediately foregrounds its concern with *diegetic* sound collection.

Throughout the rest of the film, *Sunny Side Up* continues this concern by either using explicitly diegetic music or venturing toward nondiegetic

music in subtle ways. Most song performances involve the characters ei-
ther playing their own instruments or making gestures or comments that
indicate the presence of a pit orchestra. During the rare moments when
music accompanying singing moves away from strict diegetic realism, it
does so covertly via an audio dissolve. Early on, Molly sits in her apartment
strumming her Autoharp and singing, "I'm a Dreamer (Aren't We All?)."
Though only the harp is initially heard, instruments from a small orches-
tra sneak into the underscoring. *Sunny Side Up* also uses diegetic with-
drawal: when Molly reprises the same song much later in the film, nondi-
egetic strings accompany her almost from the song's very first note. The
film's other audio dissolve—Jack's reprise of "If I Had a Talking Picture of
You"—also fits squarely within period practices by segueing directly to end-
title music, an acceptable use of nondiegetic music in the period.

The rare moments of potentially nondiegetic dialogue underscoring
also fit within period tendencies by containing at least a faint diegetic
motivation and occurring only during moments of heightened emotion.
For instance, Molly learns backstage at the charity ball that Jack will
marry Jane and that the entire audience believes that Molly is having an
affair with Jack. Distraught over Jack's decision and her knowledge that
the audience believes that she is merely a gold digger, Molly exclaims,
"I'll go back where I belong! I'll go back where people aren't so evil
minded!" During this dialogue-laden sequence, instrumental reprises of
"Sunny Side Up," "I'm a Dreamer (Aren't We All?)," and "If I Had a Talk-
ing Picture of You" express Molly's anguish over losing both the man she
loves and her optimistic outlook on life. Each instrumental reprise is
used because its lyrics match the narrative situation. For instance, "I'm a
Dreamer" indicates Molly's realization that blending in with the upper
class was nothing but a dream. The song's lyrics resonate with the issue
of class disparity by asserting, "I'm the same as you, and you, and you"
before concluding "I'm a fool" for having untenable dreams. Though the
musical selections are unrealistically convenient for the narrative, the fact
that this music occurs backstage during a variety show suggests at least
the faint possibility that even this music emerges from the diegesis. Even
if music during this sequence is read as exclusively nondiegetic, it still
fits within period practices because the filmmakers reserve it for a par-
ticularly emotional sequence.

Given *Sunny Side Up*'s general penchant for diegetic realism, it is some-
what surprising that Molly sometimes looks directly at the camera—and,

implicitly, the nondiegetic film audience—when she performs her numbers. During her first "I'm a Dreamer" rendition, the filmmakers shoot the first verse and chorus in a medium shot on Molly as she looks at the camera, and then the second chorus corresponds with a medium close-up. The effect is to draw the audience closer to a shared, private experience with Molly that seemingly exists outside of diegetic strictures, an effect heightened by the increasingly prominent nondiegetic underscore. The same effect occurs during Molly's "Sunny Side Up" number at the block party. Though the first verse and chorus appear to be directed toward the diegetic block party audience—Molly's eyes tend to focus directly below and to either side of the camera, which is positioned slightly above the audience—Molly sings the second chorus straight into the camera lens.

Molly's direct addresses constitute curious choices for a film that generally favors diegetic absorption, but they do fit within a mildly reflexive theme of the film. "If I Had a Talking Picture of You," a song about wishing to have a personal talking portrait of an absent loved one, plays during the opening and closing credits, as well as being performed twice in the film itself. At one point Jack gazes longingly at Molly's photograph, only to witness Molly's image startlingly come to life and sing a few lines from "(You've Got Me) Picking Petals Off o' Daisies." Molly's direct addresses, then, constitute another "talking picture" technique: she is framed like a portrait photograph and talks/sings to the viewer. All of these examples reflect on the medium itself, which is an early "talking picture" and features two prominent silent film stars talking in their picture for the first time.

Despite such reflexivity, however, the narrative tempers the presentational nature of Molly's direct addresses in one crucial respect. All of Molly's direct addresses occur when others are present: she performs "I'm a Dreamer" for her friend Bea and "Sunny Side Up" for the block party audience. Ostensibly, then, Molly *could* be addressing a character within the diegesis in these scenes, even if the eyeline match is not precise. Revealingly, when Molly performs "I'm a Dreamer" late in the film with no one else in the room, she looks away from the camera the entire time. Direct addresses to a nondiegetic audience in *Sunny Side Up* are substantially limited, a tendency in keeping with the film's predominantly diegetic aesthetic.

The Broadway Melody and *Sunny Side Up* were not the only early original musicals featuring mainly diegetic music. Warner Bros.' *Say It with Songs* (August 1929), despite clearly attempting to capitalize on the success

of the nondiegetic music-laden *The Singing Fool* (September 1928), tends to favor plausibly diegetic music. Many other original musicals, including RKO's *The Vagabond Lover* (November 1929), James Cruze Inc.'s *The Great Gabbo* (September 1929), MGM's *They Learned About Women* (January 1930), United Artists' *Be Yourself!* (February 1930), Paramount's *Applause* (October 1929), Cliff Broughton Pictures' *Rogue of the Rio Grande* (October 1930), and Paramount's *Morocco* (November 1930) contain *exclusively* diegetic music.[13] In hindsight it is tempting to deride such films for a poverty of imagination. But it is perhaps more useful to recognize that these filmmakers simply displayed a *different* imagination of what a musical film was. In 1929 and 1930 these musicals would have seemed to be at the cutting edge of film music practices. Rather than reiterating late silent era music's obliviousness to diegetic logic, filmmakers used a score that adhered to the period's newfound attention to diegetic sound. Moreover, by downplaying the presence of theatrical influences, filmmakers posited the musical film as a new, modern entertainment rather than as a throwback to the musical comedies and theater operettas of the previous thirty years. Ironically, however, it was precisely these older influences that would enable the film score to move in more innovative directions.

STAGESTRUCK MUSICALS, 1929–1930

Though *The Broadway Melody* and *Sunny Side Up* were high-profile successes, most early Hollywood musicals were either adaptations of well-known theater musicals or were overtly molded by the stage. In 1929, film revues enjoyed brief popularity. Such films were clearly guided by theater revues, featuring such elements as a stage, theater curtains, an intermission, orchestra pit musicians, direct addresses, and bows to the camera/audience. Warner Bros.' *The Show of Shows* (November 1929) reveals a further debt to the stage by alternating between full stage numbers and performances "in one" (meaning an act performed in front of a drawn curtain that covers most of the stage). On the stage, performances "in one" enabled theater personnel to prepare for the next full stage number, but such a technique is tactically meaningless in a film, which can simply record full stage numbers at various times and edit them together. The fact that *The Show of Shows* maintains this practice demonstrates just how closely revues attempted to mimic theater practices.

Theatrical adaptations constituted a logical choice for filmmakers in the late 1920s. As I demonstrated in chapter 1, stage musicals in the early to mid 1920s were extremely popular, and they constituted a dominant source for song hits. For the film industry, which had itself capitalized on popular songs during the late silent era, adapting stage properties or drawing on the practices of musical theater offered an opportunity to continue to plug songs. Starting in early 1929, Hollywood scoured Broadway for talent and properties.[14] One Hollywood tactic was for film producers to financially back a theatrical musical comedy in exchange for the film rights.[15] Hollywood frequently discarded the majority of a theatrical score and wrote new songs for the film version, but the industry retained the musical-number format as a means to plug songs. Hollywood's talent raid of the stage and sudden escalation of Broadway adaptations soon caused Broadway to reduce its number of plays.[16] By the end of 1929, Broadway was experiencing a severe economic downturn, caused by the Depression and the fact that audiences could now see Broadway film adaptations at a fraction of what it cost to see a theatrical production.[17]

Many adaptations were set in places and times far removed from modern American life, and this seems to have encouraged the more prevalent use of nondiegetic music. Musicals set in resort towns (*The Cocoanuts*, *Monte Carlo* [August 1930]), foreign countries (*Golden Dawn*, *The Lottery Bride* [November 1930]), or fictitious places (*The Love Parade*) all featured varying doses of nondiegetic music. Altman calls such musicals "fairy-tale musicals," a subgenre that responds to the audience's desire to be somewhere else by depicting unrealistic, fairy-tale spaces.[18] This aura of being somewhere else extended to the film score, whose nondiegetic nature helped convey a space detached from reality.

More important for the evolution of the film score, however, was the fact that when filmmakers adapted musical theater productions or drew heavily on the form, they tended to adopt its musical strategies as well. In musical theater, accompanying or incidental music typically emanates exclusively from the orchestra pit, a location conventionally understood to be *beyond* or *outside of* the diegesis. Such a practice flew directly in the face of early sound film practices, in which filmmakers typically eased toward ambiguous or nondiegetic terrain via diegetic withdrawal. Though diegetic realism often won out in original musicals, adaptations more commonly minimized or entirely jettisoned efforts to tie music to the diegesis. Frequent adaptations of stage musicals thus constitute a key reason

for the development of nondiegetic music in the early sound period. The following three musicals illustrate the ways in which theatrical precedents could encourage the expanded use of nondiegetic music.

The Cocoanuts and Presentational Aesthetics

On the surface *The Cocoanuts*—which was the Marx Brothers' first film and was adapted from their eponymous 1925 stage success—seems to adhere to the period's tendency to provide diegetic justification for its music. Instrumental music occurs in three types of situations: as underscoring to vocal performances, during Harpo and Chico's harp and piano solos, and as disengaged background music at a party toward the end of the film. All three instances can at least superficially be read diegetically. Scenes featuring the first type contain an occasional orchestra in the background; Harpo and Chico's instruments are imaged and foregrounded; and the presence of music at a party is at least plausible, even though the orchestra never appears onscreen.

Within this faint diegetic cover, however, *The Cocoanuts* begins pushing the score in directions uncharted in *The Broadway Melody* by employing a more presentational aesthetic. By "presentational aesthetics" I refer to a mode of address in which the film acknowledges that nondiegetic spectators are its targeted receivers. In the case of the musical, this often means that the film lays bare its desire to entertain.[19] Whereas *The Broadway Melody* conveys little overt awareness of the film audience, *The Cocoanuts* targets the audience more directly with its score. For instance, after the opening credits *The Cocoanuts* introduces its Florida setting by featuring various shots of people on the beach while a small, initially unseen orchestra is heard playing Irving Berlin's "Florida by the Sea." After several such shots, the image briefly reveals an unobtrusive conductor and small orchestra buried in the top left corner of the frame apparently providing music to couples that waltz nearby. This orchestra makes for an unconvincing music source, however, since "Florida by the Sea" is not a waltz and the conductor's motions clearly do not match the song's tempo. A second vocal number—"When My Dreams Come True"—similarly contains a halfhearted effort to tie image source to music: this orchestra, too, appears very briefly, is buried in the background, and seems to provide music for waltzing couples rather than the narrative performer. In both cases the filmmakers display little interest in tying mu-

sic to onscreen sources. Instead, the music seems to be channeled from the filmmakers directly to the film audience.

Some of the film's nonmusical elements also seem geared toward entertaining an unseen movie audience. Shortly after "Florida by the Sea," for instance, female bellhops perform a choreographed dance in the hotel lobby for no visible diegetic entity. Owing to the emptiness of the lobby, the dance makes sense only as a performance put on for the film audience's benefit. Later in the film, the filmmakers anticipate Busby Berkeley by four years by filming a dance number from directly above the dancers, generating a kaleidoscopic effect that can be appreciated only by the film audience, not the diegetic spectators who watch the dance.

The performance style of the Marx Brothers demanded this presentational approach.[20] The Marx Brothers had cut their teeth in vaudeville, which, as film scholar Henry Jenkins notes, thrived on overtly acknowledging the audience.[21] In vaudeville theaters performers regularly sought to provoke an immediate response in the audience, and they often did so by moving close to and interacting with the audience. A central goal of the vaudevillian performer was to establish a direct bond or sense of intimacy between performer and audience. The Marx Brothers carried this style into musical theater and then into *The Cocoanuts*. Groucho and Harpo's humor is especially reliant on periodic winks at, and shared inside jokes with, the audience. Groucho's interactions with dim-bulb Chico, for instance, gain much of their humor through Groucho's pained looks at the audience, looks that seem to say, "Can you believe I have to suffer this fool?" Harpo, meanwhile, regularly throws glances at the audience when his physical antics befuddle and frustrate a figure of dignity or authority, as if asking the audience to share in his delight over the irritation he causes.

Given the Marx Brothers' audience-based performance style, it would have made little sense for the filmmakers to bother with full diegetic justification for every music cue. A gag at the party in which Harpo steals Detective Hennessey's (Basil Ruysdael) shirt indicates why diegetic music is an irrelevant goal. Despite being the Marx Brothers' main adversary for much of the film, Hennessey's repeated pleas of "I want my shirt!" lead to an unexpected moment in which Hennessey and the Marx Brothers team up to sing the comical "I Want My Shirt" to the tune of the Habanera and Toreador songs from Georges Bizet's *Carmen*, complete with unseen orchestral accompaniment. Ostensibly, the music accompanying the singing could be emerging from an orchestra hired for the

party, but the entire song performance by its very nature makes no diegetic sense and baldly exists to entertain the film audience. The moment is pure Marx Brothers: it is an assault on a cherished piece of music with humor that relies on the abandonment of any sense of diegetic realism. The logic undergirding the Marx Brothers' humor—which derived from vaudeville—practically demanded that the music would drift away from clear diegetic sources.

Animal Crackers (August 1930)—the Marx Brothers' follow-up film and another generally faithful adaptation of their stage hit[22]—contains an even more overtly presentational style. Groucho aims several of his lines directly at the audience ("There are children present," "Could I look at a program for a minute?" "Well, all the jokes can't be good"), and he steps forward to speak directly to the camera when parodying Eugene O'Neill's stage play *Strange Interlude* (1928). Unlike the bellhops in *The Cocoanuts*, who face away from the camera, *Animal Crackers* features performers who face the camera directly, most notably during "Hooray for Captain Spaulding / Hello I Must Be Going." Consistent with this salient presentational style, the film makes no effort to even vaguely justify the presence of accompaniment music: unlike in *The Cocoanuts*, an orchestra is never visible in the image. "Hooray for Captain Spaulding / Hello I Must Be Going," for instance, takes place in the mansion of Mrs. Rittenhouse (Margaret Dumont). While an orchestra could conceivably be present in such a space, no effort is made to provide one in the image or even suggest its presence. The more the Marx Brothers violate the fourth wall and remind the audience that their film is a manufactured product produced for the audience's benefit, the more the musical accompaniment also abandons any pretense of existing within a hermetically sealed world.

The Love Parade and the Assertive Score

Though the Marx Brothers' presentational aesthetic encouraged a less stringent adherence to diegetic music, their scores remained sparse, accompanying vocal performances and occasionally providing background music. *The Love Parade*, directed by Ernst Lubitsch, also features direct addresses, clear indicators of theatricality, and nondiegetic music. But its nondiegetic music is more copious, more attentive to narrative concerns, and more assertive. By "assertive" music, I mean music that is noticeable and seems to provide an independent commentary on screen events.

The Love Parade tells the story of Renard (Maurice Chevalier), an emissary in Paris who must return to his home country—the fictional Sylvania—because of his scandalous affairs with married women of Paris. Queen Louise (Jeanette MacDonald), the ruler of Sylvania, sees Renard as the solution to her dual desires: to have a dream lover and to be married. The couple marries, but the queen's powerful position and refusal to relinquish her attitude of royal superiority nearly cause the marriage to fail. Only when Louise is willing to allow Renard to "take command . . . not only in the affairs of state . . . but also here at home," as Louise puts it, is the couple's relationship saved.

Though *The Love Parade* was adapted from a play called *The Prince Consort*, the musical's setting in an imaginary kingdom and the presence of adultery and copious champagne reveal the film's clear debt to Viennese operetta. American audiences would have been familiar with this stage form. Its popularity had been cemented in the United States as early as Franz Lehár's *The Merry Widow* (1907), and at least two major operettas—*The Desert Song* and *Rio Rita*—had already been released as sound films prior to *The Love Parade*.[23] *The Love Parade*'s personnel were steeped in the practices of the theater and would have understood the musical conventions of this form. Lubitsch had begun as a performer in vaudeville comedy and later had been an actor in Max Reinhardt's Deutsche Theater.[24] Victor Schertzinger, who composed the music for the songs, had written songs for stage musicals and was an experienced violinist, symphony conductor, silent film director, and film composer.[25] Chevalier and MacDonald had appeared in stage musicals.[26]

Lest audience members not recognize these connections to musical theater, *The Love Parade* immediately provides indications of its theatrical influence and demonstrates that its content is aimed directly at audience members for their enjoyment. After the opening credits, the film introduces Paris via an unorthodox shot featuring champagne bottles in the foreground while in the background scantily clad chorus girls dance on a theater stage as the song "Champagne" plays. Such an image references musical theater while simultaneously suggesting a presentational aesthetic: the chorus girls' stage dance seems aimed at the camera, while the shot's collage format depicts a fanciful space that has been blatantly constructed by agents external to the film.

Renard's introduction shortly thereafter reaffirms that the film clearly targets the audience. The audience hears arguing in French behind

closed doors. A door opens, Renard walks out, and in the middle of this argument he looks directly at the camera/film audience, exclaiming in English, "She's terribly jealous!" The woman enters the room and the fight escalates, only to be disrupted by different voices behind the closed door. Renard turns to the audience once more to explain: "Her husband!" In a manner similar to a vaudeville performer, Renard openly solicits the audience's vicarious participation in the scene. *The Love Parade* thus implicitly lessens any need to diegetically justify its music by frankly acknowledging that its artifice exists solely to delight the nondiegetic audience and by having Renard even switch languages so as to be comprehensible to U.S. audiences. If a character can step outside the diegesis to further the audience's pleasure, surely music can do the same.

The connection between theatricality, presentational aesthetics, and nondiegetic music becomes even clearer when Renard concludes the opening sequence by performing "Paris, Stay the Same" accompanied by music without an image source (fig. 4.1). Renard sings on his balcony overlooking the Paris cityscape while several women in nearby balconies listen to his performance. Because we see Renard from the front, the balcony seems to become his "stage," and the camera matches the location of an "audience," an interpretation bolstered by Renard's own direct addresses earlier in the scene, as well as Chevalier's career as a music hall performer. Film scholar Jane Feuer comes to a similar conclusion: "The world is transformed into a music hall, the balcony into a stage."[27] Such a shooting style helps nullify potential questions pertaining to the music's source. The shot composition demonstrates that the film—like a music hall performance—strives to directly entertain an audience and that its music should be accepted in the same manner.

Having carefully established both a theatrical and presentational aesthetic, *The Love Parade*'s score proceeds to both adhere to traditional practices and combine various approaches in innovative ways. In some respects music in *The Love Parade* functions much as in the theater. Like stage musicals, music without a source in the image accompanies singing, and some of *The Love Parade*'s songs recur—most frequently "Champagne" and "Dream Lover"—instrumentally later in the film to reflect attitudes expressed in the song lyrics. Like theatrical melodrama, nondiegetic music occasionally underlines a moment of intense emotion in nonmusical scenes. For instance, during the film's first scene, an angry

FIGURE 4.1 Renard performs "Paris Please Stay the Same" in *The Love Parade*. As he performs, one can easily imagine him addressing a music hall audience.

husband approaches Renard with a gun, and a tense, diegetically unmotivated *misterioso* passage plays on the soundtrack.

But *The Love Parade* is no mere transplant of theater music conventions onto film. Other representational practices vie for prominence. Where the previous year's *Broadway Melody* and *Sunny Side Up* had only occasionally used excerpts of previously performed songs as motifs, *The Love Parade* moves closer to silent film practices by using themes quite frequently. The filmmakers also take advantage of sound film's synchronicity by forging close connections between images and musical themes, even during scenes featuring no musical numbers. The score thus becomes more assertive, overtly revealing the thought processes of major characters and imposing value judgments on the events that occur.

The scene in which Renard and Louise first meet demonstrates this move toward an assertive score. In the previous scene Louise sang "Dream Lover," a waltz with lyrics depicting her dream that she fall in love with a romantic man. Then, just before Renard enters, Louise's advisers

express their pessimism that she will ever find the right man to marry. After Louise distractedly greets Renard, she sits at her desk and absent-mindedly lights her cigarette while a nondiegetic instrumental rendition of "Champagne" plays on the soundtrack. This version of "Champagne" is slow, painfully dissonant, and features muted and tinny brass. Brass often signifies royalty, and "Champagne" by this point has already been associated with the gaieties of Paris. By deforming "Champagne" via tinny brass and chromatic notes, the film suggests that Louise bemoans the fact that her royal position prevents her from experiencing a life of flirtation and adventure.

In the same shot, Louise suddenly looks up at Renard, and the score features a consonant, louder, faster, and more forceful rendition of "Dream Lover." The close-range shot of Louise enables the score to communicate a specific idea: the queen sees Renard as a potential solution to her marriage dilemma. After brief dialogue a medium close-up depicts Louise continuing to think, and the score again provides "Dream Lover," this time played briskly on the strings with added syncopation ("syncopation" refers to accented notes on normally unstressed beats). The breezy, syncopated rendition conveys a light, frolicking mood and suggests the possibility of romance. The shift from brass to strings—conventionally a more "emotional" set of instruments—indicates the queen's belief that she has found a man who can be both a royal figure and her own private "dream lover." Louise then picks up the file on Renard's scandalous affairs, and a close-up of the file coincides with a shift to a light, string rendition of "Champagne." As Louise reads the document, the soundtrack includes a few brass guffaws to suggest that she privately delights in Renard's escapades. Several brass guffaws also occur during shots of the grinning Renard, indicating shared internal laughter between the couple.

By using one-shots (shots with only one character in the frame) to force the audience to focus on a specific character, by moving the camera closer to Louise's face to register her expressions, and by using tunes with known lyrics, the filmmakers convey Louise's thought process precisely. Though silent films also deployed musical themes, the synchronicity between *The Love Parade*'s themes and the film's individual shots would have exceeded the abilities of silent film musicians who—owing in large part to a weekly turnover of films—generally had to settle for scene-by-scene matches rather than shot-by-shot matches. Moreover, the music—though probably not the dominant element for most audience

members—becomes more noticeable than most early sound films through its close synchronization with specific shots.

In one sense such music can be considered metadiegetic, as it conveys Louise's thought process precisely. Ironically, however, this precise reflection of a character's thoughts simultaneously enables the music to step back and lightly chastise Louise. After Louise puts down Renard's file, the music continues to mimic her thought process in a manner that strips the queen of her dignified exterior. Despite enjoying Renard's file, Louise sternly rises from her desk to a dramatic rendition of "Champagne." Her quick trip to the back room to powder her nose, however, reaffirms her delight with the story. As soon as she enters her private quarters, not only does she smile, but the music also returns to a frolicking rendition of "Champagne." Louise's trip back to her (public) office causes the tune to shift back to a serious tone. Through music and the use of close-range one-shots of Louise, the filmmakers emphasize the contrast between her public and private life and poke fun at her facade.

The Love Parade's score thus periodically expresses a particular attitude toward narrative events even as it conveys a character's thoughts. More than virtually any other sound film to this point, the score's close synchronization to specific shots implies the presence of a nondiegetic commentator or author. Such musical commentary keeps the film lighthearted in tone, but it also serves narrative purposes. By helping to foreground Louise's performative behavior, the score foreshadows the reason for the near failure of the marriage. Louise's continued efforts to "perform" as queen will render Renard useless and impotent; only "natural" behavior—which in *The Love Parade* means allowing Renard to take control of Louise's public and private life—can save the marriage. Thanks to an implied external narrator, music coaxes the audience into accepting the film's solution to Louise and Renard's marital woes.

The presence of an implied external narrator in *The Love Parade* closely matches what film music theorist Jerrold Levinson describes as "additive" or "nonnarrative" music produced by an implied filmmaker. In an important article, Levinson theorizes how viewers assign narrative responsibility for a film's nondiegetic music. For Levinson, the audience implicitly differentiates between two sources for such music: a cinematic narrator, who uses music to convey only story information, and an implied filmmaker, who uses music to provide independent authorial commentary. Music that conveys character psychology or foreshadows an

upcoming narrative event would thus qualify as "narrative music" provided by the cinematic narrator, while ironic or satirical music constitutes additive music produced by the implied filmmaker. *The Love Parade*'s music in scenes like Louise and Renard's meeting exemplifies additive music in two key respects: it provides something *beyond* or *in addition to* narrative information (what Levinson refers to as "surplus value"), and it seems to be produced by a distinct *personality*.[28]

Even as *The Love Parade* demonstrates Levinson's notion of additive music, however, it simultaneously complicates his theory. In scenes like Louise and Renard's meeting, *The Love Parade* indicates that additive music can emerge precisely *from* its narrative functions. Though Levinson acknowledges that music cues can serve narrative and additive functions simultaneously, he remains determined to classify music as predominantly narrative or additive.[29] During Renard and Louise's meeting, however, *The Love Parade*'s score seems equally an explication of character thoughts *and* a playful ridicule of such thoughts, with both functions serving key roles in the viewer's comprehension of and attitude toward the narrative. This intertwining of narrative and additive functions would remain an important tactic in early 1930s musicals.

Golden Dawn and Total Musical Immersion

If *The Love Parade* opts for a witty, commentative approach to film scoring, *Golden Dawn*—released seven months later—moves in an entirely different direction. Despite being produced in an era supposedly adverse to nondiegetic music, *Golden Dawn* features a continuous, mostly nondiegetic, score. Though such an approach may seem retrograde in 1930, the decision likely stemmed from the confluence of several competing identities, particularly musical theater, phonography, sound film, and silent film. *Golden Dawn*'s musical strategy, though not long-lived, helps illustrate the variety of ways in which representational conflicts could impact musicals in the early sound era.

Golden Dawn was a faithful adaptation of the eponymous 1927 stage musical, which featured book and lyrics by Otto Harbach and Oscar Hammerstein II, and music by Emmerich Kálmán and Herbert Stothart. The stage version received much publicity for inaugurating Hammerstein's Theatre in New York City, a theater erected in memory of the well-known Oscar Hammerstein I.[30] Though critics acknowledged the play's

lackluster plot, its music received considerable praise, and the production was a financial success.[31] Based on the film version, it seems clear that the play's music was what primarily appealed to Warner Bros. In most adaptations of the period, Hollywood discarded the bulk of the original stage score and wrote new tunes. Earlier in the year, for instance, Warner Bros.' adaptation of *Sally* (December 1929)—easily one of the most popular stage musicals of the entire 1920s—retained only two songs from the stage musical. The film version of *Golden Dawn*, however, contained vocal performances of six songs from the stage production.[32] The filmmakers used the stage version's music in the underscoring as well. This included not only instrumental reprises of all the vocally performed songs but also numerous sections from the rest of the score, including the stage production's opening music. As Warner Bros. music director Louis Silvers explained in a studio memo regarding the bulk of the underscoring, "All we did was to re-arrange [Kálmán and Stothart's] melodies in different spots."[33]

If Warner Bros.' appreciation for the stage music prompted the use of continuous music, the sound-on-disc technology's affinities with phonography would have further encouraged this choice. By 1930, Warner Bros. was the only studio using a sound-on-disc process. Though the studio's heavy financial investment in the technology surely played a role, Warner Bros. also apparently believed that sound on disc presented music at a higher sound quality than sound on film. Partly for this reason, film scholar Jennifer Fleeger argues that Warner Bros. envisioned its recorded sound largely in terms of phonograph records.[34] This conception of sound on disc would have further encouraged *Golden Dawn*'s filmmakers to feature extensive music.

Warner Bros.' successful efforts at substantial rerecording—which dated at least as far back as *The Singing Fool*—would have also made continuous music a viable option. Archival records demonstrate that only *Golden Dawn*'s vocal numbers were directly recorded; the rest of the incidental music was recorded in postproduction and mixed via rerecording.[35] When so much music can be recorded after the image track is produced, continuous music becomes far easier. Thanks to rerecording, a studio orchestra (1) can try multiple times to properly synchronize music to dialogue and (2) knows precisely what will appear onscreen at what point, since the entire performance has already been filmed. Moreover, the filmmakers know that (3) once they get it right, it will always be right

for every film screening (provided that the disc in the movie theater does not get out of synchronization). Armed with an effective rerecording process that had featured a near continuous score for the previous year's *The Squall* (May 1929), Warner Bros. would have been particularly well equipped for continuous music.

Finally, the fairly recent use of continuous music in silent and early synchronized scores also may have swayed filmmakers toward a continuous score. *Golden Dawn*'s musical motifs, in particular, have much in common with these prior practices. Vocal numbers such as "The Whip Song," "Dawn," "We Two," "Little Girl, Little Girl (Mooda's Appeal)," "Here in the Dark," and "You Know the Type: A Tiger" all recur as incidental music to reflect characters and situations associated with the initial performance of each song. During the film's climactic scene the score features rapid fragments of numerous previously performed songs, thus creating tension and underlining the fact that the final scene addresses the conflicts faced by many of the film's major characters.

If successful, *Golden Dawn* might have helped define the film musical as a genre centrally involved with immersing its audience in continuous music. But *Golden Dawn* received poor reviews and failed at the box office.[36] Musically, the filmmakers' greatest mistake may have been the deployment of nondiegetic music without the slightest textual acknowledgment of the film's theatrical source. Unlike films featuring Chevalier or the Marx Brothers, *Golden Dawn* seems to earnestly believe its own story. This likely caused a problem for narrative plausibility, since the film's story of a pale white woman who is widely believed to be black stretches credibility. Musically, because the film contains no sly winks at the camera to remind the audience of the film's artifice, the nondiegetic score would have surely seemed out of place. Nor does *Golden Dawn*'s location seem stagelike: outside of the numbers, much of the footage—though shot in Technicolor—could almost pass as an on-location ethnographic film shot in Africa. Deploying continuous nondiegetic music in such circumstances utterly violated 1930 expectations regarding film music, and it was a tactic that would not be repeated in subsequent early sound musicals.

Other Stagestruck Musicals

Many other early "stagestruck" musicals also made ample use of nondiegetic music. Warner Bros.' *Sally*, based on the phenomenally successful

1920 stage musical and starring Broadway sensation Marilyn Miller, featured substantial nondiegetic music. The same studio's follow-up, *Sunny* (November 1930), also based on a Miller stage musical hit and again starring Miller, features an even more extensive nondiegetic score, especially for scenes of romance and comedy. The operetta-inspired *Monte Carlo*—Lubitsch's follow-up to *The Love Parade*—contains previously performed songs as nondiegetic underscoring. Though United Artists' *The Lottery Bride* was an original musical, it contained numerous indicators of its theatrical influences, including a score written by major operetta songwriter Rudolf Friml and the use of stylized sets and two-dimensional backdrops.[37] It is thus not surprising that *The Lottery Bride* makes extensive use of nondiegetic music.

Warner Bros.' Al Jolson vehicle *Big Boy* (September 1930), which was based on Jolson's eponymous 1925 stage hit and features ample nondiegetic music, concludes with a particularly prominent and unorthodox reference to theatricality. *Big Boy*'s narrative focuses on the black jockey Gus (played by Jolson in blackface), who rides the horse Big Boy to victory in the Kentucky Derby. In the bizarre final scene that follows his Derby win, Gus is invited to the grandstand to give a victory speech. He says, "Listen folks, if you'll just give me a minute, I'll explain to you all how it happened." As Gus turns away from the microphone and camera and covers his face, the image dissolves to Jolson—in a suit and tie and no longer in blackface—turned away from the camera and covering his face. Jolson turns toward the camera and begins speaking into the microphone. The image cuts to a full shot of Jolson and then slowly tracks backward to reveal a stage set done exactly like the grandstand, with a painted canvas now used to represent spectators in the background. The camera tracks further backward to reveal a pit orchestra and a packed theater. The scene ends with Jolson's reprise of "Tomorrow Is Another Day," accompanied by the visible pit orchestra.

Warner Bros. apparently included the scene "to make the film acceptable to white southern exhibitors" who may have objected to a "black" man making jokes at the expense of whites.[38] From the perspective of the early film score, however, this scene's overt theatricality helps justify the inclusion of extensive nondiegetic music throughout the film. Every element in this final scene—the stage set, painted backdrop, pit orchestra, theater audience, even the reprise of a previously performed number—screams musical theater, a form that nearly always includes a nondiegetic

pit orchestra. The pit orchestra's underscoring of Jolson's last rendition of "Tomorrow Is Another Day" further indicates that theater conventions justify the film's copious nondiegetic music. Of all the early sound musicals, *Big Boy* contains perhaps the most overt reference to stage musical aesthetics.

THE DECLINE OF THE MUSICAL, 1931–1932

The enormous number of musicals produced in the early sound era proved to be the genre's undoing. During the 1930–31 season, musicals took an extraordinary and unexpected nosedive at the box office. Responding to the musical's sudden lack of success, all major studios announced a substantial reduction in their musical output for the 1930–31 season. Studios called off many planned musical productions or removed songs from films previously planned as musicals.[39] One prominent casualty was United Artists' *Reaching for the Moon* (December 1930): the studio reduced five Irving Berlin songs to one to make the film a nonmusical.[40] Studios also began substantially reducing their musical staff. In November of 1930, for instance, MGM eliminated its music department and placed Martin Broones, the music department head, in charge of synchronization instead. Songwriters who were not fired were moved to other departments. For instance, Arthur Freed—composer of the songs for the enormously successful *Broadway Melody*—was moved to the scenario-writing department.[41] Ironically, as musicals declined in popularity, they finally became a widely recognized generic category.[42]

The sudden failure of musicals unsettled fundamental assumptions about the type of entertainment that sound film provided. During the musical's brief heyday, film constituted *the* locus of contemporary popular songwriting. The phonograph industry had collapsed, and Broadway had greatly reduced its number of stage musicals, leaving film and radio as the central song-plugging venues. In June of 1930 Robert Crawford, the "executive in charge of all musical activities at Warner Bros. and First National," stated that more than 90 percent of America's creative music now came from Hollywood.[43] Thanks to tie-ins with the sheet music and recording industries, song plugging constituted an important way to turn a profit. The film industry was thus reluctant to give up on music entirely, but the box-office failure of musicals signaled that new approaches for popular songs were needed.

The pages of *Variety* and *Film Daily* reveal a fair amount of industry uncertainty over how to proceed. Paramount's latest Marx Brothers film, *Monkey Business* (September 1931), for instance, was designed so that music could be easily removed if such sequences did not seem to be "clicking" with audiences.[44] On the whole, however, the industry viewed the musical's decline as a temporary, fixable problem, and they identified two likely causes for its downward spiral. The first involved sheer quantity: musicals had oversaturated the market and thus driven audiences away. Second, musicals had failed, industry leaders believed, because musical numbers had been inserted too abruptly and awkwardly into the existing narrative.[45] With so many songwriters coming from a song-plugging background—whether Tin Pan Alley, Broadway, or both—songwriters had underestimated the importance of narrative cohesion in the musical.[46]

As filmmakers made tentative efforts to revise the techniques of the musical, many attempted to make music more integral to the story.[47] One possible way to accomplish this was to allow music performances to *recede* into the narrative. Such a strategy occurs in United Artists' *Indiscreet* (April 1931), which featured music and a screenplay by DeSylva, Brown, and Henderson, the songwriting team from *Sunny Side Up*. Where *Sunny Side Up* had featured several songs as part of a variety show—thus halting the narrative—*Indiscreet* reduced its number of songs to a mere two and used the songs to *further* the narrative.[48] The film's climactic revelation occurs because Gerry (Gloria Swanson) sings "Come to Me," a song that signals to her sister, Joan (Barbara Kent), that Gerry needs to be rescued. Hurrying to Gerry's room, Joan discovers Gerry embracing Joan's fiancé, Jim (Monroe Owsley): Gerry has set this situation up to prove that Joan's fiancé should not be trusted. Joan's discovery of Jim's philandering ways, then, is *caused* by the performance of a song and fuels the events that follow. Moreover, Gerry's performance seems not to be an attraction existing outside the narrative but simply the action of a woman desperate to save her sister from a dishonest man.

Efforts at making music recede into the narrative were not generally successful, however. *Indiscreet* was a box-office disappointment and constituted the final collaboration of DeSylva, Brown, and Henderson.[49] The films receiving the most critical attention and commercial success during the lean years of the musical came instead from Paramount. *One Hour with You*, *Love Me Tonight*, and *The Big Broadcast* all reveal an increased

interest in connecting music and narrative. This connection served to *increase* music's saliency and expand its narrational role.

Ironically, all three films expanded the score's possibilities by drawing more heavily on past conventions, particularly silent film accompaniment. Not only did the films make prominent use of musical themes, but they also drew on the practices of the nickelodeon era, including catching the falls and kidding. These practices had persisted in silent film comedy and animated sound shorts. By 1930, cartoons commonly featured a match between punctual, rhythmic musical notes and image actions like footsteps, upward/downward movement, and falls. Such a technique would come to be called "mickey-mousing" because of its prevalence in Disney's Mickey Mouse cartoons, but the technique occurred in many other early cartoons as well.[50] As the next chapter demonstrates, by late 1932 cartoon music impacted nonmusical films as well as musicals.

Filmmakers of the musical during its lean years did not draw merely on older styles, however. Paramount's musical scores audaciously tried new approaches combined with efforts to incorporate older, more successful, and often more salient tactics. The result was an often brazen rejection of diegetic music and a use of film music that sometimes distanced the audience from known reality. Thus rather than featuring overdetermined solutions, musicals—spurred by the genre's economic downturn—exhibited striking representational clashes in an effort to find a new musical style that would succeed with audiences.

One Hour with You and the Escalation of Assertive Music

Seemingly fearless of the musical's nosedive at the box office, Lubitsch directed two well-received musicals in 1931 and 1932: *The Smiling Lieutenant* (July 1931) and *One Hour with You* (February 1932). Though both films feature a substantial amount of nondiegetic music, the latter film's score was considerably more daring. If *The Love Parade*'s score occasionally suggested the presence of an external narrator commenting on the film, *One Hour with You* escalates the sense of such a presence, resulting in a score that sometimes plays a prominent narrational role.

A remake of Lubitsch's own silent film *The Marriage Circle* (1925), *One Hour with You* contrasts the happily married André (Maurice Chevalier)

and Colette (Jeanette MacDonald) with the unhappily married Mitzi (Genevieve Tobin) and Professor Olivier (Roland Young). "Wedding Ring," sung by André and Colette early in the film, and "Sweethearts," sung only by Colette about André, epitomize the couple's joyous marriage. Mitzi—Colette's old friend—sets her sights on André by feigning illness and requesting that André (a doctor) visit her bedside, thus prompting their duet "Three Times a Day." Though André successfully resists Mitzi's first advance, at a subsequent dinner party he is less successful. Seeing that he has been seated next to Mitzi, André switches her place card with another woman named Martel (Josephine Dunn). Colette, witnessing this, wrongly assumes that André is having an affair with Martel. Partly in frustration over his wife's lack of trust, André has a one-night affair with Mitzi. Colette, meanwhile, inadvertently kisses Adolph (Charlie Ruggles), a man who has long lusted after Colette. As a result of the evening's adventures, Mitzi and Professor Olivier divorce. Though the infidelities nearly break up André and Colette's marriage as well, the couple ultimately agrees to trade one infidelity for another and continue their marriage (the fact that André's infidelity was of far greater magnitude than Colette's remains unacknowledged).

As in his previous films, Chevalier directly addresses the camera. This time, however, his addresses are more frequent: he acknowledges the camera at six different points. At the end of the film Chevalier *and* MacDonald address the camera. Chevalier is often overt about the fact that he is addressing a movie audience. He opens his first address with, "Ladies and gentlemen, I must talk to you," and he poses questions directly to the audience throughout the film. Chevalier's regular camera addresses help justify the film's copious use of nondiegetic music, but they also serve to partially distance the audience from the film's narrative. By repeatedly acknowledging the camera—and by extension the artifice of filmmaking itself—the film periodically reminds audiences that they are witnessing a constructed product. Indeed, the situation resonates with vaudeville, which routinely favored direct addresses.

But distancing the audience is a tricky proposition in a mainstream entertainment like *One Hour with You,* for the film requires audience investment. Without some level of empathy for the characters, an audience would likely become indifferent to the plot's many twists and turns. This was a concern of early sound comedy more broadly, as the period's vaudeville aesthetics—which privileged a close and direct bond between

performer and audience—threatened narrative absorption.[51] To toe the line between absorbing and distancing the audience, *One Hour with You* makes heavier use of a technique found sporadically in Lubitsch's *The Love Parade*: the assertive use of musical themes in conjunction with specific shots.

During the place-card-switching scene, for instance, excerpts of previously performed songs initially draw the audience closer to André's thought process. As he considers whether to switch the place cards or allow himself to sit next to Mitzi, the nondiegetic music alternates between instrumental versions of the André/Colette love song "Wedding Ring" and the André/Mitzi duet "Three Times a Day." The songs' lyrics reflect that both women are competing for André's attention. In "Wedding Ring" Colette assured André, "You have a date for every night your whole life through," while Mitzi, in "Three Times a Day," sang to André, "I'd not complain if you were near me three times a day." Here the reiteration of these tunes gives the audience privileged access to André's psychology: he is oscillating between remaining faithful to Colette and allowing Mitzi to seduce him.

After André switches the place cards, an unexpected medium long shot of Colette reveals that she has observed André's actions from the doorway. The misunderstanding that ensues gains its humor precisely because the music helps erect a degree of *distance* between Colette and the viewer. A stinger chord timed precisely with the beginning of this shot indicates Colette's emotional jolt. As Colette walks angrily toward André, the film presents an instrumental version of "Sweethearts," a song sung earlier by Colette about her love for André. To match her anger at what she believes is André's infidelity, this version of "Sweethearts" features short sforzando chords on several of the offbeats. This match between Colette's mood and the score only reinforces the magnitude of her misguided reaction: she believes André is having an affair with Martel. Thanks to a hierarchy of knowledge and music's match with character mood, the score permits the audience to view Colette's consternation with a degree of amusement.

Such an approach differs strikingly from the scholarly consensus regarding the function of mainstream film music. It is generally accepted among scholars that film music binds an audience more closely to the narrative.[52] Yet when accompanying Colette's reaction in the card-switching scene, the film's score does precisely the opposite. By conspicuously

conveying Colette's overreaction, the music distances the audience from the characters and even reminds audience members of the film's artifice. In Levinson's terms it offers both narrative and additive value, expressing the magnitude of Colette's reaction while lightly ridiculing her for it.

Musical matches to a character's overreaction in other scenes also provoke laughs and prevent total absorption into the narrative. Earlier in the film, when Colette urges André to visit Mitzi (who is pretending to be sick), André recognizes that his visit may lead to infidelity. After a dramatic speech to his wife professing unconditional love, André walks down the stairs, out the door, and toward certain temptation. During his walk the music features a rearrangement of "Wedding Ring" in the idiom of a John Philip Sousa march, complete with snare drums and a trombone-heavy brass band. The film's cue sheet refers to this as the "Off to War" cue, which affirms its intended ridiculousness: it is as if André is marching off to a life-or-death battle instead of merely paying a house call to a flirtatious woman.[53] Yet the music arrangement provokes laughs precisely *because* it accurately reflects André's mentality—for a character played by Chevalier, fighting a war against one's libido constitutes a problem of enormous difficulty and importance. Such a cue thus gently mocks André even as it illuminates his mental state.

A similar use of music occurs later in the film when Adolph arrives at the dinner party. As he frantically hurries around the apartment, a dead-serious expression on his face, the music crescendos via rapid sixteenth-note upward runs on the violin and dramatic brass notes. It is then revealed that Adolph is looking for Colette so he can merely say "how do you do" to her. Periodically throughout the film, additive music enables the score to possess its own, separate "personality": it mocks characters, thus provoking specific—and somewhat distanced—audience responses to narrative events.

One Hour with You's filmmakers are so invested in using music as a narrative tool that they take an extremely unusual step: they allow musical themes based on previously performed songs to be substantially *adjusted* and *molded* for narrative purposes. Though operatic leitmotifs were expected to undergo significant adjustments during the course of the opera, the late silent and early sound era generally featured only slight motif adjustments.[54] *One Hour with You* sometimes also features relatively static themes. At other times, however, the filmmakers—perhaps

responding to industry pressure to make a musical's score better fit the narrative—use nondiegetic cues that have been altered substantially from a song's original version.

The film's cue sheets help illustrate this tendency. Either Richard Whiting or Oscar Straus is responsible for the film's six musical numbers, and on the cue sheets these two composers also receive credit for the numerous instances in which these six songs recur as underscoring. However, the remaining cues consist mainly of pieces written by John M. Leipold, Rudolph Kopp, and W. Franke Harling. In many cases the cue sheets explicitly state that these remaining cues are "based on" the film's songs, yet frequently these songs are merely a point of musical departure rather than a sequence of notes to be fully respected and preserved.

One example of such a cue occurs late in the film when André receives a notice that he must appear as a witness in Mitzi's divorce. This notice is devastating to André, as it will force him to admit his adultery and likely end his marriage. The accompanying music, credited to Kopp, contains clear strains of "Wedding Ring," but the majority of this fifty-five-second cue features tense, sorrowful *andante* music (a fairly slow tempo). Most of the cue is thus new material that does not occur in the song version. Though fairly simple in conception, such a cue marks an important point of departure from many silent and early sound films. Rather than merely transcribe "Wedding Ring" to a minor key or slow its tempo, the filmmakers have opted to treat the song as a malleable object that can be rewritten and expanded to more closely fit the mood, thus allowing the cue to play a stronger role in the unfolding narrative.

LOVE ME TONIGHT AND MUSICAL REFLEXIVITY

Though the score for *One Hour with You* is often assertive, it is almost tepid in comparison to Paramount's *Love Me Tonight* and *The Big Broadcast*. Both of these films present scores that comment saliently on the narrative and help separate the film world from any known reality.

Love Me Tonight reteamed Chevalier and MacDonald but made a key change by substituting director Rouben Mamoulian for Lubitsch. Beginning with his debut film, *Applause* (October 1929), Mamoulian displayed a willingness to push film sound in new directions. *Applause* had featured numerous film sound experiments, most notably the recording of two simultaneous soundtracks.[55] *Love Me Tonight*'s score overtly investi-

gates the very capabilities of film music itself, all the while drawing heavily on repetitive themes and accompaniment practices similar to nickelodeon and sound cartoon music.

Love Me Tonight centers on a tailor named Maurice (Chevalier) who must collect a sizable debt from Vicomte Gilbert de Varèze (Charlie Ruggles). Learning that Gilbert never pays his bills, Maurice attempts to collect the money by traveling to Gilbert's family castle. There, he is mistaken for a baron. To woo Princess Jeanette (MacDonald), Maurice maintains this identity and mingles with a host of eccentric characters, including the stuffy and snobbish Duke d'Artelins (C. Aubrey Smith), man-hungry Countess Valentine (Myrna Loy), hapless Count de Savignac (Charles Butterworth), and three aunts who huddle around a cauldron casting Macbeth-style spells. Maurice partakes in a stag hunt, in which he befriends the stag and sends the hunters home. In spite of Maurice's improprieties, Jeanette acquires feelings for him, and in a romantic evening in the garden, she vows to love Maurice no matter who he is. When Maurice reveals the next day that he is a tailor, however, Jeanette flees from him, and he is ordered to leave the castle. Jeanette soon realizes the error of her ways and reunites with Maurice by chasing his departing train on her horse and then planting herself on the railroad tracks to stop his train. The film features music by Richard Rodgers and Lorenz Hart, a prolific and prominent songwriting duo of numerous late 1920s stage musicals.[56]

In a technique that Mamoulian had initiated in his stage version of Porgy (1927), the film begins with the sounds of working-class Parisian life. In light of prior musicals such as The Broadway Melody and Sunny Side Up, a contemporary audience might expect this scene to feature a collection of "realistic" everyday sounds. These sounds, however—including sweeping, sawing, and cobbling shoes—occur in a distinctly rhythmic manner, thus becoming a sort of "music" and eventually leading to the film's first number, "That's the Song of Paree." This opening belies any clear differentiation between sound effects and music or between diegetic and nondiegetic music. Is the film presenting diegetic sounds that coincidentally happen to be rhythmic, or is it presenting nondiegetic sounds arranged by a nondiegetic filmmaker? By opening the film in this manner, Mamoulian signals his intent to examine musical boundaries and explore film music's potential functions. As the film progresses, Love Me Tonight overtly explores the following characteristics of film music:

1. *Film can enable a single piece of music to travel across disparate spaces.*
Because music exists on a separate track from the image and need not
anchor itself to diegetic cues, a single piece of music can play while the
image cuts across time and space. In the now-famous "Isn't It Romantic"
sequence, Maurice begins singing and passes the song from person to
person—including a customer at the tailor's, a taxi driver, a songwriter,
marching soldiers in the countryside, gypsies, and finally Jeanette in the
castle. Later the camera cuts to characters in separate rooms singing var-
ious lines of the song "Mimi." In both cases an unbroken song has been
performed despite cuts between characters in disparate spaces, all the
while being aided by a single unified orchestral accompaniment. This
passage of tunes across space foregrounds film music's potential to ex-
ceed the "realistic" spatial boundaries of the diegesis.

2. *Music can be located anywhere within the diegesis, even solely within
people's minds. Love Me Tonight's* narrative presents a seemingly impossible
problem: a common tailor and a wealthy princess have fallen in love. True
love means loving someone regardless of class, yet if the tailor stops main-
taining the fiction that he is a baron, the princess will almost surely leave
him. Thus, "true love" largely seems to be a mere fantasy. Audaciously,
the lovers perform the duet precisely within the realm of fantasy, thus
constituting a particularly overt instance of metadiegetic music. After a
passionate evening with Jeanette, Maurice lies in bed imagining a con-
versation in which he reveals his identity as a tailor and Jeanette contin-
ues to love him. This leads to their fantasy duet "Love Me Tonight." The
audience hears their singing with orchestral accompaniment on the
soundtrack while the image track shows a split screen of Maurice and
Jeanette asleep separately (fig. 4.2). Later, following Jeanette's disastrous
reaction to Maurice's true identity, Maurice leaves the castle, and Jeanette
realizes that she should have allowed her love for Maurice to override
class. In an image dissolve that simultaneously depicts Jeanette in her
room and Maurice leaving for the train station, the lovers again perform a
"mental" duet of "Love Me Tonight" (fig. 4.3). Divorced from the actions
on the image track, music can be performed in a purely mental space.

Such a technique is especially audacious because it reflects a crucial
and ordinarily hidden function of film music. Well before 1932, film au-
diences frequently heard love themes for central couples. The presence of
this love theme often encourages the fantasy that love has enough agency
to overcome all obstacles, including class. *Love Me Tonight* foregrounds

FIGURE 4.2 Music as fantasy in *Love Me Tonight*. Maurice lies in bed imagining uniting with Jeanette . . .

FIGURE 4.3 . . . and later Jeanette imagines uniting with Maurice after he departs. In both cases, split screens and dissolves visually represent this union. Maurice and Jeanette never move their lips with the song. Their singing and accompanying music seems to operate exclusively as internal wish fulfillment.

music's role in such a fantasy by associating the couple's love song with a dream world *instead* of reality. Altman points out that *Love Me Tonight*'s story of a commoner desiring the fairy-tale world of aristocracy is analogous to the everyday spectator desiring a filmic world in which personal value overrides economic value.[57] *Love Me Tonight* reveals film music as a key conduit toward convincing Maurice—and by extension the audience—that such fantasies can become reality.

3. *Because they are on recorded strips of film, the image and soundtrack can be slowed down or sped up at will.* In possibly the most reflexive device in the film, Maurice instructs the horseback riders involved with the stag hunt to go away quietly so as not to disturb the stag. The hunters then ride away in slow motion, a clear authorial manipulation that reminds audience members that they are watching a film, not reality. To accentuate this filmic manipulation further, torpid glissandos match the slow-moving pace of the riders. Music and image thus combine to aggressively confront the audience with film's identity as a recorded medium.

These musical techniques are strikingly reflexive in a period that generally preferred to stress diegetic comprehensibility. Even as the film innovates, however, its score also furthers the film's narrative concerns by drawing on a range of techniques from the silent era. For instance, the score uses repetitive themes, mickey-mousing, and kidding to suggest that the aristocratic family and working-class Maurice are linked by what might be called "equal-opportunity insanity." If the audience is induced to believe that a tailor-princess coupling is possible, this is partly because Maurice's efforts to marry a princess are no more insane than the behavior of the other guests at the castle. Valentine brazenly yearns for any man vaguely close to her age; three aunts cast spells; and Gilbert scurries around hiding from jealous husbands, the duke, and numerous debt collectors. Salient music helps convey such eccentricities and ultimately suggests that Maurice's own "madness" fits right in. The score provides the aunts, the duke, and Gilbert with their own nondiegetic themes nearly every time they enter a scene, and these motifs overtly stress their odd characteristics. The aunts' motif consists of rapid arpeggiated *ostinatos* (series of repeated notes) on the harp to denote their identities as spell casters (fig. 4.4); the stern duke receives slow, low-register, minor-key, accented octaves to indicate his gruffness and seriousness (fig. 4.5); and Gilbert's motif is played at a frantic presto tempo to reflect that he is con-

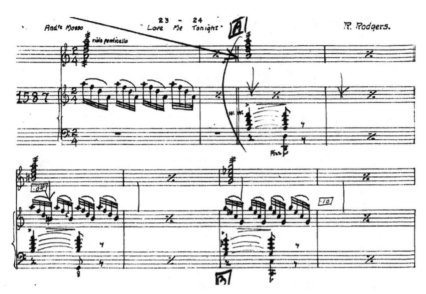

FIGURE 4.4 The conductor's part for the aunt's theme in *Love Me Tonight*.
Paramount Pictures Corporation Music Archives, Paramount Pictures, Los Angeles.

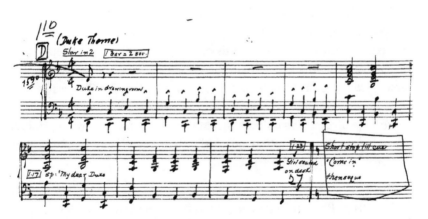

FIGURE 4.5 The conductor's part for the Duke's theme in *Love Me Tonight*.
Paramount Pictures Corporation Music Archives, Paramount Pictures, Los Angeles.

stantly on the run (fig. 4.6).[58] Both the duke and Gilbert's motifs feature parallel movement to humorous effect.[59]

The score further conveys the madness of the castle via mickey-mousing. When Count de Savignac falls off his ladder in a pitiful attempt to woo Jeanette on her balcony, the music mocks him with a concomitant glissando and cymbal crash. A different sort of mickey-mousing occurs

FIGURE 4.6 The conductor's part for Gilbert's theme in *Love Me Tonight*.
Paramount Pictures Corporation Music Archives, Paramount Pictures, Los Angeles.

when a doctor determines that Jeanette is ill because her body craves sex.[60] To draw attention to Jeanette's body during this scene, she not only disrobes but also receives glissandos as she does so. *Pizzicato* notes (notes that are plucked on string instruments with a finger) then imitate her heartbeat and pulse, which draw further attention to her body and its cravings. Nickelodeon-style kidding also occurs several times. For instance, after it is revealed that the stuffy duke's idea of entertaining guests is to provide endless rounds of bridge, a tracking shot depicts the elderly, slow-moving guests half-asleep, while a slow, solemn, minor-key version of the ordinarily peppy "Hot Time in the Old Town Tonight" plays on the soundtrack. Delving into an arsenal of salient music techniques, the filmmakers indicate that Maurice's attempts to woo a princess or save a stag from a hunt are no crazier than anything else occurring in the fairy-tale world of the aristocracy.

THE BIG BROADCAST AND MUSIC'S ASSAULT ON REALITY

If *Love Me Tonight*'s score helps make its world seem off-kilter, the score for *The Big Broadcast* constitutes an utter assault on known reality via cartoonish accompaniment, wry nondiegetic musical commentary, and diegetic music that obliterates any sense of sonic realism. *The Big Broadcast*'s nonsensical plot begins as a radio station is about to broadcast a show, but the show's main attraction—Bing Crosby (as himself in his first starring role)—has not yet arrived. Adoring women mob Bing on his way into the studio, which prevents him from performing more than

a few seconds of music on the air. The narrative then shifts to an emerging friendship between Bing and a Texan named McWhinney (Stuart Erwin), both of whom have been jilted by the women they love. After a failed joint effort to commit suicide via gas, McWhinney buys the ailing radio network and plans a big broadcast with Bing as the leading attraction. Bing fails to appear, however, and McWhinney must scour the streets for a phonograph record to stand in for Bing. Unfortunately, a series of comedic mishaps causes McWhinney to break or incinerate every record he finds. Bing saves the day by appearing at the last minute to sing "Please." Amid this manic plot the film presents many famous radio acts of the day, including George Burns and Gracie Allen, Kate Smith, the Boswell Sisters, Cab Calloway and His Orchestra, the Mills Brothers, Vincent Lopez and His Orchestra, and Arthur Tracy (also known as The Street Singer).

Like a number of musicals before it, *The Big Broadcast* justifies its brazenly nondiegetic score by flaunting a presentational aesthetic. *The Big Broadcast*'s presentational aims are particularly explicit in the opening credits, which feature labeled snapshots of each radio act that will be heard in the film. The camera then isolates each individual photograph, and the photograph comes alive by performing a brief snippet of the act before becoming motionless again. The implication is clear: radio listeners who have only seen photographs of their favorite stars will see the stars come to life in *The Big Broadcast*.[61] Unlike *Sunny Side Up*, whose picture of Molly comes to life only because a diegetic character—Jack—imagined this to be the case, here photographs "come to life" exclusively for the pleasure of nondiegetic audience members.

With presentational goals firmly declared, the film's opening sequence abandons any sense of diegetic comprehensibility, instead presenting a world often more akin to the humorous, "unrealistic" world of the period's cartoons. A freeze-frame renders a cat motionless. In a different shot a clock acquires a shocked expression via an animated mouth and eyes. Shots of Cab Calloway and His Band warp the image further: a clarinet bends like silly putty, an unattended microphone slides up and down in synchronization to sforzandos coming from Calloway's band, and the camera tilts left and right as if viscerally impacted by the jazz music.

Nondiegetic music, too, surges forward and urges the audience to treat this filmic world with humor and distance rather than absorption. Instead of remaining "unheard," the score frequently functions like a clever

nickelodeon pianist who uses music to cheerfully comment on the film. This begins immediately following the opening credits. Over a radio station sign reading, "SILENCE WHILE THE RED LIGHT IS ON," the orchestra that accompanied the opening credits halts abruptly in midphrase when the light comes on (the conductor's score demands this, with a marking reading "stop abrupt [sic] when flash of light on screen"). Already, the nondiegetic score has adopted a playful tone, preferring to slyly comment on the image rather than absorb the audience in the diegesis.

Later in the opening sequence, when Bing arrives late to the studio, the score deploys cartoon-style mickey-mousing to accentuate the unreality of what ensues. In fast motion Bing's taxicab careens through city streets and arrives at the radio station. To highlight this motion and the mayhem that ensues, the filmmakers use a cue they termed "taxi tornado." The conductor's score for this cue presents rapid upward and downward chromatic runs of parallel thirds,[62] written by Paramount staff member Ralph Rainger, that simulate the whirling of a tornado (fig. 4.7). This cue continues as Bing steps out of his cab and is immediately recognized by numerous women on the city street. Three women—including an old woman previously in a wheelchair—shout "Bing!" and run toward him. To underscore the intensity of their fandom, the music pauses before each shout and then punctuates each exclamation with a short sforzando chord. About twenty women then mob Bing and force him to the ground in their efforts to kiss him. The women's leaps on top of Bing—including one woman who downs him with a flying tackle—are synchronized to whistles and cymbal crashes. By using close synchronization between physical action and music, the film amplifies the sense of mayhem, thus furthering the impression that the film world is separate from known reality. Many women certainly loved Bing Crosby in real life,[63] but their response in this film is clearly exaggerated. Bing eventually escapes with only a shred of his hat and a face smothered with lipstick kisses.

The Big Broadcast also draws on musical kidding to comment on the narrative. Here, however, kidding occurs within the diegesis. During the scene in which Bing and McWhinney attempt suicide, Bing wishes to remain quiet so their actions go undetected while McWhinney begins having second thoughts. Their desires help draw the audience's attention to the music that follows. "I'll Be Glad When You're Dead You Rascal You" suddenly and inexplicably blares from the apartment radio, startling Bing and McWhinney. Shortly thereafter, Francesco Paolo Tosti's

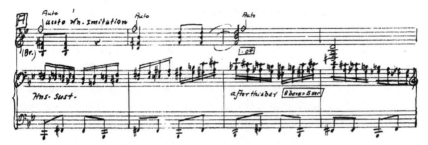

FIGURE 4.7 The conductor's part for the first four bars of "taxi tornado" in *The Big Broadcast*. Rapid chromatic runs of parallel thirds help present an exaggerated world in which Bing escapes his female fans with a shredded hat and a face covered with lipstick kisses.
Paramount Pictures Corporation Music Archives, Paramount Pictures, Los Angeles.

"Goodbye" blares loudly when McWhinney turns on a different radio. Both times, the characters hurriedly turn it off. Because diegetic characters respond to both of these tunes, kidding becomes foregrounded and closely integrated into the narrative events. Rather than functioning merely as side commentary, image and sound *unify* to produce kidding, thus increasing music's prominence in the film. In the process the unlikelihood of such convenient music playing on the radio emphasizes the film's detachment from known reality.

The film reaches the pinnacle of its musical absurdity in its thirty-minute concluding segment, in which McWhinney frantically scours the streets for a Crosby record while the radio show is performed on the air. Here the film combines two seemingly incompatible representational practices: comedic accompaniment and the era's frequent preference for diegetic or ambiguous music sources. On the image track the film cross-cuts between songs performed by the various acts in the radio studio and McWhinney's frantic search. On the soundtrack the sounds of the broadcast begin providing the soundtrack for McWhinney's search as well. When McWhinney rouses a record store owner out of bed to ask him to open his store, McWhinney and the shop owner move their lips but the audience cannot hear the dialogue because the music has taken over. As McWhinney's segments continue, music begins mickey-mousing the otherwise-silent pratfalls: brass guffaws simulate a child's laughter, downward runs occur when shelves of records fall on McWhinney, and slide whistles accompany various body falls. At one point in the conductor's

score, a handwritten note simply reads, "Have drummer catch all action on screen."[64]

This music can be read as nondiegetic accompaniment rather than music emanating from the radio. In his analysis of the film, media historian Steve Wurtzler acknowledges that the score is "intermittently and marginally grounded within the narrative space through the occasional presence of loudspeakers supposedly broadcasting the performances originating in the studios of WADX," yet he labels this music as essentially belonging to the "nondiegetic score."[65] Wurtzler, however, does not mention many additional elements that further suggest the outrageous possibility that the music closely matching McWhinney's actions is from the diegetic radio broadcast. When McWhinney scours the streets to accompanying music, a radio announcer frequently breaks in to introduce the next performer well *before* the image cuts back to the studio. This gives the impression that the music accompanying McWhinney's search is interlude music performed by the radio orchestra between acts. At one point McWhinney looks upward toward a loudspeaker when a radio announcer speaks, as if he were hearing the broadcast.

Musical similarities between the radio performances and McWhinney's accompaniment further suggest that the music is diegetic. After Vincent Lopez and His Orchestra perform "Drummer Man" on the radio—a number showing off the drummer's abilities—McWhinney's ensuing music starts off with a similar-sounding drum solo, which minimizes the sense that the music has changed spheres. Later, when the image cuts back to McWhinney following Kate Smith's radio performance of "And You Were Mine," the first few phrases of McWhinney's music consist of a faster-paced rendition of the same tune, as if the radio orchestra took up the theme following the conclusion of Smith's performance. Most tellingly, when McWhinney hurries from the street to the studio, the radio orchestra can be seen playing his accompaniment as he arrives, thus implying that the orchestra is entirely responsible for the music during this sequence.

The bizarre, ambiguous status of music in this sequence occurs because the competing identities of comedic accompaniment and diegetic music are not simply shunted into separate arenas but are *mashed together* and forced to coexist. The result is a film whose liminally located music infiltrates the narrative and plays a major role in the presentation of a cartoonish space. Music from the "big broadcast" has become so

"big" in the concluding sequence that it dominates the narrative: its pres-
ence forces McWhinney to begin his search, and it can be heard everywhere
and at all times. Indeed, one could even argue that the radio music/film
score "wants" McWhinney to fail and "causes" him to break each record.
After all, there was a widespread belief in the period that recorded perfor-
mances were appropriate only for regional and local radio stations, not the
national radio network depicted in the film. Music in *The Big Broadcast*
constitutes a central, assertive, and perhaps even controlling force.

Conclusion

When compared to the nonmusical output from the period, film musi-
cals must be viewed as a different beast. Though original musicals set in
contemporary urban America featured minimal nondiegetic music, mu-
sical theater adaptations and other films inspired by stage productions
used substantial amounts of music in a manner seldom found in dramatic
films before 1932. By 1932, the most prominent musicals offered auda-
ciously assertive scores that helped distance the film world from any known
reality. The scores for films like *Love Me Tonight* and *The Big Broadcast* not
only roam free of diegetic constraints, but they demand to be heard, often
cleaving closely to the narrative, dictating interpretations, and occasionally
seeming to possess power over diegetic characters.

The musical genre thus reveals surprising—and previously unrecog-
nized—approaches to film music. Gorbman's canonical study *Unheard
Melodies*—which explicitly avoids the musical genre—centers on the no-
tion that mainstream film scores are difficult to notice. For instance, Gorb-
man indicates that when songs with lyrics occur in dramatic films, the no-
ticeability of the lyrics threatens to divide the audience's attention between
music and narrative. Consequently, "standard feature film[s] . . . defer
significant action and dialogue during their performance."[66] In other
words, the noticeability of song lyrics prevents them from being used to
explicate key narrative events as they unfold. Although Gorbman's claim
may hold for dramatic films, the musical genre's use of previously per-
formed songs as underscoring demonstrates that *implied* lyrics can be quite
integral to narration. In countless musicals from the period, instrumental
reprises of performed numbers invoke the audience's knowledge of the
song's lyrical content. Instead of remaining an "unheard" and therefore
nondistracting element, implied song lyrics—especially when deployed as

wry commentary in films like *The Love Parade* or *Love Me Tonight*—serve presentational, commentative functions more akin to the nickelodeon period, where a pianist's personality and the audience's knowledge of song lyrics played a key role.[67] Despite efforts to eliminate such a practice nearly twenty years earlier, the use of music that depends on the audience's knowledge of song lyrics continued to thrive in early film musicals.

The musical's tendency to synchronize music to onscreen actions likewise suggests that current conceptions of Hollywood film music are too narrow. Scholars often claim that the early sound era's emphasis on creating the impression of reality contributed to its minimal use of nondiegetic film music.[68] Though this observation holds for some early sound films, attention must also be paid to the early musical's periodic efforts to provide music synchronized to onscreen action, since such efforts often direct attention *away* from the semblance of realism. The decision to match a fall with a glissando or a heartbeat with a pizzicato in *Love Me Tonight* constitutes a deliberate effort to forge a comedic mismatch between sound and image rather than a push toward the realistic presentation of diegetic sound space. Not only did many early "stagestruck" musicals avoid diegetic realism, but they sometimes pushed their extensive "background" music closer to the foreground.

The impact of these assertive musical accompaniment practices on audiences remains speculative, as eyewitness accounts on spectatorship in the period are minimal. But the musical's presentational aesthetics and periodically foregrounded scores probably resulted in films that more directly hailed and bound together their spectators. Rather than privileging individual entertainment via full narrative absorption, musicals featuring direct addresses and overtly commentative music remind audiences that they are being addressed as a collective group gathered together to be entertained. Such acknowledgment of an audience may have induced more participatory—or even rowdier—behavior, since being "hailed" encourages a response.[69] The widespread notion that film music *covertly* binds spectators together via its emotive functions clearly demands revision in light of the presentational style of many early musicals.[70] In a genre dependent on the audience's frank enjoyment of music, melodies—even many of those on the nondiegetic track—seldom labor to mask their own presence.

Musicals likely served as a catalyst for the increase in nondiegetic music in dramatic films from 1931 to 1933. Though vocal performances and theat-

rical conventions justified the early use of nondiegetic music in musicals, such music quickly spilled into narrative scenes in the musical genre where diegetic performances played no role. Nondiegetic music in film musicals also helped coax one's acceptance of musicals' fairy-tale settings, or at the very least primed the audience for films set in places far removed from reality, by providing music from a location equally removed from a recognizable space. Early "stagestruck" musicals thus provided the seeds of two tendencies found increasingly in dramatic films from 1931 to 1933: the escalation of music for narrative purposes and the use of music to denote lands, people, or mental states far removed from known, modern reality. These strategies constitute the central focus of the following chapter.

5. MUSIC AND OTHER WORLDS

The Hollywood Film Score, 1931–1933

FROM 1931 TO 1933 HOLLYWOOD INCREASED ITS USE OF NONDIEGETIC music and began utilizing it for a more consistent and specific purpose: to convey the aura of exotic, unfamiliar worlds and to represent dreams, desires, and other altered states of mind. Crisis historiography suggests that a new technology first features multiple identities and radically divergent practices before moving toward stable solutions. The period from 1931 to 1933 saw the strongest push toward this kind of stability in the sound era to date. Musical practices did not entirely solidify during the period, as strategies still varied somewhat from film to film and from studio to studio. But for the first time since the transition to sound had provoked a representational crisis, many films began to deploy nondiegetic music for similar reasons.

In this chapter I focus on the use of the score in nonmusical films released from late August of 1931 until just before the release of RKO's *King Kong* in March of 1933. My findings are based primarily on a viewing of fifty films featuring a music credit released during this time span. I begin with a consideration of general issues pertaining to the score. This includes the major reasons for the period's increase in music, the continued use of song plugging and preexisting compositions, differences across

studios, uses of jazz music, and music's role in the emergence of lengthy montage sequences. I then closely examine several films featuring extensive uses of nondiegetic music. These scores fall into two nonmutually exclusive categories. The first category includes scores employed to reflect an unusual *external* environment, including *Tabu* (March 1931), *Symphony of Six Million* (April 1932), *Bird of Paradise* (August 1932), *The Most Dangerous Game* (September 1932), and *Chandu the Magician* (September 1932). The second category contains scores that reflect *internal* dreams, fantasies, or altered emotional states: *Blonde Venus* (September 1932), *Trouble in Paradise* (October 1932), and *The Bitter Tea of General Yen* (January 1933). To date, it has not been pointed out that these two tendencies existed in early 1930s film music. The little existing scholarship on this period has attended almost exclusively to the scores of Max Steiner (*Symphony of Six Million, Bird of Paradise, The Most Dangerous Game*), often suggesting that these films constituted the industry's first tentative stabs at a full-scale movie score before *King Kong* and the "birth" of the Golden Age of film music.[1] This chapter demonstrates that Steiner's earlier scores fit within a broader tendency to associate nondiegetic music with locations and conditions divorced from familiar, material reality. This trend was established well before *King Kong*, and—as the final chapter demonstrates—would have a major impact on that film's score.

"DON'T LET'S TALK OURSELVES TO DEATH": THE INCREASE IN FILM MUSIC

As some scholars have noted, 1932 witnessed an increase in film music. Owing in large part to their heavy reliance on Steiner's writings, however, scholars regularly attribute this increase to the development of rerecording.[2] This constitutes at best a partial explanation. As I have demonstrated in earlier chapters, rerecording had been extensively used at Warner Bros. as early as 1928, and other studios also appear to have at least sporadically used this technique. Moreover, period trade articles indicate that music increased primarily as a result of the industry's resolution to reduce the amount of dialogue featured in a sound film. Rerecording improvements did occur in the early 1930s,[3] but changing assumptions regarding the appropriate proportions between dialogue and music likely played a more central role in the increased use of nondiegetic music.

A small impetus behind Hollywood's decision to reduce dialogue in the early 1930s was the ongoing issue of foreign markets. In the early sound era, extensive dialogue had caused problems for the exportation of Hollywood films to non-English-speaking countries. In 1929 and 1930 Hollywood often addressed its foreign markets by shooting films in several languages, thus making multiple versions of a film simultaneously. This technique proved too costly, and the industry turned in the early 1930s to dubbing.[4] According to a *Film Daily* survey in July of 1931, however, dubbing had been deemed "unsatisfactory" in foreign markets.[5] With multiple language versions and dubbing both problematic, the industry increasingly viewed the reduction of dialogue as a way to raise a film's marketability overseas.

The primary drive behind the effort to reduce dialogue, however, was the belief that extensive dialogue aesthetically crippled a film for domestic audiences. In February of 1931 director Paul Sloane told *Film Daily* that "overwriting"—meaning the use of excessive dialogue—was "one of the major problems of producers today." For Sloane, overwriting occurred not because less talking was needed for foreign markets but for a technological reason: sound recording offered filmmakers far less flexibility in the editing room. Where silent films could generally be edited at will, editing sound films in mid-conversation often resulted in jolting and unacceptable breaks in the soundtrack. Consequently, filmmakers regularly opted to keep long, unedited dialogue sequences in the finished film.[6]

Other industry figures, dismayed with films' excessive dialogue, urged filmmakers to combine recorded sound with the innovative and exciting filmmaking of the late silent era. Arthur Loew, an executive at MGM, urged the industry to "get back to the pantomime which made the motion picture industry. Let's supplement the pantomime with the gifts of speech with which the electrical gods have endowed us. But don't let's talk ourselves to death."[7] Audiences, too, expressed dissatisfaction with extensive dialogue. In a July 1931 *Film Daily* survey featuring responses from more than one hundred "exhibitor leaders and independent theater owners," the journal reported that "exhibitors are unanimous in declaring that pictures contain too much and too sophisticated talk."[8] This perceived connection between sophistication and dialogue likely stemmed from a widespread belief that dialogue-driven entertainment constituted a more cerebral experience, as well as a tendency to associate extensive dialogue with the legitimate theater.[9] Movie audiences may also have

been responding adversely to a film actor like Eddie Cantor, whose dialogue-heavy ethnic humor appealed more to New York City audiences than to patrons in the hinterlands.[10]

If dialogue needed to be decreased, the industry reasoned, something else would be needed to fill in for its absence. In many cases this "something else" included more music. A survey given to ten industry figures in February 1931 indicated that "the motion picture of the near future will be a cross between present talkers and silents, with music used to heighten emotional scenes." The survey responses also expressed the belief that "music is bound to grow in importance in pictures."[11] In the same year, Film Daily reported that Jack Cohn, cofounder of Columbia, planned "a policy of silent technique plus an appropriate amount of dialogue, music and sound effects."[12] The clearest connection between dialogue reduction and musical increase, however, can be found in a Variety article from March of 1931 titled "Action Films Help Music Revival." According to the unnamed author, action was increasingly taking the place of extensive dialogue. "During long intervals when there is no sound from players incidental music is being inserted to fill the gaps." The author goes on to explain, "Too lengthy breaks without sound are believed to be a strong contrast to the talk. With music the lack of talk is not noticed."[13]

Taken together, these articles reveal key aesthetic and cultural stakes behind the period's escalation of film music. Aesthetically, the articles reveal a representational crisis in the early 1930s, when conflicting sound models—one model featuring copious dialogue and another favoring silent film techniques—vied for prominence. Moreover, the proposed sound solution—a substitution of music for some dialogue—indicates that by the early 1930s, filmmakers had become far more conscious of avoiding stark contrasts in total sound. Rather than allowing sound components like dialogue and music to operate independently, the decrease in one sound type (dialogue) now required a compensatory increase in another type (music). This observation squares with Rick Altman's claim that, in the early 1930s, attention to total sound became important.[14] Culturally, the articles reveal the process whereby Hollywood swapped one marker of sophistication for another. If Hollywood reduced dialogue partly because dialogue was "too sophisticated," the industry's increased use of largely orchestral music helped the movies maintain an aura of prestige. Hollywood could eliminate a foregrounded sonic marker of prestige (extensive dialogue) that many audiences found alienating in favor of a

different indicator of sophistication (orchestral music) that appealed more to the emotions than the intellect. The cultural marker of prestige shifted from an element utterly central to the narrative to a more accessible element that depended on generalized emotional associations for its efficacy.

ORIGINAL OR PREEXISTING MUSIC?

If orchestral film music was to be increased, to what extent should filmmakers continue to use compilations of preexisting music, a strategy that characterized much of the late silent and early sound era? Increasingly during this period, studios provided larger proportions of original music composed by staff members. This may have been caused partly by the nosedive of the musical. Though studios reduced their musical staff with the decline of this genre, enough staff would have remained to provide some original music for dramatic films. Original compositions— particularly those of Steiner—also offered certain advantages, including a score that could better "fit" the narrative and draw more attention to specific elements within the story. Still, the use of preexisting music remained an important option from 1931 to 1933, and scores from the period often struck a balance between original and preexisting compositions. The effectiveness of this balance suggests that it constituted an acceptable, potentially stable technique rather than an inexorable move toward the "Golden Age" of film music, which featured largely original compositions.

Paramount's *A Farewell to Arms* (December 1932) offers an especially good example of the period's frequent and effective balancing of older and newer methods. Adapted from Ernest Hemingway's 1929 novel and Laurence Stallings's 1930 play, *A Farewell to Arms* tells the story of Frederic (Gary Cooper). Frederic is an American ambulance driver who falls in love with a British nurse named Catherine (Helen Hayes) in Italy during World War I. Catherine becomes pregnant with Frederic's child. While on the battlefield and away from Catherine, Frederic receives no letters from her because of the overzealous censorship of his friend Rinaldi (Adolphe Menjou). Sensing that something is wrong, Frederic goes AWOL and undertakes a dangerous journey back to Milan to find Catherine. Heartsick and worried about Frederic, Catherine collapses when she receives all of her returned letters. Frederic finds Catherine, who has

given birth to a stillborn child, just before she dies. War, the film indicates, created circumstances that necessarily obliterate the prospect of enduring love.[15]

Two particular aspects of the score point toward new tendencies in the 1931–33 period. First, though *A Farewell to Arms'* music is intermittent, it occupies more than 35 percent of the film, a percentage that exceeded most nonmusical films from 1929 to 1931.[16] Second, the score not only centers on an originally composed love theme by Ralph Rainger (fig. 5.1), but it substantially remolds this tune to suit the narrative. In the late silent and early sound eras, themes seldom featured modifications beyond slight adjustments in tempo, key, and instrumentation.[17] Here, however, the adjustments include modifying the rhythm as well. For instance, when Catherine asks a street artist to produce a cut out of her profile, the score provides a love theme with a different time signature,[18] tempo, and rhythm (fig. 5.2). The love theme also features grace notes (quick notes that are not essential to the melody) and other embellishments, giving it a frolicking yet edgy feel that matches Catherine's excited emotional state. Provided with more time than silent film orchestras, Paramount's music staff could produce new music and craft more intricate and extensive variations on its themes.

FIGURE 5.1 The lovers' theme in *A Farewell to Arms* as heard during the opening credits.
Transcribed from the original conductor's score, Paramount Pictures Corporation Music Archives, Paramount Pictures, Los Angeles.

FIGURE 5.2 Modification of the lover's theme during a scene in Switzerland. Not only does the orchestra play this latter version much faster, but the cue also features a different time signature, an erratic rather than steady tempo, and connecting notes between the tones in the original version. Such substantial changes to an original theme occurred infrequently in sound films prior to 1931.
Transcribed from the original conductor's score, Paramount Pictures Corporation Music Archives, Paramount Pictures, Los Angeles.

Even as *A Farewell to Arms* structures much of its score around an original motif, however, the film also draws heavily on the late silent and early sound era's tendency to use preexisting music. Doing so has considerable advantages for the film: it helps establish the setting, conveys strong emotional overtones, and amplifies character significance. During the opening credits, for instance, the filmmakers sandwich the lovers' theme between two passages from Tchaikovsky's *Capriccio Italien* (1880), thereby signaling the film's Italian location via a well-known composition.[19] Much later in the film, the filmmakers indicate war's threat to love. They use ominous selections from Richard Wagner and Tchaikovsky during a montage in which Frederic deserts the army and risks death in order to return to Milan and find Catherine. This six-minute cue alternates between snippets from Wagner's opera *Siegfried* (1876) and the storm passage from Tchaikovsky's symphonic poem *Francesca da Rimini* (1876). The selections from *Siegfried* feature harsh, low-pitched brass and a steady drumbeat, which helps to underscore Frederic's dangerous and hellish journey. *Francesca da Rimini* echoes *A Farewell to Arms'* narrative by describing lovers trapped in a violent storm in hell. The composition's repeated downward runs invoke both the subterranean location and the fierce storm. The dramatic power of Wagner and Tchaikovsky, when applied to *A Farewell to Arms*, conveys the overwhelming impact of war—a force so frightening and totalizing that it will ultimately squash the lovers' dreams of a permanent union.

Yet another prominent preexisting composition is used during the film's final moments. Wagner's "Liebestod" from the opera *Tristan und Isolde* (1865) accompanies Catherine's death. This intensely emotional music adds dramatic thrust to the film's tragic ending. For knowledgeable audience members, the use of this preexisting piece would have invoked additional resonances. Not only do both narratives feature star-crossed lovers, but the score further connects the two sets of lovers by playing the "Liebestod" when Catherine dies in *A Farewell to Arms*. In *Tristan und Isolde* the lyrics from this aria suggest the possibility of a dead lover rising after death. In *A Farewell to Arms* this notion of rising after death is furthered by the image, which shows Frederic lifting Catherine toward a brightly lit window. By paralleling Frederic and Catherine with these legendary characters, the music implicitly elevates the lovers into archetypes. For musically knowledgeable audience members, Frederic and Catherine function as representatives of the profound

and damaging impact of war, not simply as two lovers who happen to lose each other.

Based on a film like *A Farewell to Arms*, there is no reason to think that film music practitioners from 1931 to 1933 felt that lengthy original scores credited to lone individuals was the inevitable path that film music would take. Original music increasingly had its place during these years, but preexisting music still offered considerable opportunities for conveying the narrative. Additionally, by summoning Old Masters like Wagner and Tchaikovsky, the filmmakers elevated their film's prestige. For a multitude of reasons, preexisting music remained an important tool for filmmakers in the period.

DIFFERENCES ACROSS STUDIOS

Though the 1931–33 period enjoyed a substantial use of nondiegetic music, not all studios devoted equal attention to the task. Of the five major studios, RKO, Paramount, and Fox were responsible for the most prominent and substantial experiments with nondiegetic music. Paramount and Fox had used nondiegetic music from 1929 to 1931, but RKO's increase in music in 1932 constituted an about-face from the prior period. Continuing a conservatism that began with the initial transition to sound, MGM in the early 1930s provided films featuring—at most—an occasional, brief nondiegetic cue. Most surprisingly, with the abandonment of sound on disc Warner Bros., once a synchronized film music pioneer, substantially reduced its forays into nondiegetic music. Of the minor studios, only United Artists—thanks largely to music director Alfred Newman— offered several extensive nondiegetic scores.

B films, however, rarely contained nondiegetic music outside of the opening and closing credits.[20] The B film's limited time and financial resources constituted the main reason for its lack of nondiegetic music. Tight production and postproduction schedules often made it difficult to create a coherent film, and the addition of a score would have been an unnecessary and often impossible luxury. B films were also frequently rented to exhibitors for a flat fee rather than a percentage of revenue, meaning that a certain amount of money was guaranteed regardless of film quality.[21] Working within such a system, B filmmakers had little incentive to focus on an element that did not make a clear and direct contribution to narrative or action scenes.

One rare B film that bucks the musical norm is Halperin Produc-
tions' *White Zombie* (August 1932). The nondiegetic score—compiled by
Abe Meyer—helps convey the film's exotic location (the West Indies) and
supernatural elements (zombies and hypnotism). When villain Legendre
(Bela Lugosi) transforms leading lady Madeline (Madge Bellamy) into a
zombie, for instance, Meyer includes passages from Modest Mussorg-
sky's *Pictures at an Exhibition*, Gaston Borch's *Incidental Symphonies*, and
Hugo Riesenfeld's *Death of the Great Chief*. In the climactic finish two
compositions by Hen Herkan play as Legendre and his zombies fall off a
high cliff to their deaths.[22] Though the use of any music at all was ambi-
tious for a B film, Meyer clearly inserted the music in a manner that would
not have been time intensive. Rather than taking the extra time to match
music with specific actions or dialogue, Meyer instead provides only gen-
eral mood music to fit each narrative situation, which allows him to cre-
ate the score simply and quickly. With few exceptions B filmmakers in
the early 1930s avoided the time and expense of a score.

THE CONTINUATION OF SONG PLUGGING

Though the major studios placed varying emphases on nondiegetic mu-
sic, they remained unified in their desire to continue to plug songs for
marketing purposes. Even with the decline of the film musical in 1931
and 1932, Hollywood found opportunities to promote music. In certain
cases a film could become remarkably overt about its song-plugging
aims. In Fox's *After Tomorrow* (March 1932), Pete (Charles Farrell) gives
the sheet music of the film's theme song "All the World Will Smile Again
After Tomorrow," by James Hanley, to his fiancée, Sidney (Marian Nixon),
as a present. Later, Pete suggests that they try out the song on the piano,
and the film provides a close-up of the sheet music cover, which features
the song's title and composer. The song then becomes the lovers' tune:
they both independently hum the tune the following morning. The film
continues to covertly plug the song by featuring several additional scenes
in which the sheet music is visible on the piano in the background. *After
Tomorrow* thus offers not only a story about a couple in love but a model
of how sheet music should be consumed, from purchasing it as a gift to
leaving it on the piano for everyone to enjoy.[23]

A similarly brazen effort at song plugging occurs in MGM's *Red-
Headed Woman* (June 1932). After presenting a vocal rendition of the

eponymous theme song during the opening credits, a scene late in the film features a jazz orchestra at a New York City nightclub. A close-up of the conductor's score reveals the title of the song, "Red-Headed Woman," and the camera then pans to a man singing the song. After this advertisement for the theme song, the next scene features Sally (Una Merkel) in the background of the frame attempting to play "Red-Headed Woman" on the piano while making numerous mistakes. It is as if Sally had bought the sheet music featured in the previous scene and is learning to play it, thus again serving as a model consumer for the movie audience to emulate.

Hollywood also plugged its songs through nondiegetic channels. This tactic is quite evident in Warner Bros.' *The Purchase Price* (July 1932). *The Purchase Price* tells the story of a torch singer named Joan (Barbara Stanwyck), who tries to escape corrupt urban life by becoming a mail order bride for a North Dakota farmer named Jim (George Brent). Joan shuns Jim on their wedding night yet soon realizes that she truly loves him. Joan spends the rest of the film trying to warm over Jim's frosty demeanor, a task that includes toiling in the fields.

Before fleeing to North Dakota, Joan performs "Take Me Away" in a nightclub. Diegetic withdrawal then enables the theme song to drift from diegetic to nondiegetic terrain. An instrumental version of the song is heard in Joan's dressing room in the nightclub, and this music presumably comes from the nightclub orchestra. Later, however, the same song plays inside the North Dakota farmhouse, which displays no player device, and then twice when Joan helps Jim in the wheat fields. By the time "Take Me Away" plays in the wheat fields, the song has made a firm transition to nondiegetic territory.

As with early synchronized scores, these reiterations of the theme song simultaneously serve narrative and song-plugging purposes. Narratively, Joan's love for Jim is somewhat difficult to fathom given Jim's generally unpleasant disposition. However, the film's reiteration of the theme song indicates why she works so hard at winning Jim. "Take Me Away" is a torch song about wanting to fall in love and be taken far from an immoral urban environment. The lyrics seem to match Joan's inner desires and ultimately suggest that her marriage is the escapist solution she has dreamed about.[24] At the same time that the song illuminates Joan's psychology, however, it also functions as a self-sufficient entity. Every time the song plays on the soundtrack, it retains its jazz orchestration

and is heard in its entirety, never concluding until the end of the chorus. The song is thus preserved as a stand-alone commercial product, just as it would be in phonograph or sheet music form. Not surprisingly, the trailer promotes the song in a similar manner: after Joan sings a few bars, the rest of the trailer essentially consists of a set of images and texts synchronized to an instrumental version of the complete song. Musicals may have declined in 1931 and 1932, but Hollywood never abandoned its song-plugging aims.

JAZZ MUSIC AND URBAN LIFE

The dichotomy between virtuous living and the corrupting influence of urban life, explored in *The Purchase Price*, recurred thematically from 1931 to 1933. Frequently, filmmakers used jazz music to suggest the dangerous influence of modernity, thus making jazz an important tool for expressing key themes. In United Artists' *Rain* (October 1932), which features a score by Alfred Newman, the filmmakers repeatedly associate the prostitute Sadie Thompson (Joan Crawford) with W. C. Handy's well-known "St. Louis Blues." As film historian Peter Stanfield demonstrates, the tune helps suggest Sadie's "provocative and defiant female sexuality."[25] It also serves as a contrast to the missionary Alfred Davidson (Walter Huston). Warner Bros.' *Ladies They Talk About* (February 1933), another film featuring a clash between a powerful male religious figure and a female criminal, again links "St. Louis Blues" with female corruption. Nan (Barbara Stanwyck) must serve time in jail for her role in a bank robbery. The film associates jail with jazz music, including "St. Louis Blues."

Curiously, in these and other films of the early 1930s, jazz music is nearly always grounded in the diegesis. *Rain*, for instance, features classical and jazz idioms early on. Music in a classical idiom accompanies a montage of falling rain, while "St. Louis Blues" coincides with the first appearance of Sadie. Yet while *Rain* never indicates that the classical piece is anything other than nondiegetic accompaniment, the film strongly implies that all of the film's jazz music emanates from the diegesis. Not only does Sadie explicitly play "St. Louis Blues" on her phonograph later in the film, but numerous shots place the device rather conspicuously in the foreground, as if to further remind the audience of the tune's diegetic identity. Jazz music in *Ladies They Talk About* emanates explicitly from the radio in the jail's common room and the phonograph in Nan's

jail cell. Thus, while filmmakers capitalized on the transcendental con-
notations of orchestral music by allowing it to regularly exceed diegetic
boundaries, jazz music generally remained tied to a diegetic environ-
ment associated with deviance and criminality.

Linking jazz to a particular sound source could impact a film's mes-
sage in specific ways. In both *Rain* and *Ladies They Talk About* diegetic
jazz music articulates an ambivalent attitude toward female agency. Are
these deviant women agents of their transgressive behaviors or merely
victims of modernity? Stanfield points out that having Sadie actively gen-
erate the jazz soundtrack via a phonograph record implies a degree of
agency in her actions,[26] yet the phonograph's presence within the diege-
sis also suggests that modernity may have corrupted her. A similar situ-
ation occurs when Nan plays "St. Louis Blues" on her phonograph to
mask the sounds of an attempted jailbreak. This action indicates her
choice to engage in criminal behavior, yet the modern phonograph and
accompanying jazz music also imply that the urban world may have
molded her into a criminal. This complex mix of agency and victimiza-
tion helps explain why Sadie experiences a religious conversion and Nan
ultimately falls in love with a radio evangelist. On these films' terms
both characters—despite criminal behavior—are also good-hearted vic-
tims of urban life.

If playing diegetic phonograph records of jazz music can suggest that
the female has a degree of choice in her criminal behavior, a rare in-
stance of a nondiegetic jazz-inflected score instead holds modernity en-
tirely culpable for criminality. From the beginning of United Artists'
Street Scene (August 1931), Alfred Newman's score—which combines
symphonic and jazz elements—is tied explicitly to modern life in New
York City. The film begins with a shot of the cityscape and then provides
a montage of New York City waking up and engaging in morning rou-
tines. This opening was likely influenced by Rouben Mamoulian's stage
production of *Porgy* (1927), which similarly opens with a series of city
activities and sounds. Elmer Rice's stage play of *Street Scene* (1929), which
calls for city noise throughout the play, may have also been an influ-
ence.[27] Newman's jazz-inflected music accompanies the opening mon-
tage, thus linking jazz to the general routines of city dwellers rather than
the actions of specific characters. The opening montage includes cats,
dogs, horses, and humans, indicating a montage of types instead of indi-
viduals. Further linking jazz to the rhythms of the city, the music often

adjusts to individual shots: the image of workers chipping ice contains pizzicatos, while slow-paced music accompanies a horse who is too hot to walk. Newman's opening music thus belongs exclusively to the city: it symbolizes the city's routines, lifestyle, and general milieu. If this link to modern life were not already clear, the opening music also bears more than a passing resemblance to George Gershwin's famous jazz-inflected *Rhapsody in Blue* (1924), a piece already strongly associated with the modern world by 1931.[28]

Once the film begins focusing on individual characters in the city, Newman's music disappears. Like the prizewinning play on which the film was based, *Street Scene* focuses on a single working-class New York City block. Life is crowded, lacking in privacy or peace. Tenants are subjected to constant city noise, frequent gossip, and harshly judgmental neighbors. Underlying such gossip and judgmental behavior is the sense that city life provokes a feeling of helplessness over one's life. It erodes one's dignity. Characters' failings and struggles are on display for all to see: a woman and her children are evicted, a Jewish man is repeatedly bullied in public, and a married woman named Anne Maurrant (Estelle Taylor) is seeing a milk collector behind her husband's back.

The pivotal scene occurs late in the film when Anne's husband, Frank (David Landau), enraged at catching his wife cheating on him with the milk collector, murders them both. During this event, the jazz-infused score unexpectedly returns. Frank walks down the street toward his apartment building, looks toward his bedroom window, and realizes that his wife is with another man. A drum roll matches Frank's upward glance, followed by heavy brass staccato notes that accompany his movement toward the apartment.

At first blush it appears that the score has changed functions. Here it is aligned with narrative events and character psychology rather than city life as a whole. Yet the jazz-infused score's original association with general city life alters the scene's impact. By returning to strains of jazz music, the score implies that the conditions of city life are driving Frank to murder. Such an interpretation is further indicated later in the film, when Frank's daughter, Rose (Sylvia Sidney), asks a remorseful Frank why he committed murder. Frank responds, "I'd been drinkin', Rose, you see what I mean. And all this talk was going around. I just went clean off me nut, that's all." The city's close quarters, lack of privacy, and extensive gossip catalyze Frank's act. Thanks in part to the jazz-inflected score,

Street Scene offers a profoundly humanist film in which murders are committed not by bad people but by ordinary people overwhelmed by the crowds, gossip, and urban poverty. This decidedly pessimistic and disempowering message may help explain why filmmakers seldom used jazz as the predominant musical idiom of the nondiegetic score during the early 1930s.

EARLY MONTAGE SEQUENCES

As filmmakers experimented with the use of jazz as an expressive reflection of modernity's corrupting influence, they also grappled with the use of music in montage sequences. By "montage," I do not mean a dialectical collision of images in the Soviet montage style but rather a series of superimposed shots, often denoting a passage of time. Thanks in part to the improvement of optical printers,[29] montage sequences became more common in 1932 and 1933. With the increase in these sequences, filmmakers had to decide whether to provide accompanying music and—if so—what purpose it should serve.

The history of the montage sequence deserves far more attention than it has received. Scholars regularly state that the montage sequence conventionally denotes a passage of time.[30] This claim is accurate for the mid-1930s onward, but in the early sound era the montage sequence had not yet firmly adopted this convention. Instead, montage sequences evoked an emotion, sensation, or ambience even if the sequence did not denote a significant passage of time. This fact is easy to overlook and has led to erroneous claims about the period's style. For instance, when analyzing Hollywood montages, film scholar David Bordwell writes: "*Say It with Songs* (1929) includes a montage of the hero in prison, with his face singing in the center and superimpositions of canted angles of prison routines; a later sequence shows a ticking clock with calendar pages superimposed. In the montage sequence, the sound cinema had found its equivalent for the expository title, 'Time passes and brings many changes.'"[31]

Though Bordwell's analysis of these two montage sequences may initially seem sensible, the situation is not as clear-cut as he implies. During the first sequence—in which Al (Al Jolson) sings "Why Can't You?"—the superimpositions described by Bordwell in fact do *not* coincide with a significant passage of time. In the scene prior to Al's song, Al indicates to his cellmate that he will split with his wife when she visits the following

week. Then, in the scene following this song, Al visits with his wife and ends the relationship. Clearly, *little* time has passed and *few* things have changed during this montage sequence.[32] The "Why Can't You?" montage instead primarily serves to illustrate the content of Jolson's song. Through images of prison routines, the film presents the audience with an impression of the atmosphere that the song exhorts the prisoners to overcome.

Music often accompanied montage sequences in the early 1930s. Its principal contribution was to help the sequence evoke a particular atmosphere, mood, or mental state. For instance, MGM's *Possessed* (November 1931) features two montage sequences: one presenting Coney Island and the other depicting Mark Whitney's (Clark Gable) campaign for governor. Technically, both sequences mark a passage of time: characters enjoy an evening at Coney Island; time passes as Mark campaigns for governor. Yet the superimpositions and music selections plainly labor to invoke the milieu of an amusement park and campaign run. As the montage provides numerous images of Coney Island activities, the score presents tunes denoting a carnivalesque atmosphere ("The Streets of Cairo") and specific location ("The Sidewalks of New York"). The montage showing Whitney's political speeches, moreover, is accompanied by two rousing American band numbers: John Philip Sousa's "The Stars and Stripes Forever" and Theodore Metz and Joe Hayden's "A Hot Time in the Old Town." Such montages primarily provide a sense of a particular activity and surrounding milieu. Music plays a key role in this task.

The use of montages and music to create impressionistic sensations provides a useful context for a discussion of the rise of the elaborate montages provided by Slavko Vorkapich in the early 1930s. Though Vorkapich's montages typically denote the passage of time, their seemingly excessive elements constitute a flashier way for the montage sequence to continue its portrayal of atmosphere, sensation, and emotion. Consider, for instance, two early Vorkapich montage sequences in RKO's *What Price Hollywood?* (June 1932). Both sequences denote the passage of time: the rise and fall of movie star Mary Evans (Constance Bennett). Yet both sequences' visual motifs also convey the literal sensations of rising and falling. The first montage includes shots of Evans raising her head and semicircles of light radiating outward, while the second montage features images of falling newspapers, close-ups of Evans lowering her head, and semicircles of lights moving inward.

If Vorkapich's images convey the sensations of rising and falling, music plays a crucial role in this evocation. In the first sequence, rising motives and cymbal crashes denote glorious success, while Evans's decline in the second sequence is accompanied by dramatic downward minor-key motives (a "motive" is the smallest unit of a complete musical idea, often a mere phrase or particular rhythm). Time does pass in this sequence, but the music seems primarily involved with evoking and reflecting the sequence's visual motifs and abstract qualities. At many other points in *What Price Hollywood?* newspaper headlines convey a story event and concomitant passage of time, yet these sequences feature no music. Music, often seen as an essential presence during "time passage" montages, was instead principally concerned with conveying the montage's emotive and atmospheric qualities during the early sound era.

Though it is often assumed that montage music gives "a sense of cohesion to the series of rapid shot changes,"[33] a different situation obtained in the early sound era. Music instead often attended to cues within the montage images, even if this meant separating and emphasizing each image. For instance, prior to a newspaper montage sequence in Warner Bros.' *20,000 Years in Sing Sing* (December 1932), a prison warden (Arthur Byron) allows an inmate named Connors (Spencer Tracy) to leave prison after Connors gives his word of honor that he will return. Connors becomes involved with murder while defending his girlfriend and then delays returning to jail, thus causing the warden to receive heavy criticism from both the governor and the press. When Connors finally returns, a newspaper montage conveys the ensuing events, and the accompanying music shifts rapidly to accentuate each headline. The first headline indicates that Connors's return has saved the warden's job, accompanied by a noble, string-oriented theme. When the image dissolves to a different headline reading "Connors Goes on Trial for Murder," a dramatic four-note brass motif takes over the soundtrack and steadily rises in pitch, thus indicating the dramatics of the situation and also perhaps associating Connors with brass, conventionally a signifier of noble actions. When the third and final headline reveals that Connors has been convicted of murder, the cue arrives at its highest note and blasts this note several times.

The fact that the entire cue clearly comes from the same orchestra arguably provides a degree of unity to these headlines, but the music's responsiveness to each headline serves to separate the headlines and dictate

different audience responses: relief that the warden has been vindicated, anxiety over Connors's trial, and alarm that Connors has been sentenced to death as a result of defending a good woman. Early montage music centered not on the binding together of disparate images but on the evocation of particular emotions, sensations, and milieus.

MUSIC AND OTHER WORLDS

From 1931 to 1933 many films that plugged a theme song, used jazz to represent urban criminality, or deployed nondiegetic music during montage sequences provided a low percentage of total music. During this period, however, Hollywood released a series of films that made a more systematic and extensive use of the score. A number of films featured extensive music in conjunction with what might be broadly termed "other worlds." The phrase "other worlds" here encompasses two distinct—though nonmutually exclusive—spheres. One type is a physical location far removed from familiar reality. This world is often exotic and sometimes even features magic and supernatural occurrences. The other type is an internal world of fantasies, dreams, and desires. Extensive film scores remained a minority practice: of the fifty nonmusical films viewed for this chapter, nineteen make regular use of nondiegetic music. Yet the films featuring substantial nondiegetic music were often high-profile releases, and their use of music consistently fits into one or both "other world" categories.

Because otherness holds an important place in the humanities, I should emphasize that my definition of "other worlds" does not entirely coincide with critical theory's notion of otherness. In studies of subaltern groups and alterity, critical theorists like Edward Said have studied the ways in which the West has represented and defined "Other," non-Western cultures. In his well-known study *Orientalism*, for instance, Said focuses on the West's representation of Arabs and Islam to argue that the qualities often associated with non-Western cultures have more to do with the West than the "East" or "Middle East" and serve as a means to assert Western authority and superiority.[34] This notion of the "Other" as a location that is geographically separate and culturally foreign to the West is partly what I mean by "other worlds," and the stereotypical music found in these otherworldly films fuel the argument that representations of foreign locations derive heavily from Western perspectives. However, my definition of other worlds extends beyond location and cultural difference. By "other worlds,"

I mean any situation that differs markedly from familiar, material reality. This deviation from familiar reality includes films set in unfamiliar locations, but it also encompasses films addressing particular ethnicities within the United States, films that are set in the distant past, or films that explore highly charged emotional states.

Of course, for audience members, the notion of what truly constituted "familiar reality" could differ greatly depending on each audience member's ethnicity, social or economic status, profession, urban or rural environment, religious affiliation, and a host of other factors. Based on the presence and absence of nondiegetic music in the early 1930s, however, Hollywood's barometer of "ordinary" life tended to be white Christian Americans living in a large American city. The further a film strayed from these characteristics, the more likely filmmakers were to provide extensive nondiegetic music.

The association between music and other worlds had considerable roots before sound film. The notion that music contains a transcendental quality that causes it to supersede the particulars of everyday material life had enjoyed particular support during music's romantic era, and the period contained many operas set in exotic locations.[35] Musical theater in the first few decades of the twentieth century often presented narratives with fairy-tale settings, including such smash hits as Franz Lehár's *The Merry Widow* (1907), Victor Herbert's *Naughty Marietta* (1910), and Rudolf Friml's *Rose-Marie* (1924).[36] The silent era often used "exotic" cues with titles like "Indian Music," "Oriental Veil Dance," and "Chinese Music,"[37] prefiguring the close ties between music and other worlds that would exist in sound film in the early 1930s.

As we saw in chapter 3, several early sound films featuring music had been set in unfamiliar locations like the Old West (*The Big Trail* [October 1930], *Fighting Caravans* [January 1931]) or heaven (*Liliom* [October 1930]). And as I demonstrated in chapter 4, film musicals in the early sound era increasingly used music for films set in fairy-tale worlds or featuring outlandishly unrealistic narrative events.

Many film music practitioners of the early 1930s, including the three composers responsible for the period's most prominent scores—Max Steiner, Alfred Newman, and W. Franke Harling—were all well versed in romantic music and musical theater and thus would have been well aware of the association between music and other worlds. Steiner grew up in Vienna, a haven for several music styles, including romantic music.

He attended Vienna's Conservatory of Music and Performing Art and also studied with Gustav Mahler, a man who, as a composer, repeatedly sought to convey transcendental experiences.[38] Steiner composed and conducted numerous musical theater productions in London before he moved to New York City with the outbreak of World War I. On Broadway in the late 1910s and 1920s, Steiner conducted and orchestrated stage musicals for such prominent figures as George Gershwin, Jerome Kern, and Vincent Youmans.[39] Newman, similarly, had been schooled in classical and romantic music as a young piano prodigy. From the late 1910s through the 1920s, Newman served as conductor and music director for numerous high-profile Broadway shows, including some written by Richard Rodgers and Lorenz Hart, Gershwin, and Kern.[40] Harling had composed for both opera and musical theater prior to his arrival in Hollywood and had provided compositions for two fairy-tale film musicals: Paramount's *The Love Parade* (November 1929) and *Monte Carlo* (August 1930).

The use of extensive nondiegetic music in conjunction with fantasy, exoticism, and desire offered filmmakers several distinct advantages. By using music in a style that related to the film's unusual setting, filmmakers could convey the unique aura of a particular location. Additionally, since virtually every film set in a contemporary urban area shunned nondiegetic music in this period, an extensive film score could help establish a clear separation between the "other world" and familiar reality. Music could help characterize various ethnic groups and provide implicit commentary—from the cultural perspectives of the time—on the (in)appropriateness of interracial coupling. Nondiegetic music also offered an opportunity to explore and describe a character's interior state. Most broadly, nondiegetic music's lack of spatial anchoring in reality served as a useful corollary to a filmic world or emotional state that possessed an equally tenuous connection to mundane reality. As the following case studies demonstrate, in the early 1930s film music practitioners capitalized on all of these advantages.

MAX STEINER AND RKO

In 1932 Steiner composed three extensive scores for RKO films—*Symphony of Six Million*, *Bird of Paradise*, and *The Most Dangerous Game*—that used music to characterize environments unfamiliar to most audiences. A good deal of credit for the scores' existence is due David O.

Selznick, who served as executive producer on all three films.[41] Selznick was an early champion of film music, asserting in 1932 that "without an undercurrent of music, a film play is cold."[42] This section examines two of these scores: *Symphony of Six Million* and *The Most Dangerous Game.* The following section situates Steiner's score for *Bird of Paradise* in the context of several near-continuous scores in 1931 and 1932.

Scholars have devoted relatively little attention to Steiner's music for *Symphony of Six Million* and *The Most Dangerous Game,*[43] instead providing numerous analyses of his score for the following year's *King Kong.* This is unfortunate because the scores for *Symphony of Six Million* and *The Most Dangerous Game* constitute major contributions to the industry. Both scores contain music for just over 50 percent of the film, a substantial amount for dramatic films in 1932. The scores also feature early efforts to associate extensive nondiegetic music with settings unfamiliar to most audience members: the Jewish ghetto of New York City in *Symphony of Six Million* and an island run by a diabolical madman in *The Most Dangerous Game.* *Symphony of Six Million* and *The Most Dangerous Game* also feature a nearly unprecedented level of musical attention to narrative events in a dramatic film. Still, both scores are better understood as a synthesis of prior practices rather than a wholly new approach to film scoring.

Symphony of Six Million's early scenes depict the boyhood of Felix Klauber (Ricardo Cortez), his friendship with a crippled girl named Jessica (Irene Dunne), and his life at home with his family. His family includes his parents, his brother Magnus (Noel Madison), and sister Birdie (Lita Chevret) in New York City's Jewish ghetto. Felix studies to be a surgeon and eventually opens up a clinic in the Jewish ghetto on Cherry Street. Though Felix loves helping those most in need, Magnus convinces him to move his practice uptown. There he becomes rich and famous as the doctor with the "million dollar hands" who performs trivial cosmetic procedures for wealthy women.

Time causes Felix to forget his roots, and he ignores a note on his desk from Jessica (who still lives and works in the ghetto) stating that a boy in the Jewish ghetto needs medical attention. The boy dies. Shortly thereafter, Felix must operate on his own father (Gregory Ratoff), yet the operation is unsuccessful and his father dies. Frustrated by his useless uptown work and convinced that he has lost his skills as a surgeon, Felix declares that he will never work again. To restore Felix's confidence, Jessica—

whose physical condition has worsened—announces that she will take a chance on a dangerous operation to fix her spine. Knowing that he is best qualified for the procedure, Felix operates on Jessica successfully, thus restoring his belief in himself and his work.

Throughout the film Steiner's music remains tied to the Jewish ghetto—a location unfamiliar to most moviegoers—and its accompanying value system. The music generally ceases when Felix loses contact with this community. The Jewish ghetto is of such importance to the film that its presence dictates when particular themes are heard. Early in the film, for instance, a theme identified in the conductor's score as "The Son"[44] plays while Felix works as a doctor at the Cherry Street clinic (fig. 5.3). Several scenes later, when Felix considers moving his practice uptown, his recognition that such a move violates his code of using medicine to help the neediest is reflected in the score. Here, the score deforms "The Son" theme via jolting key changes and harsh chromatic notes. Up to this point one might assume that "The Son" theme will regularly follow Felix through his journey as a doctor. Yet once Felix moves uptown, this theme—as well as all other nondiegetic music—is almost entirely eliminated. Only when Felix is reminded of his roots in the Jewish ghetto, or when the practice itself is shown onscreen, does music return to the soundtrack. Felix has "lost" the music, including his own musical theme, because he has lost sight of his ethical code and abandoned his Jewish community. The values of the Jewish ghetto are so closely tied to the use of nondiegetic music that the score sometimes takes the unusual step in the early sound era of featuring a single piece of music across a scene transition to or from the ghetto, as if to suggest the overarching influence and importance of Felix's Jewish community.

Steiner's use of Yiddish songs further demonstrates the score's purpose in evoking the atmosphere and accompanying value system of a

FIGURE 5.3 Felix's theme in *Symphony of Six Million*, known as "The Son" in the conductor's score. This theme is noble, stately, and reminiscent of Edward Elgar's "Pomp and Circumstance."

Transcribed from the original conductor's part, *Symphony of Six Million* music files, Special Collections, Charles E. Young Research Library, UCLA.

Jewish community. This includes four famous Yiddish tunes—"Oyf'n Pripetshik," "Eïli, Eïli," "Kol Nidre," and "Hatikvah"—several of which occur both diegetically and nondiegetically. As film music scholar Nathan Platte has demonstrated, the unsung lyrics reflect directly on the film's Jewish community. The lyrics to "Oyf'n Pripetshik," for instance, paint "an endearing [Jewish] family scene" while simultaneously foreshadowing Felix's eventual loss of his father.[45] The scene in which Felix's father dies—which according to Steiner was the first scene scored for the film[46]—further affirms the score's link to the Jewish community and its values. When Felix operates on his father, both "Oyf'n Pripetshik" and "Kol Nidre" play just before and after the procedure. Musicologist Michael Long argues that the father embodies the "ethical Jew," loyal to his community.[47] It is thus appropriate that the score features these Yiddish tunes when the father's life—and by extension Felix's connection to the Jewish community—is at stake. In numerous ways Steiner's score attends to and reflects the community-oriented ethics of the ghetto.

Released five months after *Symphony of Six Million*, *The Most Dangerous Game* features a Steiner score that helps portray an unfamiliar—in this case, horrific—environment. Harling initially wrote a score for the film, but Merian C. Cooper rejected it, apparently feeling that the music was too light.[48] Based on the 1924 short story by Richard Edward Connell, *The Most Dangerous Game* opens with a shipwreck that immediately kills all but three men. After a shark kills two of the remaining men, lone survivor and famous big-game hunter Bob Rainsford (Joel McCrea) swims to a nearby island. There he finds a castle owned by Zaroff (Leslie Banks), a Russian aristocrat forced to flee his country because of the Russian Revolution. In the castle Rainsford meets Eve (Fay Wray) and her brother, Martin (Robert Armstrong), both survivors of a previous boat wreck. Rainsford and Eve learn that Zaroff moves the beacons to cause shipwrecks and then hunts the survivors on his island. For Zaroff, humans constitute the only challenging and invigorating prey. Zaroff first hunts and kills Martin, then gives Rainsford a two-hour head start before hunting him. Preferring Rainsford's company to Zaroff's, Eve accompanies Rainsford into the jungle. After a lengthy chase sequence on the island, Rainsford outsmarts and eventually kills Zaroff.

As with *Symphony of Six Million*, *The Most Dangerous Game* features nondiegetic music for just over half of the film. One purpose for the extensive use of music in *The Most Dangerous Game* may have been to cover for

the sparseness of dialogue during certain scenes. Many moments that feature music have little or no dialogue. Examples include the shark attack, Rainsford's arrival on the island, the discovery of Zaroff's trophy room full of stuffed human prey, and, most notably, the fifteen-minute segment in which Zaroff hunts Rainsford in the jungle. More important, however, Steiner's score helps convey the warped world that Zaroff has created, in which accepted morals are turned upside down and the privileged status of humans as hunters is inverted. Central to this concept is the score's sole prominent theme: a minor-key tune, adapted from Harling's score for the film,[49] that is known in the conductor's part (a reduced version of the score used by the conductor) as the "Russian waltz."[50] Though seemingly attached to Zaroff, this theme, like "The Son" in *Symphony of Six Million*, functions more consistently as an evocation of a particular place and value system—in this case the twisted world that Zaroff has created.

The score's specific connection to Zaroff's diabolical world is first suggested during the opening credits, which feature a bugle call and a tense, dissonant motive that rises in half steps (fig. 5.4) (a "half step" is the smallest increment between notes in Western music). This music alternates with a hand knocking three different times on Zaroff's door. Upon the third knock, the door opens, and the soundtrack features the haunting Russian waltz for the first time (fig. 5.5). The situation matches the predicament that Rainsford will soon face. By tying the film's only prominent theme to the opening door, the filmmakers present the first clue that the score will be tied to the (diabolical) entity living behind the door. Later, Zaroff plays the Russian waltz theme on the piano and also plays the lead-in to the theme on his hunting horn. Just as Zaroff is responsible for the perilous island environment, so, too, does he seem to be the catalyst for the score that represents such an atmosphere.

FIGURE 5.4 The first music heard in *The Most Dangerous Game*. This music plays prior to an image of a hand knocking on a door.

Transcribed from the original conductor's part, *The Most Dangerous Game* music files, Special Collections, Charles E. Young Research Library, UCLA.

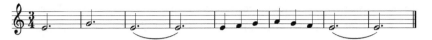

FIGURE 5.5 The Russian waltz, first heard when Zaroff's door opens following the door knock.
Transcribed from the original conductor's part, *The Most Dangerous Game* music files, Special Collections, Charles E. Young Research Library, UCLA.

Throughout the film nondiegetic music occurs only during scenes that reflect Zaroff's warped perspective. The initial scene on a routine boating expedition contains only diegetic music—not until the boat crashes and the shark devours two of the three survivors does the nondiegetic score begin. Shaking his head over the sudden deaths of his shipmates, Rainsford remarks, "It's incredible!" His statement reflects the score's central purpose in the film: to denote the incredible, diabolical events that have little connection to a modern civilized world.

This environment of inverted morality is also suggested via Steiner's decision to associate Zaroff specifically with a waltz. Waltzes traditionally function as a marker of civilized European courtship. The aristocratic Zaroff, the dialogue indicates, sees himself as civilized: hunting a human being is simply a reasonable extension of an upper-class gentleman's sport of hunting, with the conquest of the woman as the natural prize. Zaroff's ideas about sport and courtship, the film suggests, possess only the veneer of civilization, serving as a cover for twisted, savage, and primitive urges. The minor-key waltz thus reflects Zaroff's grotesque mutilation of values traditionally associated with a waltz.

Steiner's scores for both *Symphony of Six Million* and *The Most Dangerous Game* are notable for their concerted efforts to use music to convey unfamiliar settings and underscore particular narrative events. But scholars regularly argue that Steiner's contributions extend much further, and many give Steiner near-exclusive credit for the innovation of the sound film score in the early-to-mid 1930s. When situated historically, however, Steiner's principal contribution in these two scores lies not in the discovery of new techniques but in the *synthesis* of prior music accompaniment practices and the *transference* of such practices into nonmusical films.

Consider, for instance, Steiner's frequent use of themes in *Symphony of Six Million*. For a dramatic film in the early 1930s, the extent to which Steiner constructs his score around themes is highly unusual. In addition

to "The Son," he provides recurring themes that he entitles "Jessica," "The Mother," "The Ghetto," and "The Daughter."[51] Yet while the amount and frequency of musical themes were unusual in a dramatic film, musical themes had already been employed widely in opera, theater musicals, and—especially—silent films. As we saw in chapter 4, musical themes had also been used periodically in film musicals. Steiner's primary contribution was to reintroduce the theme-driven score in a dramatic context, an approach that had fallen out of favor with the advent of the 100 percent talkie.

The extent to which Steiner closely matches his music to narrative events also constituted an unusual approach for a film outside the musical genre. Steiner sometimes provides a crescendo during tense situations that culminates in a sforzando on the moment with the greatest tension. For instance, after Felix's father dies on the operating table in *Symphony of Six Million*, Felix angrily smashes a newspaper article about himself titled "The Million Dollar Hands of Dr. Klauber." Music's volume level rises in anticipation of this action and provides a sforzando at the smash. In *The Most Dangerous Game* Steiner often provides a crescendo and pause just before a key sound effect or line of dialogue. During the lengthy chase sequence, for instance, this occurs just prior to the sound of Zaroff's arrow being released from the bow and, later, just before the sound effect of birds flying out of the trees. When Eve nearly triggers the trip line designed to ensnare Rainsford, the music features a sforzando and pauses just before Rainsford exclaims, "Look out, don't touch that trip line!" Then, when Rainsford tells Eve that Zaroff has likely gone for his high-powered rifle, the sforzando and pause occur just before Eve exclaims, "His rifle!" By having the peak of the crescendo occur via diegetic sound rather than nondiegetic music, the score encourages audience members to transfer their feelings of tension from nondiegetic music to the diegetic situation, thus ratcheting up the audience's affective engagement with the narrative.

Steiner further fuses music and image in *The Most Dangerous Game* via mickey-mousing. When Rainsford swims ashore and then collapses, for instance, a modest sforzando matches his collapse. In the next sequence, the score provides loose mickey-mousing by climbing upward in pitch as Rainsford climbs a ridge. Then, as Rainsford approaches the door to Zaroff's castle, staccato notes match each step. Unlike so many disengaged musical scores from the prior period, Steiner's scores remain attentive to diegetic occurrences.

Both the crescendo-pause pattern and mickey-mousing serve important purposes, including closely binding music to narrative and aligning the audience with Rainsford's and Eve's thoughts and actions. Yet like the use of recurring themes, these techniques largely constitute a reapplication of music conventions. Using sforzandos before or after key lines of dialogue harks back to operatic recitative accompaniment. Chapter 1 demonstrated that recitatives sometimes use loud, punctuating chords before easing off or disappearing during the sung lines themselves, thus generating affect without sacrificing the comprehensibility of the lyrics. Steiner's use of sforzandos also reflects the lineage of theatrical melodrama. In its oldest form theatrical melodrama generated affect by alternating music with spoken words. This practice continued into early twentieth-century European melodrama[52]—a form with which Steiner was familiar. Steiner's mickey-mousing owes much to "word-painting" techniques of opera melodrama,[53] and more proximately to cartoons. The term "mickey-mousing" may have originated with Selznick's effort to equate Steiner's scoring techniques with cartoon music.[54] In later interviews and articles Steiner also repeatedly stated that he used a click track—a rhythmic beat timed to a certain number of frames—to help synchronize his music with the image.[55] Though it is unclear whether Steiner used a click track as early as 1932, it is worth noting that this tactic, too, derived from cartoons: composer Carl Stalling used the click track during the earliest years of Disney's sound cartoons.[56] There is much to admire in the scores for *Symphony of Six Million* and *The Most Dangerous Game*, but Steiner did not "invent" the music techniques found in these films; rather, he transferred preexisting accompaniment strategies to dramatic films.

Though Steiner did not invent new techniques, he was unprecedentedly bold in his use of noticeable music, particularly in *The Most Dangerous Game*. *Symphony of Six Million* begins with quiet music, and this music gradually increases in volume as the film progresses. *The Most Dangerous Game*, in contrast, features music that plays at a high volume throughout the film. This music drowns out many sound effects during the lengthy jungle chase sequence. Where *Symphony of Six Million* favors string compositions, much of *The Most Dangerous Game*'s score focuses on the brass section—generally a louder, more aggressive-sounding array of instruments. Steiner also draws attention to *The Most Dangerous Game*'s score via frequent harsh, dissonant chords and sharp sforzando blasts played on brass instruments. Even prior to *King Kong*, then, Steiner

had overtly signaled the score's importance for the evocation of unfamiliar worlds and the generation of affect.

CONTINUOUS MUSIC AND EXOTIC WORLDS

Both *Symphony of Six Million* and *The Most Dangerous Game* feature intermittent music, which was by far the most common approach from 1931 to 1933. However, continuous music remained an option for films set in exotic locales. This location was frequently the South Seas, though it could also include the Middle East and East Asia. Five films released in 1931 and 1932 reveal the ways in which continuous music could help evoke a world far removed from modern reality and suggest certain values regarding the locale's native inhabitants: Paramount's *Tabu*, RKO's *Bird of Paradise*, United Artists' *Mr. Robinson Crusoe* (September 1932), Fox's *Chandu the Magician*, and Paramount's *Madame Butterfly* (December 1932).

The decision to provide continuous music for the three South Seas films—*Tabu*, *Bird of Paradise*, and *Mr. Robinson Crusoe*—probably stemmed in part from the enormously popular 1912 play *The Bird of Paradise*, a production by Richard Walton Tully set in Hawaii. For incidental music Tully imported a quintet from Hawaii. The *New York Times* reviewer made a special note of this music, describing it as "weirdly sensuous."[57] This description may have been a response to the quintet's use of a slack key style on steel guitars, a technique that was unfamiliar in the United States.[58] The play's popularity sparked an overwhelming interest in Hawaiian music. The Hawaiian quintet then recorded the play's incidental music on Victor phonograph discs, and these recordings sold well. By the late 1910s, Hawaiian recordings were some of the best-selling phonograph records in the United States.[59] The success of such music in turn impacted subsequent versions of the play. Where the original stage production featured Hawaiian music only at "realistic" moments, subsequent versions incorporated more and more Hawaiian tunes.[60] *Tabu*, *Bird of Paradise*, and *Mr. Robinson Crusoe* drew on this association between music and the South Seas, using extensive scores to depict the South Seas as an "other world" far removed from modern life.

Of the three films, only *Tabu* strives to depict Polynesia from the perspective of its native inhabitants. *Tabu* tells a story of doomed love between a young man named Matahi and a woman named Reri who live on

the island of Bora Bora. One day, a messenger from the chief of Fanuma named Hitu announces that Reri has been selected as the virgin maiden to the gods. This makes Reri taboo, forbidden for all humans to touch. Matahi and Reri boldly flee to an island that has been colonized by Western civilization. There they try to secure the money needed for passage on a ship, only to discover that Matahi has unwittingly accumulated a massive debt and cannot pay for the tickets. Hitu soon discovers the lovers' location, and Reri, fearing for Matahi's safety, leaves the island with Hitu. In an effort to swim after the departing Reri, Matahi drowns.

In many respects *Tabu* constituted a throwback to silent and early synchronized film music. It was shot silent and later scored by Hugo Riesenfeld, a man with extensive experience in silent and early synchronized scores. Logistical issues must have played a role in the decision to shoot *Tabu* as a silent film with recorded music. Because *Tabu* was shot on location in Tahiti with native Tahitians in the leading roles, the nonprofessional cast would have struggled with English dialogue.[61] Moreover, outdoor recording would have been difficult: Fox's *In Old Arizona* (January 1929), probably the first sound film utilizing outdoor recording, had been released only five months before the start of production on *Tabu*. Director F. W. Murnau's decision to make a silent film may also have been influenced by the industry's hesitation toward 100 percent talking films. When Murnau left Hollywood in May 1929 to begin work on *Tabu*, silent films with synchronized scores still appeared to be a viable long-term option. Moreover, *Tabu's* producer, David Flaherty, attests that Murnau believed in the enduring artistic quality of silent filmmaking, stating that Murnau's choice to make a silent film was "dictated not by economic but by aesthetic considerations."[62]

Tabu's shooting strategies may have occurred for a variety of logistical and aesthetic reasons, but ultimately the film's dependence on an antiquated filming and musical accompaniment aesthetic served as a useful means to represent the film's "primitive," premodern setting. The notion that the South Seas remains a paradise devoid of modernity drives the early parts of the film. An opening intertitle describes Bora Bora as an island "still untouched by the hand of civilization." When Matahi and Reri lose their paradise and flee to a different island, elements of Western culture appear. Even here, however, the couple's cultural differences from the modern world remain vivid, including Matahi's limited understanding of the concepts of money and debt. By employing a "nonmodern"

accompaniment practice, *Tabu* further conveys a sense of separation between modernity and the native culture of the South Seas.

Riesenfeld further invokes silent era accompaniment through his pastiche approach to the music. The score features ample selections of classical music, including portions of a Frédéric Chopin prelude, Franz Schubert's "Death and the Maiden," Robert Schumann's "Leides Ahnung," an oratorio (Franz Liszt's "Saint Elizabeth"), a Czech symphonic poem (Bedřich Smetana's "Vltava"), and a Russian ballet (Nikolai Tcherepnin's "Romance for a Mummy"). Like certain silent scores and many early sound scores, the filmmakers combine preexisting music with original cues, in this case by Riesenfeld, Harling, Milan Roder, Corynn Kiehl, and *Tabu*'s assistant director, William Bambridge.[63] Riesenfeld also draws on late silent and early synchronized music by featuring prominent and recurring themes. These include a soaring theme to represent the doomed love between Matahi and Reri and an ominous low-register motif to denote the presence of Hitu.

Tabu's score differs from typical late silent and early synchronized film music in one crucial respect. To sonically represent the festivities and dancing in the film, Riesenfeld draws inspiration from native Polynesian music, which focuses on rhythm and chanting.[64] Consequently, the score features a contrast between two musical styles: orchestral music in a romantic idiom, which Riesenfeld typically uses for *Tabu*'s dramatic passages, and chanting and drums, which he uses to denote native festivities. Such a variety of music would have been largely unfeasible in the late silent era, and synchronized scores also did not incorporate such extensive use of vocals. Drawing on the advantages of recorded sound, in which disparate musicians can be combined on a single sound record, the film's Polynesian-inspired music helps articulate a distinct sense of place.

Of its considerable accomplishments, *Tabu* is perhaps most remarkable for devoting serious, sustained attention to the lifestyle of native Polynesians. The film restricts its perspective largely to Matahi and Reri and devotes considerable time to the presentation of Polynesian music and dancing. Subsequent South Seas films would filter the exotic world through the eyes of white characters, who often experience violent conflicts with the natives. Such is the case with *Bird of Paradise*, a film with an early continuous score that articulates the beauty and lure of the South Seas while simultaneously villainizing the native inhabitants.

Bird of Paradise opens with a scene in which white passengers sail the South Seas on a yacht, thus immediately signaling the film's Western point of view. Invited by natives to come ashore for a festival, the young sailor Johnny (Joel McCrea) finds himself infatuated with an island woman named Luana (Dolores Del Rio). Unfortunately, Luana, like Reri, is taboo, this time because she is promised to a native prince. Later, during Luana's prenuptial dance, Johnny grabs a willing Luana and takes her to a nearby deserted island. Johnny and Luana are eventually captured by the natives, who begin roasting them over a fire before Johnny's shipmates rescue them. Though Johnny holds out hope that he can take Luana back to the modern world to be his wife, the chasm between exotic Polynesia and modernity proves to be too great. Johnny becomes ill, poisoned by an arrow. Luana, believing that she has angered the volcano god Pele, chooses to sacrifice herself to the erupting volcano in an effort to save Johnny's life.

Unlike *Tabu*, *Bird of Paradise* features extensive dialogue along with virtually continuous music. The score helps conceal the film's relatively few sound effects, an issue that may have stemmed from the difficulty of recording sound effects for the sequences shot on the Hawaiian Islands.[65] More important, however, the ever-present score constantly conveys the contrast between the exotic world of Polynesia and modern life. Like *Tabu*, *Bird of Paradise* has a distinctly antimodern score, employing the silent-era tactic of near-continuous music to depict a region untouched by Western civilization. Steiner's score also foregrounds a diverse range of percussion instruments to convey this alternative world, including bells, celesta, gong, hand cymbals, marimba, timpani, and xylophone.[66] Though these are standard instruments for twentieth-century orchestral music, their presence in a film score is unusual. The soundtrack's use of Hawaiian music, including Sol Hoopi's Hawaiian chorus, lends a sense of authenticity to the music.[67] Johnny and Luana's love theme, moreover, is periodically performed on the steel guitar, an instrument widely associated with the seductive appeal of Hawaii. Steiner also conveys the lure of Polynesia through his "Call of the Islands" theme—a twinkling, hypnotic two-note ostinato—in frequent conjunction with scenes of Hawaiian landscapes (fig. 5.6).

Even the rare use of silence helps articulate the lure of the islands. After continuous music accompanies a celebration involving the shipmates and natives, the filmmakers briefly eliminate music when the

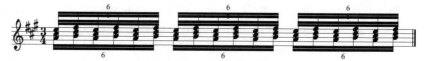

FIGURE 5.6 The first bar of "Call of the Islands" in *Bird of Paradise*.
Transcribed from the conductor's part, *Bird of Paradise* music files, Special Collections, Charles E. Young Research Library, UCLA.

shipmates—back aboard the static and visually bland interior of their boat—discuss the fact that Johnny seems to have "gone native." The music returns only when the camera cuts back to Johnny sitting by himself on deck and gazing at the island. Here, more than anywhere else in the film, the score conveys the tropics as an alternative world far removed from mundane reality, a world that can enact a pull on those who experience it.

Bird of Paradise's use of Hawaiian music—especially the employment of a steel guitar—would seem to match the "weirdly sensuous" music heard during the stage version's initial run. Steiner contrasts this music, however, with frequent chanting and drumbeats that denote the natives. This musical opposition helps convey the film's dual-focus epic structure, in which the couple's pastoral romance proves no match for cultural norms and the power of tradition.[68] Yet the chanting and drumming occurs in conjunction with several other musical techniques that conventionally denote savagery or aggression, including unresolved dissonances, parallel octaves, and heavy passages for the brass. The natives' chants are also seldom tied to lip movements of individual characters, which fosters the sense of an undifferentiated, aggressive mass. The score thus indicates that—except for Luana—the natives are merely a superstitious, belligerent, and inconvenient obstacle to Johnny's happiness. They are not worth caring about or treating with respect.

The next month saw the release of *Mr. Robinson Crusoe*, another South Seas film featuring dialogue and a continuous score. The score by Newman—like Steiner's score—harkens back to prior film accompaniment practices via extensive recurring themes. It also periodically uses a steel guitar to suggest the sensuousness of South Seas life and, again, dehumanizes and vilifies the natives. Not only does the score feature low, dissonant brass and a steady drumbeat to signal native menace, but it also mocks their impotence in the face of white male authority. When a lone

native attacks the lead character, Steve Drexel (Douglas Fairbanks), with a knife, for instance, the score provides light xylophone music. The score's implied message is arguably more offensive than in *Bird of Paradise*. Not only are natives aggressive and violent, but they are unimportant primitives to be laughed at and disregarded when pitted against a rigorous, white explorer. In both *Bird of Paradise* and *Mr. Robinson Crusoe*, then, the continuous score highlights the exotic location, yet it generally posits this environment as a playground that only white men can fully experience and enjoy.

If continuous music could convey the allure of the South Seas, it could also highlight the exoticism of other locations. Released the same month as *Mr. Robinson Crusoe*, Fox's *Chandu the Magician* uses continuous music to depict Middle Eastern exoticism and to set the tone for a narrative of hypnotism and magic. The film's initial location appears to be India, where a white man named Frank Chandler (Edmund Lowe) has been training with yogi magicians. In an apparent rite of passage ceremony, the magicians give Frank the name "Chandu." He demonstrates his abilities by performing numerous magic tricks based on hypnosis. The narrative then shifts to Egypt: the evil Roxor (Bela Lugosi) has kidnapped Chandu's brother-in-law, Robert Regent (Henry B. Walthall), and attempts to extract the secret of a death ray that Regent invented. Accompanied by Regent's family, the Egyptian princess Nadji (Irene Ware), and Chandu's bumbling assistant Miggles (Herbert Mundin), Chandu uses magic to defeat Roxor and his henchmen and rescue Regent. Along the way the film offers a few romantic moments between Chandu and Nadji.

Along with the sheer presence of continuous music, *Chandu the Magician*'s score borrows the use of recurring themes and musical "kidding" from silent-era accompaniment practices. In addition to a theme for Chandu that generally plays when he performs magic (fig. 5.7), the score also features a love theme for Chandu and Nadji (fig. 5.8) and a cartoonish, bouncing bassoon theme for Miggles (fig. 5.9). Kidding occurs during comedic moments, most noticeably via multiple uses of "How Dry I Am" when Miggles decides to drink alcohol. The film includes a silent scene: when Chandu and Nadji gaze into Chandu's crystal ball, they can see but not hear Roxor's efforts to get Robert Regent to reveal the secret of the death ray. Given these parallels to silent film music, it comes as little surprise that the music director, Louis de Francesco, had experience with silent-style continuous music. Four years earlier, de Francesco

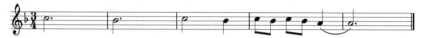

FIGURE 5.7 A dramatic, recurring theme in *Chandu the Magician*, frequently heard in conjunction with Chandu and his feats of hypnosis.
Transcribed by the author.

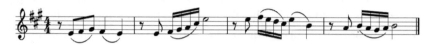

FIGURE 5.8 Chandu and Nadji's love theme in *Chandu the Magician*.
Transcribed by the author.

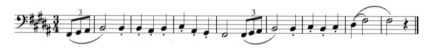

FIGURE 5.9 A goofy bassoon theme, featuring staccato and slurred notes, to represent Chandu's bumbling assistant Miggles in *Chandu the Magician*.
Transcribed by the author.

and J. S. Zamecnik had written the synchronized score for *The Wedding March* (October 1928).[69]

Armed with a retrograde, antimodern accompaniment style, *Chandu's* music encourages the audience to accept the regular presence of fantastical elements in the film. To defeat his foes, Chandu performs an array of magic tricks, including creating body doubles, turning guns into snakes, and paralyzing people. In a land of exoticism and fantasy, the equally "unrealistic" presence of nondiegetic music becomes an asset: its diegetic inexplicability helps present a space in which magic and hypnosis can exist.

If *Tabu*, *Bird of Paradise*, and *Mr. Robinson Crusoe* feature some combination of chanting, drumbeats, and unresolved dissonant brass to convey their exotic settings, *Chandu the Magician* employs its own tactics for indicating exoticism. Like the previous scores, much of the film's music is in a romantic idiom, but de Francesco invokes a more specific sense of place through another method. He periodically uses scales with an augmented second (a scale progression in which one note is raised by a half step), a stereotypical signifier of the Middle East. Like the music in *Bird of Paradise* and *Mr. Robinson Crusoe*, such music conveys the sense of "native" menace posed to white visitors. For instance, when Roxor places

the pale-skinned, blonde-haired Betty Lou (June Vlasek) on the auction block for Egyptian men to purchase, the score features a repeated and particularly pronounced series of scales with an augmented second. The contrast between the nightgown-clad Betty Lou and the ethnically infused score articulates fears of racial intermingling between white women and ethnic Others. Like several continuous scores before it, *Chandu the Magician*'s score conveys the exoticism of an unfamiliar world and the concomitant dangers of mixing with its "natives."

Continuous music could be used to invoke the exoticism of East Asia as well. At the end of 1932, Paramount released *Madame Butterfly*, which featured music from Giacomo Puccini's eponymous opera along with incidental compositions by W. Franke Harling. In an extensive analysis of this score music scholar W. Anthony Sheppard demonstrates that much of Puccini's music—without vocals—was reused in the same narrative spots as the opera. Harling invokes silent film techniques not only by reusing Puccini's "curse motif" but also by creating motifs for the main character, Pinkerton (Cary Grant), and the American consul Sharpless (Berton Churchill). For reasons that are not entirely clear, Harling eliminates Puccini's reworking of authentic Japanese folk tunes in favor of his own simulated Japanese music, which includes such stereotypical "oriental" signifiers as parallel fourths and fifths, octaves, and rapid xylophone passages.[70] Like *Tabu*, *Bird of Paradise*, *Mr. Robinson Crusoe*, and *Chandu the Magician*, *Madame Butterfly*'s continuous score helps convey an exotic world far removed from modern American life. Far from a technique that was abandoned in the early sound era, continuous scores remained an asset for early 1930s filmmakers seeking to depict "otherworldly" locales and their native inhabitants.

Toward Internal Other Worlds: *The Bitter Tea of General Yen*

The continuous scores for the films examined above principally convey *external* worlds featuring exotic or unfamiliar environments. Three other films from the period use intermittent music primarily as a reflection of the *internal* dreams, desires, and states of mind of leading characters: Columbia's *The Bitter Tea of General Yen*, Paramount's *Trouble in Paradise*, and Paramount's *Blonde Venus*. The scores play a key role in the films' cultural explorations of interracial mixing, class, and marriage. All three

scores also include important contributions from one of the unheralded composers of the early sound period: W. Franke Harling.

The Bitter Tea of General Yen, a daring film directed by Frank Capra, raises the stakes for the portrayal of interracial love. Prior films like *Bird of Paradise*, *Mr. Robinson Crusoe*, *Chandu the Magician*, and *Madame Butterfly* all presented a romantic relationship between a white man and a nonwhite, "exotic" woman. All four films treat this relationship as an unproblematic instance of love, offering little or no condemnation of the couple's feelings for each other. However, when an "exotic" *man* and a white *woman* fall in love in a patriarchal culture, the situation forces the filmmakers to proceed far more carefully. As cultural historian Richard Slotkin points out, romances between white men and nonwhite women at least "have the saving grace of preserving the political and moral hierarchy of a male-dominant ideology. In the reverse case, the non-White male assumes a tutelary and commanding role over the White woman and is implicitly permitted to penetrate her body and to mingle his sperm (figuratively his blood) with her 'blood.'"[71] Slotkin demonstrates that in American culture, such mingling constitutes a "horror" that extends all the way back to Mary Rowlandson's seventeenth-century story of Indian captivity.[72] Complicating matters further, filmmakers in the early 1930s were subject to Production Code guidelines, which prohibited the depiction of miscegenation. Though the Code was not as comprehensively enforced as it would be a few years later, filmmakers did face constraints in this period.[73] Studio correspondence indicates that the movie industry's trade association—the Motion Picture Producers and Distributors of America (MPPDA)—was concerned with sex between "whites and negroes only."[74] Still, filmmakers needed to exercise caution when depicting the relationship between any ethnically "Other" man and a white woman.

The Bitter Tea of General Yen spends its entire running time examining the circumstances and motivations that might lead a white woman to love a Chinese man. Harling's score plays an important role in this examination. Though the score occupies a mere 16 percent of the film, it becomes crucial for articulating the cultural clash between East and West by highlighting the reasons why the white, New England–bred Megan Davis (Barbara Stanwyck) falls in love with the Chinese General Yen (Nils Asther).

Beginning with the opening credits, the score strongly foregrounds the theme of a cultural clash between East and West. Over the Columbia logo, the film provides a conventional Western orchestral tune, centered

primarily on the brass section. As the image dissolves to the film's title—which is written in English but features curved "Chinese-style" lettering—a chime and then a gong interrupt the Western theme. This is followed by two other conventional signifiers of the "Orient": parallel octaves and a xylophone.

The bleak early sections of the film contain no music, which helps suggest that life in China is harsh, difficult, and dangerous. As the narrative begins, Megan arrives in Shanghai to be married to a missionary named Strike (Gavin Gordon), only to have Strike postpone their wedding so he can save nearby orphans in a war zone. As Strike and Megan set out to rescue the orphans, the film provides numerous images of China as a dirty, crowded country, ripped apart by civil war and run by vicious, power-hungry generals. Knocked unconscious in a chaotic city street, Megan is rescued from danger by General Yen and brought to his summer palace. Megan initially feels complete disgust for Yen, calling him a "yellow swine" when she (mistakenly) believes that he intends to rape her. Yet Yen's cultured demeanor and good manners fascinate Megan even as she is repulsed by his cruelty to his enemies. As her feelings change, the nondiegetic score reenters.

Megan's slow transformation from repugnance to affection for Yen first becomes apparent via her bizarre dream sequence that relies equally on images and music to convey its message. Just prior to this sequence, conventional signifiers of "oriental" music (including xylophone music) play nondiegetically as Megan observes Chinese couples wooing each other in the courtyard. Megan dozes off, and dreams that Yen, with pointed ears and long fingers reminiscent of Nosferatu, breaks into her bedroom and attempts to rape her to stereotypical "oriental" music: a gong, xylophone, and pentatonic scales ("pentatonic" music features only five notes from a diatonic scale). A masked lover dressed in Western clothes abruptly saves Megan by knocking out Yen/Nosferatu. Removing his mask, the rescuer turns out to be Yen with his actual face. The two embrace and kiss passionately on Megan's bed to a score featuring Western musical signifiers of ideal love: a soaring melody, string-heavy orchestration, and a harp.

Sheppard argues that by having this "lush amorous music" play when the Swedish Asther—in less grotesque yellow-face makeup—kisses Stanwyck, the score "helps to erase any negative connotations of this Asiatic face and forces us to accept, rather than be shocked by, this (fake) interracial kiss."[75] One might add that the score's shift from "oriental" music to

Western music also reflects Megan's own evolving feelings on Yen's suitability as a romantic interest. The film's invocation of silent-era images and sounds, however, plays an equally crucial role in articulating Megan's inner transformation. Yen's gallant rescue—along with the mask he wears—is reminiscent of Zorro, a Spanish character made popular by the silent film *The Mark of Zorro* (1920), starring top leading man Douglas Fairbanks. Yen and Megan's steamy embrace harkens back to the silent films of the famous screen lover Rudolph Valentino, who in movies like *The Sheik* (1921) had titillated audiences by rescuing and seducing damsels in distress. Parallels between the Sheik and Yen run deeper. Like the Sheik, Yen is Western-educated, kidnaps his love interest, and resolves that she will fall in love with him. Valentino was associated with a range of ethnicities: he was actually Italian, was known as the "Latin Lover," and played a supposed Arab in *The Sheik* who ultimately proved to be of English and Spanish descent. By referencing these more acceptable ethnic "Others" associated with Zorro and Valentino and by using a type of romantic music similar to what would have been heard in a late silent era movie palace, the dream sequence demonstrates Megan's emerging fantasy that a Chinese man, like Spanish or Latin men, could be an acceptable romantic interest.

On one level, then, *The Bitter Tea of General Yen*'s score operates in accordance with period assumptions: it emerges specifically for a sequence involving exoticism and fantasy. Yet Harling uses this convention to help explain how Megan changes. Megan's fiancé, Strike, focuses on pragmatic reality and lacks any sense of romance, which accounts for the absence of nondiegetic music during his scenes. Yen, however, prioritizes romance and uses the exotic beauty of Chinese culture to actively woo Megan. By associating music with Yen's actions, the filmmakers highlight his allure and sense of passion, indicating how Megan could fall in love with him. As Megan begins to recognize her feelings for Yen, the harsh dichotomy between Eastern and Western music begins to soften. For instance, when Megan finally accepts Yen's dinner invitation and prepares herself by being bathed by Chinese women, pentatonic music harmonizes with a more lyrical, Western-sounding string theme.

The most definitive musical depiction of Megan's emotional union with Yen occurs in the final scenes of the film. Mah-Li (Toshia Mori), Yen's concubine, betrays Yen to his enemies. To keep Mah-Li from being put to death, the naive Megan offers her life to Yen should Mah-Li betray him a second time. Mah-Li betrays him again, and Yen subsequently

summons Megan to his room. When Megan arrives, Yen plays a classical song on his phonograph. Both the phonograph and the musical idiom are conventionally associated with the "civilized," "cultured" West. Their presence perhaps reminds the audience that Yen has attempted to win Megan not by rough conquest but by impressing her with fine food, drink, art, and impeccable manners. Dialogue during the scene reiterates this concept: Yen at one point reminds Megan that he could have forced himself on her but chose to try to win her affections. Apparently torn between her love for Yen and the social stigma of this interracial match, Megan refuses Yen's advances. Yen gives her permission to leave the palace, yet Megan returns to his room, having "Orientalized" herself by donning heavy eye shadow and wearing a Chinese gown. Much as Mah-Li did earlier, Megan kneels by Yen's side and promises never to leave him. During this scene, the music heard previously on the phonograph returns. Megan, the score implies, returns not because she promised her life to Yen but because she is finally besotted with him. Like the recurring song on the soundtrack, Yen's cultured manner and exotic allure remain fixed in Megan's mind.

Having finally won Megan's love, Yen commits suicide. The music in the final scene, which takes place aboard a boat bound for Shanghai, reaffirms Megan's genuine love for Yen. Aboard the boat, Yen's American adviser, Jones (Walter Connolly), reminisces about his boss while Megan stares contemplatively into the distance. The same nondiegetic music from the previous scene returns, as if Megan is still hearing it. The reiteration of this theme further indicates that Megan's feelings for Yen exist outside any sense of obligation. Megan's love for Yen, it would seem, was not a momentary aberration but rather will have a profound and long-lasting impact on her life.

The Bitter Tea of General Yen thus capitalizes on the period's associations between music, fantasy, and exoticism by using music to reflect Megan's love for an "oriental" man and encourage a sympathetic reaction from the audience. Music helps convey Megan's belief that Yen, despite his ethnicity, is deserving of her love. The convention of using music to reflect emotions is mobilized in service of an unconventional film, and an even more unusual message.

TROUBLE IN PARADISE AND DREAMS

If Harling's score for *The Bitter Tea of General Yen* uses music to reflect internal desire and external exoticism, his score for the Ernst Lubitsch–directed *Trouble in Paradise* is more heavily directed toward interior states of mind. The narrative—adapted from a Hungarian play—begins with an immaculate and intimate dinner at an expensive Venetian hotel between Gaston (Herbert Marshall), an apparent baron, and Lily (Miriam Hopkins), supposedly a countess. Both Gaston and Lily are in fact con artists. They quickly see through each other's facades and then become lovers precisely because they are attracted to each other's similarities as professional crooks. One year later in Paris, with finances tight, Gaston plans to rob the extraordinarily wealthy Mariette Colet (Kay Francis) to pay for a return trip to Venice with Lily. Things go awry, however: Gaston falls in love with Mariette and is recognized by François (Edward Everett Horton), Gaston's victim in Venice. Realizing that Gaston's profession makes it unfeasible for the couple to remain together, Gaston and Mariette sorrowfully part ways, and Gaston returns to Lily.

Though ostensibly a comedy, *Trouble in Paradise* also offers a subtle yet poignant exploration of the limitations imposed by class difference in the permanent fusion of lovers. Harling's original score reflects Gaston's idealist fantasies of living a life of wealth, romance, and sophistication with a beautiful and perfect woman. In prior Lubitsch musicals like *The Love Parade* (November 1929) and *One Hour with You* (February 1932), song-based themes helped articulate a character's internal state. In a manner similar to these musicals, *Trouble in Paradise* features excerpts of two popular song-based themes—"You'll Fall in Love in Venice" and "Trouble in Paradise."[76] Both songs help demonstrate that Gaston yearns for a lifestyle and lover that are ultimately unattainable to someone of his class.

The audience first sees Gaston as he stands on a balcony staring meditatively into the distance and waiting for the "baroness" (fig. 5.10). An instrumental version of "You'll Fall in Love in Venice" plays on the soundtrack, and it contains a dreamlike quality through strings and high-pitched strumming on both the mandolin and harp (fig. 5.11). Gaston then demands that his butler create a perfect romantic evening worthy of "Casanova, Romeo, Juliet, or Cleopatra." The dreamlike "You'll Fall in Love in Venice" thus initially seems to reflect Gaston's idealist fantasies of romance, sophistication, and perfection. After Lily arrives, "You'll Fall in Love in Venice" more frequently recurs to reflect Gaston and Lily's relation-

FIGURE 5.10 The introduction of Gaston in *Trouble in Paradise*. As Gaston gazes outward toward Venice and contemplates the perfect romantic evening . . .

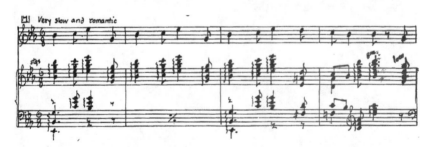

FIGURE 5.11 . . . the dreamy "You'll Fall in Love in Venice" plays on the soundtrack. Immediately, the score helps portray a man who values romance, sophistication, and perfection.
Paramount Pictures Corporation Music Archives, Paramount Pictures, Los Angeles.

ship. The song plays as Gaston removes Lily's wrap, during their ensuing intimate moments in the hotel room, and later in the film when the lovers plan a return trip to Venice. Yet by first associating the theme exclusively with Gaston, the film introduces Gaston as a dreamer. He is a man who yearns for a life that he, as merely a "self-made" crook rather than a man born into high society, can only briefly impersonate.

Gaston's dreams are also implied through the film's second theme, "Trouble in Paradise," which the filmmakers consistently connect to the relationship between Gaston and Mariette. Here the reiteration of the theme often occurs during moments when the film conflates sexual desire and dreams, thus implying that Gaston and Mariette's union must remain a mere fantasy. "Trouble in Paradise" (fig. 5.12) first plays during the opening credits, which include an image underneath the film title of a fancy antique bed floating in the clouds (fig. 5.13). The bed is made for two, which implies sex, but the clouds that surround the bed remind the audience that beds are also places for dreaming.

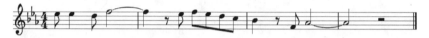

FIGURE 5.12 The eponymous theme song from *Trouble in Paradise*.
Paramount Pictures Corporation Music Archives, Paramount Pictures, Los Angeles.

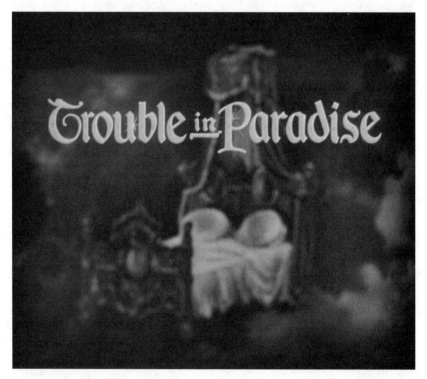

FIGURE 5.13 "Trouble in Paradise" is first heard in conjunction with a bed that floats through the clouds during part of the opening credits.

"Trouble in Paradise" does not play again until after Gaston first meets Mariette, and the filmmakers once again link the theme to a bed. As Mariette searches for her checkbook in the next room, Gaston wanders into what he presumes to be Mariette's bedroom and admires her antique bed, which bears a resemblance to the bed in the opening credits (fig. 5.14). The theme once again accompanies an object related to sex and dreams, but both elements are suggested in other ways here as well. Gaston's wandering uninvited into a bedroom in Mariette's home presumes a heightened level of intimacy, while his open admiration for the bed emphasizes economic disparity: given Gaston's working-class flat, he can only dream about sleeping on such a beautiful bed. Gaston initially enters the room in an effort to find Mariette's safe, but his admiration for the bed squares with the fantasies that the film's dialogue and score have already established.

Later, a string version of "Trouble in Paradise" plays during a sequence in which Gaston and Mariette go out dancing and then nearly succumb

FIGURE 5.14 "Trouble in Paradise" is next heard when Gaston admires Mariette's bed. In conjunction with these two images, the score connects Gaston to sex and dreams, thus indicating his desires and the likely impossibility of his obtaining them.

to sexual temptation. Once again, "Trouble in Paradise" corresponds to a merging of sex and dreams. As the camera stays resolutely fixed on a clock in Mariette's home, she and Gaston return from their night out and Gaston tells her, "You dance like a dream." When the two finally go to their separate rooms, lush strings play "Trouble in Paradise" as Gaston nearly enters Mariette's bedroom, and Mariette—the audience then learns—waits to lock her bedroom door until Gaston has closed his. By frequently playing "Trouble in Paradise" during these evocations of both dreams and sex, the score indicates that Mariette constitutes the perfect, dreamlike lover that Gaston has always sought, yet lightly implies that their union must remain a mere fantasy.

The impossibility of their union is verified in the penultimate scene, in which Gaston is forced to admit to Mariette that he is a notorious thief. In dialogue that again connects their relationship to dreams, Gaston explains, "Tomorrow morning, if you should wake out of your dreams and hear a knock, and the door opens, and there, instead of a maid with a breakfast tray, stands a policeman with a warrant, then you'll be glad that you were alone." Yet Gaston's criminal status alone does not account for his necessary departure. The film also reveals a class bias in Mariette. When Gaston informs her that Giron (C. Aubrey Smith), a trusted friend of Mariette's family, has been robbing her for years, she refuses to report Giron to the police owing to his stature and close friendship with the family. Gaston retorts, "I see. You have to be in the social register to keep out of jail. But when a man starts from the bottom and works his way up, a self-made crook, then you say, 'Call the police, put him behind bars, lock him up.'" This speech, like much of the dialogue, is mildly tongue-in-cheek, and one could argue that Gaston is merely scheming to keep himself out of jail. Yet his claim about economic privilege remains entirely consistent with his working-class flat. The score has helped to foreground his idealist equation of happiness, beauty, and romance with wealth and privilege. *Trouble in Paradise* thus becomes a film that is not merely about the yearnings of a thief but explores the desires of any lower- and middle-class person who might envy the advantages of the wealthy.

In *Trouble in Paradise*, nondiegetic music moves even more firmly toward the depiction of dreams, desires, and psychological states. Harling matches Gaston's idealist and unattainable dreams with ephemeral, affective music detached from the diegesis. Around the same time, Para-

mount released a far odder film with music that evokes very different psychological states.

BLONDE VENUS AND ALTERED EMOTIONAL STATES

As scholars have pointed out, *Blonde Venus* defies any straightforward reading, sending out cues and suggestions that pull the viewer toward contradictory interpretations.[77] This is partly due to script revisions demanded by both the MPPDA and Paramount studio chief B. P. Schulberg.[78] It is also partly due to director Josef von Sternberg's tendency to present key character decisions offscreen. Such a method resulted in a disjointed narrative containing elements of maternal melodramas, the "fallen woman" genre, and backstage musicals. Yet this disjunctive quality serves the film's purposes, as it helps depict the unreal aura of new love, the nightmarish deterioration of a family, and ultimately the importance of maintaining the fiction of enduring love. Music, with its connotations in the period of fantasy and a removal from reality, becomes an important collaborator in conveying such themes.

In *Blonde Venus*'s opening scene Ned (Herbert Marshall) and his friends discover six showgirls swimming naked in Germany's Black Forest. Ned immediately falls for a showgirl named Helen (Marlene Dietrich) and refuses to go away unless she agrees to see him after her evening show. The film abruptly dissolves to New York City some time later: Helen and Ned are married with a five-year-old named Johnny (Dickie Moore). Ned has contracted a life-threatening illness and needs money for treatment in Europe. Helen returns to the stage and receives a substantial sum of money from a millionaire named Nick (Cary Grant), implicitly for sleeping with him. Ned travels to Europe for treatment, and Helen begins seeing Nick regularly, even moving into an apartment that Nick has paid for. When Ned returns early from Europe, he learns of Helen's infidelity and orders Helen to give him Johnny and leave for good. Instead, Helen takes Johnny and flees south. The trip becomes increasingly nightmarish for Helen. With the police on her trail she has difficulty finding work and eventually—the film implies—turns to prostitution. Deciding that she is "no good," she gives Johnny to Ned and then, in a startling reversal depicted only in a short montage, sails to Paris and becomes a major musical star. There she meets Nick again, and the two become engaged and sail back to New York City. Nick arranges for Helen

to see Johnny. After bathing Johnny and putting him to bed, Helen and Ned apparently reunite for good.

Blonde Venus features three Dietrich cabaret numbers, which might lead one to categorize the film as a musical. I am discussing the film in this chapter, however, because it had little in common with contemporary musicals. Rather than featuring an integration of numbers and narrative, as was the case for musicals like *One Hour with You, Love Me Tonight* (August 1932), or *The Big Broadcast* (October 1932), *Blonde Venus*'s numbers have little connection to the film's narrative development. Perhaps for this reason period reviews generally did not describe *Blonde Venus* as a musical.[79] Moreover, much of the film's music occurs during dramatic scenes, which links *Blonde Venus* to other dramatic films during the period.

The nondiegetic music in the film's opening scene helps suggest that love-at-first-sight encounters hold little connection to the realities of quotidian existence. Ned and his friends' discovery of six naked showgirls swimming in the middle of a forest constitutes an almost too-perfect erotic fantasy. The continuous music consists of Felix Mendelssohn's "Rondo capriccioso," a brisk frolicking tune featuring light dance-like bow strokes on the strings. This sprightly music—which bears a resemblance to Mendelssohn's overture to William Shakespeare's otherworldly comedy *A Midsummer Night's Dream*—encourages the audience to view *Blonde Venus*'s opening scene as a playful, fantastical situation divorced from everyday reality. Indeed, when the scene dissolves to a shot of Johnny playing in the bathtub, the film portrays the harsher realities of their existence: Helen undertakes the unglamorous task of bathing Johnny and putting him to bed (bathing has been transformed into a sign of domesticity); Ned worries about financially supporting Helen and Johnny; and the family lives in a cramped New York City apartment. Except for a token strain of James W. Blake and Charles B. Lawlor's "The Sidewalks of New York" to signify the location shift, these early urban sequences feature very little music. The shift from vivacious music to no music at all implies that Helen and Ned's first meeting was an aberration, merely a brief period of sexually charged desire. The challenges associated with money and raising a child are the reality. The film further removes the circumstances of their meeting from the real world by revealing that their first encounter has literally been transformed into a fairy-tale bedtime story for Johnny, with a dragon substituted for the taxicab and princesses swapped for showgirls. Mendelssohn's music in the opening

scene thus helps create a striking separation between the fantasy of court-ship and the reality of life.

When Helen flees with Johnny to the South and descends into poverty and prostitution, the film increasingly presents scenes that are fragmented and not fully connected by a clear plotline. This is at least partly due to the MPPDA's objections to von Sternberg's original script. For instance, in the original script a police officer arrests Helen for prostitution, and Helen appears in court in the next scene.[80] The MPPDA would not ap-prove such a scenario, however, and in the final version Helen appears in court for "vagrancy," with no depiction of her actual arrest. The elimina-tion of key explanatory scenes characterizes the discontinuity of Helen's flight. Often, an image shows a wire report revealing her last-known whereabouts before dissolving to a scene with Johnny and her in an entirely different location. At one point an undercover policeman unwittingly tells Helen that she narrowly evaded the police in Baton Rouge, yet this is the audience's first indication that Helen had even been in that city.

These continuity gaps demand that the audience fill in the blanks with likely (and illicit) explanations, thus enabling the film to evade censor-ship. Yet this fragmented narrative also helps subjectively articulate the surreal downward spiral of Helen's life. Further indicating Helen's dete-riorating mental state, Harling provides ominous music cues during three montages of Ned's and the authorities' pursuit of Helen and a later moment in which a train takes Johnny away from Helen. These cues em-ploy standard signifiers of danger and gloom: chromatic, dissonant brass passages; string tremolos; and fast, insistent rhythms. Though the film depicts Helen attempting to remain a diligent mother during her flight from Ned, it suggests that her poverty and forays into prostitution render it impossible for her to keep Johnny and raise him responsibly. The dis-continuity and foreboding music cues can thus be read as an expression of Helen's mental state as she gradually realizes that she must forever give up her son. Music, with its connotations in the period of altered states of reality, helps describe Helen's dismal downward trajectory.

This leads to the film's unsettling conclusion, in which Helen returns to Ned. As played by Marshall and directed by von Sternberg, Ned comes across as a vindictive, cruel, and bitter man, thus making Helen's deci-sion somewhat difficult to accept. Ned displays no sympathy or under-standing toward Helen after her infidelity, despite the fact that Helen did it to save his life. Instead, Ned repeatedly directs vitriolic accusations and

insults at her, and he tries to teach Johnny to forget his mother entirely. Von Sternberg also goes to great visual lengths to prevent viewers from identifying with Ned, initially introducing him with his back to the camera and later cloaking his eyes in shadow during several key scenes, a highly unusual strategy in the period.

Though the narrative contains no explicit explanation for Helen's decision to return to such an unsympathetic man, the score's final moments help suggest that Helen returns exclusively for Johnny's well-being. Early in the film, Helen and Ned tell Johnny the fairy-tale version of their first meeting, and then Helen sings Johnny the German lullaby "Leise zieht durch mein Gemüt," by Mendelssohn, and turns a music box featuring six angels, which matches the number of women swimming at the beginning of the film. In the film's final scene Helen retells the fairy-tale story to Johnny and then turns the music box and sings the lullaby twice—the first time for Johnny and the second time while looking pleadingly at Ned. By having Helen sing a song associated with Johnny and fairy tales, the film suggests that she wishes to remain with Ned to preserve the fairy tale of their continued love for Johnny's sake.

The final shot reaffirms this: as Johnny drifts toward a comfortable sleep, his subjective shot shows his hands reaching through the bars of his crib and lovingly stroking the spinning angels. The shot indicates that Johnny's comfort and happiness is tied closely to his belief in the fairy tale of his parents' love for each other. During this shot the lullaby takes over the nondiegetic soundtrack, thus providing a definitive statement. The music implies that Helen stays with Ned to perpetuate her child's belief in fairy-tale explanations. She wants him to still believe that his parents love each other, even though they do not. Even in a film as unusual and contradictory as *Blonde Venus*, when the time came to portray inner emotions, desires, and fantasies—including the bedazzling state of infatuation, the horror of poverty and the loss of a child, or the recognition that fantasies must be maintained for the good of a child—the filmmakers adhered to the period tendency to tie nondiegetic music to heightened internal "other worlds."

CONCLUSION

The emerging use of nondiegetic music to depict other worlds reveals a shift in assumptions regarding whether and when nondiegetic music is

acceptable in a sound film. As we saw in chapter 3, from 1929 to 1931 film-makers reduced nondiegetic music partly to ensure the clear presentation of a diegetic sound space. Yet doing so marginalized a key tool for the generation of affect. From 1931 to 1933 filmmakers offered a solution to this problem. When films began drifting away from real-world, physical, familiar referents, filmmakers increasingly used music that was similarly disconnected from the "real world" of the diegesis. Through the use of a nondiegetic score Hollywood could convey less tangible qualities like exoticism, fantasies, dreams, and desires. The industry thus gained a key tool for the latter half of Hollywood's ever-present dialectic: to present a "realistic," recognizable physical environment while simultaneously entertaining audiences through wish fulfillment and the depiction of the unusual.

From a historiographical perspective this increasing use of nondi-egetic music demonstrates that aesthetic "progress" often involves a movement backward to prior models as much as it constitutes an innova-tive move forward. On the one hand, the escalation of nondiegetic music seems to move the film score closer to the Golden Age of film music, which featured extensive, narratively attentive music with little grounding in the diegesis. Yet this increase was accompanied by several techniques that stemmed from silent era practices, including a heavy reliance on themes, a continued use of preexisting music, and a periodic tendency to "catch" screen actions. Perhaps the most salient throwback to the silent era was the period's occasional use of continuous or near-continuous scores, a tactic that also harkened back to accompaniment practices in early synchronized films. Even the increased use of music in conjunction with dreams and fantasies arguably brought the audience closer to a si-lent film experience. Many elements of late silent American cinema—in-cluding the lack of diegetic sound, soft-style cinematography, and a heavy reliance on superimpositions—distanced the medium from a "faithful" depiction of reality and brought cinema closer to the quality of dreams or fantasies.[81] These elements were interrupted by the "realism" of synchro-nized sound, which added a previously unused dimension of reality to the cinema and initially focused on recording and presenting a variety of diegetic sounds. By using nondiegetic music to depict other worlds, the early 1930s score helped to partially return cinema to a medium of dreams and rapture. Stylistic progress, in many respects, stemmed from a reuse of older methods in new contexts.

Culturally, this musical focus on exoticism, fantasy, and dreams helped audiences both escape from their known reality and explore familiar emotional states. In films like *Bird of Paradise, Mr. Robinson Crusoe*, and *Chandu the Magician* music portrays exotic worlds of adventure, romance, and—especially in the South Seas films—near paradise. Along with better-known elements of 1930s cinema like glamorous movie stars, elaborate art deco sets, and opulent movie palaces, the film score must be seen as an important tool in the early part of the decade for the creation of escapist cinema. But if music could convey exoticism and adventure, it could also help portray poverty or economic lack. In *Symphony of Six Million* Yiddish music helps communicate the importance of helping community members in need. *Trouble in Paradise* uses music to transport audiences into the mind of a character whose yearnings for a wealthy and beautiful lifestyle would have resonated with Depression-era audiences. *Blonde Venus*'s music conveys the emotional horror of descending to abject poverty and being unable to care for one's own child, a situation that surely reflected the realities or fears of many audience members.

In short, early 1930s film music may have helped transport audiences to environments different from the mundane physical reality of the Depression, but some of these places or states of mind also constituted reflections and explorations of the current cultural environment. Writing about 1930s American cinema more broadly, film historian Andrew Bergman asserts, "People do not escape into something they cannot relate to. Movies [in the 1930s] were meaningful because they depicted things lost or things desired. What is 'fantastic' in fantasy is an extension of something real."[82] Though film music portrayed worlds separated from urban life, it also conveyed fantasies and heightened mental states that nevertheless would have been relatable to many audience members.

The association between music and other worlds remained a general tendency rather than a solidified convention in the early 1930s. For instance, while Universal horror films like *Dracula* (February 1931) or *Frankenstein* (November 1931) would seem to be good candidates for non-diegetic music because of their presentations of supernatural scenarios, the films' relatively low budgets likely explain their avoidance of this device.[83] Instead, as film historian Robert Spadoni has demonstrated, other elements like muteness and the separation of voice and body helped convey a sonic "uncanny" or "otherworldliness."[84] Studio policies and a film's urban setting could also deter filmmakers from using extensive

nondiegetic music. Warner Bros.' *Scarface* (March 1932) might seem an appropriate film for nondiegetic music because of its concentrated focus on Italian American culture and organized crime. Yet by 1932 Warner Bros. had moved away from nondiegetic music. This, combined with the film's urban Chicago setting, all but guaranteed the near exclusion of nondiegetic music in the film. Similarly, the lives of the wealthy in a film like RKO's *The Animal Kingdom* (December 1932) may well have seemed like an "other world" to many moviegoers. Yet despite being produced by Selznick and featuring Steiner as music director, the film's setting in and near New York City precludes the use of nondiegetic music.

Still, by early 1933, audiences would have been conditioned to expect the film score—when it was used—to relate to unfamiliar worlds of exoticism and adventure or to internal worlds of dreams and desires. These associations would have a decided impact on *King Kong* in March of 1933, which features one of the most analyzed and revered scores in film history.

6. REASSESSING *KING KONG*; OR,

THE HOLLYWOOD FILM SCORE, 1933–1934

FOR MANY SCHOLARS MAX STEINER'S MUSIC FOR RKO'S *KING Kong* (March 1933) definitively and single-handedly marks the emergence of the classical Hollywood score. Music scholar Christopher Palmer describes *King Kong*'s score as a "landmark," stating that it "marked the real beginnings of Hollywood music."[1] Laurence E. MacDonald similarly uses the word *landmark*. He calls *King Kong*'s score "the single most outstanding film-music accomplishment of the early 1930s" and claims that it "helped pave the way for all of the composers who worked in film during the Golden Age of Hollywood."[2] Recent studies of film music continue to assert the primacy of *King Kong*'s score in film history. In *A History of Film Music*, published in 2008, Mervyn Cooke declares that *King Kong* "almost single-handedly marked the coming-of-age of nondiegetic film music."[3] For scholars and film music aficionados alike, the notion that *King Kong* began the era of sound film music remains a cornerstone of American film history.

With rare exceptions, however, claims for *King Kong*'s historical importance occur in studies that display little or no awareness of the film scores discussed in the preceding chapters. When situated within the context of these other scores, *King Kong*'s place in film music history

changes radically. The first half of this chapter reassesses scholarly claims regarding *King Kong*'s score in light of the previous chapters in this study. Rather than offering a brand-new film scoring method, *King Kong* constitutes a continuation of an early sound film tendency, discussed in the previous chapter, of tying film music to "other worlds" of fantasy. Similarly, while scholars claim that *King Kong*'s use of an original symphonic score, deployment of musical themes, and musical attention to narrative events initiated the classical Hollywood score, these elements were not new to *King Kong*. Instead they had been used extensively in earlier scores, including those composed by Steiner. Ironically, the elements of *King Kong*'s score that *were* unusual for the period—particularly the presence of harsh, dissonant chords and the use of music to convey scale—generally did *not* find their way into subsequent classical Hollywood scores. My intent here is not to deride *King Kong*'s impressive score but to situate it within its historical context in order to demonstrate the already rich sound film traditions from which it emerged.

The second half of this chapter examines *King Kong*'s influence on film music in the year following its release. Despite frequent claims to the contrary, *King Kong*'s musical techniques had little immediate impact on subsequent film scores. Though the 1933–34 season featured an increase in nondiegetic music and a tendency to tie such music to other worlds, this was a continuation of general early 1930s film music practices and does not constitute evidence of *King Kong*'s overwhelming influence. Moreover, *King Kong*'s more unusual musical strategies—particularly the close and regular synchronization between music and narrative cues—remain absent from the vast majority of scores in the 1933–34 season.

Music and Fantasy in *King Kong*

To reassess the nature of *King Kong*'s contributions to film music history, one must first examine the range of innovations currently ascribed to *King Kong* by film music scholars. Of all the score's techniques, perhaps the most commented-upon element has been *King Kong*'s linkage between nondiegetic music and fantasy elements in the film's narrative. *King Kong*'s opening scenes—which depict harsh, pragmatic realities in an urban setting—feature no music of any kind. In New York City, filmmaker and explorer Carl Denham (Robert Armstrong), fearing trouble

from the authorities, must quickly find a leading lady for his next film before sailing with his production crew to unknown waters. On a city street Denham encounters Ann Darrow (Fay Wray) when she swoons from hunger. He offers her the job, which she accepts.

King Kong continues to avoid music during the next few scenes, which depict the ship's voyage. When the ship approaches the mysterious, mist-shrouded Skull Island, however, nondiegetic music occurs for the first time. Nondiegetic music continues during nearly all of the fantastical scenes on Skull Island. The party arrives on the island and witnesses a tribal ceremony in which a young native woman is being prepared as a bride for Kong. The native chief (Noble Johnson) sees Denham, halts the ceremony, approaches the party menacingly, and forces them to leave. That night, the natives abduct Ann from the ship, open the giant doors, and lead her up some steps where she is tied to two posts as an offering to Kong. Kong appears and takes Ann to his lair. Along the way, Kong fends off many aggressors, including a tyrannosaurus. Denham and company set off in pursuit, but they are thwarted first by a brontosaurus and then by Kong himself, who sends everyone in the search party but Denham and Ann's love interest, Jack Driscoll (Bruce Cabot), to their deaths. Upon reaching his lair in the side of a cliff, Kong partially disrobes Ann and tickles her. Driscoll saves Ann from possibly worse fates, and he and Ann escape Kong by climbing down a vine. Enraged at losing his prize, Kong breaks open the giant doors and destroys the native village before being subdued by a gas bomb and captured by Denham. With the exception of the tyrannosaurus battle, nondiegetic music accompanies all of these outlandish Skull Island sequences.

Music continues through many of the final scenes set back in New York City, where the marvelous world of Skull Island and the familiar, modern environment blur together. Denham shackles Kong, brings him back to New York City, advertises him as the Eighth Wonder of the World, and displays him to an astonished theater audience. Wrongly believing Ann to be in danger, Kong breaks free of his shackles and goes on a rampage through New York City. Eventually finding Ann, Kong grabs her and climbs to the top of the Empire State Building. Kong's concern for Ann becomes his undoing: he puts Ann down to keep her out of danger from approaching airplanes, and the pilots take advantage by shooting him and mortally wounding him. Kong picks up Ann one final time and lovingly pets her before plunging to his death. With the exception of Kong's

battle with the airplanes, music plays continuously throughout these final, fantasy-infused New York City sequences.

For some scholars, *King Kong*'s connection of nondiegetic music to fantasy helps evoke the island's unreal, irrational aura. Film music historians James Buhler, David Neumeyer, and Rob Deemer contrast the opening New York City scenes with the island. Where the early New York City scenes feature no music and thus constitute a "rationally organized sound space," the island uses extensive sound effects and nondiegetic music to foster the sense of a "primitive, pre-rational (because pre-linguistic)" and enchanted space. Though music is anchored once more to the diegesis back in the New York City theater, the authors point out that when Kong breaks free of his shackles, nondiegetic music again reigns supreme. Musically, as well as narratively, New York City reverts to a prerational state. The authors thus argue that throughout *King Kong* the presence of nondiegetic music helps evoke a world of fantasy and irrationality.[4]

Musicologist Robynn Stilwell similarly sees *King Kong*'s music as evoking an aura of fantasy, but she focuses on the liminal boundary between diegetic and nondiegetic music. Stilwell points out that when Denham and company arrive on the island, the music is difficult to classify. The image depicts native dancing and drumming, while the soundtrack features brass, strings, and woodwinds, in addition to drums. Such music is not precisely diegetic, as it features instrumentation plainly not visible in the image or likely in that setting. Yet it is not exactly nondiegetic either, because it retains clear connections to the dancing and drumming. Stilwell describes this as a "fantastical gap" between diegetic and nondiegetic boundaries. She writes, "The phrase 'fantastical gap' seemed particularly apt for this liminal space because it captured both its magic and its danger, the sense of unreality that always obtains as we leap from one solid edge toward another at some unknown distance and some uncertain stability—and sometimes we're in the air before we know we've left the ground."[5]

Such claims typify the general scholarly approach to *King Kong*. Though both analyses of music and fantasy are accurate and astute, the scholars' decision to discuss *King Kong* and not an earlier film score perpetuates the scholarly neglect of earlier uses of film music. As we saw in chapter 5, the absence of music in a "realistic" urban environment and its presence in an exotic fantasy world were already fairly standard practices in

1931 and especially 1932. What marked *King Kong* as unusual was not a *musical* decision to tie music to fantasy but rather a *narrative* decision to depict urban reality and exotic fantasy in the same film and to blend them together in the final act. Though previous films like Paramount's *Tabu* (March 1931), RKO's *Bird of Paradise* (August 1932) and *The Most Dangerous Game* (September 1932), United Artists' *Mr. Robinson Crusoe* (September 1932), and Fox's *Chandu the Magician* (September 1932) had used music to imply a separation from known urban reality, they avoided depicting the modern world. *Bird of Paradise* even excised the scene from the play version in which Johnny brings Luana back to the United States. *King Kong*, by spending ample time in both "realistic" *and* fantastical locations, makes their division and eventual blurring a major theme in the film. Yet musically, Steiner's score reiterated earlier practices pertaining to the use and nonuse of music rather than forging a new purpose for film music.

If Steiner's use of music for *King Kong*'s fantasy scenes fit within period practices, so, too, did his use of music to create what Stilwell would later call the "fantastical gap" between diegetic and nondiegetic music. This tactic epitomizes what I have termed "diegetic withdrawal"—the practice of featuring music with a possible source in the image before allowing music to drift into clearer nondiegetic terrain. In choosing to use ambiguously designated music early in the film, Steiner adheres to this popular early sound era strategy. Steiner's use of the "fantastical gap" between diegetic and nondiegetic boundaries is unusually nuanced for the period, as it makes especially clever use of implied music generated by the natives. Yet, conceptually, diegetic withdrawal was common well before *King Kong*'s release.

Other scholars focusing on music and fantasy in *King Kong* have instead stressed music's role in the audience's suspension of disbelief. Palmer writes that *King Kong*'s score "demonstrates, for the first time in the 'talkies,' that music has the power to add a dimension of reality to a basically unrealistic situation: in this case the survival of prehistoric monsters . . . in a modern urban civilization."[6] Cooke, after mentioning the "producers' concern that their animated gorilla puppet would provoke laughter rather than terror," states that *King Kong*'s "nondiegetic music is therefore a *locus classicus* of the promotion of suspension of disbelief."[7] Claudia Gorbman and Kathryn Kalinak reach a similar conclusion by focusing on the logic behind the presence and absence of music.

Describing *King Kong*'s first use of nondiegetic music, Gorbman writes, "The music initiates us into the fantasy world, the world where giant apes are conceivable, the underside of the world of reason. It helps to hypnotize the spectator, bring down the defenses that could be erected against this realm of monsters, tribesmen, jungles, violence."[8] Kalinak affirms the purpose of this musical entrance: "The presence of music signaled the entry into the fantastic realm, facilitating the leap of faith necessary to accept Kong as real. The score became a crucial element in films of this genre where music inherited the responsibility of creating the credible from the incredible."[9] For all these scholars *King Kong*'s historical importance lies in its use of music to absorb audiences in the narrative and make them forget the patent unreality of the situation.

The use of music to suspend disbelief admittedly has less of a lineage in earlier sound scores. Though a film like *Chandu the Magician* had already featured a supernatural tale in conjunction with extensive music, such fantastical plots were sparse in the early sound era. Yet the very notion that *King Kong*'s nondiegetic score helps audiences to accept the fantasy world of Skull Island deserves closer scrutiny. Like many aspects of early sound film music scholarship, this claim can be traced to Steiner himself, who suggests in his memoirs that the producers wanted a score because they were concerned that "the gorilla looked unreal and that the animation was rather primitive."[10] Period reviews, however, indicate that the audience's acceptance of *King Kong*'s "monsters" remained an issue even with the addition of extensive music. *Variety* reported that it took "a couple of reels" for the audience to become "used to the machine-like movements and other mechanical flaws in the gigantic animals on view" and later writes: "A most tolerant audience at the Music Hall broke down now and then, but on the whole was exceedingly kind." The reviewer also states that the most convincing illusion in the film was the Kong-tyrannosaurus fight, which is the only scene on Skull Island that *lacks* music.[11] It is thus difficult to assess whether—or to what extent—*King Kong*'s score truly popularized the notion that a film score could aid in the willing suspension of disbelief. At the very least, pre–*King Kong* scores demonstrate that the use of nondiegetic music to convey an unfamiliar, exotic, or fantastical world was not a concept that sprang full-blown from the heads of *King Kong*'s filmmakers. Rather, it was a logical application of a preexisting film music assumption.

KING KONG: THE BIRTH OF THE GOLDEN AGE?

Many scholars assert that *King Kong*'s score constituted the birth of the classical Hollywood score, inaugurating the Golden Age of film music. This section outlines several key areas in which *King Kong*'s music ostensibly points toward this practice. While *King Kong* does indeed feature several attributes of the Golden Age, these were not particularly new or original. Moreover, in some cases the score uses techniques that would *not* reflect subsequent film music practices.

Original, symphonic music. For some scholars, Steiner's score constitutes a watershed moment owing to its presentation of original music. Writing in 1979, film music historian Tony Thomas claims that *King Kong* "left no doubt in any producer's mind about the value of original music in filmmaking."[12] Though not quite as definitively, Royal S. Brown similarly asserts, "The original music by the specially bred composer that perhaps more than any other launched the classical film score was Max Steiner's *King Kong*."[13] A recent film history book by musicologist James Wierzbicki stresses the importance of *King Kong*'s use of original *and* symphonic music. Though Wierzbicki acknowledges Steiner's previous scores for *Symphony of Six Million* (April 1932), *Bird of Paradise*, and *The Most Dangerous Game*, he still claims that Steiner's score for *King Kong* was his breakthrough because it established the "'symphonic-yet-original' model that Hollywood film music would follow for the next several decades."[14]

Why *King Kong*'s original music should be especially noteworthy, however, remains unexplained in these accounts. As I indicated in chapter 5, original music had been on the rise well prior to *King Kong*'s score. Not only had several previous Steiner scores featured predominantly original music, but films such as United Artists' *Street Scene* (August 1931), Paramount's *Blonde Venus* (September 1932), and Paramount's *Trouble in Paradise* (October 1932) had also made key use of original compositions. Though many films in the past few years had continued to use preexisting music, original music would not have been viewed as especially innovative.

The belief that *King Kong* holds importance for its "symphonic" qualities may stem from Steiner's memoirs, where he states that the score required an eighty-piece orchestra. This number is indeed large, as it approaches the size of a full symphony orchestra, which typically features around one hundred members. Scholars have since determined, how-

ever, that Steiner greatly exaggerated this number, placing it instead at forty-six pieces.[15] This was still a substantial orchestra for the period, but it hardly constitutes a radical change to film music practices. In the previous year, for instance, RKO's *Symphony of Six Million* score featured an orchestra of thirty-five, and Paramount's *The Big Broadcast* (October 1932) boasted a twenty-eight-piece orchestra.[16] *King Kong*'s orchestra size, though large, would not have signaled a new film music approach.

Two-themed opening credits music. According to Cooke, "Kong illustrates all the features that were to remain typical both of Steiner's dramatic scoring in particular and Golden Age narrative music in general."[17] First on Cooke's list of typical Golden Age features is the film's two-themed opening, which "presents two contrasting idioms, one aggressive (the monster) and the other romantic (the object of his affection)."[18] *King Kong*'s title scene indeed offers two clearly contrasting idioms: fast-paced, brass-heavy music during the opening credits and a slower, lushly orchestrated string-oriented passage over a subsequent title card featuring a quotation. As I demonstrated in chapter 3, however, the use of opening music to preview a central theme was an established characteristic of films from 1929 onward. Even the specific strategy of presenting two contrasting musical idioms during the opening credits had been fairly typical beginning in 1929, and Steiner's score merely continues this strategy.

Themes. For many scholars *King Kong*'s use of themes—especially a three note descending motive that denotes Kong (fig. 6.1)—constitutes a key precursor to classical film music practice. Palmer, in a chapter revealingly titled "Max Steiner: Birth of an Era," notes the presence of Kong's theme in a variety of circumstances, including Kong's first appearance, his escape from the New York City theater, and the moments just prior to his death. Palmer focuses especially on the use of themes to articulate inner feelings, arguing that just before Kong falls to his death, "The Kong theme and Fay Wray theme . . . actually converge and become one, thus musically underlining the explicitly-stated parallel between the story of King Kong and Ann Darrow and the old fairy-tale of Beauty and the Beast. Here the music is required, perhaps for the first time in an American film, to explain to the audience what is actually happening on the screen, since the camera is unable to articulate Kong's instinctive feelings of tenderness towards his helpless victim."[19] Cooke also remarks upon the use of Kong's theme, describing it as a feature of the Golden Age and making similar comments about its recurrence.[20]

FIGURE 6.1 The "Kong" theme from *King Kong*.
Transcribed from Platte, "Musical Collaboration in the Films of David O. Selznick," 66–67.

Such claims for *King Kong*'s usage of musical themes, though not in-accurate, distort the score's historical importance and the nature of *King Kong*'s score as a whole. As my previous chapters have demonstrated, themes were common in sound film well before 1933. Even films containing very little music often featured at least one repeated theme. In the year prior to *King Kong*, themes had played key roles in genres ranging from musicals (Paramount's *One Hour with You* [February 1932]) to dramas (Paramount's *A Farewell to Arms* [December 1932], Columbia's *The Bitter Tea of General Yen* [January 1933]), not to mention Steiner's own 1932 scores.

More problematic still, discussions of *King Kong*'s themes tend to suggest that each theme is clearly differentiated. In a highly unusual move for the period, however, Steiner frequently blends the film's three major themes: "Kong," Ann's theme—known as "Stolen Love" in the original score[21] (fig. 6.2)—and "Jungle Dance" (fig. 6.3). Music scholar Peter Franklin points out that all three themes derive from the same descending three-note figure denoting Kong.[22] Consequently, Steiner often produces music that seems to consist of a single cohesive musical idea yet features a mix of themes. During the ceremony in which the natives offer Ann to Kong, for instance, the modulation from "Jungle Dance" to "Stolen Love" and back to "Jungle Dance" is so smooth that the passage plays like a single piece in sonata form, with an exposition, development, and recapitulation. Then, just after Kong first appears onscreen, "Stolen Love" is repeated rapidly, with the first note of every other repetition beginning a half step higher on the scale. When the music reaches its highest note and begins what one might expect to be the final reiteration of "Stolen Love," the subsequent descending melody shifts to Kong's theme. Capitalizing on the similar downward contours of its three main melodies, *King Kong* often blends its themes rather than marking a clear separation between them.

Such blurring was rare in the early sound era, which almost universally featured clearly individuated themes. Yet this blurring would *also* be rare in the Golden Age, which far more commonly continued to pres-

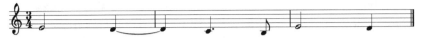

FIGURE 6.2 The "Stolen Love" theme from *King Kong*.
Transcribed from Platte, "Musical Collaboration in the Films of David O. Selznick," 66–67.

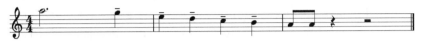

FIGURE 6.3 The "Jungle Dance" theme from *King Kong*. "Kong," "Stolen Love," and "Jungle Dance" all feature a lengthy first note followed by a descending scale. This enables Steiner to weave together the themes in a manner that sometimes renders them difficult to distinguish.
Transcribed from the conductor's score, *King Kong* music files, Special Collections, Charles E. Young Research Library, UCLA.

ent identifiable and clearly distinguishable themes. Ironically, considering *King Kong*'s reputation as the first classical Hollywood score, one of its musical features that truly *was* unusual in the period would generally *not* characterize subsequent practice.

Mickey-mousing. In addition to themes, scholars single out *King Kong*'s use of mickey-mousing as a key attribute of the narrative cueing tendencies of the Golden Age of film music. Gorbman, for instance, points to the moment when the native chief walks toward the island's visitors, and the music matches each of his steps. Nathan Platte also sees Steiner's mickey-mousing as an ingredient of the Golden Age of film music, and MacDonald argues that the "split-second synchronization of music with visual movement" is "perhaps the single most noteworthy aspect of Steiner's score for *King Kong*."[23]

King Kong's musical attention to narrative via mickey-mousing indeed constitutes a central music tactic. Escalating the mickey-mousing techniques found sporadically in his own previous scores as well as in musicals like Paramount's *Love Me Tonight* (August 1932) and *The Big Broadcast*, Steiner makes the close synchronization between music and action a consistent priority in *King Kong*. Seemingly every prominent upward or downward movement in the image receives a corresponding rise or fall in the music, including Ann's forced march up the steps to be sacrificed, the brontosaurus's periscope-like rise out of the water, and Ann and Driscoll's climb down a vine to escape Kong's lair—to name only a few.

Other types of action are also given mickey-mousing: sharp sforzandos when Driscoll jabs Kong's fingers with a knife, harp plucks (reminiscent of Jeanette disrobing in *Love Me Tonight*) when Kong plucks off Ann's clothing, trills when Kong tickles her, and cymbal crashes when Kong breaks free of his shackles in the New York City theater.

But Steiner's enormous amount of mickey-mousing in *King Kong* ultimately *distances* the score from musical practices of the Golden Age. Where typical scores from the Golden Age use only occasional mickey-mousing, Steiner seizes virtually every opportunity to match music with a salient screen action. Cooke implicitly acknowledges this: "Steiner's score seems dated . . . in its slavishly graphic mickey-mousing."[24] Steiner's mickey-mousing is so extensive that this aspect of the score arguably holds more in common with the nickelodeon era's interest in catching falls and cartoons' tight synchronization between music and action than with the subsequent strategies of classical Hollywood music.[25]

Music and sound effects. Along with mickey-mousing, scholars have suggested that *King Kong* broke new ground via the score's generation of sound effects. Film music scholar Mark Evans writes that the score "contained a vast number of musical sound effects, all invented by Steiner."[26] Though Evans provides no specifics, he may be referring to such instances as the low-pitched, rumbling brass signifying Kong's offscreen footsteps just before he appears onscreen for the first time, or the cymbal crash that stands in for the sound of his breaking the bar of the great doors later in the film. If so, Evans's claim that Steiner "invented" all the orchestra-generated sound effects constitutes a clear overstatement. Chapter 2 demonstrated that orchestras in late silent and early synchronized films regularly mimicked narrative sound effects in a manner similar to *King Kong*. For instance, Warner Bros.' *The Better 'Ole* (October 1926) features timpani strikes for the sound of cannon blasts, and Universal's *Uncle Tom's Cabin* (November 1927) and *The Man Who Laughs* (April 1928) both use cymbals to denote the shattering of glass. What is more unusual is the use of orchestral effects for *offscreen* sounds like Kong's footsteps. Where early synchronized films generally used orchestral sound effects to illustrate implied onscreen sounds, here the orchestra attends also to suggested offscreen sound events. Steiner thus adopts a previous technique (orchestral sound effects) to service the sound era's newfound interest in creating a diegetic soundscape.

Other scholars have focused on the score's coordination with non-orchestra-generated sound effects. *King Kong* featured an unprecedented amount of postproduction sound manipulation to generate the noises of the island "monsters," and scholars laud the score's awareness of other sound elements. Cooke, for instance, claims that *King Kong*'s score constitutes a "landmark" partly as a result of the innovative idea of stopping the music during Kong's airplane battle so as to allow the "deafening sound of the biplanes' machine guns" to dominate the soundtrack.[27]

Once again, however, while *King Kong*'s score accommodated probably an unprecedented amount of sound effects, its methods for doing so were not especially innovative. *King Kong*'s music is coordinated with sound effects in three main ways. First, music ceases entirely during Kong's sound-effects-laden battles with the tyrannosaurus and the airplanes. This tactic dates back to early synchronized films such as Warner Bros.' *Old San Francisco* (June 1927) and MGM's *Speedway* (September 1929), which halted music for an entire reel to showcase then-innovative sound effects. Second, Steiner occasionally provides a brief pause in the music in coordination with a prominent sound effect. For instance, when Kong is first introduced, the score provides three deep notes played by brass to denote his footsteps and then pauses to allow Kong's first roar to be clearly heard before continuing with notes played by the brass. Such musical pauses for sound effects, though not common, can be found in films prior to *King Kong*. They are perhaps most notable in Steiner's own score for *The Most Dangerous Game*, which features musical pauses to accentuate key sound effects (see chapter 5). Third, at times the volume level dips just prior to an animal sound. Yet by 1933, the practice of lowering music's volume to favor key diegetic sounds was commonplace. In short, Steiner's score for *King Kong* displays considerable attention to sound effects, but it draws on practices already developed—or at least initiated—in earlier years.

Native music. Finally, several scholars posit Steiner's musical approach to native peoples as a key precursor to the birth of the Golden Age of film music. Both Brown and Cooke note Steiner's use of open fourths and fifths, with Cooke remarking that such a tactic was "a useful and economic formula" that would later appear "ubiquitously in Hollywood scores for 'other' peoples as diverse as Native Americans and ancient Romans."[28] Yet while *King Kong* plainly uses these techniques, Cooke's use of the

word *formula* begs the question of why the film's use of open fourths and fifths to denote the natives deserves particular mention. By 1933 this technique was entirely conventional and thus would not have seemed especially noteworthy. Gorbman has demonstrated that tom-tom beats, open fourths and fifths, and melodies featuring falling thirds had already come to symbolize Native Americans in nineteenth-century theater. This representation of Native Americans stemmed from a "European-American all-purpose shorthand" for representing a wide range of "primitive or exotic peoples" in the late eighteenth and nineteenth centuries.[29] These tactics continued in early twentieth-century film music, often serving as a catchall for various "primitive" ethnic groups. Not only did tom-tom beats, open fourths and fifths, and falling thirds signify Native Americans in silent film music collections of the 1910s and 1920s,[30] but these methods signified other ethnic groups, including African Americans. Joseph Carl Breil's score for *The Birth of a Nation* (1915), for instance, accompanies the film's first title ("The bringing of the African to America planted the first seed of disunion") with tom-tom beats and a pentatonic melody (another denotation of "primitivism") featuring a falling third.[31]

Sound cinema prior to *King Kong* continued to apply such music to natives. Steiner's own *Bird of Paradise* musically depicts natives via open fourths and fifths, dissonant chords, heavy passages played by the brass, chanting, and a heavy, simplistic drumbeat. Alfred Newman's score for *Mr. Robinson Crusoe* uses similar tactics. *King Kong* does feature a more extensive use of dissonant chords and brass than these previous sound films, partly because Steiner links these techniques to Kong as well. By featuring similar musical styles between apparently African natives and an ape, Steiner's music both dehumanizes the natives and implicitly marks Kong as an ethnic "Other" and racial threat to Ann. Yet stylistically, Steiner's native music remained largely a continuation of a musical tradition in which numerous ethnically "Other" groups received the same stereotypical musical treatment. Thus, while *King Kong*'s musical representation of the natives may recur in numerous subsequent scores, its methods derived from earlier, widely accepted conventions pertaining to the musical depiction of natives.

Writing about native music in *King Kong* from a different perspective, musicologist Mark Slobin credits Steiner's music in *King Kong*—as well as in *Bird of Paradise*—with initiating the practice of "commercial-film

ethnomusicology." For Slobin, commercial-film ethnomusicology in- volves the association of people in specific locations with a particular brand of film music.[32] Once again, however, many previous sound films also engaged in this process. Warner Bros.' *The Squall* (May 1929) fea- tured numerous selections from Hungarian composers; Fox's *Liliom* (Oc- tober 1930), set in Hungary, included music in the native verbunkos style; and films set in East Asia like Paramount's *Madame Butterfly* (December 1932) or Columbia's *The Bitter Tea of General Yen* used stereotypical East Asian music. As Slobin himself points out, the early 1930s marked a peak of anthropological exploration.[33] It thus stands to reason that many other early sound films would forge associations between a particular music style and the native peoples of a certain region. Like many other aspects of *King Kong's* score, the musical treatment of natives did not initiate a sound film tradition.

King Kong's Musical Innovations

The preceding analysis is not meant to discredit Steiner's musical abili- ties or suggest that his score for *King Kong* is derivative or uninteresting. But ostensibly "new" practices seldom emerge from the head of a lone individual. To trace an accurate history of the period, one must recognize the extent to which Steiner drew on the assumptions and techniques found in earlier sound films. Conversely, through a more comprehensive understanding of music in the early sound era, one can also gain a new appreciation for *King Kong's* more innovative—or at least unusual—mu- sical approaches.

As indicated above, certain elements—particularly the blurring of themes and an extraordinarily large amount of mickey-mousing—dif- fered from common practice. The sheer duration of film music also devi- ated from the norm. From opening to closing titles, music occupies nearly three-quarters of the film. Though the occasional continuous score in the 1929–32 period featured higher percentages of music, 75 percent was an extremely large amount of music in an intermittent score. Two other as- pects of the score were also quite unusual and deserve recognition, al- though, like the blurring of themes and extensive mickey-mousing, they hold little in common with the Golden Age of film music.

Musical saliency. *King Kong's* music constitutes a noticeable presence through much of the film. This is partly due to the music's unusually

loud mix vis-à-vis dialogue and, especially, sound effects. More important, however, Steiner's score draws attention to itself via the frequent use of dissonant chords. *King Kong* was not the first to make prominent use of dissonant chords. I demonstrated in chapter 5 that Steiner incorporated this technique into *Bird of Paradise* and *The Most Dangerous Game* as well. Yet Steiner's use of dissonance constitutes one of the most unique aspects of his early sound scores—no other composer from the period employed this technique with Steiner's regularity. Brown, MacDonald, and Cooke all link Steiner's score to modernism, with MacDonald explicitly claiming that Steiner's unresolved dissonances "tended to emulate the French Impressionist style of Claude Debussy, whose harmonic patterns often defy traditional rules of chord progression."[34] Brown goes further in his recognition of this unusual technique, stating that *King Kong*'s music "would no doubt have scandalized most concert-going audiences of the time with its open-interval harmonies and dissonant chords, its tritone motifs, or such devices as the chromatic scale in parallel, minor seconds."[35]

Left unmentioned in the above analyses, however, is the fact that such modernist techniques run *counter* to the characteristics said to embody Golden Age music. According to numerous scholars, the Golden Age typically featured music in a late-romantic idiom and constituted an "unheard" presence. Film music scholarship has thus created a paradox. While *King Kong* is said to begin the Golden Age of film music, possibly its most "groundbreaking" technique is one that clashes directly with the very techniques of that era. Scholars to date have avoided this contradiction, sometimes even positing *King Kong* as the beginning of the Golden Age and describing its harsh dissonances in consecutive sentences.[36] Yet the bombastic, dissonant quality of *King Kong*'s music suggests that in certain respects its score served not as a model for film music but as a special case that would not be widely imitated.

Scale and sets. *King Kong*'s loud, salient score, combined with the music's close attention to image details, results in another unusual method: the use of music to emphasize the film's scale and striking settings. In a modern era of special-effects-laden action films, it is easy to forget that *King Kong* was a visually stunning film in 1933. Regarding the "studio and camera technology," the 1933 *Variety* reviewer remarked: "*Kong* sur-

passes anything of its type which has gone before it in commercial film-making."[37] In particular, the filmmakers' handling of scale in order to convey Kong's enormous size was unprecedented and regularly singled out for praise. The *Variety* reviewer gushed: "In adhering to the proper perspective the technical crew has never missed. The illusion of comparative size is splendid."[38] Mordaunt Hall of the *New York Times* singled out the film's use of scale in the final New York City sequences: "One step and the beast traverses half a block. If buildings hinder his progress, he pushes them down, and below him the people look like Lilliputians." Hall also marveled at such moments as when Kong's head fills an entire bedroom window.[39]

Though unacknowledged by the reviewers, Steiner's score contributes to the convincing presentation of Kong's size. During the jungle sequences especially, the score cleaves closely to physical actions, using music to match the movements of Kong and his pursuers. When Denham and company race through the jungle trying to rescue Ann, Steiner frequently provides short, rapid thirty-second notes. This contrasts strikingly with the music that evokes Kong's giant footsteps, which consists of low-pitched notes more widely spaced in time. This loose mickey-mousing calls attention to the colossal size difference between Kong and the humans, thus rendering Kong all the more massive. The extent to which characters can be heard over the often-loud music also contributes to the film's presentation of size difference. Where the gigantic monsters emit noises that generally either match or exceed the score's volume, human noises—outside of dialogue—are more commonly at a lower volume than the music. The score virtually drowns out the generalized shouting during the jungle dance, and potential human-generated sound elements such as the footsteps of Ann's search party are inaudible. As a result, the film suggests the humans' impotence on the island against Kong and emphasizes the enormous differences in size between the monsters and humans.[40]

Music's close coordination with images also helps direct attention to the film's sets, another aspect that contemporary reviews singled out for praise. When an unusual, striking setting is first revealed, Steiner tends to provide a noticeable musical shift. Consider, for instance, the film's first shot of Skull Island. In the previous scene the sailors try unsuccessfully to find the island in thick fog, and the score

provides quiet music featuring a harp, strings, and distant drums. The first shot of the island (fig. 6.4), however, coincides exactly with a long, ominous note played by the brass section. This shift in music marks Skull Island as an unusual setting worthy of attention. A few moments later, when the sailors canoe toward the island, the camera provides a new shot—positioned closer to the island—that renders the island's giant wall in more detail (fig. 6.5). Exactly coinciding with this shot change is a mild sforzando and the introduction of an oboe playing rapid thirty-second notes. This correspondence between music and establishing shot draws attention to this closer view of the island and imbues the setting with particular significance. Similarly, much later in the film the score provides a strong orchestra chord for the first shot displaying Kong's lair, which offers a striking backdrop of the island and ocean (fig. 6.6). Thanks to Steiner's predilection for precise musical timings with the image, the score helps accentuate *King Kong*'s impressive visual accomplishments.

FIGURE 6.4 Musical shifts accompany initial depictions of the remarkable and unusual settings of Skull Island in *King Kong*. This includes the first shot of Skull Island . . .

FIGURE 6.5 ... a closer view of Skull Island's walls ...

FIGURE 6.6 ... and the first shot of Kong's lair. By shifting music with shot changes, Steiner's score encourages the audience to marvel at the film's set design.

KING KONG AND MUSIC FOR AN
ACTION-ADVENTURE FILM

Earlier sound film practices—including the use of music for other worlds, the presence of original music, the soundtrack's relationship between music and sound effects, and the use of native music—account for many of the musical techniques found in *King Kong*. But why does *King Kong*'s score also include elements that were atypical in the early sound era, including the blurring of themes, extensive music, and unprecedentedly dogged synchronization between music and image? The answer likely stems from *King Kong*'s oddity as an early 1930s film. Whereas films from the period commonly featured fairly extensive dialogue in contemporary urban settings, *King Kong* went for broke in its action and fantasy elements. According to period assumptions, both elements lent themselves to extensive music. We saw in chapter 5 that music served as a sound substitute in the absence of dialogue and that other worlds regularly featured music. Given a film that upped the ante in terms of the amount of action, Steiner—already inclined toward having music attend closely to screen events—responded with what is essentially an action score. Mickey-mousing draws attention to physical action, regular dissonance conveys the physical danger faced by the explorers, and the score's evocation of size difference and unusual settings contributes to the sense of peril and adventure as humans grapple with colossal, prehistoric beasts.

The notion that *King Kong* used an action-based score may also help explain the score's tendency to blur its major themes. For some scholars, the deliberate melodic resemblance across themes opens up levels of psychological engagement and association, particularly between Ann and Kong.[41] Yet this blurring of themes in some ways also limits musical attention to character psychology. In films where themes are clearly separated, the tempo, key, and instrumentation of various characters' themes often reveal key attributes of each character's psyche and help trace the character's evolving feelings. *King Kong*'s blurred themes, in contrast, tend to direct attention away from the mind-set of a single character. Through the regular presence of dissonant, bombastic music and blended themes, *King Kong*'s score often seems focused more on conveying the sense of physical action and danger than on probing internal states. Kong's death scene, in which the score evokes sympathy for Kong by using a slow tempo and string-oriented orchestration, constitutes an anomaly

in a score far more intent on portraying the horror of and physical danger imposed by Skull Island's various monsters.

King Kong's score thus stands as a testament both to the influence of earlier film music practices and the extent to which an unorthodox film could help push a score into unfamiliar territory. However, it may have been precisely the unusual nature of *King Kong* as a film that would prevent its musical techniques from being accepted as a new, durable approach to film music.

MORE OF THE SAME: THE FILM SCORE, 1933–1934

According to scholars, the impact of *King Kong*'s score was immediate and substantial. Thomas writes that *King Kong* featured "the film score that brought Steiner to everyone's attention." Evans states that the score's "throbbing, pulsating quality made it an immediate classic." More recently, MacDonald asserts, "Few scores in the history of the motion picture have had an impact as immediate as Steiner's ingenious work on *King Kong*." And Slobin posits *King Kong* as "the film that really drew attention to the composer's contribution to a movie's success."[42]

Period newspapers and trade journals, however, provide no indication that *King Kong*'s score was heralded as a breakthrough. *Variety*'s review of the film does spend part of one sentence praising its "gripping and fitting musical score."[43] But few other contemporary publications provide any mention of *King Kong*'s music.[44] This does not mean that the score remained entirely unnoticed, but it does suggest that *King Kong* was not immediately seen as making an overwhelming contribution to film music.

If *King Kong* received little attention in the press, its influence on film music in the year following its release was also minimal. The remainder of this chapter assesses *King Kong*'s immediate musical impact based on my viewing of forty-three films featuring music from the 1933–34 season. Despite the release of the widely seen *King Kong* in March of 1933, the 1933–34 season featured essentially the same musical trends and techniques found from 1931 to 1933. As in the 1931–33 period, filmmakers gradually increased their use of nondiegetic music and continued to tie music to other worlds that differed from familiar, urban reality. Where *King Kong* had broken the mold via a more salient score and an obsessively close synchronization to narrative details, 1933–34 films continued

to provide relatively unobtrusive music and only occasionally attended closely to minute narrative cues. *King Kong* did not provide a new, widely accepted solution for the use of film music but rather constituted a model that was routinely ignored.

Of the films likely to imitate *King Kong*'s music, those depicting the exploration of dangerous, unfamiliar environments might seem to be the top candidates. One such film was Paramount's *Four Frightened People* (January 1934), which features a narrative that is in certain ways suggestive of *King Kong*. In *Four Frightened People* a ship bound for New York City suffers an influx of the bubonic plague, and the ship's four white travelers—schoolteacher Judy Jones (Claudette Colbert), chemist Arnold Ainger (Herbert Marshall), socialite Fifi Mardick (Mary Boland), and famed reporter Stewart Corder (William Gargan)—escape the ship by seizing a lifeboat and rowing ashore to the nearby Malay Peninsula. As in *King Kong*, the party arrives ashore to be confronted by the sound of drumming and the presence of potentially dangerous natives. To catch a freighter, the party must—as in *King Kong*—venture into the unfamiliar jungle and brave danger there, including water buffalo, cobras, and a hostile Sakai tribe. Like *King Kong*, the film concludes with scenes back in the United States, which in this case depict Ainger's decision to divorce his wife and marry Judy.

Despite narrative similarities, however, the scores for *Four Frightened People* and *King Kong* have little in common. Where *King Kong* showcases the power of original music stemming from one creative mind, *Four Frightened People* not only features no screen credit for music but continues Paramount's tendency to create a score via a group of staff members, in this case Karl Hajos, Milan Roder, Heinz Roemheld, and John Leipold.[45] More important, unlike *King Kong*'s score, the music in *Four Frightened People* devotes little attention to scenes of danger and action. When the characters square off against a deadly water buffalo, are nearly bitten by a cobra, and face danger from two tribes, no music plays on the soundtrack. Mickey-mousing is also avoided—rapid "hurry" music to accompany Judy running constitutes one of the only instances in which the filmmakers tie music to screen action.

Instead, the score attends exclusively to Judy's character transformation. Initially prim and sexually repressed, Judy—as a result of jungle living—eventually sheds her glasses and conservative clothing, dons revealing outfits crafted from jungle leaves and animal skins, and "blos-

FIGURE 6.7 Judy's theme in *Four Frightened People*.
Transcribed by the author.

soms" into a confident, sexual woman. Every musical cue ties to Judy's
gradually coming to terms with her sexuality, resulting in a far sparser
score. Slow cello music plays when Judy realizes that she must sleep next
to the men at night because of the dangers of the jungle. Later, a soaring
theme (fig. 6.7) plays when she exhibits love for the first time by whisper-
ing to Carter while he sleeps and then tenderly hanging his wet socks
and shoes by the fire. Soon it becomes clear that this theme represents
Judy's metamorphosis. It plays as Judy showers naked under a waterfall,
when Ainger grabs her and declares to her that she is beautiful, when Judy
looks at herself in the mirror for the first time in the film and puts on lip-
stick, and when she displays a sexy new leaf-crafted outfit for the men and
enjoys their sudden attentiveness. In the next step of Judy's sexual awaken-
ing, she takes control of her allure. The theme plays when Judy, despite
being dramatically kissed by Carter, recognizes his shallowness and re-
jects his advances. The theme plays again when Judy and Ainger broach
the topic of marriage, the final step in her transformation from spinster to
mature, sexual woman. The score thus avoids *King Kong*'s musical atten-
tion to danger and action, instead using a clearly delineated theme to posit
Judy's character development as the central feature of the narrative.

Universal's *S.O.S. Iceberg* (September 1933) also depicts the physical
danger of an unfamiliar environment. Shot on location in Greenland
and Iceland, *S.O.S. Iceberg* tells the story of explorers stranded on an ice-
berg who must be rescued before the iceberg breaks and sends them to
their deaths. The film was a coproduction between Germany and the
United States, and the filmmakers shot two versions simultaneously: one
in German, the other in English. Though the basic story remains the
same across the two versions, they contain differences in footage, actors,
editing, and even narrative structure and detail. I focus here on the Eng-
lish-language version because this was the version released in the United
States.

S.O.S. Iceberg features a score by the German composer Paul Dessau,
recorded by the Berlin Symphony Orchestra.[46] Whether Dessau would

have been aware of *King Kong*'s score when he composed for *S.O.S. Iceberg* remains an open question, but his score does contain superficial similarities to *King Kong*. This includes the amount of music (roughly 80 percent for *S.O.S. Iceberg*, 75 percent for *King Kong*)[47] and the use of music to convey the difficulties of a strange environment. For instance, when the explorers trek across the snowy landscape or try to escape from a hungry polar bear, Dessau offers dissonant chords and minor-key passages to denote these dangers. However, the score's general lack of precise synchronism differs substantially from *King Kong*'s score and renders music a less salient element. A few choice actions receive music matches, such as quick cymbal crashes to represent explorer Johannes Brand's (Gibson Gowland) repeated leaps into freezing water as he attempts to swim for help, or timpani rolls to accompany certain depictions of iceberg breakups. But on the whole the score attends only to general moods rather than specific actions.

S.O.S. Iceberg also displays a different logic behind the places where music occurs. Unlike *King Kong*'s score Dessau's music attends to the *concept* of adventure and exploration rather than emphasizing the *separation* between the mundane and the unfamiliar. For instance, in an early prevoyage scene in a banquet hall, lead explorer Carl Lawrence (Rod La Rocque) discusses the expedition as a noble pursuit of scientific knowledge begun by Wegener, who died in the arctic. Where *King Kong* avoids music in early mundane settings, Dessau underscores even this "ordinary world" with a majestic theme. This theme then recurs at numerous points in the film, including the moment when Lawrence decides to push forward despite the danger; several times when Lawrence and his wife, Ellen (Leni Riefenstahl), embrace; and when an airplane finally rescues Brand. The theme is thus tied to a host of elements related to the voyage: the separation of loved ones, the noble pursuit of scientific knowledge, and the trip's extreme danger. Whereas *King Kong*'s score draws attention to the strangeness of an exotic land, *S.O.S. Iceberg*'s score—by playing even prevoyage—instead helps foreground what it means to explore such a land in the first place.

Genres other than adventure films feature even fewer similarities with *King Kong*'s salient, hypersynchronized score. MGM's *Manhattan Melodrama* (May 1934) features a modest nondiegetic score. Nondiegetic music plays for six minutes of the nine-minute prologue, which depicts turn-of-the-century New York City. When the film shifts to contemporary New

York City for the remainder of the narrative, the filmmakers provide predominantly diegetic music. However, nondiegetic music does play during a scene between the gambler Blackie (Clark Gable) and his girlfriend Eleanor (Myrna Loy) on a yacht and later in a tear-jerking scene when Blackie sacrifices his life to save best friend Jim's (William Powell) career.

Despite the presence of nondiegetic music, the musical techniques themselves hold virtually nothing in common with *King Kong*'s score. Unlike *King Kong, Manhattan Melodrama*'s music remains at a very low volume level vis-à-vis dialogue and sound effects. The score also eschews Steiner's tendency to match music to particular moments in the narrative, providing only general mood music. The lone exception occurs just after Blackie's death, in which the introduction of a nondiegetic harp suggests that Blackie's noble sacrifice for the sake of his friend's career will send Blackie to heaven. *Manhattan Melodrama* also does not display *King Kong*'s fondness for recurring themes—no nondiegetic musical themes are repeated during the film.

MGM's willingness to use a score at all reflects the period's increasing receptiveness to nondiegetic music. Since the coming of sound, MGM had remained the most musically conservative studio, regularly releasing films containing only diegetic music.[48] Yet *King Kong* probably had little influence on MGM's gradually increasing receptivity to nondiegetic music. Despite *Manhattan Melodrama*'s periodic use of accompanying music, by far the majority of MGM films from 1933 to 1934 continued to offer little or no nondiegetic music. This includes films set in contemporary urban locations like *Penthouse* (September 1933), *Men in White* (April 1934), *Sadie McKee* (May 1934), and *The Thin Man* (May 1934)—all of which feature New York City—and the Los Angeles/Chicago set *Sons of the Desert* (December 1933), a vehicle for Stan Laurel and Oliver Hardy. That *King Kong* had little impact on MGM's musical practices is most apparent in MGM's *Tarzan and His Mate* (April 1934). Despite being set in a jungle far removed from civilization, the film avoids any use of nondiegetic music outside of the beginning and end title sequences.

The comedy genre, which traditionally contained very little nondiegetic music, featured a few music experiments from 1933 to 1934. *Good-Bye Love* (November 1933), a zany comedy produced by Jefferson Pictures and distributed by RKO, features extensive music in the background of the soundtrack (the music is credited to S. K. Wineland and Abe Meyer). *Good-Bye Love*'s early scenes are set in an urban environment and feature

divorce, alimony, stocks, and jail. Though these topics are treated light-heartedly, they nevertheless denote harsh, pragmatic reality, and the scenes feature only diegetic music. When butler Oswald Groggs (Charles Ruggles) uses his master's money to take a paradisiacal trip to Atlantic City, however, music with no clear source plays. Such music continues through most of Groggs's trip and then even begins spilling over into scenes set back in the city.

Good-Bye Love's music is extensive, with 40 percent of the film featuring music with no clear image source. Still, the film's concern with diegetic plausibility, its frequent song plugging, and its only occasional mickey-mousing tie more closely to late 1920s and early 1930s scores than to *King Kong*. Where *King Kong* features only a few efforts to link its music to the diegesis, *Good-Bye Love* adheres to the tendency, found especially from 1929 to 1931, of always offering at least a faint possibility that the music is diegetic. Music thus plays only in plausibly diegetic locations, such as a hotel lobby or dance floor, and halts for a scene on the Atlantic City beach. Song plugging is extensive in *Good-Bye Love*, as the eponymous title song plays repeatedly throughout the film. This was a practice most closely associated not with *King Kong*—which features no song plugging—but with late 1920s and early 1930s musicals and select non-musicals. *Good-Bye Love*'s occasional use of mickey-mousing and kidding for comedic effect also derives from early sound musicals. For instance, the film provides a stinger when a Ping-Pong ball hits Groggs in the eye and plays "How Dry I Am" and "For He's a Jolly Good Fellow" when two women become drunk. These efforts to create humor via close musical attention to the narrative owe more to previous zany musicals like *Love Me Tonight* and *The Big Broadcast* than to the more dramatic mickey-mousing of *King Kong*.

In 1933 and 1934, B films—which almost universally avoided nondiegetic music earlier in the 1930s—experimented increasingly with film scores. *Good-Bye Love* shares elements of A and B films: it runs for only sixty-seven minutes yet features a modest star of A films in Ruggles. Universal's horror film *The Black Cat* (May 1934) provides an example of extensive music in a more clear-cut B film. Though *The Black Cat* featured horror stars Bela Lugosi and Boris Karloff, it contained a short shooting schedule, a low budget, and a short running time.[49] *The Black Cat*'s score has enjoyed a large amount of attention,[50] primarily because the horror genre would come to depend heavily on music to generate affect. Before

1934, however, Universal—the studio that specialized in horror films—had exhibited a marked aversion to film music, providing little nondiegetic music in its horror successes *Dracula* (February 1931) and *Frankenstein* (November 1931).[51] Indeed, according to several sources, *The Black Cat*'s music-drenched score (some form of music occupies nearly 80 percent of the film) occurred only because Carl Laemmle Sr., the founder of Universal, was out of town during postproduction.[52] Still, aside from tying music to "other worlds"—a strategy of the early 1930s more broadly—*The Black Cat*'s score has little in common with *King Kong*.

The Black Cat's music connects quite clearly to an "other world," in this case the twisted world of Hjalmar Poelzig (Boris Karloff) and his Hungarian mansion. As *The Black Cat* begins, novelist Peter Allison (David Manners) and his wife Joan (Julie Bishop) are riding alone in a train compartment on their honeymoon and must suddenly share their compartment with a stranger named Dr. Vitus Werdegast (Bela Lugosi). This encounter with Werdegast, who is tormented by the loss of his wife, constitutes the couple's first step toward a world of obsession and madness. As Werdegast sits down in the compartment, he inadvertently jostles the couple's phonograph player and cuts off the music. The couple no longer controls the film's music, just as their lives will soon spiral out of control in Poelzig's world, which features copious nondiegetic music. When an accident forces Peter, Joan, and Werdegast to stay at Poelzig's home, nondiegetic music plays almost continuously while the plot descends into Satanism, necrophilia, and sadism. The audience eventually learns that Poelzig keeps Werdegast's dead wife preserved in a glass case in the cellar, has married Werdegast's daughter, and plans to sacrifice Joan in an upcoming Satanic ceremony. Late in the film, Werdegast, finally gaining the upper hand on Poelzig, begins delightedly flaying the skin off of Poelzig's face. Like *King Kong* (and *The Most Dangerous Game*) ordinary characters enter a twisted and evil environment controlled by an extraordinary entity, and extensive nondiegetic music serves to mark off this space from safe, known reality.

Here, however, *The Black Cat*'s musical parallels with *King Kong* end. Unlike *King Kong*, *The Black Cat*'s music director, Heinz Roemheld, uses predominantly preexisting works, including reorchestrated and sometimes modified compositions by Johann Sebastian Bach, Ludwig van Beethoven, Johannes Brahms, Frédéric Chopin, Franz Liszt, Franz Schubert, Robert Schumann, and Pyotr Tchaikovsky.[53] In the 1920s, Roemheld had served as music director and orchestra conductor of the Alhambra Theater in

Milwaukee, and the creation of the pastiche score would have been a familiar process to him.[54] The use of preexisting compositions also encouraged a loose correlation between music and screen actions, a technique that differs considerably from *King Kong*'s extreme synchronization. *The Black Cat*'s music does consistently link characters and settings to particular themes, and on occasion narrative events and music do prominently coincide. For instance, during the scene in which Werdegast kills a black cat, one of Schubert's primary themes from the first movement of the *Unfinished Symphony* coincides with Joan's arrival in the room, and a cymbal crash matches a shot of Poelzig dramatically clenching the statue of a naked woman. According to Paul Mandell, both image and music were edited in this scene so that certain moments would "correspond to the crescendos and diminuendos."[55] The filmmakers, however, steer well clear of the punctual, mickey-mousing synchronization tactics that populate *King Kong*'s score.

The musical genre constitutes a final type of film that was not significantly influenced by *King Kong*'s score. After its nosedive in the 1930–31 season, this genre enjoyed an equally dramatic rebound in 1933. Thanks to the unexpected success of Warner Bros.' *42nd Street* (March 1933), all the major studios rapidly increased their production of musicals.[56] Rather than capitalize on the extensive nondiegetic music strategies found in *King Kong*, however, the musical returned to a more diegetically restrained form of film scoring.

The musical conservatism of *42nd Street* likely stemmed from its gritty urban setting and backstage format. Film historian Tino Balio points out that "unlike the Lubitsch-type operettas, [*42nd Street* and its immediate successors] were set in the very real world of Depression America and told gritty stories of backstage life spiced with platoons of chorus girls, upbeat music, and sex."[57] With *42nd Street*'s "realistic" portrayal of urban life came a hesitancy to commit to fully nondiegetic music. Paramount's operettas from 1929 to 1932 had featured salient motifs that often cleaved closely to character actions and thoughts and even commented wryly on the diegesis. But *42nd Street* provided music that was either explicitly diegetic or that played in locations where live or recorded music might conceivably be heard, such as a restaurant, several hotel and apartment rooms, and a dressing room.

In many cases the songs heard in such spaces are the same ones that would be performed in the upcoming show, particularly Al Dubin and

Harry Warren's "You're Getting to Be a Habit with Me," "Young and Healthy," and "42nd Street." Their placement generally reflects on the narrative in some way. "You're Getting to Be a Habit with Me," for instance, plays only during scenes involving the relationship between Broadway star Dorothy (Bebe Daniels) and her ex-partner Pat (George Brent). The application of this song is narratively appropriate. Not only does Dorothy perform the song during rehearsal, but the title also reflects the nature of the couple's relationship. Through dialogue, the audience learns that Dorothy and Pat have become too dependent on each other, thus preventing Pat from making a living. The use of the same music onstage and off also helps unify the two spheres. It conveys what would become a staple of backstage musicals: the resolution of romantic relationships *off*stage matches the production of an outstanding show *on*stage.[58]

The reiteration of show tunes primarily serves song-plugging purposes, however, an approach found nowhere in *King Kong*. By the show's grand opening—which includes performances of "Young and Healthy," and "42nd Street"—the film audience has already heard one instrumental version of "Young and Healthy" and five renditions of "42nd Street." So important is song plugging that the songs' presence strains narrative credibility. When Dorothy meets Pat in a restaurant, for instance, a jazz rendition of "You're Getting to Be a Habit with Me" plays, which suggests a possible radio or phonograph in the restaurant. Yet the song's presence makes no narrative sense because the cast has only just started rehearsing this number for the upcoming show, where it will presumably debut. The same illogic exists for the songs "Young and Healthy" and "42nd Street," both of which can be heard in small hotel-room parties the night before the show's opening.

The spate of musicals that immediately followed *42nd Street* exhibited much the same diegetic conservatism and song-plugging tactics. Warner Bros.' *Gold Diggers of 1933* (May 1933) and *Footlight Parade* (October 1933) feature predominantly diegetic music and play the show's songs prior to the show's debut. Musicals at other studios, including MGM's *Dancing Lady* (November 1933) and Paramount's *Murder at the Vanities* (May 1934), likewise use largely diegetic music and reiterate performed songs. Even a film like Warner Bros.' *Wonder Bar* (March 1934), which features accompanying music for most of the film, uses the presence of a nightclub orchestra throughout the film to grant much of the music at least a semblance of diegetic plausibility.

The musical's newfound preference for such plausibility constitutes a striking reversal of the situation that obtained in 1931 and 1932, where musicals offered some of the most audacious and salient nondiegetic accompaniment of the entire 1926–34 period. The return of the backstage musical format certainly precluded the use of nondiegetic music during the show's numbers, but even the genre's narrative sequences avoided the nondiegetic mickey-mousing and closely synchronized themes that characterized many early 1930s musicals. At a time when Steiner's score for *King Kong* was adopting the musical's close coordination between music and image, the musical actually veered away from these very tactics.

THE SCORES OF MAX STEINER, 1933–1934

The only post–*King Kong* composer to continue Steiner's close matches between music and image was Steiner himself. Though a number of Steiner's post–*King Kong* scores continue to supply only opening and concluding nondiegetic music—such as RKO's *Spitfire* (March 1934)—a few attend quite closely to specific moments in the narrative. One film that does this is RKO's *Little Women* (November 1933), which on the surface would seem to have little in common with *King Kong*. Where *King Kong* features extensive action sequences in a fantastical world, *Little Women* offers limited physical action, portraying small-town New England family life in the 1860s. This depiction of a bygone era, however, justifies the inclusion of nondiegetic music. The opening credits begin with the family's theme played on a clavichord, an instrument primarily associated with the sixteenth to eighteenth centuries and thus strongly suggestive of a long-ago era.[59] Through the prominent use of this instrument, the score positions itself as part of the film's larger project of retrieving and re-presenting the past. Further tying music with the evocation of the past, the score features a medley of well-known songs associated with the Civil War, including "Tramp, Tramp, Tramp" (1864), "Battle Hymn of the Republic" (1861), and "The Girl I Left Behind" (date unknown).

Like Steiner's score for *King Kong*, the score for *Little Women* exhibits an unusually high attentiveness to narrative. During the first dialogue exchange, the children's mother, "Marmee" March (Spring Byington), talks to an old man whose four sons have either been killed, captured, or have fallen ill during Civil War combat. The scene lasts only a minute and a half, but the score adjusts to virtually every line of dialogue. When the

man mentions that his son is sick in the hospital, a string orchestration conveys the nobility of his son's sacrifice. When the man reveals that his other three sons were either killed in the war or taken prisoner, the score shifts to a standard signifier of the Union: "Battle Hymn of the Republic." Deeply touched by his sacrifice, Marmee gives him some money, and the score reflects her sympathy for the man's emotional troubles by providing a high-pitched, slow, sad tune on the violin. As the man wishes Marmee a Merry Christmas, a strain of "Silent Night" is heard. After the man leaves, a minor-key violin passage plays as Marmee remains visibly moved by the conversation. When she mentions to another woman that the man's son may die, a distant bugle signifying military sacrifice plays on the soundtrack. Finally, when Marmee acknowledges, "I have my four girls to comfort me," the main theme, which will come to signify the March family and especially the sisters' close bond, plays. At every possible juncture in this conversation, Steiner's score overtly shifts to reflect the newest line of dialogue. Such precise coordination between music and narrative cues can be found only in Steiner's scores in the 1933–34 season.

The remainder of *Little Women*'s score does not attend to dialogue or other narrative events quite as closely. Still, the score does feature regular adjustments to reflect shifts in emotion. For instance, Steiner's music often halts abruptly when a mood is broken. Music stops when Jo (Katharine Hepburn), musing on the secret that she has published a story, unexpectedly bumps into love-interest Theodore "Laurie" Laurence (Douglass Montgomery) on the street; when Laurie notices Jo sitting sadly by herself under a tree after her sister Meg's (Frances Dee) cheerful wedding; and when Jo, depressed that she will not travel to Europe with her aunt, is greeted by the friendly Professor Bhaer (Paul Lukas). Music also shifts to reflect the changing emotions of the family. When Jo's sister Beth (Jean Parker), near death, shows unexpected signs of recovery, the music switches from a slow minor-key theme to a faster tune played lightly on the strings. More than any non-Steiner score from 1933 to 1934, *Little Women*'s music is often coordinated precisely with narrative events.

Still, the scores for *Little Women* and *King Kong* contain important differences. *Little Women* eschews the bombastic, dissonant chords of *King Kong* and provides music for a mere quarter of the film. The score that most clearly continues the techniques found in *King Kong* is RKO's *The Lost Patrol* (February 1934), a film that—like *Little Women*—featured *King Kong* codirector Merian C. Cooper as an executive producer. In terms of

percentage, *The Lost Patrol*'s score exceeds even *King Kong*, with music playing for roughly 90 percent of the film. Like *King Kong* and early 1930s scores, the music's presence can be justified by the film's "otherworldly" setting—in this case the desert of Mesopotamia during World War I.

The Lost Patrol also shares with *King Kong* the use of music to suggest ever-present danger. As the film begins, the only man who knows the patrol's position and mission is shot and killed, leaving the rest of the patrol dangerously lost. Music plays during these opening moments and then stops when the patrol members stumble on an oasis and believe they are safe from the dangers of the desert. Yet music soon returns, and members of the patrol are subsequently picked off one by one by enemy snipers. Like music during *King Kong*'s Skull Island sequences, then, much of *The Lost Patrol*'s nondiegetic music is tied specifically to scenes depicting the danger inherent in an uncharted landscape.

The Lost Patrol's score also features many of the same techniques that made *King Kong*'s score so salient, including high volume music, dissonant chords, and heavy brass passages. These devices are especially prominent during several scenes in which various members of the patrol, driven insane by fear, rush into the desert, only to be shot and killed by unseen Arabs. During these scenes, music floods the soundtrack and generates the bulk of the emotional impact and sense of danger. So central is music to the generation of affect that it occasionally overwhelms narratively important sounds. For instance, when Morelli (Wallace Ford) runs out into the desert in an attempt to save his fallen comrade Abelson (Sammy Stein), the music's volume level far exceeds the sound of enemy gunshots as snipers attempt to take Morelli's life.

In comparison to *King Kong*, *The Lost Patrol*'s score actually escalates its coordination between sound and image tracks. Many brief musical pauses occur just before sounds that signal some alteration in the patrol's collective mood or focus. Pauses often occur just before the sergeant (Victor McLaglen) gives the patrol an order, which emphasizes the command that the sergeant holds over the outfit and reflects the fact that the patrol must mentally shift gears by performing a new task. Music also halts when a character finds his train of thought broken by the words of another soldier. Sounds that mark key events or turning points are also preceded by a sudden pause in the music. For instance, when a soldier discovers that the Arabs have stolen the patrol's horses, the score features a crescendo and then pauses just before a soldier shouts, "Where

are the horses? They're gone!" The music also pauses to accentuate every gunshot that results in the death of another soldier and in some cases provides a stinger to match the subsequent body fall.

The score's attention to narrative also includes an extraordinary amount of rigorously deployed themes. A marching tune (fig. 6.8), often heard when the patrol discusses issues or operates as a team, reflects the patrol's camaraderie and teamwork. Steiner provides themes to characterize particular patrol members: an Irish-inflected tune for the Irishman Jock MacKay (Paul Hanson) (fig. 6.9), an instrumental chorale for the religious Sanders (Boris Karloff) (fig. 6.10), a brisk dance tune for the happy-go-lucky George Brown (Reginald Denny) (fig. 6.11), and so on. The danger posed by the unseen Arabs is reflected via a chromatic theme with slow, solemn drumbeats (fig. 6.12). Steiner even provides what might be called a "command" motif, which consists of a bugle call that follows each order given by the sergeant (fig. 6.13). This bugle call reflects what might be heard on a patrol, except that this patrol never features an onscreen bugler.

FIGURE 6.8 A rousing patrol march in *The Lost Patrol*.
Transcribed by the author.

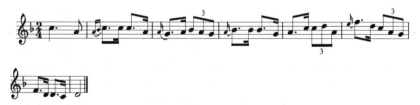

FIGURE 6.9 A grace-note-infused theme for Jock in *The Lost Patrol*.
Transcribed by the author.

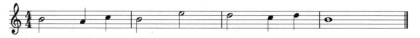

FIGURE 6.10 A simple chorale for the religious Sanders in *The Lost Patrol*.
Transcribed by the author.

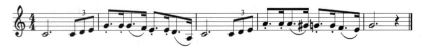

FIGURE 6.11 A breezy theme for the colorful George Brown in *The Lost Patrol*.
Transcribed by the author.

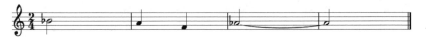

FIGURE 6.12 A somber theme for the Arabs in *The Lost Patrol*.
Transcribed by the author.

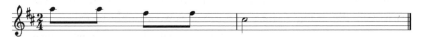

FIGURE 6.13 A short bugle call in *The Lost Patrol*.
Transcribed by the author.

The large number of themes recalls the earliest synchronized scores, yet Steiner's scrupulous deployment exceeds even those films. The slightest conversational reference to the danger posed by the Arabs results in the reuse of the Arab theme. Sometimes a single medium close-up of a particular soldier serves as sufficient grounds to play his theme. Even minute shifts in conversation are enough to trigger an appropriate theme. For instance, at one point Morelli tries to tell the sergeant about his days as a music hall performer. The sergeant, distracted by the unseen enemy, mutters toward the desert, "If only something would move out there." Despite the sergeant's lack of attention, Morelli proceeds with his story. Where nearly every non-Steiner film score from the period would provide a single piece of music for such a conversation, Steiner instead changes themes when each person talks, providing the Arab theme when the sergeant speaks and a lighter tune in a popular idiom for Morelli's story.

By escalating the musical matching that was already rampant in *King Kong*, Steiner's music for *The Lost Patrol* in one sense offers an exceptionally good "fit" with the narrative. Yet ironically, the music's close molding to the narrative draws more attention to the score's presence. This effect is tantamount to a film that features a sound and image edit at the same moment. By doubly marking the edit, such a tactic often draws at-

tention to the presence of editing itself. Similarly, by featuring such precise matches between music and narrative, the musical shifts become more prominent. The film industry indeed took notice, nominating *The Lost Patrol* for "Best Score" in the first year that the Academy of Motion Picture Arts and Sciences established this category. Yet the score's scrupulous attention even to minute filmic details was an anomaly in a season that nearly always featured music with a far looser connection to precise moments in the narrative.

CONCLUSION

If *King Kong*'s score incorporated a number of earlier musical practices, provided techniques not typical of Golden Age tendencies, and featured little discernible impact on subsequent film production, why have scholars singled out its score as marking the birth of the Golden Age of film music? As I have noted, the history of the early sound era has seldom been a central topic for film music historians, theorists, or analysts. Consequently, film scholars have sought to capture the early sound era in a few quick strokes before moving to a topic of greater interest—generally the Golden Age of film music. In these film histories *King Kong*'s score has probably been singled out for particular praise because it remains a well-known film, thus constituting a readily accessible candidate for the "birth" of the Golden Age.[60]

The myth that *King Kong* revolutionized film music also survives because it offers a striking, clear-cut, and seemingly comprehensive explanation for the rise of the Golden Age of film music. That Steiner "discovered" how to use film music in *King Kong* affirms the "genius" of the composer. It also provides a clear cause-effect sequence in which a single film used music so effectively that it laid all of the groundwork for the subsequent Golden Age. This explanation also appears comprehensive: because filmmakers did not "understand" what film music could do before *King Kong*, no previous films are relevant. Closer inspection of earlier sound films, however, reveals that *King Kong* constitutes one of many films that furthered a series of musical trends found throughout the period: the escalation of nondiegetic music, the link between nondiegetic music and "other worlds," and an increasing use of original music. *King Kong*'s score did not mark an immediate and decisive turning point; in

fact, film scores in the following season merely continued these trends and ignored the more unusual elements of *King Kong*'s score.

Why were *King Kong*'s unusual musical approaches—particularly its dogged synchronization between music and specific narrative cues—avoided by virtually every other film music practitioner in the period? Again, we should remember that *King Kong*'s amount of emphasis on fantasy and action was virtually unprecedented in 1933 and that its score in many ways contributed to these specific appeals. *King Kong*'s score may have been seen as effective but only for a rare kind of film. Thus, even if other filmmakers *did* take notice of the score, they probably did not see many of its musical techniques as being broadly applicable.

Ironically, if one were forced to choose a film that gave "birth" to the Golden Age of film music, Steiner's *Symphony of Six Million* would constitute a better candidate. In the Golden Age the score was expected to remain unnoticed.[61] Where *King Kong*'s music sometimes constitutes a nearly overwhelming presence, *Symphony of Six Million*'s score is far less obtrusive, beginning quietly and only gradually increasing its volume as the film progresses. Both *King Kong*'s and *Symphony of Six Million*'s scores are cued closely to narrative events, another staple of the Golden Age. But whereas *King Kong* features obsessive mickey-mousing, *Symphony of Six Million* typifies subsequent practice through its use of regular, clearly distinguishable themes and only an occasional direct match between music and a punctual screen action. Unlike *King Kong*, *Symphony of Six Million* incorporates a dose of preexisting music, a tactic that would remain in place during the Golden Age. Finally, *Symphony of Six Million* was released a full year before *King Kong* and predates a host of other significant early 1930s film scores, including *Bird of Paradise*, *Blonde Venus*, *Chandu the Magician*, *The Most Dangerous Game*, *Trouble in Paradise*, *A Farewell to Arms*, and *The Bitter Tea of General Yen*. That the relatively obscure *Symphony of Six Million* has received minimal scholarly attention for its music further affirms that *King Kong*'s score has benefited greatly from that film's fame and longevity.[62]

The case of *King Kong* ultimately demonstrates that the appeal of straightforward, dramatic explanations can exert a strong yet problematic pull on historical writing. A thorough explanation of the origins of the Golden Age needs to view the evolution of Hollywood film music not as a craft revolutionized by a single film or individual but rather as a

gradual process influenced by an array of different approaches. Only through a detailed consideration of the myriad musical techniques of the early sound era can one understand the forces behind the emergence of the Golden Age. These early sound techniques and their influence on Golden Age film music constitute the subject of this study's conclusion.

CONCLUSION

Scholarship on film music in the early sound era generally reduces the period to the scores of only a few "representative" films. After making brief references to Warner Bros.' *Don Juan* (1926), *The Jazz Singer* (1927), and the early 1930s scores of Max Steiner, scholars typically focus on *King Kong* (1933) and the "true" birth of the Golden Age of film music. The historical record thus depicts the early sound era as featuring only a few primitive stabs at sound film music, followed by an absence of music until Steiner's innovative scores. By casting a wider net over the early sound era, this study reveals a far different story and suggests several surprising conclusions.

First, the story of early sound film music is not one in which Steiner's music arose from a scoreless void but rather features a narrative spanning several years in which filmmakers negotiated with the influences of prior musical models. From silent film accompaniment came the use of themes and song plugging, as well as the deployment of continuous, pre-existing music. The early sound era's rising use of intermittent rather than continuous music derived from the traditions of theatrical melodrama and stage musicals. The use of classical music for purposes of prestige stemmed from several 1920s traditions, including phonography,

radio, and silent film. Throughout the early sound era, film music was influenced by multiple aesthetic practices.

Consequently, the early sound era was marked by a diversity of musical models, many of which predated Steiner's entrance into sound filmmaking. One approach—found in early synchronized films, as well as *The Squall* (1929), *Golden Dawn* (1930), *City Lights* (1931), and *Tabu* (1931)—was to essentially transplant the continuous music practices of the late silent era onto the sound film. Other films, like *Liliom* (1930) and *The Big Trail* (1930), opted for a far sparser musical technique. The theatrically inspired musical took a more daring approach, sometimes offering commentative music via closely synchronized themes, ample mickey-mousing, and kidding. Despite the diversity of techniques in the period, common tendencies arose, most notably diegetic withdrawal and the association between music and "other worlds." Rather than single-handedly inventing the sound film score, Steiner joined and participated in a budding practice that had already employed a wide range of musical techniques. Though Steiner was an important contributor to film music, he did not initiate a radically new accompaniment practice, and he drew on many preexisting sound film strategies.

Second, a detailed examination of the early sound era also reveals that early film music practitioners were not as crippled by technological restrictions and simple-minded aesthetic assumptions as Steiner and many subsequent film music historians have supposed. Though Steiner states that rerecording was impossible when he arrived in Hollywood in 1930, its use at Warner Bros. and other studios suggests that technological restrictions did not play an overwhelming role in the late 1920s' reduction of film music. Steiner's claim that filmmakers entirely avoided nondiegetic music also demands revision, as many films in the period used ambiguous or outright nondiegetic music. The early sound era was not dictated by a single-minded paranoia that audiences would wonder about the source of film music. Instead, the period was the site of conflicting notions regarding music's function in film, the sonic boundaries of sound film, and by extension the definition of sound cinema itself. Many films reflected the belief that film music should contribute to the presentation of an exclusively diegetic sound space, but many others explored film music's potential to define characters, generate affect, convey other worlds, generate ancillary profits, elevate prestige, and even imbue a film with mythological significance. Through all of this the early sound era

remained a rich period that posited multiple answers to issues that were basic to the definition and parameters of a sound film.

Finally, this study demonstrates the value of comprehensiveness when writing a history of film style. By attending to "ordinary" films, along with the better-known films from the period, and by examining a large number of films rather than a few case studies, film historians will find that a rich and multifaceted account of early sound film music emerges. Film history in general can only benefit from such an approach, since studies of film style often restrict their focus to films of high artistic merit, thus implying that those films represent the whole of film production from a particular period. Such selective scholarship tends to distort the true situation, since "exceptional" films often constitute a tiny, unrepresentative fraction of a period's output. As more early sound films are discovered, preserved, and made available for viewing, perhaps scholars will attain an even greater sense of the diverse musical approaches taken in the early sound era.

THE GOLDEN AGE OF FILM MUSIC

The film music approaches taken during the early sound era did not die out with the advent of the Golden Age of film music. Rather, the early sound era featured the seeds for a variety of Golden Age strategies. A full examination of early sound music's influence on the Golden Age would require a book-length study of its own, but the basic outlines of the issue can be traced here. For most scholars the Golden Age spans roughly from 1935 to 1950.[1] This periodization means that the Golden Age includes the release of three important scores in 1935—Franz Waxman's *Bride of Frankenstein*, Steiner's *The Informer*, and Erich Wolfgang Korngold's *Captain Blood*—yet excludes the early 1950s, which saw the rise of jazz-inflected scores. Scholars also generally claim that the Golden Age featured a set of basic principles regarding the use of nondiegetic music. Claudia Gorbman states several now-canonical principles of classical film music, including inaudibility, the signification of emotion, narrative cueing, continuity, and unity.[2] Writing five years after Gorbman, Kathryn Kalinak identifies many of the same features as Gorbman, stressing also the prioritization of narrative exposition and the matching of musical tempo to physical action.[3] Although these studies are valuable, neither study closely examines the early sound era's impact on Golden Age film music.

One of the Golden Age's strongest links to the early sound era is its continued tendency to tie nondiegetic film music to the depiction of other worlds. As we saw in chapter 5, "other worlds" in the early 1930s encompassed two spheres: unfamiliar—often exotic—external settings and internal evocations of a character's dreams, desires, or fears. Though the Golden Age used nondiegetic music in a far broader range of films than the early sound era, Golden Age filmmakers still reserved many of their most extensive scores for films that focused on other worlds. In 1935 Waxman composed an unusually lengthy score for *Bride of Frankenstein*, a film that features not only a supernatural story set in the past but also an opening scene in which Mary Shelley (Elsa Lancaster) announces to Lord Byron (Gavin Gordon) and Percy Shelley (Douglas Walton) that there is a second part to her Frankenstein story. Waxman's score thus accompanies a film that is multiply removed from contemporary reality via its setting, its supernatural events, and its overt identity as a fictional tale. In the same year, Steiner's score for *The Informer* uses Irish folk tunes to set the scene in 1920s Dublin, and Korngold's score for *Captain Blood* accompanies a seventeenth-century tale set in locations ranging from England to Barbados to Port Royal.

The tendency to associate nondiegetic music with other worlds persisted throughout the Golden Age. In 1937 the industry released three films featuring important scores that helped portray what film music historian Laurence MacDonald calls "mythical places and exotic locales."[4] Dimitri Tiomkin's score for *Lost Horizon* evokes the utopian Shangri-La, and Alfred Newman returns once more to the South Seas in his score for *The Hurricane* and conjures the fictional central European country of Ruritania in *The Prisoner of Zenda*. In later years Steiner's score for *Gone with the Wind* (1939) would evoke the Old South; Waxman's music for *Rebecca* (1940) would accompany depictions of European wealth at Monte Carlo and Manderley; and Newman's score for *The Song of Bernadette* (1945) would help convey a young woman's "otherworldly" religious vision in nineteenth-century France.

If the film score continued to depict external other worlds, it also continued to convey altered interior states of mind that differ from rational, material reality. Gorbman offers a range of descriptors that can be associated with Golden Age music, including *irrationality, romantic fantasy, dream,* and *loss of control.*[5] The link between these internal states and music had already been established in early sound films like *Liliom,*

Blonde Venus (1932), *Trouble in Paradise* (1932), and *The Bitter Tea of General Yen* (1933). Gorbman also suggests that music can help articulate the point of view of a character, including the "marked addition of reverberation for suggesting strongly subjective experiences."[6] Again, the connection between music and subjective moments has filmic roots in early 1930s films, such as Megan's (Barbara Stanwyck) dream sequence in *The Bitter Tea of General Yen*.

The early 1930s film score's association with other worlds also provides a key context for what Caryl Flinn sees as an important feature of the classical Hollywood score: the association between film music and idealized pasts. In *Strains of Utopia* Flinn argues that heavily orchestrated scores in historical films suggest the grandeur and stability of an earlier time, that background scores accompanying flashback sequences often "function as gates of refuge from the diegetic present," and that folk tunes in films like *Gone with the Wind* and *Red River* (1948) suggest a nostalgic longing for the past.[7] Even a low-budget film noir like *Detour* (1945), Flinn demonstrates, uses music to link nostalgia, utopian fantasies, and femininity.[8] Though Flinn traces a number of intellectual traditions that have connected film music to utopic pasts, one should also recognize that early 1930s film music—with its connection to exotic settings, dreams, and desires—constitutes an important proximate influence on this Golden Age tendency.

The classical era's strategies for determining where to place music often reveal a particular debt to film music assumptions developed in the early 1930s. In one common patriarchal trope, male "voices of reason" cut into female "other worlds" of nondiegetic music and fantasy, thus halting both feminine irrationality and the nondiegetic score in their tracks. In the first half of *Gone with the Wind*, for instance, Scarlett O'Hara (Vivien Leigh) embodies in many ways the otherworldly antebellum South: she is well-versed in southern manners and charms, and like many southern characters remains oblivious to the fact that this lifestyle will soon disappear. Steiner's music plays for Scarlett's frivolous flirtations and for more general utopic depictions of the South. Rhett Butler's (Clark Gable) cool-eyed view of the world, however, enables him to see through both Scarlett's veneer of social propriety and the myth of the South's durability. Consequently, his appearances and speeches—especially before his eventual marriage to Scarlett—are often marked by an absence of music. Thanks to assumptions about music's otherworldly qualities,

music marks a division between Scarlett, who in the film's first half stands for the fantasies of the Old South, and Rhett, who represents a more rational approach to the world.

Male voices of authority similarly cut through a world of femininity and irrationality in *The Song of Bernadette*, but in this film the rationally minded people appear to be mistaken. When peasant girl Bernadette (Jennifer Jones) gazes on what she describes as a "beautiful lady"—possibly the Virgin Mary—this transcendental experience is communicated aurally by Newman's score, which contains a soaring melody and a wordless chorus. However, when the film provides scenes featuring male figures of authority who doubt her story and demand concrete, rational proof—including a church dean, mayor, imperial prosecutor, police commissioner, psychiatrist, and bishop—music generally vacates the soundtrack. Once again, music's association with the otherworldly enables the soundtrack to mark a clearer division between a feminine world of simplicity and religious vision, and a male world of power, authority, and rationality. This logic behind the presence and absence of music also helps erect a dual-focus structure—quite common during the classical era—which features two characters or groups with markedly opposing qualities.[9]

Additional examples of music's connection to other worlds—tied frequently but not always to femininity—abound in the classical era. In *Rebecca*, Waxman's score plays for the majority of scenes at the posh Monte Carlo resort and Manderley mansion but halts for the rational, pragmatic, male-driven inquest into the death of Rebecca. In Bernard Hermann's score for *Citizen Kane* (1941) the only lush orchestral passage features Charles Kane as a boy playing in the Colorado snow. A cut inside the boardinghouse to a world of paperwork, money, and legal dealings corresponds to a halt in the music. This innocent boyhood will later become Kane's lost, idealized "other world." In *Double Indemnity* (1944) Miklos Rozsa's music periodically accompanies Walter Neff (Fred MacMurray) as he concocts a crazily daring plan—motivated partly by his infatuation with Phyllis Dietrichson (Barbara Stanwyck)—to scam his insurance company. Scenes featuring Barton Keyes (Edward G. Robinson), however—a pragmatic, level-headed insurance claims agent who studies actuary tables and thrives on detecting phony claims—contain virtually no music. Hugo Friedhofer's score for *The Best Years of Our Lives* (1946) is at its loudest and most dissonant when returning serviceman Fred Derry (Dana Andrews) relives his war experiences while sitting in

the cockpit of a grounded bomber plane. This music initially overwhelms the voice of another character who calls to him in the real world, indicating Fred's almost total absorption in his interior other world. While nondiegetic music occurred in a far broader range of contexts during the classical era, it often remained associated with the presentation of other worlds.

Many other aspects of early sound era music continued—with varying frequency—during the Golden Age. Orchestral music had ruled the roost in both the late silent and early sound era, and it remained the favored nondiegetic musical idiom in virtually all films from 1935 to 1950. The early 1930s had seen an increase in the use of original music, and this type of music would dominate the Golden Age. Musical themes—a staple of the late silent and early sound eras—also continued to play a major role in the Golden Age. Friedhofer's score for *The Best Years of Our Lives*, for instance, is based heavily on themes, including prominent ones for Homer's girlfriend, Wilma (Cathy O'Donnell), and for his middle-class neighborhood. The film's main theme plays regularly during scenes featuring all three returning servicemen, thereby suggesting that the trio is unified in a common struggle to reintegrate into American life. Not every Golden Age score ties musical themes explicitly to characters or even narrative events, but it was expected that all scores would repeat at least some of their melodic material throughout the film.

Despite a general preference for original music during the Golden Age, preexisting music—used extensively in the early sound era—remained an important option. In the Deanna Durbin musical *One Hundred Men and a Girl* (1937) the filmmakers take advantage of a narrative featuring famed conductor Leopold Stokowski and his orchestra by using preexisting orchestral pieces as nondiegetic underscoring. Folk and pop tunes also remained in use throughout the classical era. *Stagecoach*'s (1939) opening credits advertise a score "based on American Folk Songs" compiled by four men, including early sound era composers W. Franke Harling and John Leipold. As in the early sound era, the song's lyrics—though never sung—often comment on the narrative. For instance, *Stagecoach*'s main theme—based on "Oh Bury Me Not on the Lone Prairie"—plays during many extreme long shots of the stagecoach traveling across the prairie, thus reminding the audience of the ever-present danger faced by the travelers. At one point in the film, an un-imaged piano suggests sympathy for the prostitute Dallas (Claire Trevor) by playing "She Is More to Be Pitied Than Censured," a famous 1894 song by William B. Gray urg-

ing compassion for a "fallen" woman. Steiner's score for *Gone with the Wind* incorporates an enormous number of Civil War–era tunes, including "Dixie," "Oh Maryland," "When Johnny Comes Marching Home Again," "Bonnie Blue Flag," "Tramp, Tramp, Tramp," "Old Folks at Home," "Battle Hymn of the Republic," and "Beautiful Dreamer." Scores for films set in the modern era sometimes include popular tunes. Royal S. Brown points out that the final showdown between Walter and Phyllis in *Double Indemnity* includes the popular songs "Tangerine," by Johnny Mercer and Victor Schertzinger, and "My Ideal," by Richard A. Whiting and Newell Chase. "Tangerine" features lyrics about a "femme fatale whose heart belongs to just one—herself,"[10] while "My Ideal" comments bitterly on what Walter has failed to find in Phyllis. Though it seldom dominated a score as it did during much of the early sound era, preexisting music remained an important tool in the Golden Age.

Like preexisting music, song plugging in the Golden Age—outside of the musical genre—never approached late 1920s levels. Yet one can still find song plugging in nonmusicals that resonates with early sound era tactics. *The Paleface* (1948), for instance, features only two vocal numbers— "Painless" Peter Potter's (Bob Hope) rendition of "Buttons and Bows" and saloon girl Pepper's (Iris Adrian) performance of "Meetcha 'Round the Corner"—and thus would not qualify as a musical by most standards. Yet "Buttons and Bows" recurs at numerous other points in the film. It plays during the opening and closing credits, serves as an instrumental "love theme" for Painless and Calamity Jane (Jane Russell), and is even transposed to a minor key when Calamity Jane discovers that her contact person has been killed. Like early sound era films such as *The Wild Party* (1929), *Millie* (1931), and *The Purchase Price* (1932), *The Paleface* centers its music track on a single song, features diegetic performances of that song, and also uses the song as underscoring.

The closely synchronized comedic accompaniment strategies found in musicals like *The Love Parade* (1929), *One Hour with You* (1932), *Love Me Tonight* (1932), and *The Big Broadcast* (1932) also retained a small yet important role in the Golden Age. In *The Love Parade* and *One Hour with You* the filmmakers had used instrumental reprises of previously performed songs to reflect a character's sudden internal realization, often to comedic effect. This tactic also occurs in *Meet Me in St. Louis* (1944). Late in the film, Lon Smith (Leon Ames)—the father of the Smith household—sits in a chair and ponders his decision to move the family to New York City. As the

camera slowly dollies toward him, the soundtrack plays three renditions of the opening motive to "Meet Me in St. Louis." Each reiteration of the motive begins several steps higher and is more densely textured. On the third rendition brass instruments enter the song, and the father looks upward as if a light has suddenly gone on in his head, a visual impression augmented by the lit match he holds in his hand. It is at this moment that the father realizes his family must stay in St. Louis. Such a reiteration of a previously performed song to mimic a character's thought process is virtually identical to *The Love Parade*'s instrumental rendition of "Dream Lover" when Louise (Jeanette MacDonald) decides to pursue Renard (Maurice Chevalier), or the place-card scene in *One Hour with You* in which a hostile rendition of "Sweethearts" indicates Colette's (MacDonald's) belief that she has discovered André's (Chevalier's) infidelity. Also like *The Love Parade* and *One Hour with You*, this use of a previously performed song in *Meet Me in St. Louis* strips away the character's dignity and lays bare the character's thought process to comedic effect. Just as "Dream Lover" reveals Louise's romantic wishes beneath her queenly facade, the audience is induced to chuckle at Lon's slow-dawning realization of something the rest of the family knew all along: the Smith family belongs in St. Louis.

Meet Me in St. Louis also demonstrates the persistence of comedic mickey-mousing and stingers in the Golden Age, strategies used prominently in *Love Me Tonight* and *The Big Broadcast*. *Meet Me in St. Louis* reserves its most dogged synchronization for the Halloween sequence, in which four-year-old Tootie (Margaret O'Brien) must stand up to the bigger kids in the neighborhood and later throw flour in the face of the supposedly sinister Mr. Braukoff (Mayo Newhall). During this lighthearted sequence, MGM staff composer Conrad Salinger provides dramatic stingers to convey the fright that Tootie tries to cause in others and experiences herself, as well as mickey-mousing when Tootie throws flour at Mr. Braukoff.[11] This close, exaggerated synchronization serves as a corollary to Tootie's feelings and perhaps elicits a fond chuckle in the audience. To her, demonstrating her bravery on Halloween night is of paramount importance. Such comically tight synchronization to the image in *Meet Me in St. Louis* was surely influenced by period cartoons, but the use of mickey-mousing and stingers for a live-action sound comedy stemmed from the early sound era.

Not all early sound tactics survived in the Golden Age. As film music became an increasingly widespread and conventionalized practice, its

duration in a given film settled into a more predictable range. Though work remains to be done in this area, Golden Age scores generally used nondiegetic music for between 25 and 65 percent of the film.[12] Thus the sparse musical strategies of *Liliom* or *The Bitter Tea of General Yen* are difficult to find in the classical era, as are the continuous or near continuous scoring practices found in early sound films like *The Squall, Golden Dawn, Fighting Caravans* (1931), *Bird of Paradise* (1932), and *Chandu the Magician* (1932). Diegetic withdrawal, a staple of the early sound era, also largely disappeared from Golden Age practices. As film music became an increasingly expected element in a broad range of classical Hollywood films, the perceived need to diegetically justify music receded. Typically in the Golden Age, nondiegetic music's first appearance after the opening credits features no diegetic justification.

This lack of diegetic withdrawal is emblematic of a crucial difference between early sound music and the Golden Age. In the Golden Age, film music needed no explanation for its presence because it had become accepted as a fundamental narrational tool. This new understanding of film music among composers can be gleaned from a widely recounted Golden Age anecdote. When one of Alfred Hitchcock's people asked composer David Raksin where the music was coming from for his score to the ocean-set film *Lifeboat* (1944), Raksin replied, "Go back and ask him where the camera comes from and I'll tell him where the music comes from!"[13] This story is often taken as evidence of the broader industry's idiocy regarding film scores or the public's general tendency not to notice mainstream film music. Yet Raksin's reply also reveals an assumption that film music—like the movie camera—is simply another nondiegetic filmmaking tool. Just as the use of a camera to present a story needs no diegetic explanation, by the 1940s film music similarly required no explanation.

Any study of the transition from the early sound era to the Golden Age must take into account the process by which music shifted from being a specialized tactic for conveying other worlds to a widespread tool that contributed to basic narrational aims like story clarity and continuity. Korngold's 1935 score for *Captain Blood* provides an early indication of this new assumption for film music. In one sense *Captain Blood*'s nondiegetic music helps convey the film's otherworldly setting in various non-American seventeenth-century cities and ports. Yet the score is bound to the film's storytelling aims in ways not often found in the early sound era. The music stops for the film's initial expository dialogue, for

example, thereby ensuring maximum viewer comprehension of the plot's fundamental building blocks. During the film's first dialogue sequence, the audience learns that there has been a feeble attempt at a revolution and that King James—the ruler of England—is probably not a just leader. Dialogue also indicates that Peter Blood (Errol Flynn) is somewhat boyish, is single, is fairly disinterested in revolution or politics, and has had six years of adventure in the military and as a seaman but now prefers the life of a peaceful doctor. This information drives much of the plot that follows. Blood will become firmly opposed to King James's tyrannical rule when his desire to peacefully practice medicine is challenged, causing Blood to put his skills as a fighter and seaman to use by becoming a pirate. Eventually, Blood will "grow up" by supporting his country through his fight for good King William and by winning the love of a woman. Korngold does not eliminate music during *Captain Blood*'s initial dialogue scene out of a general reluctance to accompany dialogue, since many other conversations in the film contain background scoring. Rather, Korngold's score operates in concert with the narrative, ducking out during moments when information presented by dialogue is central to an understanding of the plot. In the early sound era the removal of music for expository dialogue never cohered as a standard practice. In the classical era, however, this practice occurs frequently,[14] and it represents the period's heightened effort to coordinate music with storytelling concerns.

Captain Blood's score also aids narrational aims by frequently playing a single piece of music during scene transitions. Doing so furthers the sense that *Captain Blood* features a unified and cohesive narrative rather than a discontinuous series of edited-together scenes. In many cases Korngold starts a cue several seconds before the end of a scene and continues it into the following scene. When music does not occur in a scene, Korngold still regularly provides a brief cue that plays only during the scene transition. Even when a new musical piece *does* precisely coincide with a change of scene, the music features no gap between tunes, thus enabling it to flow continuously across the scene change. These tactics differ substantially from the early sound era, where music bridges were rare. *Captain Blood*'s dogged use of music bridges between scenes reflects music's heightened commitment to narrative continuity, a basic feature of the Golden Age.[15]

Captain Blood thus reveals an innovative and crucial shift in film music's identity during the Golden Age. Rather than being mobilized to

evoke a *particular* environment, music's presence and absence is partly dictated by the presence of scene changes and expository dialogue, issues applicable to *all* Hollywood films. This is not to say that classical film music entirely abandoned its otherworldly connotations in favor of practical narrative concerns. Rather, the classical Hollywood score featured an increased ability to serve pragmatic narrative functions while simultaneously retaining a connection with the "otherworldly." Crisis historiography stipulates that a stabilized practice must feature a considerable range of benefits.[16] Such was the usefulness of classical Hollywood film music that it could continue to evoke external and internal other worlds while simultaneously functioning as a basic narrational tool.

Like the early sound score, then, Golden Age film music emerged by drawing on certain prior practices, discarding other techniques, and developing new strategies based on shifting representational assumptions. A "new" aesthetic practice like Golden Age music did not arise suddenly from the musicless void of the early sound era but rather took advantage of a wealth of early sound score experimentation. Armed with a fuller picture of the early sound score, film music history becomes characterized less by sudden innovations and dramatic ruptures with the past and more by continuities with prior practices even in the midst of apparently radical aesthetic and technological change. Understanding the early sound score grants us a better sense of the historical trajectory of film music, as well as the unique concerns, challenges, and representational assumptions that characterized the volatile early sound era.

Chronological Filmography, 1926–1934

Below is a list of every feature-length film from 1926 to 1934 that I have viewed for this project. The list was constructed based on films that have been credited with some type of music (whether in the original credits or in modern sources) and my own prior knowledge of films with scores in the early sound era. For the films analyzed in this study, I include film title, date of the premiere, producer/distributor, director, known sound personnel, and songs featured within the diegesis. For the remaining films I provide the film title, general release date, producer/distributor, and director.*

Don Juan
 August 6, 1926
 Warner Bros.
 Director: Alan Crosland
 Music arrangement: Maj. Edward Bowes and David Mendoza
 Original music: William Axt
 Music performed by the New York Philharmonic

* Sources for this appendix include the *American Film Institute Catalog*; credits listed at the beginning and/or end of each film; and archival materials in the Paramount Pictures Corporation Music Archives at Paramount Pictures in Los Angeles, the Warner Bros. Archives at the University of Southern California, and the RKO music collection at UCLA.

Conductor: Henry Hadley
Recording engineer: George G. Groves

The Better 'Ole
October 7, 1926
Warner Bros.
Director: Charles Reisner

When a Man Loves
February 3, 1927
Warner Bros.
Director: Alan Crosland
Original music composer: Henry Hadley
Synchronization: Vitaphone Symphony Orchestra
Conductor: Herman Heller

Old San Francisco
June 21, 1927
Warner Bros.
Director: Alan Crosland
Music score compiled by Hugo Riesenfeld
Music synchronization: Vitaphone Symphony Orchestra
Conductor: Josiah Zuro

Sunrise: A Song of Two Humans
September 23, 1927
Fox
Director: F. W. Murnau
Score: Hugo Riesenfeld

The Jazz Singer
October 6, 1927
Warner Bros.
Director: Alan Crosland
Music score and Vitaphone director: Louis Silvers
Sound: George R. Groves
"Mammy," by Sam Lewis, Joe Young, and Walter Davidson; "Toot, Toot, Tootsie!"
by Gus Kahn, Ernie Erdman, and Dan Russo; "Dirty Hands, Dirty Face," music by
James V. Monaco, lyrics by Edgar Lewis, Grant Clarke, and Al Jolson; "Blue Skies,"
by Irving Berlin; "Mother of Mine, I Still Have You," by Al Jolson, Louis Silvers, and
Grant Clarke; "Kol Nidre," traditional hymn

Uncle Tom's Cabin
November 4, 1927
Universal
Director: Harry Pollard
Music score: Erno Rapee

Street Angel
April 9, 1928
Fox
Director: Frank Borzage

The Man Who Laughs
April 27, 1928
Universal
Director: Paul Leni
"When Love Comes Stealing," by Walter Hirsch, Lew Pollack, and Erno Rapee

Tempest
May 17, 1928
Joseph M. Schenck Productions/United Artists
Director: Sam Taylor

Lights of New York
July 6, 1928
Warner Bros.
Director: Bryan Foy

The Singing Fool
September 19, 1928
Warner Bros.
Director: Lloyd Bacon
Music conductor: Louis Silvers
Music performed by the Vitaphone Symphony Orchestra
"Sonny Boy" and "It All Depends on You," by Lew Brown, B. G. DeSylva and Ray Henderson; "I'm Sittin' on Top of the World," words by Sam Lewis and Joe Young, music by Ray Henderson; "Keep Smiling at Trouble," words by Al Jolson and B. G. DeSylva, music by Lewis Gensler; "Golden Gate," words by Billy Rose and Dave Dreyer, music by Al Jolson and Joseph Meyer; "There's a Rainbow 'Round My Shoulder," by Billy Rose, Al Jolson, and Dave Dreyer.

Noah's Ark
 November 1, 1928
 Warner Bros.
 Director: Michael Curtiz

The Flying Fleet
 January 19, 1929
 MGM
 Director: George Hill

Weary River
 January 24, 1929
 First National
 Director: Frank Lloyd
 Musical score and Vitaphone Symphony Orchestra conducted by Louis Silvers
 "Weary River" and "It's Up to You," words by Grant Clarke, music by Louis
Silvers

The Broadway Melody
 February 1, 1929
 MGM
 Director: Harry Beaumont
 Recording engineer: Douglas Shearer
 "The Wedding of the Painted Doll," "Broadway Melody," "Love Boat," "Boy
Friend," "Harmony Babies," and "You Were Meant for Me," music by Nacio Herb
Brown, lyrics by Arthur Freed; "Truthful Deacon Brown," by Willard Robison

Wild Orchids
 February 23, 1929
 MGM
 Director: Sidney Franklin

Desert Nights
 March 9, 1929
 MGM
 Director: William Nigh

The Wild Party
 March 30, 1929
 Paramount
 Director: Dorothy Arzner

Recording engineer: Earl Hayman
"My Wild Party Girl," words by Leo Robin, music by Richard A. Whiting

High Voltage
April 7, 1929
Pathé Exchange
Director: Howard Higgin

Alibi
April 8, 1929
Feature Productions/United Artists
Director: Roland West
Music arrangement: Hugo Riesenfeld

The Pagan
April 27, 1929
MGM
Director: W. S. Van Dyke

The Squall
May 9, 1929
First National
Director: Alexander Korda
Music synchronization and score: Leo Forbstein
"Gypsy Charmer," words by Grant Clarke, music by Harry Akst

Eternal Love
May 11, 1929
Feature Productions/United Artists
Director: Ernst Lubitsch
Music score: Hugo Riesenfeld

The Cocoanuts
May 24, 1929
Paramount
Director: Joseph Santley, Robert Florey
Music director: Frank Tours
"Florida by the Sea," "The Monkey Doodle-Doo," "Tale of the Shirt," and "When My Dreams Come True," by Irving Berlin

The Hollywood Revue of 1929
June 20, 1929
MGM
Director: Charles Reisner

Evangeline
July 27, 1929
Edwin Carewe Productions/United Artists
Director: Edwin Carewe

The Single Standard
July 27, 1929
MGM
Director: John S. Robertson

Say It with Songs
August 6, 1929
Warner Bros.
Director: Lloyd Bacon
Recording engineer: George R. Groves
"Little Pal," "I'm in Seventh Heaven," "Why Can't You?" and "Used to You," by Al Jolson, Lew Brown, B. G. DeSylva, and Ray Henderson; "Back in Your Own Back Yard" and "I'm Ka-razy for You," by Al Jolson, Billy Rose, and Dave Dreyer; "Mem'ries of One Sweet Kiss," by Al Jolson and Dave Dreyer

Speedway
September 7, 1929
MGM
Director: Harry Beaumont

They Had to See Paris
September 8, 1929
Fox
Director: Frank Borzage
Sound: George P. Costello
"I Could Do It for You," by Sidney Mitchell, Archie Gottler, and Con Conrad

The Great Gabbo
September 12, 1929
James Cruze/Sono Art–World Wide Pictures
Director: James Cruze

· *Sunny Side Up*
October 3, 1929
Fox
Director: David Butler
Music director: Howard Jackson, Arthur Kay
Recording engineer: Joseph Aiken
"I'm a Dreamer (Aren't We All?)," "If I Had a Talking Picture of You," "Turn on the Heat," "Sunny Side Up," and "(You've Got Me) Picking Petals Off o' Daisies," by Buddy DeSylva, Lew Brown, and Ray Henderson

Applause
October 7, 1929
Paramount
Director: Rouben Mamoulian

The Phantom in the House
November 1, 1929
Trem Carr Productions/Continental Talking Pictures
Director: Phil Rosen

The Kiss
November 15, 1929
MGM
Director: Jacques Feyder

The Love Parade
· November 19, 1929
Paramount
Director: Ernst Lubitsch
Chief Recording Engineer: Franklin Hansen
Instrumental music: W. Franke Harling, John M. Leipold
"Champagne," "Dream Lover," "My Love Parade," "Paris, Stay the Same," "Let's Be Common," "March of the Grenadiers," "Nobody's Using It Now," "Gossip," "Anything to Please the Queen," "Ooh, La La," and "The Queen Is Always Right," words by Clifford Grey, music by Victor Schertzinger

The Show of Shows
November 20, 1929
Warner Bros.
Director: John G. Adolfi

The Vagabond Lover
November 26, 1929
RKO
Director: Marshall Neilan

It's a Great Life
December 6, 1929
MGM
Director: Sam Wood

Glorifying the American Girl
December 7, 1929
Paramount
Director: Millard Webb

Sally
December 23, 1929
First National
Director: John Francis Dillon

Party Girl
January 1, 1930
Personality Pictures/Tiffany Productions
Director: Victor Halperin
Music: Harry Stoddard
Sound: Roy Clayton
Recording engineers: William R. Fox, Alfred M. Granich, Ben Harper
"Farewell" and "Oh! How I Adore You," by Harry Stoddard and Marcy Klauber

They Learned About Women
January 31, 1930
MGM
Director: Jack Conway, Sam Wood

Be Yourself!
February 8, 1930
Joseph M. Schenk Productions/United Artists
Director: Thornton Freeland

Song o' My Heart
 March 11, 1930
 Fox
 Director: Frank Borzage

Mammy
 March 26, 1930
 Warner Bros.
 Director: Michael Curtiz

King of Jazz
 May 2, 1930
 Universal
 Director: John Murray Anderson

The Silent Enemy
 May 19, 1930
 Burden-Chanler Productions/Paramount
 Director: H. P. Carver

Hell's Angels
 May 27, 1930
 The Caddo Co./United Artists
 Director: Howard Hughes
 Music arrangement: Hugo Riesenfeld
 Sound: Lodge Cunningham
 Sound Assistant: James M. Thornburn

Golden Dawn
 June 14, 1930
 Warner Bros.
 Director: Ray Enright
 Recording engineer: Glenn E. Rominger
 Music performed by: Vitaphone Orchestra
 Conductor: Louis Silvers
 "The Whip," "My Bwanna," "We Two," words by Otto Harbach and Oscar Hammerstein II, music by Emmerich Kálmán and Herbert Stothart; "Dawn," words by Otto Harbach and Oscar Hammerstein II, music by Herbert Stothart and Robert Stoltz; "Little Girl, Little Girl (Mooda's Appeal)," by Emmerich Kálmán and Herbert Stothart; "Africa Smiles No More" and "Jungle Bungalow," by Grant Clarke and Harry Akst; "You Know the Type: A Tiger," by Robert E. Dolan and Walter O'Keefe.

With Byrd at the South Pole
June 19, 1930
Paramount

Abraham Lincoln
August 25, 1930
Feature Productions/United Artists
Director: D. W. Griffith
Music arrangement: Hugo Riesenfeld
Sound recording: Harold Witt

Monte Carlo
August 27, 1930
Paramount
Director: Ernst Lubitsch

Animal Crackers
August 29, 1930
Paramount
Director: Victor Heerman
Music arrangement: John W. Green
Recording engineer: Ernest F. Zatorsky
"Collegiate," by Moe Jaffe and Nat Bonx; "Some of These Days," by Shelton Brooks; "Why Am I So Romantic?" and "Hooray for Captain Spalding," by Bert Kalmar and Harry Ruby

Big Boy
September 6, 1930
Warner Bros.
Director: Alan Crosland
General musical director: Erno Rapee
Music performed by the Vitaphone Orchestra
Conductor: Louis Silvers
Recording engineer: Hal Bumbaugh
"What Will I Do Without You?" music by Joe Burke, lyrics by Al Dubin; "Liza Lee" and "Tomorrow Is Another Day," by Bud Green and Sammy Stept; "Down South," music by William H. Myddleton, lyrics by Sigmund Spaeth; "The Handicap March," by Dave Reed Jr. and George Rosey

Liliom
October 3, 1930
Fox

Director: Frank Borzage
Original music score: Richard Fall
Sound recording: George P. Costello
"Dream of Romance" and "Thief Song," by Richard Fall and Marcella Gardner

Half Shot at Sunrise
October 4, 1930
RKO
Director: Paul Sloane

Up the River
October 10, 1930
Fox
Director: John Ford
Sound recording: W. W. Lindsay Jr.
"Prison 'College' Song," words by Joseph McCarthy, music by James F. Hanley

Rogue of the Rio Grande
October 15, 1930
Cliff Broughton Productions/Sono Art–Wide World Productions
Director: Spencer Gordon

The Big Trail
October 24, 1930
Fox
Director: Raoul Walsh
Incidental Music: Arthur Kay
Sound Recording: Bill Brent, Paul Heihly
Chief Sound Technical: Donald Flick, George Leverett

Check and Double Check
October 25, 1930
RKO
Director: Melville Brown
Recording: George D. Ellis
"Three Little Words" and "Nobody Knows but the Lord," music by Harry Ruby, lyrics by Bert Kalmar

Sunny
November 9, 1930
First National
Director: William Seiter

Morocco
November 14, 1930
Paramount
Director: Josef von Sternberg

The Lottery Bride
November 22, 1930
Joseph M. Schenck/United Artists
Director: Paul L. Stein

Reaching for the Moon
December 29, 1930
Feature Productions/United Artists
Director: Edmund Goulding

Little Caesar
January 9, 1931
First National
Director: Mervyn LeRoy
General music director: Erno Rapee

Other Men's Women
January 17, 1931
Warner Bros.
Director: William A. Wellman
General music director: Erno Rapee
Vitaphone Orchestra conductor: Louis Silvers

The Painted Desert
January 18, 1931
Pathé Exchange/RKO Pathé Pictures
Director: Howard Higgin

Fighting Caravans
January 23, 1931
Paramount
Director: Otto Brower
Score: Max Bergunker, Emil Bierman, Arcady Cousminer, Karl Hajos, Herman Hand, Emil Hilb, Sigmund Krumgold, John M. Leipold, and Oscar Potoker

Cimarron
>
> January 26, 1931
> RKO
> Director: Wesley Ruggles
> Score: Max Steiner
> Recording: Clem Portman
> Assistant Recording: Ralph Spotts

City Lights
>
> January 30, 1931
> Charles Chaplin Productions/United Artists
> Director: Charles Chaplin
> Music composer: Charles Chaplin
> Music arrangement: Arthur Johnston
> Music director: Alfred Newman
> Sound and recording: Ted Reed

Seas Beneath
>
> January 30, 1931
> Fox
> Director: John Ford
> Sound Recording: W. W. Lindsay Jr.
> "My Loves," by Troy Sanders; "Marinero (Sailor Lad)," by Maria Grever; "Estrellita," by Manuel Ponce; "Here's My Hand—You're in My Heart," music by James F. Hanley, lyrics by Joseph McCarthy; "Zamboanga," composer unknown

Millie
>
> February 6, 1931
> Charles G. Rodgers Productions/RKO
> Director: John Francis Dillon
> Music director: Arthur Lange
> Sound technical: Robert Pritchard
> "Millie," by Nacio Herb Brown

Die Dreigroschenoper
>
> February 19, 1931 (Berlin opening)
> Warner Bros.; Gemeinschaft mit Tobis
> Director: G. W. Pabst

Lonely Wives
>
> February 22, 1931
> Pathé/RKO

Director: Russell Mack
Music director: Frances Gorman
Sound engineer: Charles O'Loughlin, T. A. Carman

Tabu
March 18, 1931
Golden Bough/Paramount
Director: F. W. Murnau
Music settings: Hugo Riesenfeld
Additional music: W. Franke Harling, Milan Roder, Corynn Kiehl, William Bambridge

Indiscreet
April 25, 1931
Feature Productions/United Artists
Director: Leo McCarey
Music director: Alfred Newman
Sound recording: Oscar Lagerstrom
"If You Haven't Got Love" and "Come to Me," by B. G. DeSylva, Lew Brown, and Ray Henderson

Public Enemy
May 15, 1931
Warner Bros.
Director: William A. Wellman

The Black Camel
June 21, 1931
Fox
Director: Hamilton MacFadden

The Smiling Lieutenant
July 10, 1931
Paramount
Director: Ernst Lubitsch

The Woman Between
August 8, 1931
RKO
Director: Victor Schertzinger

Street Scene
> August 26, 1931
> Feature Productions/United Artists
> Director: King Vidor
> Music director: Alfred Newman
> Sound technical: Charles Noyes

Monkey Business
> September 19, 1931
> Paramount
> Director: Norman McLeod

Friends and Lovers
> October 3, 1931
> RKO
> Director: Victor Schertzinger

Possessed
> November 21, 1931
> MGM
> Director: Clarence Brown
> Recording director: Douglas Shearer
> Sound: Anstruther MacDonald
> "How Long Will It Last?" music by Joseph Meyer, lyrics by Max Lief

Corsair
> November 28, 1931
> United Artists
> Director: Roland West

Tonight or Never
> December 4, 1931
> United Artists
> Director: Mervyn LeRoy

Arrowsmith
> December 7, 1931
> Howard Productions/United Artists
> Director: John Ford

The Struggle
December 10, 1931
D. W. Griffith/United Artists
Director: D. W. Griffith

Dr. Jekyll and Mr. Hyde
December 31, 1931
Paramount
Director: Rouben Mamoulian

The Greeks Had a Word for Them
February 3, 1932
Feature Productions/United Artists
Director: Lowell Sherman

Murders in the Rue Morgue
February 21, 1932
Universal
Director: Robert Florey

One Hour with You
February 24, 1932
Paramount
Director: Ernst Lubitsch
Interpolated music: Richard A. Whiting
Additional music: W. Franke Harling, Rudolph Kopp, John Leipold
Sound: M. M. Paggi
"Police Number," "We Will Always Be Sweethearts," and "Oh! That Mitzi!" music
by Oscar Straus, lyrics by Leo Robin; "One Hour with You," "Three Times a Day,"
"What Would You Do?" "What a Little Thing Like a Wedding Ring Can Do," and "It
Was Only a Dream Kiss," music by Richard A. Whiting, lyrics by Leo Robin

Ten Minutes to Live
March 1932
Micheaux Pictures/State Rights
Director: Oscar Micheaux

After Tomorrow
March 4, 1932
Fox
Director: Frank Borzage

Sound: George Leverett
"All the World Will Smile Again After Tomorrow," by James Hanley

Scarface
 March 31, 1932
 The Caddo Co./United Artists
 Director: Howard Hawks

Tarzan the Ape Man
 April 2, 1932
 MGM
 Director: W. S. Van Dyke

Symphony of Six Million
 April 14, 1932
 RKO
 Director: Gregory La Cava
 Music: Max Steiner
 Recording: George Ellis

Young America
 April 17, 1932
 Fox
 Director: Frank Borzage

Uncle Moses
 April 20, 1932
 Yiddish Talking Pictures
 Director: Aubrey Scotto

Mystery Ranch
 June 12, 1932
 Fox
 Director: David Howard

What Price Hollywood?
 June 24, 1932
 RKO
 Director: George Cukor
 Music director: Max Steiner
 Recording: George Ellis

Red-Headed Woman
 June 25, 1932
 MGM
 Director: Jack Conway
 Recording director: Douglas Shearer
 Sound: James Brock
 "The Red-Headed Woman," by Raymond B. Egan and Richard A. Whiting

Skyscraper Souls
 July 16, 1932
 MGM
 Director: Edgar Selwyn

The Purchase Price
 July 23, 1932
 Warner Bros.
 Director: William A. Wellman
 Vitaphone Orchestra conductor: Leo F. Forbstein

White Zombie
 August 4, 1932
 Halperin Productions/United Artists
 Director: Victor Halperin
 Music arrangement: Abe Meyer
 Sound Engineer: L. E. Clark

Bird of Paradise
 August 12, 1932
 RKO
 Director: King Vidor
 Music: Max Steiner
 Recording: Clem Portman

Speak Easily
 August 13, 1932
 MGM
 Director: Edward Sedgwick

Love Me Tonight
 August 18, 1932
 Paramount

Director: Rouben Mamoulian
Sound: M. M. Paggi
Instrumental music: Richard Rodgers, John Leipold
"Isn't It Romantic?" "Love Me Tonight," "Lover," "Mimi," "The Poor Apache,"
"The Son of a Gun Is Nothing but a Tailor," "That's the Song of Paree," and "A
Woman Needs Something like That," by Richard Rodgers and Lorenz Hart

Horse Feathers
August 19, 1932
Paramount
Director: Norman McLeod

Blonde Venus
September 16, 1932
Paramount
Director: Josef von Sternberg
Score: W. Franke Harling, John Leipold, P. A. Marquardt, Oscar Potoker, Ralph
Rainger
Sound: Harry D. English
"Hot Voodoo," music by Ralph Rainger, lyrics by Sam Coslow; "You Little So-
and-So," by Sam Coslow and Leo Robin; "I Couldn't Be Annoyed," by Leo Robin
and Dick Whiting

The Most Dangerous Game
September 16, 1932
RKO
Director: Ernest B. Schoedsack
Music: Max Steiner
Recording: Clem Portman
Sound effects: Murray Spivack

Mr. Robinson Crusoe
September 16, 1932
The Elton Corp./United Artists
Director: Edward Sutherland
Music score composer: Alfred Newman

Thirteen Women
September 16, 1932
RKO
Director: George Archainbaud

Chandu the Magician
 September 18, 1932
 Fox
 Director: Marcel Varnel, William C. Menzies
 Music director: Louis De Francesco
 Sound recording: Joseph E. Aiken

The Crooked Circle
 September 25, 1932
 World Wide Pictures/Astor Pictures
 Director: H. Bruce Humberstone

Illegal
 September 29, 1932
 Warner Bros.
 Director: William McGann

Strange Justice
 October 7, 1932
 King Motion Pictures/RKO
 Director: Victor Schertzinger

Rain
 October 12, 1932
 Feature Productions/United Artists
 Director: Lewis Milestone
 Music score: Alfred Newman
 Sound: Frank Grenzbach
 "St. Louis Blues," by W. C. Handy; "Baby Face," by Harry Akst and Benny Davis

The Big Broadcast
 October 14, 1932
 Paramount
 Director: Frank Tuttle
 Sound: J. A. Goodrich
 Instrumental Music: Ralph Rainger, John Leipold, Herman Hand
 "The Blue of the Night," by Roy Turk, Bing Crosby, and Fred E. Ahlert; "Trees,"
 lyrics by Joyce Kilmer, music by Ralph Rainger; "Hush! Hush! Hush!" "Please,"
 "Here Lies Love," "Kicking That Gong Around," "Major, Sharp and Minor," "Hold

That Tiger," "Crazy People," and "And You Were Mine," lyrics by Leo Robin, music by Ralph Rainger

Trouble in Paradise
October 21, 1932
Paramount
Director: Ernst Lubitsch
Score: W. Franke Harling
Music arrangement (opening and closing titles): John Leipold
Sound: M. M. Paggi
"Trouble in Paradise," music by W. Franke Harling, lyrics by Leo Robin

Uptown New York
November 27, 1932
K.B.S. Film Co./World Wide Pictures
Director: Victor Schertzinger

The Sign of the Cross
November 30, 1932
Paramount
Director: Cecil B. DeMille

A Farewell to Arms
December 8, 1932
Paramount
Director: Frank Borzage
Sound recording: Harold C. Lewis
Score: Ralph Rainger, John Leipold, Bernhard Kaun, W. Franke Harling, Paul Marquardt, Herman Hand

Haunted Gold
December 17, 1932
Warner Bros./Vitagraph
Director: Mack V. Wright

Madame Butterfly
December 23, 1932
Paramount
Director: Marion Gering
Incidental music: W. Franke Harling
Sound: Harry Lindgren

Rasputin and the Empress
 December 23, 1932
 MGM
 Director: Richard Boleslavsky

20,000 Years in Sing Sing
 December 24, 1932
 First National
 Director: Michael Curtiz
 Music score: Bernard Kaun
 Vitaphone orchestra conductor: Leo F. Forbstein

The Intruder
 December 26, 1932
 Allied Pictures Corp.
 Director: Albert Ray

The Animal Kingdom
 December 28, 1932
 RKO
 Director: Edward H. Griffith

Strange Interlude
 December 30, 1932
 MGM
 Director: Robert Z. Leonard

Cavalcade
 January 5, 1933
 Fox
 Director: Frank Lloyd

The Bitter Tea of General Yen
 January 6, 1933
 Columbia
 Director: Frank Capra
 Music score: W. Franke Harling
 Sound engineer: E. L. Bernds

She Done Him Wrong
 January 27, 1933
 Paramount
 Director: Lowell Sherman

Hallelujah I'm a Bum
 February 3, 1933
 Feature Productions/United Artists
 Director: Lewis Milestone

Ladies They Talk About
 February 4, 1933
 Warner Bros.
 Director: Howard Bretherton
 Music played by: Vitaphone Orchestra
 Conductor: Leo F. Forbstein
 "If I Could Be with You," music by James P. Johnson, lyrics by Henry Creamer;
"St. Louis Blues," by W. C. Handy

Topaze
 February 8, 1933
 RKO
 Director: Harry d'Abbadie d'Arrast

King Kong
 March 7, 1933
 RKO
 Director: Merian C. Cooper, Ernest B. Schoedsack
 Music: Max Steiner
 Recording: Earl A. Wolcott
 Sound effects: Murray Spivack

Christopher Strong
 March 9, 1933
 RKO
 Director: Dorothy Arzner

42nd Street
 March 9, 1933
 Warner Bros.
 Director: Lloyd Bacon

Vitaphone Orchestra director: Leo F. Forbstein
Sound: Nathan Levinson, Dolph Thomas
"42nd Street," "It Must Be June," Shuffle Off to Buffalo," "Young and Healthy,"
and "You're Getting to Be a Habit with Me," by Al Dubin and Harry Warren

The Phantom Broadcast
March 15, 1933
Monogram/State Rights
Director: Phil Rosen

The Telegraph Trail
March 18, 1933
Warner Bros./Vitagraph
Director: Tenny Wright

Gabriel over the White House
March 31, 1933
MGM
Director: Gregory LaCava

Marius
April 13, 1933
Paramount
Director: Alexander Korda

A Shriek in the Night
April 18, 1933
Allied Pictures
Director: Albert Ray

The Barbarian
May 12, 1933
MGM
Director: Sam Wood

Gold Diggers of 1933
May 27, 1933
Warner Bros.
Director: Mervyn LeRoy

Somewhere in Sonora
 May 27, 1933
 Warner Bros./Vitagraph
 Director: Mack V. Wright

International House
 June 2, 1933
 Paramount
 Director: Edward Sutherland

His Private Secretary
 June 10, 1933
 Screencraft Productions/Showmen's Pictures
 Director: Philip H. Whitman

Laughing at Life
 June 26, 1933
 Nat Levine Productions/Mascot Pictures
 Director: Ford Beebe

Midnight Mary
 June 30, 1933
 MGM/Loew's
 Director: William A. Wellman

Baby Face
 July 1, 1933
 Warner Bros.
 Director: Alfred E. Green

Man from Monterey
 July 15, 1933
 Warner Bros./Vitagraph
 Director: Mack V. Wright

Sing Sinner Sing
 August 1, 1933
 Majestic Pictures
 Director: Howard Christy

Tarzan the Fearless
August 11, 1933
Sol Lesser Productions/Principal Distributing Corp.
Director: Robert F. Hill

Morning Glory
August 18, 1933
RKO
Director: Lowell Sherman

Dinner at Eight
August 23, 1933
MGM
Director: George Cukor

The Big Chance
August 29, 1933
Eagle Pictures
Director: Victor Potel

Sensation Hunters
September 1, 1933
Monogram/State Rights
Director: Charles Vidor

Lady for a Day
September 7, 1933
Columbia
Director: Frank Capra

Penthouse
September 8, 1933
MGM
Director: W. S. Van Dyke

Torch Singer
September 8, 1933
Paramount
Director: Alexander Hall

The Emperor Jones
September 19, 1933
John Krimsky and Gifford Cochran/United Artists
Director: Dudley Murphy

Doctor Bull
September 22, 1933
Fox
Director: John Ford

S.O.S. Iceberg
September 22, 1933
Universal
Director: Tay Garnett
Original music composer: Paul Dessau
Sound engineer: Zoltan G. Kegl

Thunder over Mexico
September 22, 1933
Mexican Picture Trust/Principal Distributing Corp.
Director: Sergei M. Eisenstein

I'm No Angel
October 6, 1933
Paramount
Director: Wesley Ruggles

The Private Life of Henry VIII
October 7, 1933
London Film Productions/United Artists
Director: Alexander Korda

Meet the Baron
October 20, 1933
MGM
Director: Walter Lang

Footlight Parade
October 21, 1933
Warner Bros.
Director: Lloyd Bacon

Good-Bye Love
 November 10, 1933
 Jefferson Pictures/RKO
 Director: H. Bruce Humberstone
 Music: S. K. Wineland, Abe Meyer
 Sound recording: Lodge Cunningham
 "Good-Bye Love," by Con Conrad, Archie Gottler, and Sidney Mitchell

The Invisible Man
 November 13, 1933
 Universal
 Director: James Whale

Little Women
 November 16, 1933
 RKO
 Director: George Cukor
 Music: Max Steiner
 Recording: Frank H. Harris, George D. Ellis
 Recording Assistant: Ellis Fesler, Victor Appel

Duck Soup
 November 17, 1933
 Paramount
 Director: Leo McCarey

Dancing Lady
 November 24, 1933
 MGM
 Director: Robert Z. Leonard

Flying Down to Rio
 December 21, 1933
 RKO
 Director: Thornton Freeland

Queen Christina
 December 26, 1933
 MGM/Loew's
 Director: Rouben Mamoulian

Sons of the Desert
December 29, 1933
MGM
Director: William A. Seiter

His Double Life
January 12, 1934
Eddie Dowling Pictures/Paramount
Director: Arthur Hopkins

Four Frightened People
January 26, 1934
Paramount
Director: Cecil B. DeMille
Score: Karl Hajos, Milan Roder, Heinz Roemheld, John Leipold
Sound recording: Harry Lindgren

Search for Beauty
February 2, 1934
Paramount
Director: Erle C. Kenton

The Lost Patrol
February 16, 1934
RKO
Director: John Ford
Music director: Max Steiner
Sound: Clem Portman, P. J. Faulkner
Music recording: Murray Spivack

Palooka
February 16, 1934
Reliance Pictures/United Artists
Director: Benjamin Stoloff

It Happened One Night
February 22, 1934
Columbia
Director: Frank Capra

Spitfire
March 8, 1934
RKO
Director: John Cromwell

Catherine the Great
March 16, 1934
London Film Productions/United Artists
Director: Paul Czinner

Wonder Bar
March 31, 1934
First National
Director: Lloyd Bacon

Chloe, Love Is Calling You
April 1, 1934
Pinnacle Productions
Director: Marshall Neilan

In Love with Life
April 1, 1934
Invincible Pictures/Chesterfield Motion Pictures
Director: Frank Strayer

Men in White
April 6, 1934
MGM/Loew's
Director: Richard Boleslavsky

Stand Up and Cheer!
April 19, 1934
Fox
Director: Hamilton MacFadden

Tarzan and His Mate
April 20, 1934
MGM
Director: Cedric Gibbons

We're Not Dressing
April 27, 1934
Paramount
Director: Norman Taurog

The Lost Jungle
May 1, 1934
Mascot Pictures
Director: Armand Schaefer

Manhattan Love Song
May 1, 1934
Monogram
Director: Leonard Fields

Manhattan Melodrama
May 4, 1934
MGM
Director: W. S. Van Dyke
Orchestra: Paul Marquardt, Maurice de Packh
Recording director: Douglas Shearer
Synchronization: Dr. William Axt
"The Bad in Every Man (Blue Moon)," music by Richard Rodgers, lyrics by Lorenz
Hart

The Black Cat
May 7, 1934
Universal
Director: Edgar G. Ulmer
Music director: Heinz Roemheld

Sadie McKee
May 9, 1934
MGM
Director: Clarence Brown

Born to Be Bad
May 18, 1934
20th Century Pictures/United Artists
Director: Lowell Sherman

Murder at the Vanities
 May 25, 1934
 Paramount
 Director: Mitchell Leisen

The Thin Man
 May 25, 1934
 MGM
 Director: W. S. Van Dyke

The House of Mystery
 May 30, 1934
 Monogram
 Director: William Nigh

Little Miss Marker
 June 1, 1934
 Paramount
 Director: Alexander Hall

Randy Rides Alone
 June 18, 1934
 Monogram
 Director: Harry Fraser

Baby Take a Bow
 June 22, 1934
 Fox
 Director: Harry Lachman

Kiss and Make-Up
 June 28, 1934
 Paramount
 Director: Harlan Thompson

Of Human Bondage
 June 28, 1934
 RKO
 Director: John Cromwell

The Old Fashioned Way
July 13, 1934
Paramount
Director: William Beaudine

The Star Packer
July 30, 1934
Monogram
Director: R. N. Bradbury

The Cat's-Paw
August 7, 1934
Harold Lloyd/Fox
Director: Sam Taylor

Treasure Island
August 17, 1934
MGM
Director: Victor Fleming

The Moonstone
August 20, 1934
Monogram
Director: Reginald Barker

Chained
August 31, 1934
MGM
Director: Clarence Brown

Dames
September 1, 1934
Warner Bros.
Director: Ray Enright

Charlie Chan in London
September 12, 1934
Fox
Director: Eugene Forde

Wagon Wheels
September 14, 1934
Paramount
Director: Charles Barton

King Kelly of the U.S.A.
September 15, 1934
Monogram
Director: Leonard Fields

The Scarlet Empress
September 15, 1934
Paramount
Director: Josef von Sternberg

Belle of the Nineties
September 21, 1934
Paramount
Director: Leo McCarey

Chu Chin Chow
September 21, 1934
Gaumont-British Picture Corp.
Director: Walter Forde

Judge Priest
September 28, 1934
Fox
Director: John Ford

The Return of Chandu
October 1, 1934
Principal Pictures
Director: Ray Taylor

Cleopatra
October 5, 1934
Paramount
Director: Cecil B. DeMille

Peck's Bad Boy
 October 5, 1934
 Principal Productions/Fox
 Director: Edward F. Cline

365 Nights in Hollywood
 October 12, 1934
 Fox
 Director: George Marshall

Man of Aran
 October 18, 1934
 Gainsborough Pictures/Gaumont-British Picture Corp. of America
 Director: Robert Flaherty

The Gay Divorcee
 October 19, 1934
 RKO
 Director: Mark Sandrich

Marie Galante
 October 26, 1934
 Fox
 Director: Henry King

We Live Again
 November 1, 1934
 Samuel Goldwyn/United Artists
 Director: Rouben Mamoulian

Evelyn Prentice
 November 9, 1934
 MGM
 Director: William K. Howard

The Marines Are Coming
 November 20, 1934
 Mascot Pictures
 Director: David Howard

Imitation of Life
November 26, 1934
Universal
Director: John M. Stahl

Babes in Toyland
November 30, 1934
MGM/Loew's
Director: Gus Meins

The Private Life of Don Juan
November 30, 1934
London Film Productions/United Artists
Director: Alexander Korda

The Ghost Walks
December 1, 1934
Invincible Pictures/Chesterfield Motion Pictures
Director: Frank R. Strayer

Bright Eyes
December 20, 1934
Fox
Director: David Butler

Forsaking All Others
December 23, 1934
MGM
Director: W. S. Van Dyke

The Little Minister
December 28, 1934
RKO
Director: Richard Wallace

NOTES

INTRODUCTION

1. Evans, *Soundtrack*; Prendergast, *A Neglected Art*; Thomas, *Music for the Movies*; Thomas, *Film Score*.

2. Gorbman, *Unheard Melodies*.

3. Brown, *Overtones and Undertones*; Flinn, *Strains of Utopia*; Kalinak, *Settling the Score*; Lack, *Twenty-Four Frames Under*; MacDonald, *The Invisible Art of Film Music*; Marks, *Music and the Silent Film*; Marmorstein, *Hollywood Rhapsody*.

4. Altman, *Silent Film Sound*; Cooke, *A History of Film Music*; Wierzbicki, *Film Music*. The lists in these first four notes contain only some of the more prominent books on film music, and they do not even address the wealth of scholarly articles and edited book collections on the subject.

5. Two authoritative—though very different—works on music in the silent era are Altman, *Silent Film Sound*; and Marks, *Music and the Silent Film*.

6. Gorbman's *Unheard Melodies* and Kalinak's *Settling the Score* lay out the most detailed explanation of the Golden Age's scoring practices. For work on film composers during the Golden Age see Thomas's *Film Score* and *Music for the Movies*.

7. Thomas, *Music for the Movies*; Thomas, *Film Score*; Evans, *Soundtrack*. The exception is Prendergast's *A Neglected Art*, where the author devotes a small

chapter to music in the early sound film and acknowledges that scores in the period were a group effort.

8. Steiner, "Scoring the Film," 217–19.

9. In the 1970s, portions of this quotation and similar Steiner quotations appear in Prendergast, *A Neglected Art*, 16–17; Thomas, *Music for the Movies*, 146; and Thomas, *Film Score*, 66–68.

10. Gorbman asserts that during Hollywood's transition to sound, there was a five-year absence of background music (*Unheard Melodies*, 42). Kalinak, drawing partly on Steiner's wandering violinist example, argues that underscoring was avoided in the early sound era because such a practice was at odds with the period's aesthetic of realism and was precluded by a lack of sound mixing (*Settling the Score*, 66–69). Brown also cites Steiner and claims that outside of musicals and "quasi-silent" films like *Tabu* (March 1931), film music all but left the early sound film (*Overtones and Undertones*, 56–57).

11. Cooke, *A History of Film Music*, 85.

12. Thomas, *Film Score*, 67–68.

13. For a discussion of the Great Man theory and its drawbacks for film scholarship see Allen and Gomery, *Film History*, 110–13.

14. Thomas, *Film Score*, 68.

15. The tendency to label the early sound era "primitive" is similar to the problems once faced by scholarship on the first ten years of silent cinema. Many scholars initially dismissed early cinema as "primitive" owing to its supposed storytelling ineptitude. Led by André Gaudreault and Tom Gunning, scholars began to understand early cinema as a period with its own aims and methods, rather than as an era of failed early attempts to create a narrative cinema (See Gunning's "The Cinema of Attractions" for the best-known article on the subject). Music in the early sound era should similarly be approached on its own terms rather than continuously compared to the ostensibly richer Golden Age.

16. Wierzbicki, *Film Music*, 130.

17. See Altman, *Silent Film Sound*, 15–23.

18. The difference between the premiere date and release date could often be substantial in the early sound era. Films regularly received premieres in prominent New York City or Los Angeles theaters well prior to their general release. Warner Bros.' *Don Juan*, for instance, premiered in New York City in August of 1926 but was not released for the general public until February of 1927.

19. See Gorbman, *Unheard Melodies*.

20. Wierzbicki, *Film Music*, 125.

1. A Wide Array of Choices

1. Bandy, *The Dawn of Sound*, 49.

2. Altman, *Silent Film Sound*, 15–23.

3. Much of Gomery's work on the subject has been collected in Gomery, *The Coming of Sound*. See pages xv–xx for a detailed explanation of Gomery's three-step model.

4. Gomery's model does suggest the potential for instability during the "innovation" stage, yet for Gomery this stage featured mild alterations to what was an essentially stable, already-recognized product.

5. Crafton, *The Talkies*, 6.

6. This is the periodization proposed by Grout and Williams in *A Short History of Opera*, though they do trace the origins of opera as far back as ancient Greek theater.

7. Film music scholars have differed on the question of whether operatic scoring conventions contain significant commonalities with the Hollywood sound film score. While scholars such as Roy Prendergast and Mervyn Cooke have found film music to be essentially operatic in certain ways (Prendergast, *A Neglected Art*, 4; Cooke, *A History of Film Music*, 78), Royal S. Brown argues that the connections between opera and film scoring are tenuous at best. Brown claims that opera, unlike film, predominantly features singing, which necessitates a much closer coordination between music and voice. Moreover, Brown argues—perhaps inaccurately given the fact that the libretto is generally composed before the music—that in opera the composer has "the luxury of developing an ongoing interaction between musical and dramatic logic" (*Overtones and Undertones* 48), while music for a film is generally tacked on after the screenplay has been written and the story has been filmed. Brown also states that opera necessitates near-continuous music, while film can enjoy long stretches of time without music. Brown further points out that film tends to repeat its motifs too often and with too little variation to qualify as being "operatic" (*Overtones and Undertones*, 43–48). Though Brown's critique is persuasive, perceptive, and quite valuable to anyone wishing to understand operatic and film music aesthetics, he collapses the distinction between the *ontological* properties of opera and film and the *historical uses* of those media. Writing from a moment when music in sound films has been used for nearly seventy years, Brown is quite right to claim that films permit long passages without music, that their musical motifs are repeated frequently and varied little, and that the creation of the score generally begins after the creation of the film narrative. But ontologically, there is no reason why a film *cannot* feature continuous music, vary its themes, or present a score that evolves in tandem with the narrative. In the late 1920s, scoring rules were not set, and films had

the option of adopting the scoring strategies of an operatic form that was similarly concerned with the linkage between music and narrative.

8. Whittall, "Leitmotif," 1137.

9. Grout and Williams, *A Short History of Opera*, 365.

10. Deathridge and Dahlhaus, *New Grove Wagner*, 112.

11. Ibid., 79. Wagner's theoretical writings generally featured terms other than *leitmotif* to describe the concept, but Whittall points out that he did use the term in a print article in 1879 ("Leitmotif," 1137).

12. Buhler, "Wagnerian Motives."

13. This idea is discussed in Deathridge and Dahlhaus, *New Grove Wagner*, 99.

14. Altman, *Silent Film Sound*, 372.

15. Ibid., 372–79.

16. Monson, "Recitative," 1251.

17. Rimsky-Korsakov, *Principles of Orchestration*, 120.

18. Preston, *Opera on the Road*, xii.

19. Levine, *Highbrow/Lowbrow*, 6, 176–77. Preston, who argues that the public had widespread familiarity with opera in the nineteenth century, agrees with Levine that turn-of-the-century elites took opera out of popular venues (*Opera on the Road*, 316–17).

20. Ironically, as Levine points out, the elites were often inaccurate in their understanding of how the fine arts were originally received. See Levine, *Highbrow/Lowbrow*, esp. 229, for a more detailed discussion.

21. Broyles, "Art Music from 1860 to 1920," 215, 222–25.

22. Horowitz, *Classical Music in America*, 88–91, 250–53.

23. *Variety*, Feb. 5, 1930, 46.

24. *Film Daily*, Sept. 16, 1932, 1.

25. For a detailed account of what pieces were typically used as silent film overtures, see Altman, *Silent Film Sound*, 310–13, 380.

26. The audience *would* have been familiar with recurring musical passages, but mainly as they functioned in silent films rather than opera, as I discuss later in the chapter.

27. Shapiro, "Action Music in American Pantomime and Melodrama," 56. Rousseau added the hyphen to the Italian term *melodramma*, which refers to opera and sung recitative. In essence, Rousseau separated music and drama. My thanks to Michael Pisani for help with the history of melodrama.

28. Shapiro, "Action Music," 57.

29. David Mayer has argued persuasively that in the first decade of the twentieth century, "toga films" (melodramatic films set in the postrepublican Roman Empire) aspired to be like "toga plays" since the latter were much more reputable (*Playing Out the Empire*, xi).

30. Altman, *Silent Film Sound*, 39.

31. My thanks to Michael Pisani for this information.

32. Belasco, *The Heart of Maryland*, 175, 221, 236.

33. McLucas uses the version of *The Count of Monte Cristo* that was "owned originally by J. B. Studley and used by him in his New York appearances in the 1880s." Studley had played the villain in the play's first New York production in 1873 (*Later Melodrama in America*, xiv–xv).

34. McLucas, *Later Melodrama in America*, xviii–xix.

35. Pisani, *Music for the Melodramatic Theatre*.

36. Altman, *Silent Film Sound*, 39.

37. A diminished seventh chord occurs when the seventh note of a minor-key chord has been lowered by a half step. The result is a chord that conventionally denotes tension and a lack of tonal resolution.

38. Altman, *Silent Film Sound*, 37.

39. Shapiro, "Action Music," 65.

40. Taken from the play script in McLucas, *Later Melodrama in America*, 32.

41. Ibid.

42. My thanks to Michael Pisani for identifying this general tendency.

43. Altman, *Silent Film Sound*, 37.

44. Pisani, *Music for the Melodramatic Theatre*, 202–203.

45. Ibid., 37.

46. Preston, "The Music of Toga Drama," 27.

47. Ibid., 30. For a more detailed discussion of combination companies see Mayer and Mayer, "A 'Secondary Action' or Musical Highlight?" 220–31.

48. Pisani, *Music for the Melodramatic Theatre*, 156.

49. Altman, *Silent Film Sound*, 42.

50. Levine traces the efforts—which seem to have begun by the 1880s—to divide entertainment into highbrow and lowbrow categories in *Highbrow/Lowbrow*, 171–242.

51. Savran, "The Search for America's Soul," 460. Though Savran claims that musical theater and vaudeville were the most popular theatrical entertainment forms, vaudeville's substantial economic decline in the 1920s suggests that it did not hold as great an appeal as musical theater.

52. This is not to downplay the revue-style films that enjoyed a relatively brief production surge, including *The Show of Shows* (Nov. 1929), *Paramount on Parade* (April 1930), and *King of Jazz* (May 1930). However, most films featuring music sought to connect music with a screen narrative.

53. Admittedly, both Berlin (*Music Box Revue*, *Ziegfeld Follies*) and Gershwin (*George White's Scandals*) were high-profile composers of musical revues, but each composer also wrote scores for musicals featuring narratives.

54. Altman, *Silent Film Sound*, 33–35.

55. Gänzl, *The Musical*, 159–60.

56. Ibid., 171.
57. Drowne and Huber, *The 1920s*, 197.
58. See Magee, "'Everybody Step.'"
59. Gänzl, *The Musical*, 171.
60. Ibid., 178–79.
61. McMillin, *The Musical as Drama*, 15–19.
62. Ibid., 128.
63. Exceptions do exist, however. George Gershwin's overture and entr'acte for *Girl Crazy* (1930), for example, features a series of tunes that are interwoven and thus repeat themselves frequently.
64. A leading tone refers to the seventh note of a scale. Conventionally, such a note "wants" to resolve by changing to the "tonic" note (the first note of the scale). Holding a leading tone thus offers a useful way to build expectation for the beginning of a vocal performance. To name one example, this technique is used each time a new woman sings "I Want to Be Happy" during the "Three Happies" number from *No, No, Nanette*. This can be heard on the CD for Youmans, *No, No, Nanette*.
65. A book-length discussion of this tendency can be found in McMillin, *The Musical as Drama*.
66. This example is on the CD for Youmans, *No, No, Nanette*.
67. Friml, Harbach, Hammerstein, and Stothart, *Rose-Marie*.
68. Kern, *Show Boat*.
69. In a compelling study of the conventions of stage musicals, McMillin argues that the orchestra is omniscient: it knows what is coming, understands the significance of plot turns, and so on. McMillin considers this orchestral omniscience to be a Wagnerian aesthetic: it features a "musical narrator" who grasps the innermost essence of things. For McMillin, even the orchestra's unseen presence in the pit suggests its ability to transcend the mere flesh-and-blood characters onstage. Though McMillin scarcely addresses song underscoring, this technique only furthers his argument (see *The Musical as Drama*, 126–48).
70. Levine, *Highbrow/Lowbrow*, 221.
71. Savran, "The Search for America's Soul," 474.
72. For a more detailed discussion of this characteristic of phonography and radio see Chanan, *Repeated Takes*, 8–9.
73. For evidence that the phonograph was originally conceived as a business technology, see Edison, "The Phonograph and Its Future."
74. Various aspects of this process are discussed in Thompson, "Machines, Music and the Quest for Fidelity"; and Katz, *Capturing Sound*, 54–61.
75. Wurtzler, *Electric Sounds*, 126–27.
76. Gelatt, *The Fabulous Phonograph*, 141–57.

77. Millard, *America on Record*, 92.
78. Kenney, *Recorded Music in American Life*, 89, 92.
79. For just two of the many discussions on this topic see Doerksen, *American Babel*, 2–20; and Hilmes, *Radio Voices*, 1–33.
80. Patnode, "'What These People Need Is Radio,'" 285–305.
81. Doerksen, *American Babel*, 2–20.
82. Barnouw, *A Tower in Babel*, 117–22.
83. Douglas, *Listening In*, 86.
84. Melnick, "Station R-O-X-Y," 220.
85. Barnouw, *A Tower in Babel*, 117–26.
86. Millard, *America on Record*, 27.
87. Ibid., 72–79.
88. Sound theorist James Lastra has claimed that the goal of phonographic recording was to approximate the concert hall in terms of "nuances of tone, performance, reverberation, and volume" (*Sound Technology and the American Cinema*, 163).
89. This concept is discussed in greater detail in Chanan, *Repeated Takes*, 58–59, though his primary focus is on phonography, not radio. Chanan's ideas, in turn, are inspired by Read and Welch, *From Tin Foil to Stereo*, 237–38.
90. Millard, *America on Record*, 137–43.
91. Gelatt, *The Fabulous Phonograph*, 219–28.
92. Barnouw, *A Tower in Babel*, 126.
93. Gelatt, *The Fabulous Phonograph*, 255.
94. Melnick, *American Showman*, 64–80.
95. Altman, *Silent Film Sound*, 289–320.
96. Some theaters employed many more musicians than this. Altman states that the Capitol Theatre, one of the premiere New York City motion picture palaces, featured "over seventy concert-level musicians" (*Silent Film Sound*, 300).
97. Altman, *Silent Film Sound*, 300–308.
98. Buhler, Neumeyer, and Deemer, *Hearing the Movies*, 264.
99. Altman, *Silent Film Sound*, 345–54.
100. Buhler, Neumeyer, and Deemer, *Hearing the Movies*, 268.
101. Altman, *Silent Film Sound*, 315.
102. Ibid., 345–65.
103. Ibid., 361.
104. This precise example appears in a 1914 *Moving Picture News* column, the author stating that such "kidding" in a serious film is "out of place." Quoted in Altman, *Silent Film Sound*, 224.
105. Altman, *Silent Film Sound*, 203–26, 367–88.
106. Ibid., 359–60.
107. Ibid., 370.

108. Ibid., 367–88.
109. Quoted in Buhler, Neumeyer, and Deemer, *Hearing the Movies*, 265. Their source is the "Manual of Instructions and Information for Publix Theatres Employees" (1926).
110. Altman offers an extensive list of pieces typically heard as overture numbers in *Silent Film Sound*, 308–19.
111. Altman, *Silent Film Sound*, 359–60.
112. Buhler, Neumeyer, and Deemer, *Hearing the Movies*, 268; Kalinak, *Settling the Score*, 58–60.
113. Altman, *Silent Film Sound*, 372–88.
114. Ibid., 379.
115. Ibid.
116. Ibid., 379–88.

2. MUSIC IN EARLY SYNCHRONIZED AND PART-TALKING FILMS

1. Buhler, Neumeyer, and Deemer, *Hearing the Movies*, 295.
2. Virtually the only films to receive scholarly attention for their music are *Don Juan* and *The Jazz Singer*. For an analysis of *Don Juan*'s music see Geduld, *The Birth of the Talkies*, 134–36. Discussions about music in *The Jazz Singer* include Buhler, Neumeyer, and Deemer, *Hearing the Movies*, 291–93; Rosenberg, "What You Ain't Heard Yet"; and Wolfe, "Vitaphone Shorts and *The Jazz Singer*."
3. Crafton, *The Talkies*, 10, 75.
4. Gomery, *The Coming of Sound*, 36.
5. According to Preston Hubbard, the *New York Times*, *Independent Literary Digest*, and *New York Commercial* all remarked about Vitaphone's ability to elevate the level of music in small towns and rural communities ("Synchronized Sound and Movie-House Musicians, 1926–29," 43). Crafton wryly points out that the redundant term "small hamlet" recurs in several press publications about the event, suggesting the influence of the Warner Bros. publicity machine (*The Talkies*, 73).
6. Kalinak, *Settling the Score*, 66.
7. Altman, *Silent Film Sound*, 391.
8. Riesenfeld, "Music and Motion Pictures," 61.
9. Crafton, *The Talkies*, 102.
10. Ibid., 88.
11. *Don Juan* featured original music by silent film score composer William Axt and music arrangement by Major Edward Bowes and David Mendoza, managing director and conductor, respectively, of the Capitol Theatre, a major motion picture venue in New York City. Hugo Riesenfeld, who compiled synchronized

scores before becoming general music director of United Artists in 1928, had until 1925 been a prominent music arranger and manager of the Rivoli, Rialto, and Criterion movie theaters in New York City, all three of which were known for providing a top-quality musical experience. Erno Rapee, another prominent creator of early synchronized scores and theme songs, was the music director of the Roxy Theatre. New York City was so important for film music in the early sound era that at least up through the middle of 1929, most films were sent to New York for music synchronization (David Mendoza, "The Theme Song," *American Hebrew*, March 29, 1929, 124).

12. Ibid.

13. For a full discussion of themes and leitmotifs in the late silent era see Altman, *Silent Film Sound*, 373–79.

14. Geduld, *The Birth of the Talkies*, 134–35.

15. Buhler, Neumeyer, and Deemer argue that this technique is typical in film music. A hero will often be provided with his own theme, while the heroine's theme will be tied to her relationship with the male, thus coercing the audience into thinking of the heroine solely in terms of that relationship (*Hearing the Movies*, 198).

16. The instrumentation and register of Buckwell's theme are similar to Wagner's leitmotif for Alberich, the dragon, and Hagen in the *Ring* cycle. All three characters are connected with greed, jealousy, and desire for power. I wish to thank Bob Cook for pointing out this connection.

17. Ross Melnick discusses "Angela Mia" and its success in *American Showman*, 318–23.

18. Another high-profile use of a theme song is "When Love Comes Stealing," from Universal's *The Man Who Laughs*. This example is particularly interesting for the extent to which the theme song actually disrupts the dramatic and somber tone of the film. During Gwynplaine's dramatic and lengthy escape from the royal court, fast-paced melodramatic action music is heard, yet when Gwynplaine finally escapes successfully and rows across a river to join his true love, Dea, at the end of the film, the music abruptly shifts to a romantic, soaring, vocally performed version of "When Love Comes Stealing," with only a single tonic note to serve as a transition. Though the effect is jarring, this salient transition does serve to remind audiences that "When Love Comes Stealing" is a separate commodity purchasable via phonograph record or sheet music.

19. *Variety*, Jan. 2, 1929, 29 (my emphasis).

20. Koszarski, "On the Record," 16.

21. Spring, "Pop Go the Warner Bros., et al.," 74–76.

22. *Variety*, Jan. 2, 1929, 21. It would be difficult to overstate the prevalent culture of song plugging during this period. For example, in September of 1929 Warner

Bros. sent the theme song "Love Will Find a Way," from the film *In the Headlines* (August 1929), to five hundred ministers in California. Along with the theme song, which was arranged for an organist and choir, Warner Bros. suggested a sermon that could be written on the topic. According to a *Film Daily* article, at least one church had already agreed to do this (*Film Daily*, Sept. 18, 1929, 1).

23. Mendoza, "The Theme Song," *American Hebrew*, March 29, 1929, 124.

24. For instance, synchronization was one of many issues that plagued various synchronized sound efforts in the 1907–9 period (Altman, *Silent Film Sound*, 158–66).

25. Carter, "Word-Painting." I am also indebted to Robert Cook for assisting me with this history.

26. Altman, Jones, and Tatroe explore this issue in greater detail in "Inventing the Cinema Soundtrack."

27. In *Unheard Melodies* Gorbman explores how the boundary between diegetic and nondiegetic music can be blurred, but she implies that this is done only in isolated circumstances by exceptional directors (22). Recent explorations into the ambiguities between diegetic and nondiegetic music include Stilwell, "The Fantastical Gap Between Diegetic and Nondiegetic"; Smith, "Bridging the Gap"; and Winters, "The Non-diegetic Fallacy." The scholar who has undertaken the most extensive consideration of the topic is David Neumeyer. For his evolving thoughts on this issue see his "Source Music, Background Music, Fantasy and Reality in Early Sound Film"; "Performances in Early Hollywood Sound Films"; and "Diegetic/Nondiegetic."

28. Crafton, *The Talkies*, 174.

29. *Variety*, Jan. 30, 1929, 14, 22.

30. According to Geduld, Silvers provided scores for three D. W. Griffith silent films: *Way Down East* (1920), *Dream Street* (1921), and *Isn't Life Wonderful* (1924) (*The Birth of the Talkies*, 187). Silvers thus had experience with continuous silent scoring practices before applying the technique to *The Jazz Singer*, *The Singing Fool*, and *Weary River*.

31. For the most thorough explanation of crisis historiography see Altman, *Silent Film Sound*, 15–23.

32. These claims are familiar to anyone with even a casual acquaintance with film history, and are far too numerous to cite here. See Crafton's *The Talkies*, 516–20, for a discussion of the erroneous claims made about *The Jazz Singer*.

33. Crafton, *The Talkies*, 275. Eight years after the publication of Crafton's book, Gomery reaches a similar conclusion in *The Coming of Sound*, though he inexplicably claims to be refuting Crafton's argument (55–61, 154).

34. Crafton, *The Talkies*, 81.

35. Charles Wolfe cogently argues that in certain respects the lack of *narrative* connections between many of the performances and the overarching story

also results in a more pronounced sense of division between silent and sound portions ("Vitaphone Shorts and *The Jazz Singer*," 67–75).

36. Mary Lee Bandy's notes on Vitaphone's feature-length films indicate that Warner Bros. provided separate discs for the musical numbers in *The Jazz Singer* (*The Dawn of Sound*, 50). Brief moments of silence on the soundtrack would have allowed the projectionist to change discs before and after each song.

37. A similar point is made in Buhler, Neumeyer, and Deemer, *Hearing the Movies*, 291. The authors admit, however, that the film does "hedge its bets" by also providing several recorded performances of synagogue singing.

38. Crafton, *The Talkies*, 275; Gomery, *The Coming of Sound*, 55–61, 154.

39. Barrios, *A Song in the Dark*, 49.

40. Michael Rogin refers to *The Singing Fool*'s music numbers in his analysis of the film's portrayal of ethnicity and gender roles (*Blackface, White Noise*, 142–50). The film's extensive underscoring, however, is not mentioned.

41. *The Singing Fool* makes prominent use of J .S. Zamecnik and Gaston Borch, both of whom composed music for silent film accompaniment.

42. This tally is based on Richard Barrios's breakdown of the film in *A Song in the Dark*. Barrios includes Jolson's performance of "The Spaniard Who Blighted My Life," which survives on the sound disc but not on film prints (52).

43. The authorship of this cue remains in question. The Warner Bros. cue sheet for *The Singing Fool* credits "Klemm" (no first name provided) with "Fanchonette." This likely refers to Gustav Klemm, a composer, conductor, and arranger who had provided music for some of Victor Herbert's later shows (Gould, *Victor Herbert*, 513–14). Complicating matters, however, is the fact that Louis Clapisson wrote the opera *Fanchonnette*, which features a tune with a similar rhythm and shape (three rising eighth-notes followed by a longer note). The keys differ, however, and the notes themselves do not precisely match. Perhaps Klemm adapted Clapisson's motif, and the filmmakers used Klemm's version in the film.

44. Rick Altman advances a similar argument for three other films released during this period: *The First Auto* (June 1927), *Lights of New York* (July 1928), and *Noah's Ark* (November 1928). For Altman these three films generally feature an on/off strategy in which different types of sounds remain "wholly uncoordinated" (Altman, Jones, and Tatroe, "Inventing the Cinema Soundtrack," 347). In chapter 3 I discuss this argument in relation to music practices.

45. *Film Daily*, Sept. 21, 1928, 1. Parts of this review are quoted in Crafton, *The Talkies*, 273.

46. Claims that rerecording was entirely avoided in the early sound era can be found in Prendergast, *A Neglected Art*, 22; and Brown, *Overtones and Undertones*, 56. Other scholars, including Barry Salt and Kathryn Kalinak, describe

rerecording as a rarely used process. See Salt, "Film Style and Technology in the Thirties," 30; and Kalinak, *Settling the Score*, 66.

47. Salt, "Film Style and Technology in the Thirties," 30; Gorbman, *Unheard Melodies*, 51; Gitt and Belton, "Bringing Vitaphone Back to Life," 267; Crafton, *The Talkies*, 240; Buhler, Neumeyer, and Deemer, *Hearing the Movies*, 310; and Wierzbicki, *Film Music*, 125.

48. Steiner, "Scoring the Film," 218. This quotation has been influential, appearing in several books on film music history, including Prendergast, *Film Music*, 22; and Brown, *Overtones and Undertones*, 56.

49. Prendergast (*A Neglected Art*, 22–23) and Brown (*Overtones and Undertones*, 56) discuss additional logistical and aesthetic problems related to providing music on the set. See also Gorbman, *Unheard Melodies*, 51; Kalinak, *Settling the Score*, 66; and Thompson and Bordwell, *Film History*, 216.

50. Gitt and Belton, "Bringing Vitaphone Back to Life," 265–66.

51. Geduld, *The Birth of the Talkies*, 165; Crafton, *The Talkies*, 240.

52. Jacobs, "The Innovation of Re-recording in the Hollywood Studios," 6–7.

53. Ibid., 6–14.

54. The conductor's part can be found in *The Singing Fool* music files, Warner Bros. Archives, University of Southern California.

55. Jacobs, "The Innovation of Re-recording in the Hollywood Studios," 11.

56. Gitt and Belton, "Bringing Vitaphone Back to Life," 266.

57. *George Groves*, 23–24. Jacobs quotes Groves's description of the Warner Bros. system ("The Innovation of Re-recording in the Hollywood Studios," 11), and his description matches closely the other two accounts in this paragraph.

58. James Stewart recited this description to sound technician and film historian Robert Birchard. I wish to thank Birchard for this information.

59. Spring, "Pop Go the Warner Bros., et al.," 78.

60. Ibid., 78–79.

61. Ibid.

62. These differing experiences have commonalities with Tom Gunning's influential argument presented in "The Cinema of Attractions," in which he argues that the first ten years of silent cinema offered a "cinema of attractions" rather than one of narrative absorption. The trajectory laid out in this section would suggest that Gunning's theory has great applicability to other moments of substantial technological change in film history, including the coming of sound.

63. Altman, *Silent Film Sound*, 22.

64. *Metronome*, Sept. 1928, 50.

65. *Film Daily*, Nov. 6, 1929, 11.

66. Ibid., 1–2.

67. *Film Daily*, Sept. 18, 1929, 1.

68. Buhler, Neumeyer, and Deemer, *Hearing the Movies*, 295.

69. See, e.g., Fones-Wolf, "Sound Comes to the Movies"; Hubbard, "Synchronized Sound and Movie-House Musicians, 1926–29"; and Kraft, *Stage to Studio*.

70. *Metronome*, Sept. 1928, 50.

71. *Metronome*, April 1929, 25.

72. *Metronome*, March 1929, 41.

73. *Metronome*, March 1930, 16.

74. Eisler and Adorno express a similar idea in *Composing for the Films*, 54.

75. *Variety*, July 24, 1929, 1.

3. Toward a Sparse Music Style

1. Crafton, *The Talkies*, 268.

2. One of the only sources to note *Lights of New York*'s extensive music is Eyman, *The Speed of Sound*, 176, a book that is not specifically about film music.

3. Altman, Jones, and Tatroe, "Inventing the Cinema Soundtrack," 351. It should also be noted that the film is not entirely consistent in terms of its spatio-acoustic logic. At one point no music is heard even though Hawk's door is open, while dialogue that takes place outside Hawk's door is sometimes accompanied by music and sometimes not, despite the fact that Hawk's office is right next to the dance floor. This would suggest that in spite of their best efforts, filmmakers did not always have a clear or consistent strategy for this early all-talking film.

4. Ibid., 351–52.

5. The same tune can be heard when Eddie asks his mother for money, and at the end of the film when Molly confesses to the killing of Hawk. The shared tune is so lacking in a clear melody, however, that it is likely that few if any audience members would have noticed.

6. *The Squall* music files, Warner Bros. Archives, University of Southern California.

7. Buhler, Neumeyer, and Deemer, *Hearing the Movies*, 295.

8. *Metronome*, May 1930, 25.

9. Altman, *Silent Film Sound*, 315, 318; Melnick, *American Showman*, 221. Axt collaborated with David Mendoza, a veteran of late silent-era accompaniment.

10. This claim is based mainly on the cue sheets that I have surveyed from Warner Bros. and Paramount during these years. This is admittedly not a comprehensive sample, as it includes only two studios, but based on my listening to films from other studios, compilations seem to be the dominant practice in this period.

11. Pool and Wright, *A Research Guide to Film and Television Music in the United States*, 65.

12. Buhler, Neumeyer, and Deemer, *Hearing the Movies*, 306.

13. Pool and Wright, *A Research Guide to Film and Television Music in the United States*, 28.

14. Ibid., 65.

15. For an early iteration of many of the claims discussed below see Steiner, "Scoring the Film."

16. Both Claudia Gorbman and Royal S. Brown argue for an aesthetic of realism (*Unheard Melodies*, 45–49; *Overtones and Undertones*, 57–58).

17. Evidence similar to what I have laid out for *The Singing Fool* and *The Squall* can be found in the files for *Sally* and *Golden Dawn* in the Warner Bros. Archives, University of Southern California.

18. The most prominent example is Gorbman, *Unheard Melodies*, 51. I make this claim myself in Slowik, "'The Plasterers' and Early Sound Cinema Aesthetics," 66.

19. Morgan, "Scoring, Synchronizing, and Re-recording Sound Pictures," 276.

20. Ibid., 285.

21. Ibid., 270–71, 275.

22. Jacobs, "The Innovation of Re-recording in the Hollywood Studios," 11.

23. Gitt and Belton, "Bringing Vitaphone Back to Life," 267.

24. Jacobs, "Innovation of Re-recording," 9–11, 30.

25. Ibid., 14–17.

26. In Fox's *Up the River*, for example, a prison conveniently features professional-caliber musicians who perform after lights out. In a different scene passengers on a New England hayride are serenaded by a choir, accordionist, saxophonist, and violinists, all of whom perform on the moving hayride.

27. Crafton, *The Talkies*, 355, 456. Claudia Gorbman writes, "The film industry would hardly have gone to the expense of reequipping all facets of production and exhibition had the enormous gain of the human voice not impelled it" (*Unheard Melodies*, 41). As I demonstrated in chapter 2, Hollywood sound films initially avoided the voice in favor of music-and-effects-only scores, but following this period, Hollywood did indeed attend closely to the representation of the voice.

28. Crafton *The Talkies*, 445–79. Rick Altman points out that around 1930, a sound concentrator, which was attached to the microphone, served to aid in the recording of intelligible dialogue ("The Technology of the Voice," 10).

29. Buhler, Neumeyer, and Deemer, *Hearing the Movies*, 301.

30. The only exception is Red Flack's single line of dialogue in the desert, which features nondiegetic music at a low volume.

31. "*Hell's Angels*" entry, *American Film Institute Catalog*; Crafton, *The Talkies*, 349–50.

32. Altman, *Silent Film Sound*, 380.

33. Buhler, Neumeyer, and Deemer write that by the late 1930s, opening titles often received a dramatic "musical theme whose beginning coincides with the main title," followed by a "second, more lyrical, and usually quieter theme" before concluding with an ending flourish and "winding down" into the film's first scene (*Hearing the Movies*, 166).

34. Scholarly work noting film music's easy slippage between diegetic and nondiegetic terrain includes Buhler, Neumeyer, and Deemer, *Hearing the Movies*, 66–67; Gorbman, *Unheard Melodies*, 4; Smith, "Bridging the Gap"; and Stilwell, "The Fantastical Gap Between Diegetic and Nondiegetic."

35. Crafton, *The Talkies*, 313–80.

36. *Alibi*'s pressbook states that the song "is being spotlighted by theatres, restaurants, dance halls, night clubs, radio stations and music stores." The pressbook further urges the exhibitor to find a singer to perform the song as the prologue to the film.

37. See Neumeyer, "Performances in Early Hollywood Sound Films," 50. Neumeyer defines "disengaged background music" as "music that interacts so little with the image track that it could be listened to separately and autonomously."

38. In an important article on the topic David Neumeyer uses diegetic factors like those listed in this paragraph to reach a similar conclusion: film music regularly incorporates characteristics of both source (diegetic) music and background (nondiegetic) music. For Neumeyer, even seemingly nondiegetic music like a stinger chord to denote shock can often be interpreted as a portrayal of a character's shocked state, thus granting the chord a small diegetic characteristic ("Performances in Early Hollywood Sound Films"). For one of Neumeyer's most recent discussions of diegetic and nondiegetic categorizations see "Diegetic/Nondiegetic." Jeff Smith similarly theorizes diegetic/nondiegetic distinctions in terms of several factors: "The music's relation to narrative space, the film narration's self-consciousness and communicativeness, and the music's aural fidelity" ("Bridging the Gap," 1). Smith, however, uses these factors as a means to claim that surprisingly few instances of music occupy murky diegetic/nondiegetic boundaries. This project, in contrast, suggests that various diegetic and nondiegetic factors in the early sound era cause the score to frequently rest somewhere between diegetic and nondiegetic poles.

39. For a discussion of the promotion of *Check and Double Check* see Wurtzler, *Electric Sounds*, 19–22.

40. Bellman, "Verbunkos," 425–26; Randel, "Verbunkos," 908.

41. I address this phenomenon in Borzage's films in "Love, Community, and the Outside World."

42. The main characters in Borzage's Oscar-winning *7th Heaven* (May 1927), for instance, establish a love space on the top floor apartment of a city building.

With a window overlooking the sky the lovers seem tied more closely to the heavens than to the earth. This theme would also be articulated in Borzage's follow-up film, *Street Angel* (April 1928), in which the couple's relationship is saved by a quasi-transcendental experience. For more on this tendency see Slowik, "Love, Community, and the Outside World."

43. This scenario is similar to the notion of the "valley," which Altman and Feuer cite as a characteristic of many film musicals. The valley is a utopian space in which two characters from entirely different worlds can come together (Altman, *The American Film Musical*, 86–87; Feuer, *The Hollywood Musical*, 72–73).

44. In a chapter on *The Big Trail* Scott Simmon writes, "Silent Westerns had previously exploited the scenic hardships of the route, so that *The Big Trail* arrived with a sense of overfamiliarity to critics—'only a noisy *Covered Wagon*,' *Variety* groused" (*The Invention of the Western Film*, 107).

45. *Billy the Kid*, another 1930 high-profile A western, was released in Realife, a different 70 mm widescreen process that, according to John Belton, used Grandeur cameras borrowed from Fox (*Widescreen Cinema*, 49).

46. See *Variety*, Oct. 29, 1930.

47. Belton, *Widescreen Cinema*, 48.

48. The differences between the versions can be determined by viewing the two-disc DVD release of *The Big Trail* (Twentieth Century Fox, 2008), which offers the film in both the Academy and Grandeur versions.

49. The release of *The Big Trail* was a major event for Fox. Not only was it the first film shot in Grandeur, but it was also an expensive production because of its massive scale and substantial amount of outdoor sound recording. For important recent work on the western see Kalinak, *How the West was Sung*; and Kalinak, *Music in the Western*.

50. If the beginning and end are not included as part of the running time, then *The Big Trail* still features music for approximately 25 percent of its total. Interestingly, this presence of nondiegetic music conflicts with the generally "naturalistic" approach to sound in *The Big Trail* identified in Stadel, "Natural Sound in the Early Talkie Western," 113–36.

51. Though I have not calculated percentages for every film viewed for this project, *The Big Trail* contains more music than the vast majority of the "all-talking" nonmusical films released between 1929 and the summer of 1931 that I viewed (see appendix for the specific films that I consulted).

52. Altman, *Silent Film Sound*, 39.

53. Slotkin, *Gunfighter Nation*, 1–26.

54. Brown, *Overtones and Undertones*, 8–9.

55. Slotkin, *Regeneration Through Violence*; Slotkin, *The Fatal Environment*; and Slotkin, *Gunfighter Nation*.

56. Slotkin, *Gunfighter Nation*, 1–26.

57. Ibid., 231–54.
58. As Scott Simmon points out, such overt engagement with American history and identity was typical of A westerns of the 1930s (*The Invention of the Western Film*, 99–113).
59. Discussing music during Hollywood's Golden Age, Mervyn Cooke writes, "It is a cliché for individual cues to end with some kind of interrupted cadence" (*A History of Film Music*, 83).
60. Kalinak, *Settling the Score*, 70. Kalinak takes Steiner's quotation from Max Steiner, "The Music Director," 392.
61. Kalinak, *Settling the Score*, 219. Either Steiner's or Kalinak's citations are in error, however. No mention of the score appears for the date and page number for the *Los Angeles Times* or *Hollywood Reporter* that Kalinak lists in a footnote.
62. Ibid., 70–71.
63. Contrary to Kalinak's claim, the musicians *do* appear on the screen in an extreme long shot. For Kalinak's take on the score see *Settling the Score*, 70.
64. An "open fifth" refers to two notes that are five scale intervals apart and span exactly seven semitones. In Western music, open fifths conventionally denote primitivism, particularly in relation to Native Americans. For a detailed look at the history of music in association with Native Americans see Pisani, *Imagining Native America in Music*.
65. Crafton makes a similar point in *The Talkies*, 376.
66. Chaplin, *My Autobiography*, 328. Quoted in Woal and Woal, "Chaplin and the Comedy of Melodrama," 11.
67. "*City Lights*" entry, *American Film Institute Catalog*.
68. Chaplin even described plans to build his own studio that would produce only silent films (Crafton, *The Talkies*, 360, 374).

4. INTERLUDE

1. Film musicals are beyond the scope of Brown, *Overtones and Undertones*; Gorbman, *Unheard Melodies*; and Kalinak *Settling the Score*. Cooke devotes seven pages to early sound musicals, but he offers no analysis of the scores for any of these films (see Cooke, *A History of Film Music*, 146–52).
2. Neumeyer, "Melodrama as a Compositional Resource," 63. In "Merging Genres in the 1940s," Neumeyer does state, "Technological limitations of recording and reproduction dictated that most sound films employing music in any significant way before 1932 were musicals—that is, feature-length films belonging to the romantic comedy genre but highlighting (not merely including) musical performances" (122). It is unclear, however, whether this "significant" use of music includes nondiegetic experimentation or merely the presentation of diegetic musical numbers.

3. Altman, *The American Film Musical*, 62–74.

4. Barrios, *A Song in the Dark*, 118. For Fehr and Vogel's discussion of background music in *Lullabies of Hollywood* see 88–91; Marmorstein's discussion of songwriters and their music during the early sound era can be found in *Hollywood Rhapsodies*, 36–67.

5. Altman, *Film/Genre*, 32.

6. *Variety*, Jan. 2, 1929, 9.

7. *Variety*, June 25, 1930, 102.

8. I am not including *The Singing Fool* as a musical because, as a part-talkie, its aesthetic was rather removed from theatrical antecedents. Trade press articles seldom if ever lumped the film together with the industry's tendency to produce "musical films."

9. Two lucid explanations of this process in *The Broadway Melody* can be found in Crafton, *The Talkies*, 236; and Buhler, Neumeyer, and Deemer, *Hearing the Movies*, 300.

10. Altman, *The American Film Musical*, 151.

11. Buhler, Neumeyer, and Deemer, *Hearing the Movies*, 320.

12. Gorbman, *Unheard Melodies*, 22–23.

13. All of these films also feature narratives about putting on a musical show or shows, which suggests the extent to which *The Broadway Melody* influenced subsequent musical production.

14. *Variety*, April 10, 1929, 1.

15. *Variety*, March 27, 1929, 1.

16. One *Variety* article mentions that because of Broadway's reduction in its number of plays, many Broadway showgirls were out of work. See *Variety*, August 4, 1929.

17. By November of 1929, *Variety*'s articles contain frequent references to Broadway's sudden decline. The articles regularly identify sound film and the stock market crash as the primary culprits.

18. Altman, *The American Film Musical*, 127.

19. Jane Feuer explores this point in *The Hollywood Musical*, 49–66.

20. In their early vaudeville years the Marx Brothers adopted a style that thrived on drawing attention to the artifice of the theater. According to historian Joe Adamson, the Marx Brothers' vaudeville acts included "Chico running up and down the aisles, Harpo riding up and down with the curtain, and everybody climbing up and down the backdrop. . . . In time they learned to play their audience like another instrument" (*Groucho, Harpo, Chico, and Sometimes Zeppo*, 46–47).

21. Jenkins, *What Made Pistachio Nuts?* 59–95.

22. The musical number "Hooray for Captain Spaulding / Hello I Must Be Going" and many of the comic scenes—including Groucho's riff on Eugene

O'Neill's play *Strange Interlude* and the intricately choreographed scenes involving adjacent bedrooms—were directly transplanted from the stage to
the film (Hischak, *Through the Screen Door*, 38–39; Mordden, *Make Believe*,
195–97).

23. For a discussion of characteristics of Viennese operetta as they relate to film
musicals, see Altman, *The American Film Musical*, 131–41.

24. Thompson, *Herr Lubitsch Goes to Hollywood*, 19.

25. Schertzinger wrote the full orchestra score to *Civilization* (1916). The score was
a great success and generated a major hit with "Peace Song" (Altman, *Silent
Film Sound*, 295–96).

26. This was the first film role for Jeanette MacDonald, who was previously known
only as a stage performer (Crafton, *The Talkies*, 334).

27. Feuer, *The Hollywood Musical*, 38.

28. Levinson, "Film Music and Narrative Agency."

29. Levinson writes, "What is roughly true is this: if a cue has significant narrative functions, whether or not it functions in addition nonnarratively, then it
is a narrative cue, whereas if a cue has no significant narrative function, then
it is an additive cue" ("Film Music and Narrative Agency," 278).

30. *New York Times*, Dec. 1, 1927.

31. Mordden, *Make Believe*, 173–74.

32. The film version of *Golden Dawn* retained "The Whip," "My Bwana," "We Two,"
"Dawn," "Little Girl, Little Girl (Mooda's Appeal)," and "Here in the Dark." This
information derives from the film's cue sheets, located in the Warner Bros. Archives, University of Southern California.

33. Louis Silvers, Warner Bros. music director, to E. H. Murphy, memorandum,
Feb. 26, 1930, Warner Bros. Archives, University of Southern California. According to the cue sheets, three songs—"Africa Smiles No More," "Jungle Bungalow," and "You Know the Type: A Tiger"—and a brief instrumental cue were
written for the film. Two other previously written favorites—"Rule Britannia"
and "It's a Long Way to Tipperary"—also occur briefly. Yet the rest of the
score consists entirely of Kálmán and Stothart music written for the stage.

34. Fleeger, "How to Say Things with Songs," 31.

35. *Golden Dawn* file, Warner Bros. Archives, University of Southern California.

36. Barrios, *A Song in the Dark*, 292.

37. In the 1920s Friml composed the massively successful stage operettas *Rose-
Marie* (1924) and *The Vagabond King* (1925).

38. Crafton, *The Talkies*, 409.

39. Trade journals during the 1930–31 season are filled with articles pertaining to
the musical's sudden decline. For secondary literature on the topic see Altman,
Film/Genre, 31–34; Barrios, *A Song in the Dark*, 323–41; and Fehr and Vogel,
Lullabies of Hollywood, 75–100.

40. *Variety*, Nov. 19, 1930, 4; Jan. 7, 1931, 22.

41. *Variety*, Nov. 5, 1930, 4.

42. Altman, *Film/Genre*, 31–34.

43. *Variety*, June 25, 1930, 1.

44. *Variety*, March 11, 1931, 3.

45. The oversaturation argument is most evident in press articles from 1931 that describe an impending revival of the musical, though this revival never in fact occurred. See, for instance, *Variety*, July 21, 1931, 6. The belief that musical numbers needed to be better integrated into the narrative was quite prevalent in the trade presses. For two examples see *Variety*, Feb. 18, 1931, 4; and *Film Daily*, August 12, 1931, 1.

46. This argument appears as early as July of 1930 from MGM executive producer Irving Thalberg, a man renowned for his sharp observation of studio trends and audience tastes; see *Variety*, July 9, 1930, 3.

47. Such a goal is mentioned explicitly in many trade publications in the period, including *Variety*, Feb. 18, 1931.

48. According to Fehr and Vogel, the team of DeSylva, Brown, and Henderson wrote fifteen songs for *Indiscreet*, with only two surviving in the film (*Lullabies of Hollywood*, 76).

49. Barrios, *A Song in the Dark*, 311.

50. In the Disney Silly Symphony *Ugly Duckling* (December 1931), a xylophone plays a downward run to match the Ugly Duckling's fall down a plank. Other actions, such as the Ugly Duckling jumping repeatedly on a bellows to save the lives of his fellow ducklings, are timed rhythmically to the sforzandos in the music, meaning that the image is at least partly following music here. Nor is mickey-mousing limited to Disney. Max Fleischer's Betty Boop cartoons use cymbals for body falls and whistles or downward notes for fast movements (such as leaps) in films such as *Dizzy Dishes* (August 1930) and *Barnacle Bill* (August 1930).

51. This is the central focus of Jenkins, *What Made Pistachio Nuts?*

52. For three examples see Gorbman, *Unheard Melodies*, 73–88; Kalinak, *Settling the Score*, 86–89; and Cooke, *A History of Film Music*, 85–86.

53. Cue sheets for *One Hour with You* can be found in the Paramount Pictures Corporation Music Archives, Paramount Pictures, Los Angeles.

54. Silent film music personnel sometimes made small changes in tempo, key, and instrumentation, yet the basic sequence of notes generally remained unaltered (Altman, *Silent Film Sound*, 372–75).

55. "*Applause*" entry, *American Film Institute Catalog*.

56. Prominent late 1920s Rodgers and Hart musicals include *The Garrick Gaieties* (1925), *A Connecticut Yankee* (1927), *Present Arms* (1928), and *Spring Is Here* (1929).

57. Altman, *The American Film Musical*, 153–55.

58. An "arpeggio" occurs when the notes of a chord are played in succession rather than simultaneously. An "ostinato" refers to the repetition of a phrase. Octave chords are the simultaneous playing of two notes in which one note is twice the frequency of the other. In musical terms this means that both notes have the same letter name.

59. Parallel movement means that each note of a chord moves in the same direction (either upward or downward in pitch) from one chord to the next. Except in particular circumstances, this technique is generally considered anathema in "serious" Western compositions.

60. The scene's footage has partially been lost, yet the song lyrics survive in the Paramount Pictures archive. According to archival records, the doctor's excised lines include, "A car needs ignition to keep in condition, and a woman needs something like that," and "A peach must be eaten, a drum must be beaten, and a woman needs something like that." Earlier in the song, Jeanette either sings or says to the doctor, "Before a single instrument you cram in me, tell me are you a man of noble birth?" These and other lines focusing on sex and MacDonald's body were edited out of the 1949 reissue, and the footage was subsequently lost. See Barrios, *A Song in the Dark*, 349, for additional information on these excisions.

61. Barrios writes that *The Big Broadcast* experienced particular success in smaller towns, where audiences had never been able to see their favorite radio stars perform (*A Song in the Dark*, 353).

62. *Thirds* refers to instances in which two notes span three scale intervals. In Western music, this is a common interval between notes of a chord.

63. For a succinct exploration of the crooner and his particular impact on women see McCracken, "God's Gift to Us Girls."

64. This note, and indeed the entire conductor's score, is located in the Paramount Pictures Corporation Music Archives, Paramount Pictures, Los Angeles.

65. Wurtzler, *Electric Sounds*, 258.

66. Gorbman, *Unheard Melodies*, 20.

67. Altman discusses this practice in detail in *Silent Film Sound*, 220–26.

68. This "aesthetics of realism" argument appears in Brown, *Overtones and Undertones*, 57–58; and Gorbman, *Unheard Melodies*, 45–49. In fairness Gorbman acknowledges that musical numbers tend to operate at a considerable remove from reality. Had Gorbman included musicals in her study, her assessment of the early sound period—which made extensive use of the musical genre—might be quite different.

69. Althusser, "Ideology and Ideological State Apparatuses," 170–77.

70. The notion that mainstream film music forges a covert collectivity is most closely associated with Gorbman. See especially *Unheard Melodies*, 53–69. Eisler

and Adorno also discuss music's tendency to foster a sense of inclusiveness in *Composing for the Films*, 21.

5. MUSIC AND OTHER WORLDS

1. Sources giving only cursory treatment to *Symphony of Six Million, Bird of Paradise*, or *The Most Dangerous Game* before moving to a more extensive analysis of *King Kong* include Brown, *Overtones and Undertones*, 62; Cooke, *A History of Film Music*, 87–88; MacDonald, *The Invisible Art of Film Music*, 25; and Thomas, *Music for the Movies*, 113. Two recent studies—Wierzbicki's *Film Music* and Platte's "Musical Collaboration in the Films of David O. Selznick"—do recognize the importance of these pre–*King Kong* scores, but neither study examines the ways in which these scores fit within broader film music tendencies in the period. For unusually extensive treatments of music in *Symphony of Six Million* and *Bird of Paradise*, respectively, see Long, *Beautiful Monsters*, 82–100; and Slobin, "The Steiner Superculture." A rare in-depth examination of a non-Steiner score from the period—Paramount's *Madame Butterfly*—can be found in Sheppard, "Cinematic Realism, Reflexivity and the American 'Madame Butterfly' Narratives."

2. Brown, *Overtones and Undertones*, 58; Buhler, Neumeyer, and Deemer, *Hearing the Movies*, 310; Gorbman, *Unheard Melodies*, 50–52; Kalinak, *Settling the Score*, 66–70.

3. Salt, "Film Style and Technology in the Thirties," 30.

4. Crafton, *The Talkies*, 438.

5. *Film Daily*, July 17, 1931, 1, 8.

6. *Film Daily*, Feb. 24, 1931, 1, 8.

7. *Film Daily*, July 17, 1931, 8.

8. Ibid., 1, 2.

9. Crafton traces early beliefs surrounding dialogue and sophistication in *The Talkies*, 447–60.

10. For a more detailed assessment of Eddie Cantor's early sound career see Jenkins, *What Made Pistachio Nuts?* 153–84.

11. *Film Daily*, Feb. 20, 1931, 1, 12.

12. *Film Daily*, Oct. 7, 1931, 1.

13. *Variety*, March 25, 1931, 2.

14. Altman, Jones, and Tatroe, "Inventing the Cinema Soundtrack," 353. According to these authors, this attention to total sound would remain a priority throughout the remainder of the classical Hollywood era.

15. Because of the downbeat nature of such a message, Paramount also offered exhibitors an alternative version featuring a happy ending (Balio, *Grand Design*, 245).

16. This statement is based on viewing the nonmusicals listed in the appendix from 1929 to 1931. As I indicated in chapter 3, *The Big Trail*—which features music for just under 30 percent of the film—constituted an unusually high percentage of music for the 1929–31 period.

17. Altman, *Silent Film Sound*, 372–75.

18. A time signature indicates the number of beats in a measure and which type of note receives a single beat. In the Switzerland scene the love theme shifts from four beats in a measure to three beats, lending the tune a waltz-like, romantic feel.

19. Many viewers would have known "Capriccio Italien," because the composition had been regularly featured as overture music during the silent years of the 1910s and 1920s (Altman, *Silent Film Sound*, 311).

20. I take my definition of the "B film" from film historian Brian Taves: B films occupied the bottom half of a double bill, featured leads with moderate to no box-office appeal, had limited budgets and shooting schedules, and ran between fifty-five and seventy minutes ("The B Film," 314).

21. Altman, *Silent Film Sound*, 311.

22. Rhodes, *White Zombie*, 109–10.

23. The theme song recurs in other places as well; it accompanies the opening and closing credits (the latter over a blank screen) and is played on a phonograph record.

24. MGM's *Possessed* (November 1931) similarly features a song, first performed diegetically, that recurs nondiegetically at later, narratively appropriate, points. Marian (Joan Crawford) entertains dinner guests by playing the piano and singing Joseph Meyer and Max Lief's "How Long Will It Last?" The song then recurs nondiegetically during moments when Marian fears that she will lose Mark (Clark Gable), the man she loves.

25. Stanfield, "An Excursion into the Lower Depths," 100.

26. Ibid.

27. The opening stage directions in Rice's play read, "Throughout the act and, indeed, throughout the play, there is constant noise. The noises of the city rise, fall, intermingle: the distant roar of the 'L' trains, automobile sirens and the whistles of boats on the river; the rattle of trucks and the indeterminate clanking of metals; fire-engines, ambulances, musical instruments, a radio, dogs barking and human voices calling, quarreling and screaming with laughter. The noises are subdued and in the background, but they never wholly cease" (*Street Scene*, 5).

28. George Gershwin's *Rhapsody in Blue* famously premiered in a 1924 concert titled "An Experiment in Modern Music." Music scholar David Schiff notes that many listeners understood *Rhapsody in Blue* as an epitome of the Jazz Age (*Gershwin*, 82), and the Jazz Age was strongly associated with modern, urban

life. Gershwin also recounted that the piece emerged from the sounds of the modern world, including the train's "steely rhythms" and "rattle-ty-bang. . . . I heard it as a sort of musical kaleidoscope of America—of our vast melting pot, of our unduplicated national pep, of our blues. Our metropolitan madness" (quoted in Pollack, *George Gershwin*, 297). The opening music's similarity to Gershwin's 1920s concert techniques in general is noted by Matthew Malsky. Commonalities include "jazzy syncopated figures and ornaments; moving accompanimental response lines in contrary motion with the melody; 'stinger' chords repeated in motor patterns; bold skips in the melodic line; pentatonic collections juxtaposed against expressive blue notes; a fragmentary, nondevelopmental, 'modular' form; and a striking orchestration" ("Sounds of the City," 110).

29. Salt, "Film Style and Technology in the Thirties," 27–28.
30. Bordwell, Staiger, and Thompson, *The Classical Hollywood Cinema*, 74; Buhler, Neumeyer, and Deemer, *Hearing the Movies*, 187.
31. Bordwell, Staiger, and Thompson, *The Classical Hollywood Cinema*, 74.
32. The second "montage sequence" description by Bordwell is problematic for a different reason. The shot in fact consists of the *shadow* of the clock cast upon a calendar, thus giving the audience the impression that a superimposition is *not* being used. Such a tactic runs counter to what would become the codified montage sequence, in which *overt* superimpositions help denote the passage of time.
33. Buhler, Neumeyer, and Deemer, *Hearing the Movies*, 188.
34. Said, *Orientalism*.
35. Slobin, "The Steiner Superculture," 4.
36. For a discussion of *The Merry Widow* and *Rose-Marie* as precursors to the "fairy-tale" musical see Altman, *The American Film Musical*, 135–40.
37. Altman, *Silent Film Sound*, 259. These titles are taken from the first volume of J. S. Zamecnik's *Sam Fox Moving Picture Music* (1913). For a broader account of the long history of exoticism in Western music see Locke, *Musical Exoticism*.
38. MacDonald, *The Invisible Art of Film Music*, 26; Thomas, *Music for the Movies*, 111–12. I wish to thank Nathan Platte for assistance with the musical milieu of Vienna and the musical background of Mahler.
39. MacDonald, *The Invisible Art of Film Music*, 26.
40. Palmer, *The Composer in Hollywood*, 69–74; Thomas, *Film Score*, 127–31.
41. By Steiner's own admission, Selznick encouraged the composer to provide an extensive score for *Symphony of Six Million* (see Thomas, *Film Score*, 77).
42. *Film Daily*, Sept. 26, 1932, 1.
43. Notable exceptions include a treatment of *Symphony of Six Million* in Long, *Beautiful Monsters* (82–100); and an analysis of both films in Platte, "Musical Collaboration in the Films of David O. Selznick" (38–55, 59–63).

44. *Symphony of Six Million* music files, Special Collections, Charles E. Young Research Library, UCLA.

45. Platte, "Musical Collaboration in the Films of David O. Selznick," 43.

46. Thomas, *Music for the Movies*, 113.

47. Long, *Beautiful Monsters*, 89–100.

48. Whitaker, "Lost Worlds and Forgotten Music."

49. Platte, "Musical Collaboration in the Films of David O. Selznick," 60.

50. *The Most Dangerous Game* music files, Special Collections, Charles E. Young Research Library, UCLA.

51. These labels appear in the music files for *Symphony of Six Million* and *The Most Dangerous Game*, Special Collections, Charles E. Young Research Library, UCLA.

52. Neumeyer, "Melodrama as a Compositional Resource," 66–84.

53. Neumeyer analyzes word painting in Beethoven's score to the opera *Fidelio* (1805) in "Melodrama as a Compositional Resource," 72.

54. In a 1937 studio memo Selznick implies his coinage of the term, writing that "an interpretation of each line of dialogue and each movement musically" is "what I term 'Mickey Mouse' scoring" (quoted in Platte, "Musical Collaboration in the Films of David O. Selznick," 36).

55. Steiner describes the click track in Thomas, *Film Score*, 79–80.

56. Curtis, "The Sound of Early Warner Bros. Cartoons," 195.

57. *New York Times*, Jan. 9, 1912.

58. See Balme, "Selling the Bird," 11–17. "Slack key" refers to music in which the strings are regularly retuned, thus producing a meandering, lingering sound.

59. Ibid., 13.

60. Ibid., 14.

61. Bergstrom, "Murnau in America," 454.

62. Quoted in ibid., 453.

63. This information derives from *Tabu*'s cue sheets, Paramount Pictures Corporation Music Archives, Paramount Pictures, Los Angeles.

64. For a brief overview of Polynesian music see Kaeppler, "The Music and Dance of Polynesia."

65. According to the *American Film Institute Catalog* entry on the film, some exteriors were shot on the Hawaiian Islands. Other locations included Santa Catalina Island, the RKO-Pathé lot in Culver City, and the First National lot in Burbank.

66. *Bird of Paradise* music files, Special Collections, Charles E. Young Research Library, UCLA.

67. Platte, "Musical Collaboration in the Films of David O. Selznick," 58–59.

68. On dual-focus narrative see Altman, *A Theory of Narrative*, 55–98.

69. Weinberg, review of *The American Film Institute Catalog of Motion Pictures Produced in the United States, Feature Films 1921–1930*, 62.

70. Sheppard, "Cinematic Realism." Sheppard points out that Harling's efforts to better approximate authentic Japanese music were somewhat compromised in the recording process (75).

71. Slotkin, *Gunfighter Nation*, 371.

72. Ibid. Rowlandson's story is titled *The Soveraignty and Goodness of God, Together with the Faithfulness of His Promises Displayed: Being a Narrative of the Captivity and Restauration of Mrs. Mary Rowlandson.* Slotkin describes the language of the captivity myth and Rowlandson's impact on the creation of this myth in *The Fatal Environment*, 51–80. Slotkin also discusses Rowlandson's work in detail in *Regeneration Through Violence*, 102–15.

73. Jacobs, *The Wages of Sin*, 27–42.

74. This quotation is taken from Colonel Jason S. Joy, head of the Association of Motion Picture Producers (AMPP), July 1932 (quoted in Sheppard, "Cinematic Realism," 79).

75. Sheppard, "Cinematic Realism," 77n46.

76. The first song is never named in the film, but studio correspondences refer to it as "You'll Fall in Love in Venice." Both songs were published as sheet music because of their frequent use in the film (Paramount Pictures Corporation Music Archives, Paramount Pictures, Los Angeles).

77. Baxter, *Just Watch!*; Jacobs, *The Wages of Sin*, 86–105.

78. For a more detailed discussion of script changes see Jacobs, *The Wages of Sin*, 86–105; and Baxter, *Just Watch!* 39–80.

79. *New York Times*, Sept. 26, 1932; *Variety*, Sept. 27, 1932.

80. Jacobs, *The Wages of Sin*, 92.

81. Silent cinema's distance from reality enabled film theorist Rudolf Arnheim to famously argue that silent cinema constituted an art form owing to its inability to fully capture reality (*Film as Art*). On "soft style" cinematography of the 1920s (which refers to blurred, diffused visuals) see Bordwell, Staiger, and Thompson, *The Classical Hollywood Cinema*, 287–93. The connection between dreams and silent cinema appears periodically in film scholarship. For instance, when discussing silent film stars, Jeanine Basinger writes, "Between them and the men and women in the seats was a strong connection forged in a quiet world of dreams and imagination" (*Silent Stars*, 7).

82. Bergman, *We're in the Money*, xii.

83. Interestingly, though Universal's tendency to use minimal music for its horror films holds for English versions, foreign-language versions sometimes contained more music. The Spanish language version of *Dracula*, for instance, features substantially more nondiegetic music than the English version. My thanks to Titas Patrikis for bringing this to my attention.

84. Spadoni, *Uncanny Bodies*, 54–60, 79, 101–2, 112–14.

6. REASSESSING *KING KONG*

1. Palmer, *The Composer in Hollywood*, 19.
2. MacDonald, *The Invisible Art of Film Music*, 25, 31.
3. Cooke, *A History of Film Music*, 88.
4. Buhler, Neumeyer, and Deemer, *Hearing the Movies*, 331. It bears mentioning that though the authors state that music emerges from the pit orchestra, no instruments are visible. The theater music is probably best considered plausibly diegetic.
5. Stilwell, "The Fantastical Gap Between Diegetic and Nondiegetic," 187.
6. Palmer, *The Composer in Hollywood*, 28.
7. Cooke, *A History of Film Music*, 88.
8. Gorbman, *Unheard Melodies*, 79.
9. Kalinak, *Settling the Score*, 71.
10. Quoted in ibid.
11. *Variety*, March 7, 1933, 14.
12. Thomas, *Film Score*, 74.
13. Brown, *Overtones and Undertones*, 62.
14. Wierzbicki, *Film Music*, 130.
15. Fred Steiner, liner notes to the LP *King Kong: Original 1933 Motion Picture Score*. Kalinak addresses differing accounts of *King Kong*'s orchestra size in *Settling the Score*, 223.
16. Information on *Symphony of Six Million*'s orchestra size can be found in the original conductor's score, Special Collections, Charles E. Young Research Library, UCLA. Information about *The Big Broadcast*'s orchestra size is based on recording logs housed in the Paramount Pictures Corporation Music Archives, Paramount Pictures, Los Angeles.
17. Cooke, *A History of Film Music*, 88.
18. Ibid. The musical representation is actually more complex than Cooke acknowledges. The brass-based music features themes that will come to be associated with Kong, the natives, and Ann Darrow. The string-oriented music, however, is merely a reorchestration of Kong's theme and plays during a title card of an ostensible "Old Arabian Proverb," which reads, "And lo, the beast looked upon the face of beauty. And it stayed its hand from killing. And from that day, it was as one dead." Musically, the opening indeed suggests both aggression and tenderness, but it reflects these values by reorchestrating Kong's theme.
19. Palmer, *The Composer in Hollywood*, 29.
20. Cooke, *A History of Film Music*, 88.
21. *King Kong* music files, Special Collections, Charles E. Young Research Library, UCLA.

22. Franklin, *"King Kong* and Film on Music," 98.
23. Gorbman, *Unheard Melodies,* 88; Platte, "Musical Collaboration in the Films of David O. Selznick," 53; MacDonald, *The Invisible Art of Film Music,* 32.
24. Cooke, *A History of Film Music,* 89.
25. Altman demonstrates that during the nickelodeon era, sound effects and music were so commonly intertwined that commentators treated the two terms as if they were virtually interchangeable (*Silent Film Sound,* 209–20).
26. Evans, *Soundtrack,* 29.
27. Cooke, *A History of Film Music,* 88.
28. Brown, *Overtones and Undertones,* 41; Cooke, *A History of Film Music,* 89.
29. Gorbman, "Scoring the Indian," 235–37. A "falling third" occurs when a melody lowers in pitch and features notes that are spaced apart by three scale intervals.
30. Ibid., 236.
31. The score for this passage can be viewed in Marks, *Music and the Silent Film,* 113. Marks also suggests that this tune is reminiscent of a Negro spiritual (156).
32. Slobin, "The Steiner Superculture," 10.
33. Ibid., 13.
34. Brown, *Overtones and Undertones,* 118; MacDonald, *The Invisible Art of Film Music,* 31; Cooke, *A History of Film Music,* 88. One of the first retrospective pieces that considers *King Kong*'s score also connects it to Debussy. Writing in 1937, Bruno David Ussher states that Steiner "work[ed] like a French impressionist of the Debussy period" ("Music in Current Pictures," *Hollywood Reporter,* Nov. 20, 1937, 14).
35. Brown, *Overtones and Undertones,* 118.
36. Cooke introduces *King Kong* with the following sentences: "Steiner's ambitious score for *King Kong* . . . is universally acknowledged as his most important achievement, one that almost single-handedly marked the coming-of-age of nondiegetic film music: it established a style and technique of scoring that was not only much imitated during the Golden Age, but continues to be reflected in mainstream narrative scoring practices to the present day. In many ways its turbulent and dissonant idiom was, in its filmic context, so outrageous for its time that many later scores—including Steiner's own—seem tame by comparison" (*A History of Film Music,* 88).
37. *Variety,* March 7, 1933, 14.
38. Ibid.
39. Mordaunt Hall, review of *King Kong, New York Times,* March 3, 1933.
40. Conversely, the airplanes that ultimately defeat Kong emit sounds that nearly drown out Kong's roars, thus suggesting that Kong has finally met a more powerful foe.
41. Franklin, *"King Kong* and Film on Music"; Platte, "Musical Collaboration in the Films of David O. Selznick," 63–72.

42. Thomas, *Music for the Movies*, 73; Evans, *Soundtrack*, 29; MacDonald, *The Invisible Art of Film Music*, 32; Slobin, "The Steiner Superculture," 8.

43. *Variety*, March 7, 1933, 14.

44. Platte points to the *Hollywood Herald* (Feb. 18, 1933) as one of the only reviews to mention the score ("Musical Collaboration in the Films of David O. Selznick," 69).

45. *"Four Frightened People"* entry, *American Film Institute Catalog*.

46. *"S.O.S. Iceberg"* entry, *American Film Institute Catalog*.

47. These percentages were obtained by noting the DVD time code corresponding to each point when the music starts and stops. The numbers are rounded to the nearest 5 percent.

48. This observation is based on the 240 films viewed for this project.

49. *The Black Cat* was shot in three weeks (including retakes), made on a budget of $95,745.31, and has a running time of sixty-five minutes (*American Film Institute Catalog*).

50. Brown, *Overtones and Undertones*, 58–61; Mandell, "Edgar Ulmer and *The Black Cat*," 46–47; Rosar, "Music for the Monsters," 402–5.

51. Universal's *The Mummy* (December 1932) bucked this trend by using a more significant amount of music. Yet the Universal horror film that preceded *The Black Cat*—*The Invisible Man* (November 1933)—featured nondiegetic music during only the film's beginning and end sequences. For an assessment of music in Universal's entire 1930s horror oeuvre—including *Dracula*, *Frankenstein*, *The Invisible Man*, and *The Black Cat*—see Rosar, "Music for the Monsters."

52. Mandell, "Edgar Ulmer and *The Black Cat*," 47; see also Isenberg, *Edgar G. Ulmer*, 56, 311n5.

53. Brown, *Overtones and Undertones*, 58–59; Mandell, "Edgar Ulmer and *The Black Cat*," 46–47; Rosar, "Music for the Monsters," 402–5.

54. Rosar, "Music for the Monsters," 393.

55. Mandell, "Edgar Ulmer and *The Black Cat*," 47.

56. *Variety*, April 25, 1933, 4.

57. Balio, *Grand Design*, 214.

58. For a discussion of the syntax of the "show musical" see Altman, *The American Film Musical*, 212.

59. Ripin, "Clavichord."

60. Platte similarly argues that *King Kong*'s status as a pop culture icon may have helped preserve the score ("Investigating the Emergence of the Hollywood Symphonic Score").

61. Gorbman, *Unheard Melodies*, 76–79.

62. Further indicating *Symphony of Six Million*'s importance for Golden Age music, Platte points out that in post–*King Kong* scores Steiner more commonly

drew on preexisting music and implemented less-dense orchestration, elements that characterize *Symphony of Six Million*, not *King Kong* ("Investigating the Emergence of the Hollywood Symphonic Score").

CONCLUSION

1. This is the periodization used in MacDonald, *The Invisible Art of Film Music*; and Prendergast, *A Neglected Art*. Other periodizations include the early 1930s to the mid-1950s (Cooke, *A History of Film Music*); the 1930s and 1940s (Gorbman, *Unheard Melodies*); and 1933 to 1949 (Wierzbicki, *Film Music*). In choosing 1935 to 1950, I am essentially taking the mean of these ranges.

2. Gorbman, *Unheard Melodies*, 73–91.

3. Kalinak, *Settling the Score*, 78–110.

4. MacDonald, *The Invisible Art of Film Music*, 41–45.

5. Gorbman, *Unheard Melodies*, 79–81.

6. Ibid., 83.

7. Flinn, *Strains of Utopia*, 109.

8. Ibid., 108–32.

9. Altman, *A Theory of Narrative*, 55–98.

10. Brown, *Overtones and Undertones*, 132.

11. Neumeyer, "Merging Genres in the 1940s," 125.

12. Caryl Flinn, citing a 1940 George Antheil article, states that film scores ran for roughly 25 to 50 percent of a classical Hollywood film (*Strains of Utopia*, 18). Based on my calculations for a handful of classical Hollywood films, the range is probably closer to 25 to 65 percent. Clear nondiegetic music occupies roughly 25 percent of *Laura* (1944), 35 percent of *Citizen Kane* and *The Best Years of Our Lives*, 40 percent of *Double Indemnity*, 45 percent of *Lost Horizon* and *The Song of Bernadette*, and 50 percent of *The Informer*. Nondiegetic music exceeds 50 percent, however, in *Captain Blood* and *Stagecoach* (both 55 percent), as well as *Bride of Frankenstein*, *Gone with the Wind*, and *Rebecca* (all 65 percent).

13. This quotation, which comes from Raksin himself, opens Kalinak's *Settling the Score* (xiii).

14. For instance, no music is heard when dialogue establishes characters and their situations on an airplane in *Lost Horizon*, in the town of Tonto in *Stagecoach*, on an airplane in *The Best Years of Our Lives*, or following the mysterious rescue of Calamity Jane in *The Paleface*.

15. Gorbman, *Unheard Melodies*, 89–90.

16. Altman, *Silent Film Sound*, 21–23.

BIBLIOGRAPHY

This list does not include newspaper or magazine articles, which are cited in full in the notes.

Adamson, Joe. *Groucho, Harpo, Chico, and Sometimes Zeppo: A History of the Marx Brothers and a Satire on the Rest of the World*. New York: Simon and Schuster, 1973.

Adorno, Theodor W. "A Social Critique of Radio Music." 1945. In *Strunk's Source Readings in Music History*, edited by Oliver Strunk, 1464–69. New York: Norton, 1998.

Allen, Robert C., and Douglas Gomery. *Film History: Theory and Practice*. New York: McGraw-Hill, 1985.

Althusser, Louis. "Ideology and Ideological State Apparatuses." 1970. In *Lenin and Philosophy and Other Essays*. Translated by Ben Brewster, 127–77. New York: Monthly Review Press, 1972.

Altman, Rick. *The American Film Musical*. Bloomington: Indiana University Press, 1987.

——. *Film/Genre*. London: BFI, 1999.

——. "An Interview with Rick Altman." *Velvet Light Trap* 51 (Spring 2003): 67–72.

——. "Introduction." In "Cinema/Sound," edited by Rick Altman. Special issue, *Yale French Studies* 60 (1980): 3–15.

——. *Silent Film Sound*. New York: Columbia University Press, 2004.

——. "The Technology of the Voice." *Iris* 3, no. 1 (1985): 3–20.

——. *A Theory of Narrative.* New York: Columbia University Press, 2008.

Altman, Rick, with McGraw Jones and Sonia Tatroe. "Inventing the Cinema Soundtrack: Hollywood's Multiplane Sound System." In Buhler, Flinn, and Neumeyer, *Music and Cinema*, 339–59.

American Film Institute Catalog. www.afi.com/members/catalog/search.aspx.

Arnheim, Rudolf. *Film as Art.* 1933. Berkeley: University of California Press, 1957.

Atkins, Irene Kahn. *Source Music in Motion Pictures.* Rutherford, NJ: Fairleigh Dickinson University Press, 1983.

Baker, David. "The Phonograph in Jazz History and Its Influence on the Emergent Jazz Performer." In *The Phonograph and Our Musical Life,* edited by H. Wiley Hitchcock, 45–51. Brooklyn, NY: Institute for Studies in American Music, 1977.

Balio, Tino. *Grand Design: Hollywood as a Modern Business Enterprise, 1930–1939.* New York: Scribner, 1993.

Balme, Christopher B. "Selling the Bird: Richard Walton Tully's *The Bird of Paradise* and the Dynamics of Theatrical Commodification." *Theatre Journal* 57, no. 1 (2005): 1–20.

Bandy, Mary Lea, ed. *The Dawn of Sound.* New York: Museum of Modern Art, 1989.

Banfield, Stephen. *Jerome Kern.* New Haven, CT: Yale University Press, 2006.

——. "Popular Song and Popular Music on Stage and Film." In *The Cambridge History of American Music,* edited by David Nicholls, 309–44. Cambridge: Cambridge University Press, 1998.

Barnouw, Erik. *A Tower in Babel.* New York: Oxford University Press, 1966.

Barrios, Richard. *A Song in the Dark: The Birth of the Musical Film.* 2nd ed. Oxford: Oxford University Press, 2010.

Basinger, Jeanine. *Silent Stars.* Hanover, NH: Wesleyan University Press, 1999.

Baxter, Peter. *Just Watch! Sternberg, Paramount and America.* London: BFI, 1993.

Beck, Jay, and Tony Grajeda, eds. *Lowering the Boom: Critical Studies in Film Sound.* Urbana: University of Illinois Press, 2008.

Belasco, David. *The Heart of Maryland.* 1895. In *"The Heart of Maryland" and Other Plays by David Belasco,* edited by Glenn Hughes and George Savage, 169–250. Princeton, NJ: Princeton University Press, 1941.

Bellman, Jonathan. "Verbunkos." In Sadie, *The New Grove Dictionary of Music and Musicians,* 26:425–26.

Belton, John. "Awkward Transitions: Hitchcock's 'Blackmail' and the Dynamics of Early Film Sound." *Musical Quarterly* 83, no. 2 (1999): 227–46.

——. "Technology and Aesthetics of Film Sound." In *Film Sound: Theory and Practice,* 63–72. New York: Columbia University Press, 1985.

——. *Widescreen Cinema.* Cambridge, MA: Harvard University Press, 1992.

Benjamin, Walter. "The Work of Art in the Age of Mechanical Reproduction." 1955. In Braudy and Cohen, *Film Theory and Criticism*, 791–811.

Berenstein, Rhona J. "White Heroines and Hearts of Darkness: Race, Gender, and Disguise in 1930s Jungle Films." *Film History* 6, no. 3 (1994): 314–39.

Bergman, Andrew. *We're in the Money: Depression America and Its Films*. New York: New York University Press, 1971.

Bergstrom, Janet. "Murnau in America: Chronicle of Lost Films." *Film History* 14, no. 3/4 (2002): 430–60.

——. "Murnau, Movietone and Mussolini." *Film History* 17, no. 2/3 (2005): 187–204.

Bordwell, David. *Making Meaning: Inference and Rhetoric in the Interpretation of Cinema*. Cambridge, MA: Harvard University Press, 1989.

——. *The Way Hollywood Tells It*. Berkeley: University of California Press, 2006.

Bordwell, David, Janet Staiger, and Kristin Thompson. *The Classical Hollywood Cinema: Film Style and Mode of Production to 1960*. New York: Columbia University Press, 1985.

Bordwell, David, and Kristin Thompson. *Film Art: An Introduction*. 9th ed. New York: McGraw-Hill, 2010.

Braudy, Leo, and Marshall Cohen, eds. *Film Theory and Criticism*. 6th ed. New York: Oxford University Press, 2004.

Brown, Royal S. *Overtones and Undertones: Reading Film Music*. Berkeley: University of California Press, 1994.

Broyles, Michael. "Art Music from 1860 to 1920." In *The Cambridge History of American Music*, edited by David Nicholls, 214–54. Cambridge: Cambridge University Press, 1998.

Buhler, James. "Wagnerian Motives: Narrative Integration and the Development of Silent Film Accompaniment." In *Wagner and Cinema*, edited by Jeongwon Joe and Sander L. Gilman, 27–45. Bloomington: Indiana University Press, 2010.

Buhler, James, Caryl Flinn, and David Neumeyer, eds. *Music and Cinema*. Hanover, NH: University Press of New England, 2000.

Buhler, James, David Neumeyer, and Rob Deemer. *Hearing the Movies: Music and Sound in Film History*. New York: Oxford University Press, 2010.

Carli, Philip C. "Musicology and the Presentation of Silent Film." *Film History* 7, no. 3 (1995): 298–32.

Carter, Tim. "Word-Painting." In Sadie, *The New Grove Dictionary of Music and Musicians*, 27:563–64.

Chanan, Michael. *Repeated Takes: A Short History of Recording and Its Effects on Music*. London: Verso, 1995.

Chaplin, Charles. *My Autobiography*. New York: Simon and Schuster, 1964.

Chion, Michel. *Audio-Vision: Sound on Screen*. Ed. and trans. Claudia Gorbman. New York: Columbia University Press, 1994.

Cohen, Annabel J. "Film Music: Perspectives from Cognitive Psychology." In Buhler, Flinn, and Neumeyer, *Music and Cinema*, 360–78.

Cooke, Mervyn. *A History of Film Music*. Cambridge: Cambridge University Press, 2008.

Crafton, Donald. *The Talkies: American Cinema's Transition to Sound, 1926–1931*. New York: Scribner, 1997.

Curtis, Scott. "The Sound of Early Warner Bros. Cartoons." In *Sound Theory/ Sound Practice*, edited by Rick Altman, 191–203. New York: Routledge, 1992.

Deathridge, John, and Carl Dahlhaus. *The New Grove Wagner*. London: Macmillan, 1984.

Deutsch, Stephen. "Music for Interactive Moving Pictures." In *Soundscape: The School of Sound Lectures, 1998–2001*, edited by Larry Sider, Diane Freeman, and Jerry Sider, 28–34. London: Wallflower, 2003.

Doerksen, Clifford J. *American Babel: Rogue Radio Broadcasters of the Jazz Age*. Philadelphia: University of Pennsylvania Press, 2005.

Douglas, Susan. *Listening In: Radio and the American Imagination*. Minneapolis: University of Minnesota Press, 2004.

Drowne, Kathleen, and Patrick Huber. *The 1920s*. Westport, CT: Greenwood Press, 2004.

Dunne, Michael. *American Film Musical Themes and Forms*. Jefferson, NC: McFarland, 2004.

Edison, Thomas. "The Phonograph and Its Future." *North American Review* 126 (May-June 1878): 527–36.

Eisler, Hanns, and Theodor Adorno. *Composing for the Films*. 1947. Atlantic Highlands, NJ: Athlone, 1994.

Evans, Mark. *Soundtrack: The Music of the Movies*. New York: Hopkinson and Blake, 1975.

Eyman, Scott. *The Speed of Sound: Hollywood and the Talkie Revolution, 1926–1930*. New York: Simon and Schuster, 1997.

Fehr, Richard, and Frederick G. Vogel. *Lullabies of Hollywood: Movie Music and the Movie Musical, 1915–1992*. Jefferson, NC: McFarland, 1993.

Feuer, Jane. *The Hollywood Musical*. Bloomington: Indiana University Press, 1982.

Fischer, Lucy. "*Applause*: The Visual and Acoustic Landscape." In *Sound and the Cinema: The Coming of Sound to American Film*, edited by Evan William Cameron, 182–201. Pleasantville, NY: Redgrave, 1980.

——. "1929: Movies, Crashes, and Finales." In *American Cinema of the 1920s: Themes and Variations*, edited by Lucy Fischer, 234–56. New Brunswick, NJ: Rutgers University Press, 2009.

Fleeger, Jennifer. "How to Say Things with Songs: Al Jolson, Vitaphone Technology, and the Rhetoric of Warner Bros. in 1929." *Quarterly Review of Film and Video* 27, no. 1 (2010): 27–43.

Flinn, Caryl. *Strains of Utopia: Gender, Nostalgia, and Hollywood Film Music.* Princeton, NJ: Princeton University Press, 1992.

Fones-Wolf, Elizabeth. "Sound Comes to the Movies: The Philadelphia Musicians' Struggle Against Recorded Music." *Pennsylvania Magazine of History and Biography* 118, no. 1/2 (1994): 3–31.

Franklin, Peter. "*King Kong* and Film on Music: Out of the Fog." In *Film Music: Critical Approaches*, edited by K. J. Donnelly, 88–102. New York: Continuum International, 2001.

Friml, Rudolf, Otto Harbach, Oscar Hammerstein, and Herbert Stothart. *Rose-Marie: A Musical Play.* New York: Harms, 1925.

Gabbard, Krin. *Jammin' at the Margins: Jazz and the American Cinema.* Chicago: University of Chicago Press, 1996.

Gänzl, Kurt. *The Musical: A Concise History.* Boston: Northeastern University Press, 1997.

Geduld, Harry M. *The Birth of the Talkies: From Edison to Jolson.* Bloomington: Indiana University Press, 1975.

Gelatt, Roland. *The Fabulous Phonograph, 1877–1977.* 1954. Rev. ed. New York: Macmillan, 1977.

George Groves: Sound Director. Interview by Elizabeth I. Dixon. Oral History Program, University of California Regents, University Library, UCLA, 1968.

Gitt, Robert, and John Belton. "Bringing Vitaphone Back to Life." *Film History* 5, no. 3 (1993): 262–74.

Goldmark, Daniel. *Tunes for 'Toons: Music and the Hollywood Cartoon.* Berkeley: University of California Press, 2005.

Gomery, Douglas. *The Coming of Sound: A History.* New York: Routledge, 2005.

——. *Shared Pleasures: A History of Movie Presentation in the United States.* Madison: University of Wisconsin Press, 1992.

Gorbman, Claudia. "Scoring the Indian: Music in the Liberal Western." In *Western Music and Its Others*, edited by Georgina Born and David Hesmondhalgh, 234–53. Berkeley: University of California Press, 2000.

——. *Unheard Melodies: Narrative Film Music.* Bloomington: Indiana University Press, 1987.

Gould, Neil. *Victor Herbert: A Theatrical Life.* New York: Fordham University Press, 2008.

Greenspan, Charlotte. "Irving Berlin in Hollywood: The Art of Plugging a Song in Film." *American Music* 22, no. 1 (2004): 40–49.

Grout, Donald Jay, and Hermine Weigel Williams. *A Short History of Opera.* 4th ed. New York: Columbia University Press, 2003.

Gunning, Tom. "The Cinema of Attractions: Early Film, Its Spectator and the Avant-Garde." 1986. In *Space, Frame, Narrative*, edited by Thomas Elsaesser, 56–62. London: BFI, 1990.

Hall, Roger A. *Performing the American Frontier, 1870–1906*. Cambridge: Cambridge University Press, 2001.

Hilmes, Michele. *Hollywood and Broadcasting: From Radio to Cable*. Urbana: University of Illinois Press, 1990.

——. *Radio Voices: American Broadcasting, 1922–1952*. Minneapolis: University of Minnesota Press, 1997.

Hirsch, Louis A., James Montgomery, and Otto Harbach. *Going Up*. New York: M. Witmark and Sons, 1918.

Hischak, Thomas S. *Through the Screen Door: What Happened to the Broadway Musical When It Went to Hollywood*. Lanham, MD: Scarecrow, 2004.

Horowitz, Joseph. *Classical Music in America: A History of Its Rise and Fall*. New York: Norton, 2005.

Hubbard, Preston J. "Synchronized Sound and Movie-House Musicians, 1926–29." *American Music* 3, no. 4 (1985): 429–41.

Isenberg, Noah. *Edgar G.. Ulmer: A Filmmaker at the Margins*. Berkeley: University of California Press, 2013.

Jacobs, Lea. "The Innovation of Re-recording in the Hollywood Studios." *Film History: An International Journal* 24, no. 1 (2012): 5–34.

——. "Unsophisticated Lady: The Vicissitudes of the Maternal Melodrama in Hollywood." *Modernism/Modernity* 16, no. 1 (2009): 123–40.

——. *The Wages of Sin: Censorship and the Fallen Woman Film, 1928–1942*. Madison: University of Wisconsin Press, 1991.

Jenkins, Henry. *What Made Pistachio Nuts? Early Sound Comedy and the Vaudeville Aesthetic*. New York: Columbia University Press, 1992.

Kaeppler, Adrienne L. "The Music and Dance of Polynesia." In *The Garland Encyclopedia of World Music*. Vol. 9, *Australia and the Pacific Islands*, edited by Adrienne L. Kaeppler and J. W. Love, 768–70. New York: Garland, 1998.

Kalinak, Kathryn. *How the West was Sung: Music in the Films of John Ford*. Berkeley: University of California Press, 2007.

——, ed. *Music in the Western: Notes from the Frontier*. New York: Routledge, 2012.

——. *Settling the Score: Music and the Classical Hollywood Film*. Madison: University of Wisconsin Press, 1992.

Katz, Mark. *Capturing Sound: How Technology Has Changed Music*. Berkeley: University of California Press, 2004.

Kenney, William Howland. *Recorded Music in American Life: The Phonograph and Popular Memory, 1890–1945*. Oxford: Oxford University Press, 1999.

Kern, Jerome, and Guy Bolton. *Sally: A New Musical Play in 3 Acts*. London: Chappell, 1921.

Kern, Jerome, and Oscar Hammerstein II. *Show Boat*. Milwaukee: Hal Leonard, 1927.

Koszarski, Richard. "On the Record: Seeing and Hearing the Vitaphone." In *The Dawn of Sound*, edited by Mary Lee Bandy, 15–21. New York: Museum of Modern Art, 1989.

Kraft, James P. *Stage to Studio: Musicians and the Sound Revolution, 1890–1950.* Baltimore: Johns Hopkins University Press, 1996.

Lack, Russell. *Twenty-Four Frames Under: A Buried History of Film Music.* London: Quartet, 1997.

Langer, Mark. "Flaherty's Hollywood Period: The Crosby Version." *Wide Angle* 20, no. 2 (1998): 38–57.

Lastra, James. "Film and the Wagnerian Aspiration: Thoughts on Sound Design and the History of the Senses." In Beck and Grajeda, *Lowering the Boom*, 123–40.

——. *Sound Technology and the American Cinema: Perception, Representation, Modernity.* New York: Columbia University Press, 2000.

Levine, Lawrence W. *Highbrow/Lowbrow: The Emergence of Cultural Hierarchy in America.* Cambridge, MA: Harvard University Press, 1988.

Levinson, Jerrold. "Film Music and Narrative Agency." In *Post-Theory: Reconstructing Film Studies*, edited by David Bordwell and Noël Carroll, 248–82. Madison: University of Wisconsin Press, 1996.

Locke, Ralph P. *Musical Exoticism: Images and Reflections.* New York: Cambridge University Press, 2009.

London, Justin. "Leitmotifs and Musical Reference in the Classical Film Score." In Buhler, Flinn, and Neumeyer, *Music and Cinema*, 85–98.

London, Kurt. *Film Music: A Summary of the Characteristic Features of Its History, Aesthetics, Technique; and Possible Developments.* London: Faber and Faber, 1936.

Long, Michael. *Beautiful Monsters: Imagining the Classic in Musical Media.* Berkeley: University of California Press, 2008.

MacDonald, Laurence E. *The Invisible Art of Film Music: A Comprehensive History.* New York: Ardsley House, 1998.

Magee, Jeffrey. "'Everybody Step': Irving Berlin, Jazz, and Broadway in the 1920s." *Journal of the American Musicological Society* 59, no. 3 (2006): 697–732.

Malsky, Matthew. "Sounds of the City: Alfred Newman's 'Street Scene' and Urban Modernity." In Beck and Grajeda, *Lowering the Boom*, 105–22.

Maltby, Richard. "The Production Code and the Hays Office." In Balio, *Grand Design*, 37–72.

Mandell, Paul. "Edgar Ulmer and *The Black Cat*." *American Cinematographer* 65, no. 9 (1984): 34–47.

Maretzek, Max. *Revelations of an Opera Manager in 19th-Century America: Crotchets and Quavers & Sharps and Flats.* 1855. New York: Dover, 1966.

Marks, Martin Miller. *Music and the Silent Film: Contexts and Case Studies, 1895–1924.* New York: Oxford University Press, 1997.

Marmorstein, Gary. *Hollywood Rhapsody: Movie Music and Its Makers, 1900 to 1975*. New York: Schirmer Books, 1997.

Matthew-Walker, Robert. *From Broadway to Hollywood: The Musical and the Cinema*. London: Sanctuary, 1996.

Mayer, David. "The Music of Melodrama." In *Performance and Politics in Popular Drama: Aspects of Popular Entertainment in Theatre, Film and Television, 1800–1976*, edited by David Bradby, Louis James, and Bernard Sharratt, 49–64. Cambridge: Cambridge University Press, 1980.

——, ed. *Playing Out the Empire: "Ben-Hur" and Other Toga Plays and Films, 1883–1908: A Critical Anthology*. Oxford: Clarendon Press, 1994.

Mayer, David, and Helen Mayer. "A 'Secondary Action' or Musical Highlight? Melodic Interludes in Early Film Melodrama Reconsidered." In *The Sounds of Early Cinema*, edited by Richard Abel and Rick Altman, 220–31. Bloomington: Indiana University Press, 2001.

McCarty, Clifford, ed. *Film Music 1*. New York: Garland, 1989.

McCracken, Allison. "'God's Gift to Us Girls': Crooning, Gender, and the Re-creation of American Popular Song, 1928–1933." *American Music* 17, no. 4 (1999): 365–95.

McLucas, Anne Dhu, ed. *Later Melodrama in America: "Monte Cristo" (ca. 1883)*. New York: Garland, 1994.

McMillin, Scott. *The Musical as Drama*. Princeton, NJ: Princeton University Press, 2006.

Melnick, Ross. *American Showman: Samuel "Roxy" Rothafel and the Birth of the Entertainment Industry, 1908–1935*. New York: Columbia University Press, 2012.

——. "Station R-O-X-Y: Roxy and the Radio." *Film History* 17, no. 2/3 (2005): 217–33.

Metz, Christian. "Aural Objects." 1980. In Braudy and Cohen, *Film Theory and Criticism*, 366–69.

Millard, A. J. *America on Record: A History of Recorded Sound*. Cambridge: Cambridge University Press, 2005.

Monson, Dale E. "Recitative." In Sadie, *The New Grove Dictionary of Opera*, 3:1251–56.

Mordden, Ethan. *Make Believe: The Broadway Musical in the 1920s*. New York: Oxford University Press, 1997.

Morgan, K. F. "Scoring, Synchronizing, and Re-recording Sound Pictures." *Transactions of the Society for Motion Picture Engineers* 13, no. 38 (1929): 268–85.

Neumeyer, David. "Diegetic/Nondiegetic: A Theoretical Model." *Music and the Moving Image* 2, no. 1 (2009): 26–39.

——. "Melodrama as a Compositional Resource in Early Hollywood Sound Cinema." *Current Musicology* 57 (Spring 1995): 61–94.

——. "Merging Genres in the 1940s: The Musical and the Dramatic Feature Film." *American Music* 22, no. 1 (2004): 122–32.

——. "Performances in Early Hollywood Sound Films: Source Music, Background Music, and the Integrated Sound Track." *Contemporary Music Review* 19, no. 1 (2000): 37–62.

——. "Source Music, Background Music, Fantasy and Reality in Early Sound Film." *College Music Symposium* 37 (Fall 1997): 13–20.

Ottenberg, June C. *Opera Odyssey: Toward a History of Opera in Nineteenth-Century America*. Westport, CT: Greenwood Press, 1994.

Palmer, Christopher. *The Composer in Hollywood*. London: Marion Boyars, 1990.

Patnode, Randall. "'What These People Need Is Radio': New Technology, the Press, and Otherness in 1920s America." *Technology and Culture* 44, no. 2 (2003): 285–305.

Paulin, Scott D. "Wagner and the Fantasy of Cinematic Unity: The Idea of the *Gesamtkunstwerk* in the History and Theory of Film Music." In Buhler, Flinn, and Neumeyer, *Music and Cinema*, 58–84.

Pierce, David. "'Carl Laemmle's Outstanding Achievement': Harry Pollard and the Struggle to Film *Uncle Tom's Cabin*." *Film History* 10, no. 4 (1998): 459–76.

Pisani, Michael. *Imagining Native America in Music*. New Haven, CT: Yale University Press, 2005.

——. Melos *and the 19th-Century Popular Drama: Theatres, Actors, Audiences, and Music*. Iowa City: University of Iowa Press, forthcoming.

——. *Music for the Melodramatic Theatre in Nineteenth-Century London and New York*. Iowa City: University of Iowa Press.

Platte, Nathan R. "Investigating the Emergence of the Hollywood Symphonic Score." Conference paper presented at the meeting of the American Musicological Society Midwest Chapter, Oakland University, Spring 2011.

——. "Musical Collaboration in the Films of David O. Selznick, 1932–1957." PhD diss., University of Michigan, 2010.

Pollack, Howard. *George Gershwin: His Life and Work*. Berkeley: University of California Press, 2006.

Pool, Jeannie Gayle, and H. Stephen Wright. *A Research Guide to Film and Television Music in the United States*. Lanham, MD: Scarecrow, 2010.

Prendergast, Roy M. *A Neglected Art: A Critical Study of Music in Films*. New York: New York University Press, 1977.

Preston, Katherine K. "The Music of Toga Drama." In Mayer, *Playing Out the Empire*, 23–29.

——. *Opera on the Road: Traveling Opera Troupes in the United States, 1825–60*. Urbana: University of Illinois Press, 1993.

Randel, Don Michael. "Verbunkos." In *The New Harvard Dictionary of Music*, ed. Don Michael Randel, 908. Cambridge, MA: Belknap, 1986.

Read, Oliver, and Walter T. Welch. *From Tin Foil to Stereo: Evolution of the Phonograph*. New York: Howard W. Sams, 1976.

Rhodes, Gary D. *"White Zombie": Anatomy of a Horror Film.* Jefferson, NC: McFarland, 2001.

Rice, Elmer L. *Street Scene, a Play in Three Acts.* New York: Samuel French, 1929.

Riesenfeld, Hugo. "Music and Motion Pictures." *Annals of the American Academy of Political and Social Science* 28 (Nov. 1926): 58–62.

Riis, Thomas L. "The Music and Musicians in Nineteenth-Century Productions of *Uncle Tom's Cabin.*" *American Music* 4, no. 3 (1986): 268–86.

Rimsky-Korsakov, Nicolas. *Principles of Orchestration, with Musical Examples Drawn from His Own Works.* 1922. New York: Dover, 1964.

Ripin, Edwin M. "Clavichord." In *The New Harvard Dictionary of Music,* edited by Don Michael Randel, 176–77. Cambridge, MA: Belknap, 1986.

Rogin, Michael. *Blackface, White Noise: Jewish Immigrants in the Hollywood Melting Pot.* Berkeley: University of California Press, 1996.

——. "Making America Home: Racial Masquerade and Ethnic Assimilation in the Transition to Talking Pictures." *Journal of American History* 79, no. 3 (1992): 1050–77.

Romberg, Sigmund, Otto Harbach, Oscar Hammerstein, and Frank Mandel. *The Desert Song.* New York: Warner Bros., 1927.

Rosar, William H. "Music for the Monsters: Universal Studios' Horror Film Scores of the Thirties." *Quarterly Journal of the Library of Congress* 40, no. 4 (1983): 390–421.

Rosenberg, Joel. "What You Ain't Heard Yet: The Languages of *The Jazz Singer.*" *Prooftexts* 22, nos. 1–2 (2002): 11–54.

Rushton, Julian. "The Art of Orchestration." In *The Cambridge Companion to the Orchestra,* edited by Colin Lawson, 92–111. New York: Cambridge University Press, 2003.

Sabaneev, Leonid. *Music for the Films.* Translated by S. W. Pring. London: Pitman and Sons, 1935.

Sadie, Stanley, ed. *The New Grove Dictionary of Music and Musicians.* 29 vols. New York: Grove, 2001.

——, ed. *The New Grove Dictionary of Opera.* 4 vols. London: Macmillan, 1992.

Said, Edward W. *Orientalism.* New York: Pantheon, 1978.

Salt, Barry. "Film Style and Technology in the Thirties." *Film Quarterly* 30, no. 1 (1976): 19–32.

Sanjek, Russell. *American Popular Music and Its Business: The First Four Hundred Years.* 3 vols. New York: Oxford University Press, 1988.

Savran, David. "The Search for America's Soul: Theatre in the Jazz Age." *Theatre Journal* 58, no. 3 (2006): 459–76.

Schatz, Thomas. *The Genius of the System: Hollywood Filmmaking in the Studio Era.* New York: Pantheon, 1988.

Schiff, David. *Gershwin: Rhapsody in Blue*. Cambridge: Cambridge University Press, 1997.

Shapiro, Anne Dhu. "Action Music in American Pantomime and Melodrama, 1730–1913." *American Music* 2, no. 4 (1984): 50–72.

Sheppard, W. Anthony. "Cinematic Realism, Reflexivity, and the American 'Madame Butterfly' Narratives." *Cambridge Opera Journal* 17, no. 1 (2005): 59–93.

Simmon, Scott. *The Invention of the Western Film: A Cultural History of the Genre's First Half-Century*. Cambridge: Cambridge University Press, 2003.

Slobin, Mark. "The Steiner Superculture." In *Global Soundtracks: Worlds of Film Music*, edited by Mark Slobin, 3–35. Middletown, CT: Wesleyan University Press, 2008.

Slotkin, Richard. *The Fatal Environment: The Myth of the Frontier in the Age of Industrialization, 1800–1890*. New York: Atheneum, 1985.

——. *Gunfighter Nation: The Myth of the Frontier in Twentieth-Century America*. New York: Atheneum, 1992.

——. *Regeneration Through Violence: The Mythology of the American Frontier, 1600–1860*. Middletown, CT: Wesleyan University Press, 1973.

Slotten, Hugh Richard. "Radio's Hidden Voice: Noncommercial Broadcasting, Extension Education, and State Universities During the 1920s." *Technology and Culture* 49, no. 1 (2008): 1–20.

Slowik, Michael. "Love, Community, and the Outside World: The Visualization of Utopian Space in the Films of Frank Borzage." MA thesis, University of Chicago, 2005.

——. "The Plasterers and Early Sound Cinema Aesthetics." *Music, Sound, and the Moving Image* 4, no. 1 (2010): 55–75.

Smith, Jeff. "Bridging the Gap: Reconsidering the Border Between Diegetic and Nondiegetic Music." *Music and the Moving Image* 2, no. 1 (2009): 1–25.

Spadoni, Robert. *Uncanny Bodies: The Coming of Sound Film and the Origins of the Horror Genre*. Berkeley: University of California Press, 2007.

Spring, Katherine. "Pop Go the Warner Bros., et al.: Marketing Film Songs During the Coming of Sound." *Cinema Journal* 48, no. 1 (2008): 68–89.

Stadel, Luke. "Natural Sound in the Early Talkie Western." *Music, Sound, and the Moving Image* 5, no. 2 (2011): 113–36.

Stanfield, Peter. "An Excursion into the Lower Depths: Hollywood, Urban Primitivism, and 'St. Louis Blues,' 1929–1937." *Cinema Journal* 41, no. 2 (2002): 84–108.

Steiner, Fred. Liner notes to *King Kong: Original 1933 Motion Picture Score*. Southern Cross Records, 1976, LP.

Steiner, Max. "The Music Director." In *The Real Tinsel*, edited by Bernard Rosenberg and Harry Silverstein, 387–98. London: Macmillan, 1970.

———. "Scoring the Film." In *We Make the Movies*, edited by Nancy Naumberg, 216–38. New York: Norton, 1937.

Stilwell, Robynn J. "The Fantastical Gap Between Diegetic and Nondiegetic." In *Beyond the Soundtrack: Representing Music in Cinema*, edited by Daniel Goldmark, Lawrence Kramer, and Richard Leppert, 184–202. Berkeley: University of California Press, 2007.

Tankel, Jonathan D. "The Impact of *The Jazz Singer* on the Conversion to Sound." *Journal of the University Film Association* 30, no. 1 (1978): 21–25.

Taves, Brian. "The B Film: Hollywood's Other Half." In Balio, *Grand Design*, 313–50.

Thomas, Tony. Film Score: The Art and Craft of Movie Music. Burbank: Riverwood, 1991.

———. *Music for the Movies*. Los Angeles: Silman-James, 1997.

Thompson, Emily. "Machines, Music and the Quest for Fidelity: Marketing the Edison Phonograph in America, 1877–1925." *Musical Quarterly* 79, no. 1 (1995): 131–71.

———. *The Soundscape of Modernity: Architectural Acoustics and the Culture of Listening in America*. Cambridge, MA: MIT Press, 2002.

Thompson, Kristin. *Herr Lubitsch Goes to Hollywood: German and American Film After World War I*. Amsterdam: Amsterdam University Press, 2005.

Thompson, Kristin, and David Bordwell. *Film History: An Introduction*. New York: McGraw-Hill, 1994.

Tierney, Harry, Joseph McCarthy, and James Montgomery. *Irene: A Musical Comedy in Two Acts*. London: Francis, Day and Hunter, 1920.

Vaillant, Derek W. "Sounds of Whiteness: Local Radio, Racial Formation, and Public Culture in Chicago, 1921–1935." *American Quarterly* 54, no. 1 (2002): 25–66.

Weinberg, Herman G. Review of *The American Film Institute Catalog of Motion Pictures Produced in the United States, Feature Films 1921–1930*. *Film Quarterly* 25, no. 2 (1971–72): 59–64.

Whitaker, Bill. "Lost Worlds and Forgotten Music: Max Steiner's Legendary RKO Scores." *The Son of Kong / The Most Dangerous Game*. Naxos Film Music Classics, cat. no. 8.570183, 2006, CD liner notes. www.naxos.com.

Whitcomb, Ian. *After the Ball: Pop Music from Rag to Rock*. New York: Simon and Schuster, 1972.

Whitfield, Stephen J. "Is It True What They Sing About Dixie?" *Southern Cultures* 8, no. 2 (2002): 9–37.

Whittall, Arnold. "Leitmotif." In Sadie, *The New Grove Dictionary of Opera*, 2:1137–41.

Wierzbicki, James. *Film Music: A History*. New York: Routledge, 2009.

Winters, Ben. "The Non-diegetic Fallacy: Film, Music, and Narrative Space." *Music and Letters* 91, no. 2 (2010): 224–44.

Woal, Michael, and Linda Kowall Woal. "Chaplin and the Comedy of Melodrama." *Journal of Film and Video* 46, no. 3 (1994): 3–15.

Wolfe, Charles. "Vitaphone Shorts and *The Jazz Singer.*" *Wide Angle* 12, no. 3 (1990): 58–78.

Wurtzler, Steve J. *Electric Sounds: Technological Change and the Rise of the Corporate Mass Media.* New York: Columbia University Press, 2007.

Youmans, Vincent. *No, No, Nanette: Original Broadway Cast Recording.* 1971. New York: Columbia Broadway Masterworks, 1999, CD.

Young, William H. *The 1930s.* Westport, CT: Greenwood Press, 2002.

INDEX

Hanley, James F., 119, 188
Hanson, Paul, 261
Harbach, Otto, 156
Hardy, Oliver, 253
Harling, W. Franke, 166, 197, 201, 208, 213, 214, 216, 218, 222, 225, 272
Hart, Lorenz, 167, 198
"Hatikvah" (song), 201
Haunted Gold (film), 299
Hawk (character Lights of New York), 89, 91, 92
Hayden, Joe, 194
Hayes, Helen, 184
The Heart of Maryland (melodrama), 19
Helen (character Blonde Venus), 223, 224, 225, 226
Hell's Angels (film), 106, 107, 110, 111, 117, 287
Hemingway, Ernest, 184
Henderson, Ray, 113, 143, 161
Hepburn, Katherine, 259
Herbert, Victor, 23, 197
"Here in the Dark" (song), 158
Herkan, Hen, 188
high-class music, 29, 34. See also classical music
High Voltage (film), 283
hillbilly music, 31
His Double Life (film), 307
His Private Secretary (film), 303
A History of Film Music (Cooke), 4, 230
Hitchcock, Alfred, 275
Hitu (character Tabu), 207, 208
Hjalmar Poelzig (character The Black Cat), 255, 256
Hobart, Rose, 120
Hollywood musicals: The Big Broadcast and music's assault on reality, 172–77; The Cocoanuts and presentational aesthetics, 148–50; decline of, 1931–1932, 160–62; defining, 138–40; Golden Dawn and total musical immersion, 156–60; Love Me Tonight and musical reflexivity, 166–72; The

Love Parade and the assertive score, 150–56; One Hour with You and the escalation of assertive music, 162–66; original musicals, 1929–1930, 140–46; overview, 136–37; stagestruck musicals, 1929–1930, 146–60
Hollywood Reporter, 5, 131
The Hollywood Revue of 1929 (film), 284
Hollywood Rhapsody (Marmorstein), 137
Homer (character The Best Years of Our Lives), 272
Hoopi, Sol, 209
"Hooray for Captain Spaulding/Hello I Must Be Going" (song), 150
Hoover, Herbert, 31
Hope, Bob, 273
Hopkins, Miriam, 218
Horowitz, Joseph, 17
Horse Feathers (film), 297
Horton, Edward Everett, 218
"A Hot Time in the Old Town" (song), 172, 194
The House of Mystery (film), 310
"How Dry I Am" (song), 134, 211, 254
human element (in film music), 80–86
Hungarian Dance no. 3 (Brahms), 94
The Hurricane (film), 269
hurry music, 20, 250
Huston, Walter, 190

"If I Had a Talking Picture of You" (song), 144, 145
"I'll Be Glad When You're Dead You Rascal You" (song), 174
Illegal (film), 298
illustrated song slides, 38
"I'm a Dreamer (Aren't We All?)" (song), 144, 145
image, musical styles suggested by, 56
image sources, 4, 10, 102, 108, 142, 148, 152, 254. See also source in the image
Imitation of Life (film), 314
I'm No Angel (film), 305
"Impish Elves" (song), 63, 64

FILM AND CULTURE
A series of Columbia University Press
EDITED BY JOHN BELTON